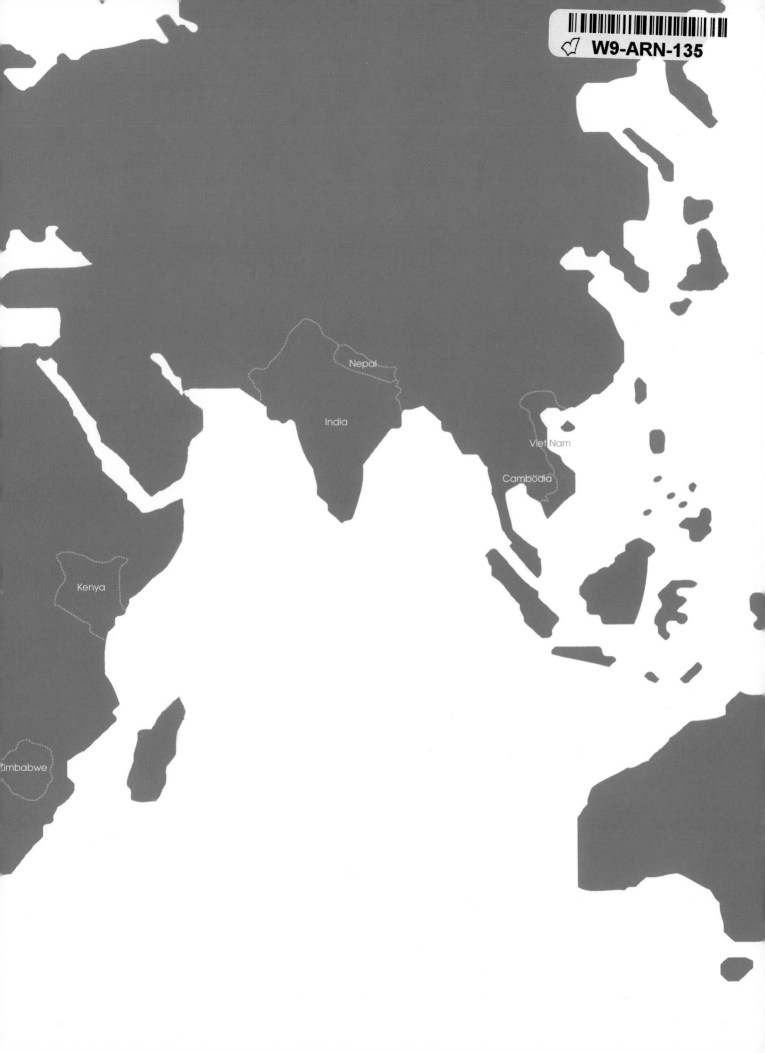

W9-ARN-135

WOMEN
WHO LIGHT
THE DARK

Paola Gianturco

powerHouse Books

Brooklyn, NY

TABLE OF CONTENTS

Introduction		4
Foreword		6
Zimbabwe	Empowering Girls	8
Viet Nam	Dealing with Domestic Violence	28
Cuba	Nourishing Dreams	40
Morocco	Redefining Rights	50
Ecuador	Claiming Power	66
Argentina	Creating Safe Haven	78
Slovakia	Ending Discrimination	98
Brazil	Educating Girls	112
Nepal	Expanding Opportunities	126
Kenya	Accessing Water	142
India	Taking Schools to Children	160
Cambodia	Thwarting Sex Traffickers	168
Nicaragua	Training Tradeswomen	184
Cameroun	Preventing AIDS, Helping Orphans	198
USA	Enabling Leaders	214
Acknowledgements		233
Information, Contacts, and Bibliography		234
Index		237

INTRODUCTION

Across the world, local women are helping one another tackle the problems that darken their lives—domestic violence, sex trafficking, war, poverty, illiteracy, discrimination, inequality, malnutrition, disease. These women may lack material resources, but they possess a wealth of an even more precious resource: imagination. And their imaginations light the dark.

Moroccan women create and produce plays that educate illiterate people about women's rights. Girls in Zimbabwe compose and perform poetry that shocks communities into fighting child rape. In Viet Nam, counselors heal survivors of domestic violence—who are so traumatized that they won't allow themselves to be touched—by turning on music and starting line dances. Teachers in India invent puppet shows that help homeless children understand AIDS. Brazilian math teachers inspire girls from the favelas to learn arithmetic by originating fashion shows. Roma women in Slovakia collaborate with non-Roma women to design postcards, kindling communication in place of suspicion. Lesbians in Argentina develop and stage street skits, demonstrating against discrimination. A master ballet teacher instructs a thousand poor Cuban children in classical dance.

Sometimes imagination takes the form of innovative strategies. In Nepal, women teach their sisters to drive taxis and guide treks, and in Nicaragua, to become welders, carpenters, and, electricians—all supposedly "men's jobs." In Kenya, mothers get wells dug so their daughters can go to school instead of walking seven hours to fetch water. In Cambodia, doctors and nurses conduct mobile clinics and arrange loans to give indigent women the health and funds to start businesses, foiling sex traffickers who try to lure women with promises of income. In Cameroun, medical specialists train traditional rulers and healers whose behavior has inadvertently spread AIDS to become health educators. Activists in the United States introduce women with disabilities to camping, whitewater rafting, ropes challenge courses, and swimming, empowering them to lead others who are disabled.

I first noticed women who light the dark while working on other books. *¡Viva Colores!* took me to one country, *In Her Hands* to twelve, *Celebrating Women* to fifteen. Over the past ten years, I have photographed and interviewed women in 40 countries. The grassroots groups I met were using a new form of collective leadership in which staff, volunteers, and beneficiaries united to quell intractable problems. Their energy, initiative, and imagination took my breath away.

The idea of creating a photographic book began percolating. Surely in a world full of bad news, good news would be heartening. At a time when the international women's movement faces challenges, women's successes would be a reminder that positive change is underway. Because nonprofit enterprises have limited resources, reading the women's stories might inspire others to help. A woman from Rwanda urged me on: "Show what we are doing," she said, "Show that we are capable of helping ourselves and are worthy of respect. Show others how to march with us."

My research identified grassroots women's groups that met four criteria: organizations that were effective, represented different human rights issues, were geographically dispersed, and whose activities might make interesting photographs. (The women's creativity was not a criterion, it was a serendipitous discovery.)

I photographed in Cuba in 2001 and in India in 2005. Some of the next groups I wanted to visit were grantees of the Global Fund for Women whose work I follow and support. I went to see my friend Kavita Ramdas, President and CEO, to ask for introductions. Frankly, I was worried that my idea might seem old hat to her since The Global Fund has made 5,000 grants to local women's groups in 164 countries. Instead, Kavita's face lit up, "Well, this is synchronicity indeed! We were going to call you, Paola. The Global Fund for Women will celebrate its 20th anniversary in 2007 and we would love to have our grantees' work documented in a book." We agreed that I would choose the groups to feature and write the text without the organization's direction or review. After reading hundreds of grantee profiles shared by program officers, I made my selection. A staff member helped with arrangements; I spent one week with

each of eighteen grantees, and visited five other groups, in 2006. The fifteen chapters in this book are snapshots of life (and facts) at the time I visited.

Upon arrival in each country, I introduced myself as an independent photojournalist so no one would worry that what they told me might affect future Global Fund grant decisions. I also explained that I did not consider this "my book." I said, "Your chapter will be as interesting as you and I can make it together." The women not only contributed ideas for pictures and stories, they made time to record hours of conversation so their opinions and experiences could be expressed in their own words. Their interpreters translated the interviews and later fact-checked the manuscript. The book in your hands is, indeed, "our book."

Eager to have you accompany me on this journey, I decided to write in the first person present tense and, when appropriate, use camera angles shot from the center of the action. You will sit with me on the floor talking with sex workers; interview members of parliament; visit a shanty where a baby is starving; climb Annapurna (well, 7,000 feet of it) with burning lungs; watch a traditional healer at work; ride in a taxi while political protesters are taken prisoner only blocks away; attend a party with ambassadors, rabbis, bishops, and cabinet ministers; eat lunch as soldiers carry sandbags to the roof and prepare for battle; witness a ceremony that welcomes indigenous babies to the world.

By purchasing this book, you have already begun to help women who light the dark because the author's royalties will be given to the Global Fund for Women. The gift is timely due to their 20th anniversary, but it was not motivated by that event. When *In Her Hands* was published in 2000, the Global Fund for Women was one of the nonprofit organizations that received the authors' royalties. That gift and this one were inspired by four facts. Global Fund applicants can request grants with letters handwritten in their own languages. The organization treats its staff, donors, and beneficiaries as equals: a poor woman in Bangladesh who contributes a dollar is acknowledged alongside affluent Americans who give thousands. The Global Fund for Women isn't resting on its laurels even though it is now the largest fund in the world that exclusively supports women-led organizations advancing human rights; it is sharing its experience and seeding women's funds in eighteen countries, all to encourage local philanthropy. Most of all, Global Fund grantees, using creativity as leverage, are transforming life for themselves, their families and communities, and our world.

After *In Her Hands* was published, $110,000 was donated by readers, none of whom I knew, to indigent women around the world. When I revisited India after a devastating earthquake, I wept when I saw women rebuilding their houses with money a generous reader had wired. Standing in the Gujarat wind, I remembered a poem by Marge Piercy who could have been writing about those readers and the women in this book:

> It goes on one at a time,
> it starts when you care
> to act, it starts when you do
> it again after they said no,
> it starts when you say *We*
> and know who you mean, and each
> day you mean one more.

The women you are about to meet are showing us how to use our time, talent, resources and imagination to cause change. I hope their stories will inspire you to join them, perhaps by supporting organizations like the Global Fund for Women, for surely it will take all of us working together to kindle new hope and possibilities for our world.

—Paola Gianturco

FOREWORD

"Unlike any other visual image, a photograph is not a rendering, an imitation, or an interpretation of its subject, but actually a trace of it."
—John Berger

This year the Global Fund for Women turns twenty. We celebrate the vision of our founders—women from New Zealand, the United States, and Barbados who dared to dream of a different world. Our founding mothers hoped for an environment in which all human beings could live in peace and equality, where women were free of violence, fear, and poverty and could fully contribute to their societies with dignity and a sense of purpose.

The Global Fund's mission is to translate that vision into reality by channeling financial resources directly into the hands of women around the globe. Our grants to locally-based women's rights organizations are designed to seek out and encourage risk-takers and social entrepreneurs—women who are creative, determined, and enterprising in how they challenge some of the toughest issues facing communities. Whether fighting discrimination in the legal system, providing schools for girls, ensuring clean drinking water for the poorest families, or protecting victims of human trafficking, these women are true leaders. The resilient, locally-based community organizations that they establish in small villages, urban slums, and suburban neighborhoods, and the sophisticated regional networks of lawyers, doctors, and academics that transcend narrow national boundaries, exemplify a commitment to human rights for all people. They implement diverse programs and projects for the advancement of women's rights that vividly demonstrate how small actions can create giant ripples of change in the most conservative and traditional societies.

As president and CEO of the Global Fund for Women for the past ten years, I have had the privilege of visiting and meeting with many of these incredible leaders around the globe. Yet we are constantly challenged by how best to share the energy, hope, and inspiration being generated daily by the over 3,000 women's organizations we are proud to call grantee partners in our 20-year history. We fill annual reports and newsletters with eloquent essays, yet the very first time I saw a photograph by Paola Gianturco of a young girl looking up from her sewing in a small Panamanian village, I knew, in the core of my being, that the old cliché remains true: a picture really is worth a thousand words.

It is, therefore, a great pleasure for me to be able to write the foreword to this collection of photographs by Paola Gianturco and, in so doing, to be able to share with each of you a few of the shining sparks that have lit up the past twenty years of Global Fund for Women history. I know you will find yourself moved by these portraits of indomitable women who light the darkest recesses of ignorance, deprivation, and hunger with infinite compassion, possibility, and change.

John Berger, the art critic and author, once said, "All photographs are there to remind us of what we forget." Indeed, Paola's photographs documenting the accomplishments of courageous women from Cuba to Kenya do exactly that. They remind us about what is often forgotten. They remind us that behind the grim news headlines of civil war and starvation there are ordinary women refusing to accept discrimination and injustice. They provide us with evidence that hope is alive and well in the most remote villages of Africa and in the small towns of America. They confirm that women and girls are competent and caring leaders, whether they are activists for disability rights from Armenia, Nepali trekking guides, or teenagers challenging sexual abuse in Zimbabwe's schools.

At the Global Fund for Women, we are deeply grateful to Paola and awestruck by the power of these vivid images to convey the spirit and resistance of the remarkable women's groups we support across the globe. We are proud to partner with Paola in advancing the human rights of women and girls worldwide. Not unlike the Global Fund, Paola serves as a bridge between worlds; her images link and connect different societies and cultures; they open windows into the lives of strangers whom we soon befriend.

As a result, *Women Who Light the Dark* is not simply a beautiful visual testimony of women's tenacity and creativity. The gritty realities of everyday life emerge in both the images and words Paola chooses to share. And although, characteristically, Paola downplays her own role, I know firsthand how her personal commitment and passion fueled this project. She used frequent flyer miles to travel the globe, she always sought to minimize any impositions on Global Fund staff, and she conducted extensive visits and in-depth interactions with humility and respect, earning her the trust of women's groups across the world and our shared admiration.

I have no doubt that in reading this book you will come to feel as we do about Paola Gianturco. There are but a small handful of writers and photographers who have considered women, particularly those from non-Western societies, worthy enough to be portrayed as catalysts for positive social change. Fewer still have allowed those women to speak for themselves about how they view their lives, how they define and solve problems, and how they envision their future. It is a good thing that her name is on this book about women making change, for Paola Gianturco is herself a fearless torch that lights the dark. The Global Fund for Women is honored to celebrate our 20th year with this salute to her work as an artist and activist.

—Kavita N. Ramdas

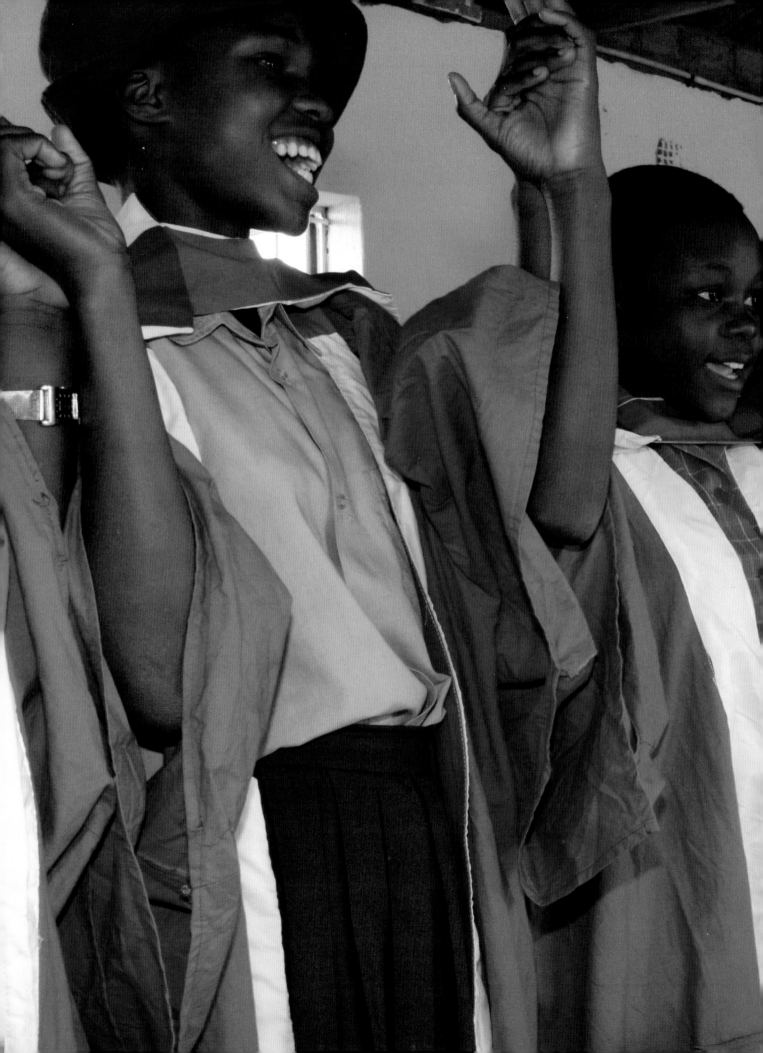

ZIMBABWE
EMPOWERING GIRLS

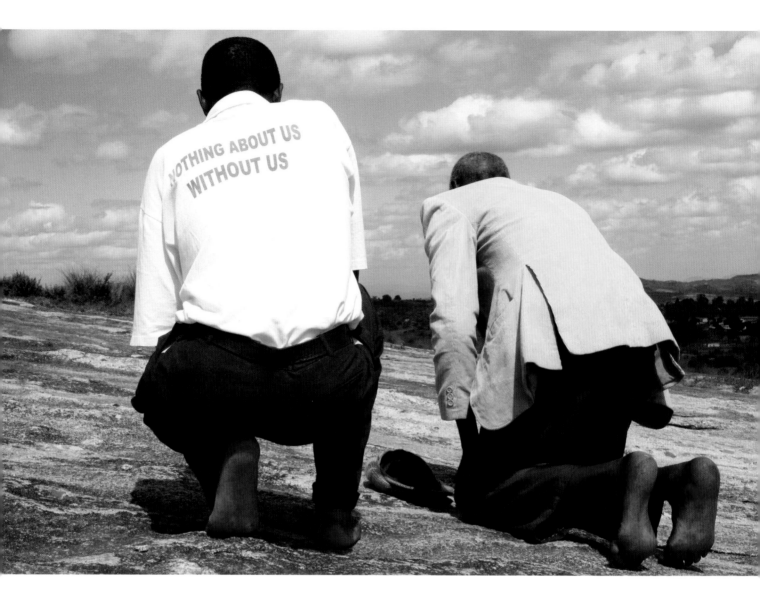

Two barefooted tribal elders lead us up the mountain, then fall to their knees to announce to the ancestral princesses that we have arrived. Betty Makoni, 34, and I walk alone across the sloped rock that is striated with orange lichen and streaked with healing waters. Looking over deep valleys interrupted by stacks of balancing rocks, Betty recounts history. In the 1800s, her grandmother, Masere, walked with her brother to Zimbabwe from Tanzania. This sacred mountain was designated for Masere, who became a paramount chief. For 200 years, it has been the burial place of princesses; every August, women conduct rainmaking ceremonies here.

A few years ago when Betty asked the Makoni elders for a place to build a Girl's Empowerment Village, the men responded, "You are a princess. The mountain is yours." We are looking down on the

thatched roofs of huts that cloister girls who are given refuge by the Girl Child Network.

The organization began in 1999 when Betty was head of the English department and teaching literature at Zengeza High School in Chitungwiza, near Harare. She started an extracurricular theater arts club after school so girls could deal with their life experiences. The idea inspired similar groups at other schools, and, to link them, Betty and six tenth grade students co-founded the Girl Child Network. Today, GCN has 350 chapters with 20,000 primary and high school members throughout the country. Over the years it has expanded its activities from conversations to empowerment to activism.

The country's economy makes life hard for Zimbabweans, especially girls. Recession has lasted eight years. This month, the inflation rate hit 913 percent,

highest in the world. This morning's toast, coffee, and orange juice cost me a big stack of bills: two million Zimbabwe dollars (US $22). Few locals could afford even such a simple breakfast with unemployment at 80 percent. Operation Restore Order recently plowed under a million houses, many of which doubled as places of business. Expensive licenses are now required just to sell tomatoes by the road. In much of Africa people walk purposefully along the highway, but here people just drift around despite the fact that they are educated and capable.

HIV-AIDS has touched nearly everyone. A hand-lettered sign, "Coffins", hangs above the door of an abandoned factory in Chitungwiza. Twenty-eight of Betty Makoni's family members have been buried in "the cemetery," a rolling field where tall grass makes it impossible for relatives to find the markers one season later. Twenty percent of the population is infected, half of them women. Life expectancy is the lowest in the world: 36 years (34 for women). One in five children has been orphaned.

Traditional healers counsel men with the virus that they will be cured if they have intercourse with virgins; others say if they have sex with their daughters. Some promise men will get rich if they rape a maiden. Some say old men will become potent again if they take a girl child.

Religious sects perform virginity tests and present certificates in church, inadvertently identifying exactly whom to target. The consequences are appalling. In 2003 a two-week old girl was raped; a shaken physician reported her death to the Girl Child Network. Since 1998, GCN has received more than 20,000 reports about sexual abuse of girls younger than sixteen years

old. Although perpetrators are often relatives, Betty estimates that half the rapes take place in child-headed households, where girls are particularly vulnerable.

Stopping child rape has become a national issue and GCN members and staff lead the movement. They have earned support from people in government, churches, nongovernmental organizations, businesses, and from educators, Kraal

heads, chiefs, politicians, men, boys, and women.

The first step for GCN: empower girls to protect and defend themselves, and to help one another. If a girl is raped, GCN obtains medical, psychological, and legal counseling and provides safe haven for up to 100 at its three Empowerment Villages in Rusape, Hwange, and Chihota. The organization also conducts media campaigns against rape perpetrators, and pushes for laws that levy stringent penalties for rapists *and* the traditional healers who counsel them.

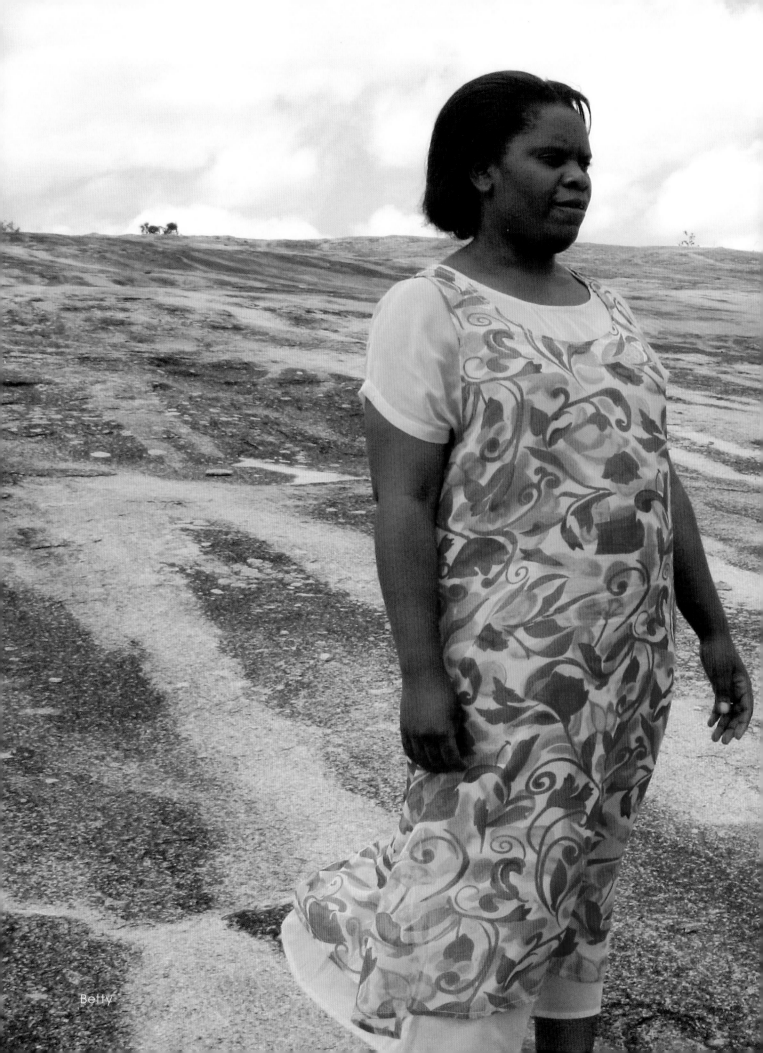

Betty

The day is past and yet I saw no sun
And now I live and now my life is done.
My tale was heard and yet it was not told.
My fruit is fallen and yet my leaves are green.
My youth is spent and yet I am not old.
I saw the world and yet I was not seen.
And now I live, and now my life is done.

—Chidiock Tichborne

I arrive before the Executive Committee meeting begins, expecting to see social workers and educators filling the tall chairs that surround a table covered in white cloth. Instead, fourteen girls aged nine to sixteen arrive wearing blue robes. Each, elected for a two-year term to represent a cluster of girls clubs, delivers a formal report describing her area's achievements and challenges.

Reginah Bobo, Harare's delegate, reports that 22 girls accused two teachers of rape, one of whom was fired. The representative from Bindura tells about a member who was violated by a deputy school head; when GCN reported him to the police, he was arrested and is out on bail awaiting trial. The Chihota delegate says a ten-year-old's uncle sexually abused her; GCN had him arrested. The newly-elected representative from Hwange missed the bus after school and asked a policeman for help; he forced her into an empty house and tried to rape her but

she escaped. The girls form break-out groups and ask each other, "What should she have done in those circumstances?" The girls take notes so they can report effective strategies to their constituents. These are the achievements.

The challenges? Believing education is the basis of empowerment, many GCN clubs are raising money to pay girls' school fees. To date, GCN has sent 15,000 girls to primary and secondary school. But these days, it costs $200 per year for fees, school uniforms, shoes, and exercise books. Even with help from GCN, many girls struggle to stay enrolled. The problem is exacerbated by the lack of sanitary napkins, which few girls can afford. After missing a week of school every month, many drop out permanently. (*The Economist* reports that five million women and girls in Zimbabwe may be substituting newspapers, rags, and tree fiber.) GCN clubs are growing and selling vegetables, vending secondhand goods or

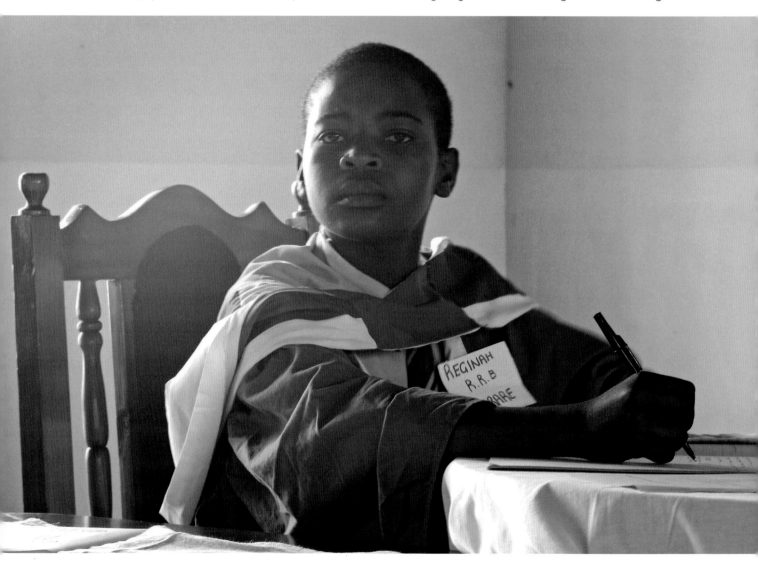

sponsoring dances to raise money to buy sanitary pads for members. To maximize their investment, GCN members cut each napkin in half.

After the meeting, I ask three members of the Girls National Executive Committee to tell me what is on their minds. Like any CEO, Pamela Mapfumo, 17, committee president, reflects on the budget. "When I ran for office, getting donations was my campaign promise. If we had funds, we could solve our problems in Macheke East in two months. Half our 79 members need help with school fees. Most do not have shoes. They may have three books for a class of 39, so 13 or 14 share one book—or girls borrow from other classes. I am discussing this with Betty Makoni. I am thinking I could donate my bus fare. Since I have it, I could give it to someone who needs it." Suddenly she is inspired with an idea for me: "I wonder if your readers could post us money, clothes, or shoes. GCN's *Women as Role Models* program helps donors sponsor girls."

"Of all the GCN work you are doing, what makes you proudest?" I ask Sarah Chinhire, who is twelve and a half. "Teaching my colleagues what to do when they are abused," she replies. "I tell them they must not shut up. They must tell someone their worries so they won't form something hard in their hearts. If they tell someone trusted, they will be free." It occurs to me that GCN members are going to be tomorrow's leaders, so I ask Sarah what she would like this country to be like in five years. "Peaceful, developed, no fuel problems, and we'll have electricity in the rural areas instead of candles and kerosene."

Reginah Bobo, 15, admits she was shy before she joined GCN two years ago. "But now I have to stand on my own and talk in assemblies. I am confident in what I do and say, and proud of our work. There was a so-called White House where girls were abused. The first time we reported it, the police didn't react. So we marched as a club to the police station and said we would not go away unless

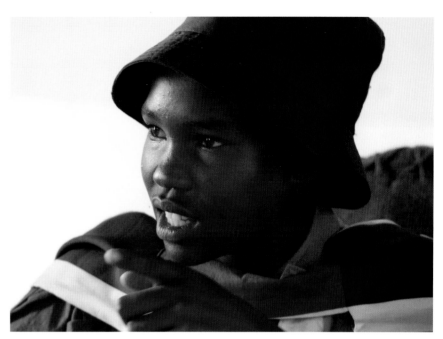

the officers accompanied us to the White House. They did. The girls had been impregnated. The boys smoked cannabis. Everything was scruffy. The police closed the house and put the boys in jail for five years. We said if they were allowed out on bail, we would come back." She is also proud of her club's record on school fees. "We formed a peer support system with the boys. We borrowed the school's public address system and advertised that on Saturday everyone could enjoy music for 50,000 Zimbabwe dollars (50 cents US). Many came to dance. We paid school fees for 18 girls and had some money left so we paid for five boys, too."

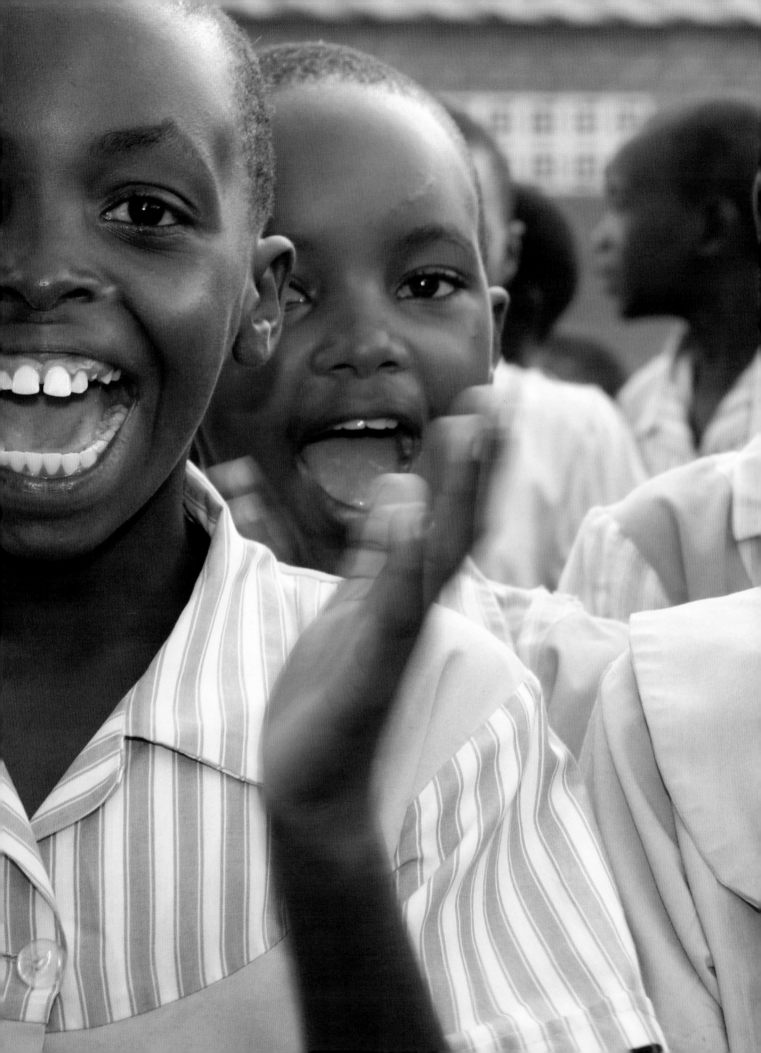

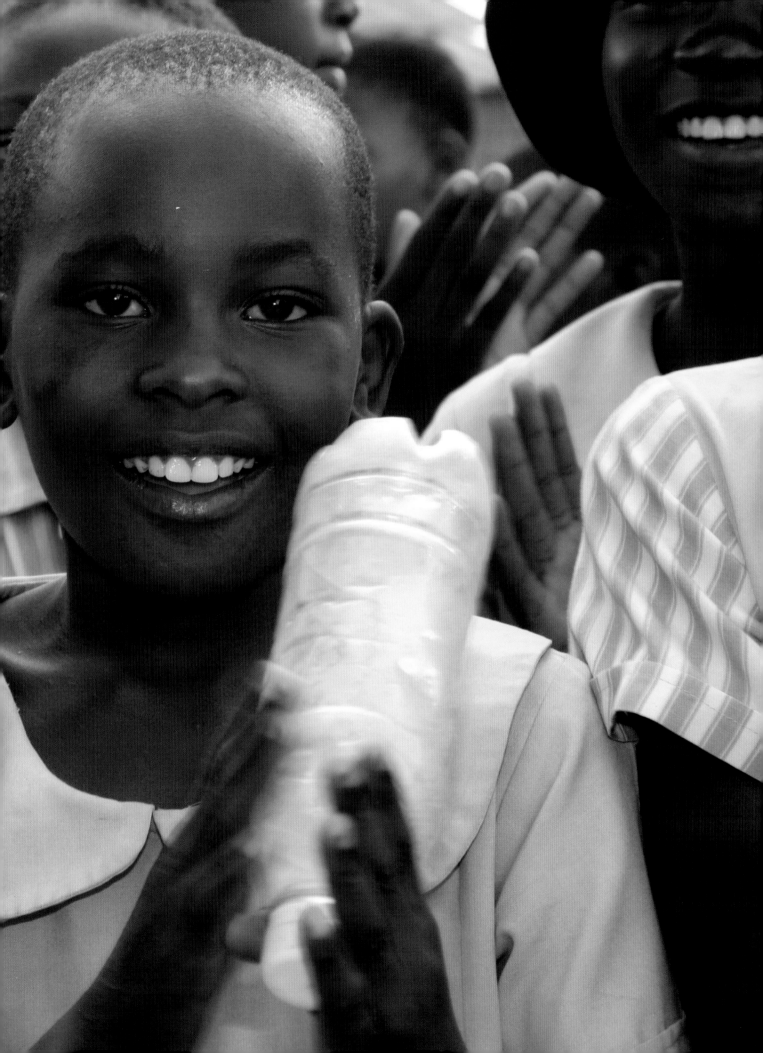

Poetry and its performance are important in the Shona culture; people praise each other with poetry. Ex-English literature teacher Betty Makoni is herself a poet. Each new GCN member receives a journal for poetry, art, and reflections. Girls fill them and periodically share them with GCN's coordinators (volunteer teachers who advise each group).

After 200 club members wearing school uniforms greet me in a primary school yard in Chitungwiza singing ("Welcome! Feel at home!") and the club president gives me a tour of the vegetable garden (corn and beans will pay for school fees), the club coordinator installs me in her office to read journals whose construction paper covers are protected by Saran Wrap. The first page of every journal is the girls' signed GCN pledge "to be cooperative, reliable, efficient, determined, and confident in all that I do."

Carol Mandizvidza, 12, has pasted her snapshot on the cover of her journal: she wears her black graduation gown. The tassels on her cap are fuchsia. She introduces herself on page two: "I'm a tall, slim girl and I'm brown in complexion. I've big ears and a small mouth which speaks out big words." In one poem she dreams of being a lawyer. Here is another:

Now my life hasn't got
The joy of growth
Neither the glory of power.
So tell me
Why I can call you uncle?

Each girl's journal brims with personality, jokes, recipes, and intimate experiences. Entries are written in Shona and English, in colored ink, and in artistic fonts (the word "scary" is written in wavery letters). Many are illustrated with designs, doodles, drawings, cartoons, and magazine clippings.

A shameful thought,
A shameful act,
Shamefully, you can destroy your daughter's life
For she can never be your wife.

—Barbara Nyamajikia

My mother is a cross border trader.
My father is no more.
I was raped by my uncle.
Thinking of it
Tears fill my eyes.

—Elito Phiri

The club coordinator invites me to join the girls who are meeting under the trees. They sing for me, dancing to the music of their own voices. (GCN songs have just been recorded on a lilting, professionally-produced CD).

I tell them about my work and invite them to help with my research. They answer each question without hesitation.

"What," I ask, "are you supposed to do to avoid being raped?"

"Be careful what you wear."

"Say no to boys."

"And what if you are threatened?"

"Scream."

"Bite."

"Pull on his penis."

"Pinch."

"Poke your finger in his eye."

"And what if those things don't work?"

"Go to a clinic and show the evidence."

"Get an injection within 72 hours."

"Report to the police. Even report your boyfriend or father."

"Don't give up until the case is over."

"Help girls you see being raped."

April 4, 2006. I open the door of my hotel room and pick up *The Herald*. The banner headline reads: "Obadiah Msindo Arrested." Although there has never before been a photograph of a man accused of rape in a Zimbabwe newspaper, the front page carries a picture of this 36-year-old leader being escorted to prison, charged with raping his young maid five times. Reverend Msindo is a prominent pastor, founder of the Destiny of Africa Network. The case against him was filed months ago but, according to *The Standard*, the powerful political party Zanu PF "ordered that Msindo be given sacred cow treatment because he is the only man of God who supports the ruling party."

Later, I chat with a 23-year-old standing in the hall of the Girl Child Network office: Loveness Chinyoka, Msindo's maid. Before coming to GCN, she appealed to other organizations for help but they said, "He is too powerful. No one will believe you." Betty Makoni, having heard thousands of rape stories, told me later that she knew Loveness was telling the truth. Not only did Betty give Loveness sanctuary, but at one point Betty went to President Mugabe to demand action: "Arrest Msindo or I will organize a nationwide protest of women."

Loveness is afraid for her life. Behind the offices is a house whose bunk beds are occupied temporarily by girls who need refuge from men who rape them. Out the window, I can see the walls that surround the modest GCN headquarters: cement block walls with glass shards on top. A security guard sits inside the steel gate and another on the front porch. Betty admits that her own life has been threatened. "If I die, let it be for a good cause," she tells members of the Girls National Executive Committee; "If you die, you must be sure it is for a good cause." For the first time, I realize just how risky this business is.

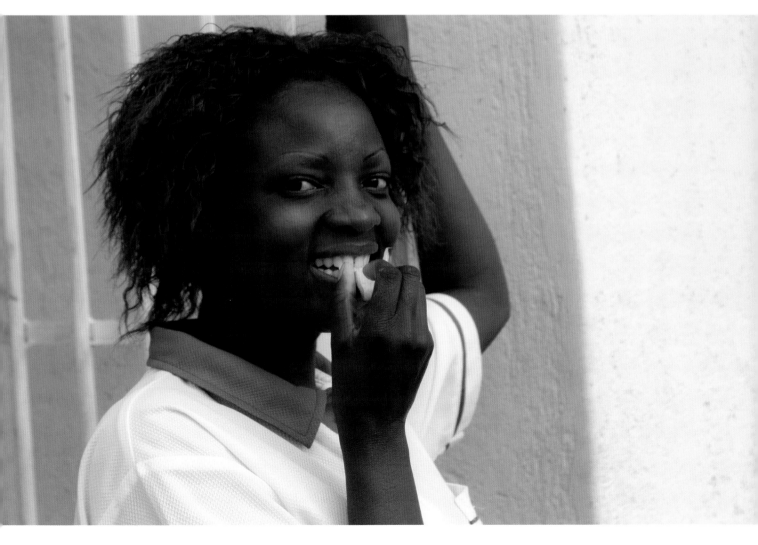

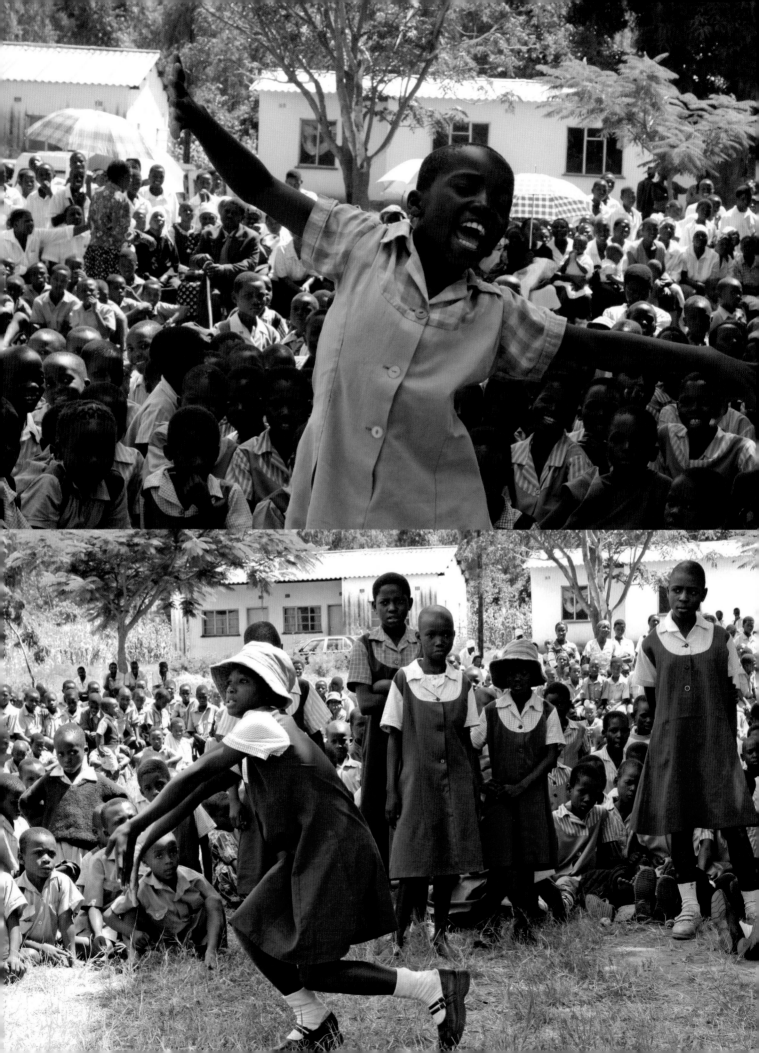

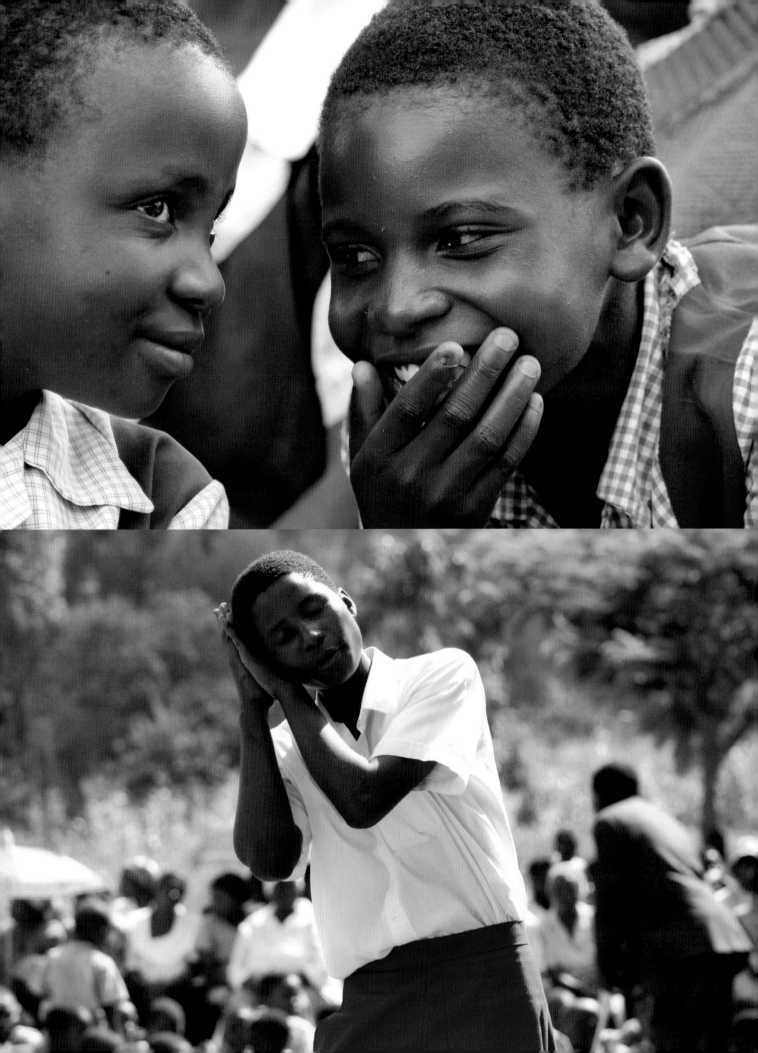

The staff is preparing to launch Club #351. Three staff members count the money to buy food for hundreds of guests. The stacks of bills on the table are preposterously bulky but then, as one says, "20,000 Zimbabwe dollars would buy, maybe, a banana." They count out a million in $50,000 bills, wrap the stack and put the bundles into a carton that originally contained reams of paper; the camouflage will avoid attention. Costa Moyo and Clifford Kashambira siphon a jerry can of gas into the truck, then load two more—enough to get us to a rural village in Eastern Zimbabwe without having to pay $10 a gallon if, indeed, anyone has gas to sell. Assistant Director Nyasha Mazango, Communications Manager Patience Chizodza, and I toss our duffel bags in the back. We arrive during a power outage ("They never last more than two hours.") Only in the morning can I see the landscape: magenta bougainvillea; majestic trees; precariously balanced stacks of rocks; red earth; red huts.

As soon as we turn off the main road, little girls surround our truck, singing, dancing, escorting us to the school. Traveling with Betty is like traveling with a rock star.

Although she is in the car behind us, girls peer eagerly into our truck, then run back to greet her. Only two other vehicles are parked in front of the school. Nine hundred people have walked to Mutasa's remote Sherukuru Primary School, whose rooms are partially open to the sky (wind blew the metal roof off three years ago). Uniformed students from this school and others nearby sit in the blistering sun, waiting.

The girls have done an impressive job of preparation. Big blackboards with welcome greetings

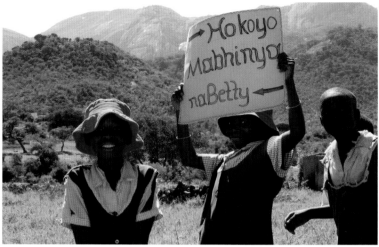

written in colored chalk are propped up in the schoolyard. There are tin cans full of roses, cosmos, and daisies. Betty and I are given leis of nasturtiums and Styrofoam beads that have been colored with watercolor paint. VIP name tags cut from cardboard are pinned on all of us who sit under a marquee: local businesspeople, tribal elders, politicians, school officials, and even the regional Minister of Education.

Members of the Girls National Executive Committee chant in Shona, "I am unique! I am the best! I am proud of myself!" Drummers accompany the mothers who parade in wearing white shirts and navy skirts (uniforms are important here); they sing, "Wake up, girl child! All these people are here to support you!"

And, indeed, there are lots of people. Men and boys sit together clapping rhythmically to honor the girls. Members of the Apostolic faith arrive, dressed in white (traditionally, they marry their 13 year old daughters to old men; Betty smiles, "They are starting to join us.") Two GCN clubs from local high schools stand under the trees watching. And the 81 members of the Sherukuru girls' club, all wearing green uniforms, sit on the ground in the shade facing the VIPs, waiting for their club to become official.

Women candle makers recite "I Will Not Be Silent," a poem about a real primary school where a girl was molested and GCN reported it. A local "Victim Friendly" policeman assures the girls of support. Girls perform skits, speeches, and dances. Then there is a hush.

It's time for the girls to stand, recite, and act out their poems. Little moves the audience more than to hear the girls describe their experiences.

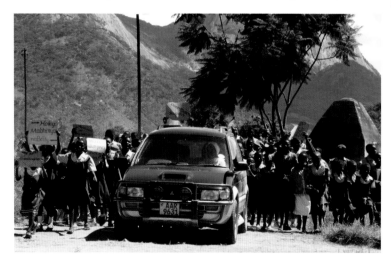

Gillian Bomba
Watch Out

We can do anything, the sky is the limit.
You did what you did to us
But this time we will not let you escape.
Don't say we didn't warn you.
We will harm you.
Only to make sure that we are free and safe…

Charmaine Mufanebadza
Orphans

When it came to light that my parents died of AIDS
You started separating me from other children.
You no longer listened to me or my problems…
Neither do you joke or have fun with me…
You find it better to eat in the same plate
With the child of a robber.
It is now easy for you to drink from the same cup
With the child of a thief…
You fear me more than those my age do.
Why? Why? Am I HIV-positive?

A Glenview High School club member:
My Teacher

I don't know whether to call him
My teacher,
Monica's husband,
Or Prisca's Sugar Daddy.
In 3A1 he kissed Teclar.
In 4A1 he impregnated Daizy.
In 2A2 he fondled Lucia's breasts.
In his storeroom I can't say;
Only the books are witness.

Enia Matanga
Child Abuse and Exploitation

Children cry when they are hurt.
They say no to sex when they are empowered.
Their hearts break when they are abused…
Parents! Don't just give birth…
Give moral support to your children!

Sarah Chinhire
The Girl Child

They regard us as special, yet…
We cook, clean the house
And look after the children.
We are used to appeasing the evil spirits.
We are forced to marry in times of hunger.
Why the girl child and not the boy child?

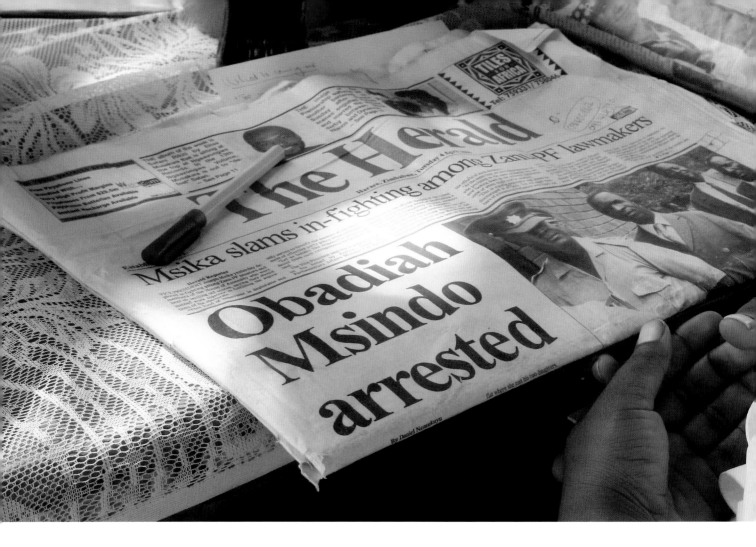

Now it's time for Betty to step to the center of the grass circle. She holds up *The Herald* with its Msindo headline; "We are here to celebrate together. There will be no rape in this country. It doesn't matter how important the man is, if he rapes a girl, he must go. If he is in government, he must go. If he is a religious man, he must go. If he is a teacher, he must go.

"Heads are beginning to roll. We have already presented the authorities with the names of accused persons, among them a deputy minister, a senator, members of the House of Assembly, chiefs, a permanent secretary, and business executives." (I am surprised that she makes this announcement in the hinterlands, but she assures me later, "It will be heard in Harare," and thanks to the local *Manica Post*, it is).

She asks for two volunteers, a middle aged man and a six-year-old girl. She puts her arms around the child and addresses the crowd, "You married men with many wives—you are still not satisfied and abuse young girls. Can you imagine this big strong man violating this young, innocent girl? How are you taking

this as a community—knowing this takes place, then singing "hallelujah, hallelujah" in church?"

She invites the VIPs to shake hands with the new members and "Tell each one something they will remember all their lives."

After the girls recite the GCN pledge, Betty calls each girl's name and presents her with a journal. "In 20 years you will read your dreams and know this book has made you into what you will become."

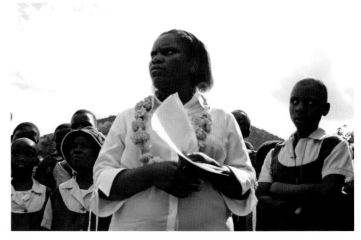

Betty conducts a group therapy session in the tribal meeting hut at the Rusape Empowerment Village, which nestles against Chitsotso, the Princesses' mountain. It's so quiet that I can hear goats bleating outside.

"The more you share, the more you heal. I will support you," Betty promises. "Some of you have been raped; I was raped by a neighbor when I was six. Some of you have lost parents; my mother died when I was nine, the victim of domestic violence. Some of you are poor and have been living on the streets; when I was young, I was poor."

The first girl to speak is the daughter of blind parents she never knew. She grew up on the streets selling cigarettes and sodas. She made her way to the capital, 530 miles away, hitchhiking when she could. "I am having a good life here, the best I have ever experienced," she says. Betty tells me, "She earned the highest marks in her school."

Another girl says, "I was born in a family of five girls and stayed with my grandparents. My grandfather raped all of us. Starting when I was in the fourth grade, he raped me for ten years. He was a traditional healer, and extracted blood from my vagina for healing." (In an aside, Betty tells me GCN "took him to a village court. When he was released, he shot himself dead.")

I listen for three hours. One girl repeatedly hid in the forest while her father beat her mother; one girl's uncle sliced her buttocks with a knife; one girl's

father, having served a jail term for rape, came to rape his daughter the day he was released; two sisters were raped in full view of each other by their HIV-positive father.

Their stories break my heart. There is no Kleenex so the girls dry their eyes with the cuffs of their school uniforms. No one interrupts their tears; they are allowed the dignity of their grief.

I interview many women on GCN's staff, ranging from Gemma Rushoko, administrative assistant to the counselors and trainers, even Nyahsha Mazango, the assistant director. They are effective, educated, experienced, and committed. Indeed, this chapter would not exist without their input.

But what surprises me is the male staff members. "The presence of men was a U-turn," Betty admits. "I had gone to girls' schools. I was used to that environment." But "there are some good men. Why can't we have them? Some of our men have also suffered abuse. One married a rape survivor. One was born of rape. They are role models. After I blast men about rape in public, I try to neutralize that by saying 'Not every man is bad after all. Good men are not abusive, and they stand in defense of us.'"

The GCN male staff members impress me. They are important for rescue missions but it becomes clear that they contribute much more. Robinson Chikowero (one of Betty's English literature students in 1998, a long-time employee) tells me, "Sometimes

little girls write Betty Makoni for help because they saw her on television. Many letters arrive postage due; they have no money for stamps. The GCN staff interviews the girl and asks what she thinks would be the best option for her. Normally, girls want to go to the Empowerment Village but we always do what is in the best interest of the child: report to the police and support her in court." What is most gratifying about his work? "As an intern, I felt so happy that the girls felt free to talk to me about everything, that I thought I should just continue doing all I can." Today, Robinson is responsible for GCN fundraising: "If you are in a fortunate position, there is no way you can be more blessed than helping those in a less fortunate position, and girls are more vulnerable than boys."

Just as men are important in her organization, men are important in Betty's private life. "Many people wonder if I'm married, thinking if you're an activist you won't be. But I am in a very good relationship." She met her husband Irvine when they were both students at the University of Zimbabwe. "I vent my frustrations on him but I deeply admire this guy. He is very strong inside. When things get difficult, he is really there—quite professional and cool the way he handles issues. He has contributed massively and strategically, set up systems such as internal audits, and he is brilliant at communications. I want to appreciate him in your presence."

Betty is the mother of sons. "I have two biological sons (one is eight; the ten-year-old already knows how to stand up for girls). The adopted son is quite a darling—I don't want to miss him because he is the last. I am also the foster mother of a boy (eighteen) and girl (fifteen). But my children are countless. All the girls say they are mine and I say that, too."

I enter the largest hut at the Chitsotso Empowerment Village, which is architecturally unique. The floor, which is the bare, steep rock of the sacred mountain, slants upward across the hut, its apex 20 feet above the door. One hundred and twenty girls, all of whom live in the Empowerment Village or belong to a local GCN club, stand near the thatched ceiling, ready to perform their poems for me, an audience of one.

Nyahsha Mazango

"I am not an orphan; all the men and women of Zimbabwe are my parents…"

"The sky's the limit! No need to cry…"

A ten year old who has been accompanying the words on a tall drum steps forward to recite the last poem. I know her painful personal story from the therapy session. I brace.

Unbelievably, she performs a poem written by a Nepalese mother, taken from the book Toby Tuttle and I created, *In Her Hands*. A program officer who used to work at the Global Fund for Women gave GCN a copy. This little girl has memorized the words to surprise and honor me.

*"My girl child must have a voice louder
and clearer than mine.
She must be able to move with certainty—
Shoes on her feet, walking with dreams at her side.
The present I have given her is not enough.
Her arms are different; they will reach for the sky
where freedom lives."*

GCN members are moving with certainty, bringing child rape to a halt. I hope one day they will have shoes on their feet. They are my heroines.

VIET NAM
DEALING WITH DOMESTIC VIOLENCE

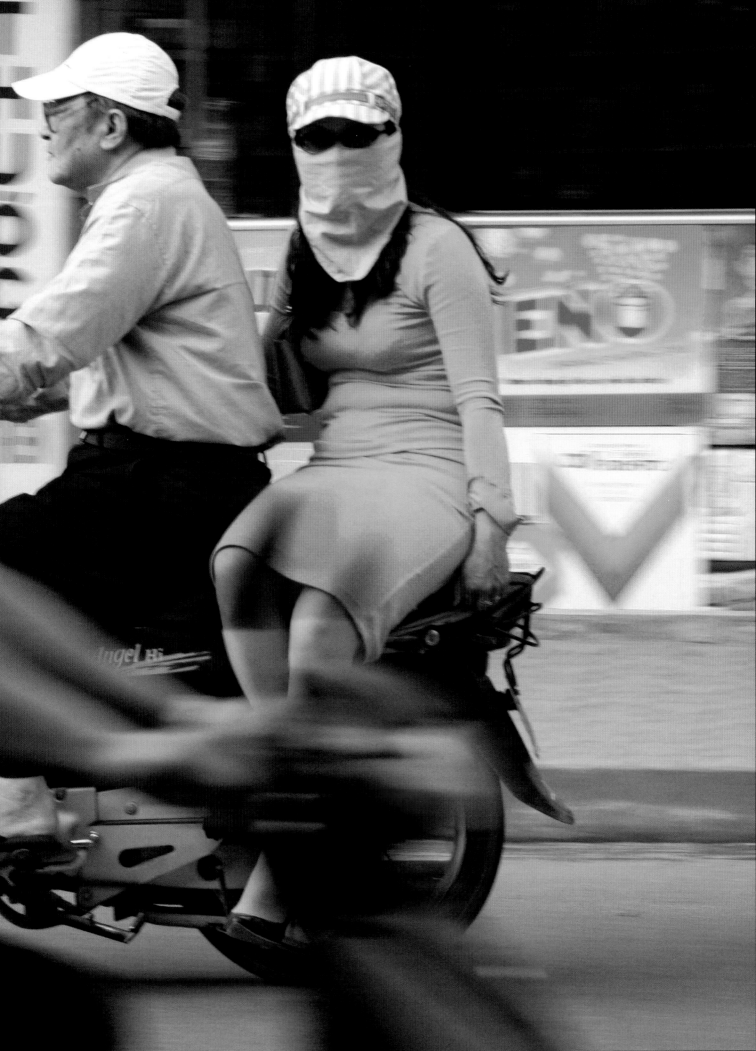

Chinese flourishes decorate the houses that line the street and burrow through the block, each built one room wide to minimize taxes that are allocated by the number of front feet. We pass Lenin Park and head into the embassy district with its fenced gardens and traditional French buildings. Around us: the architectural legacy of occupying powers.

In a few days, it will be Tet, lunar New Year. Some scooters are dwarfed by the bushy, fruit-laden kumquat trees tied behind their seats (kumquats invite wealth, luck, and peace). A florist's scooter zooms past, laden with poinsettia plants: red for happiness. Women brave the traffic carrying poles across their shoulders, selling bright bundles that contain three pairs of shoes to symbolize the favorite Tet legend The Kitchen God.

In that story, a woman left her first husband and remarried. When her first husband came to her home as a beggar, she fed him out of pity. Her second husband misunderstood her motives and accused her of infidelity. Insisting on her innocence, the woman jumped into the fire. When her husband realized his

The taxi driver glances at the address, written in Vietnamese by the hotel desk clerk, and steers to the center of a screaming swarm of scooters, many carrying a family sandwich: dad, child, mom. It's rush hour in Ha Noi. The few cars and cabs seem to float in the sea of motorcycles. We are moving so slowly that the driver pulls down his sun visor, revealing a Sony DVD player, and watches *House of Flying Daggers*.

error, he followed her into the flames. The first husband, moved by the couple's sacrifice, also jumped into the blaze. The Heavenly Emperor, impressed by their devotion, appointed the trio as the Kitchen God, associating their burning with the kitchen hearth.

What, I wonder, does this story suggest about marital relations in Viet Nam? I take a new look around: what is family life really like in the houses we are passing? Surely marriages here, as everywhere, begin with high hopes. The buzzing cycles remind me that Vietnamese engagement ceremonies begin when the groom arrives at the bride's house carrying his family's gifts in a luxurious, rented bicycle taxi with an elegant golden awning. Then what?

Thanks to a thousand years of Confucian influence, women are expected to obey their husbands without question, to be mothers, and to kindle family harmony. I already know that role is not easy here: in the Ha Noi Women's Museum, a giant, golden statue of mother and child stands in the marble lobby; the text panel says, "Woman welcomes a glorious, prosperous future for her children while

shouldering responsibility and difficulty." I am about to find out how much difficulty.

We have turned into an enclave of Communist-style apartment buildings. Building B3 looks like its concrete neighbors, with a ramp that I assume leads to the lobby (no, despite the reception desk, it is a garage for motorbikes). I take the elevator to the eighth floor and locate the office of The Center for Studies and Applied Sciences in Gender, Family, Women, and Adolescents (CSAGA). I count 30 pairs of shoes lined up in the hallway: glittery heels, flip-flops, flats, running shoes, and slippers.

NGUYEN VAN AHN AND HOÀNG KIM THANH

Founder-Director Nguyen Van Anh and Vice-Director Hoàng Kim Thanh are waiting for me, with Le Thi Hong Giang, who heads the public relations department. They have invited an interpreter and set a low table in Van Anh's office with placemats, pottery cups, and oranges. I contribute cookies from the bakery in my hotel; they serve green tea.

Both Van Anh and Thanh hold degrees in Social Sciences and Humanities, and both have taught literature. Just when I take a sip of tea and think, "What a nice way to conduct an interview!" my MiniDisc recorder malfunctions. Since I always want to quote people precisely, I jiggle the dials and consult the manual frantically—in vain. Van Anh smiles, "I'll loan you mine. I was a reporter for the Voice of Vietnam for ten years."

While she was working for the radio network, many women confided that they had been abused. Van Anh decided to do something about it. In 1997, she established the Linh Tam counseling line, the first hotline in Ha Noi to provide psychological and emotional counseling to victims of intimate partner abuse. It was swamped.

The subject of violence against women had been taboo in this culture. Almost no statistics measured the extent of the problem, but the hotline confirmed that gender-based violence was prevalent.

In 2001, Van Anh registered CSAGA as a nongovernmental organization. Thanh, who had been trained in counseling victims of domestic violence and in dealing with family conflict, joined the organization to teach. In 2003, UNICEF gave them an award for their groundbreaking work. By 2005, CSAGA had trained 50 counselors and advised 300,000 clients, either in face-to-face or on the phone. Today the organization provides free online counseling to thousands in Viet Nam, the United Kingdom, France, the United States, and Canada.

CSAGA runs nine topic-specific information lines in 22 Vietnamese cities and provinces. Every day 5,000 people call for recorded information about such subjects as "Love, marriage, and family" and "Sex education." There are lines for men, women, and teenagers. And there is a "Line for fun." Fun is something victims of domestic violence don't have. As CSAGA expanded its services, fun became an important component and, ultimately, a teaching tool.

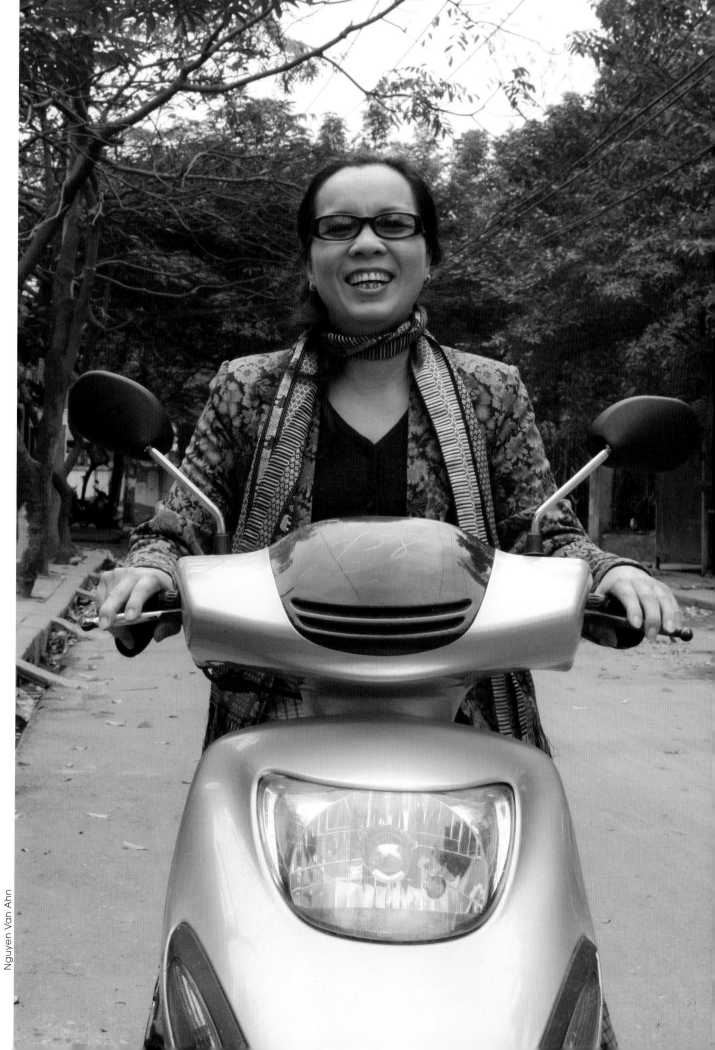

THE SHARING TOGETHER CLUB

I ride behind Van Anh on her motor scooter. We zoom past an open-air men's hair salon where barbers' chairs are lined up on the sidewalk and customers, oblivious to passersby, are getting trims. We're en route to the hall that CSAGA rents for its new pilot project, the Sharing Together Club.

Over traffic noise, Van Anh describes the club's history. "The first participants were identified at our request by the Viet Nam Women's Union" (a government organization started in the 1930s that now has 11 million members and thousands of local units).

"After a while, participants invited their friends. The club has been in existence for six months. We will evaluate its effectiveness at the end of one year. If it is successful, CSAGA will launch more Sharing Together Clubs."

"How does it seem to be going?"

"At first the women could do nothing but cry. But now they are friends and they support each other. It's easier to disclose their experiences."

The rented hall is decorated with red and blue velvet curtains, silk flowers in ceramic vases, and a white plaster bust of President Ho Chi Minh. In 1960, he acknowledged, "Man-preference has been seen for thousands of years and is embedded in the mind of every individual, every family, from all walks of life. Abolishing such a chronic attitude is a major and difficult revolution. Each individual, each family, the entire people, should be part of the revolution leading to true gender equality."

"Is there true gender equality here?" I whisper as we walk in.

Van Anh responds, "Ho Chi Minh was the ideologist and said many important things about gender. We are still in the process."

Thirty women sit in a circle on folding chairs. They are old and young, elegantly dressed and simply clad. Giang sits next to me, ready to interpret.

Thanh starts recorded music and invites the women to stand and sway to the rhythm. "Take a step," Thanh directs. "Now go anywhere you want!"

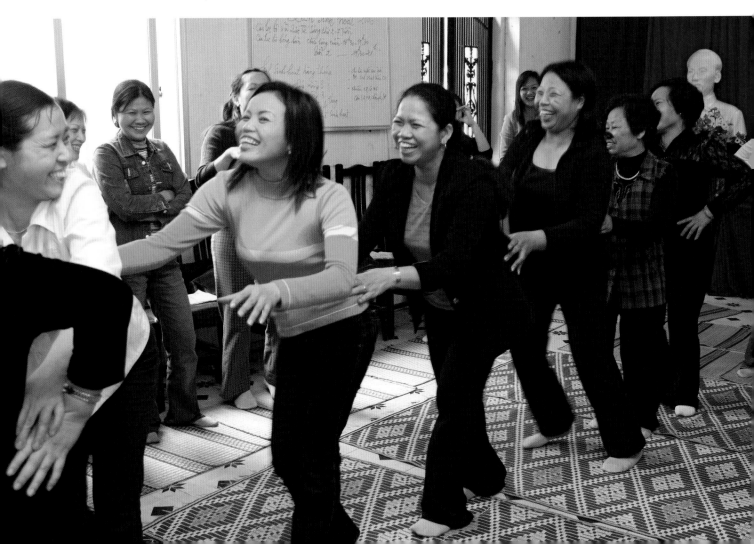

she says, freeing them. They run into each other unexpectedly, laughing in surprise. (Giang, like a whispering sports announcer, explains: "This allows for fun, freedom to be themselves, a reminder that they are not alone.")

As the music speeds up, Thanh invites the women to form a line, then zigzag and hop. The women hang on, steadying each other, laughing. (Giang: "Many victims will not allow themselves to be touched or to touch others. This is progress!")

Van Anh divides the participants in half, gives out stuffed animals, and invites each group to create a story about domestic violence. The women near me agree immediately on the roles each animal will play: the bear is father; the horse is mother; the frog and duck are the children; the dog, a neighbor; the cat, the counselor.

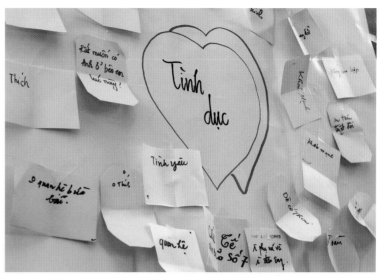

Giang keeps up a running commentary: "Bang! The alcoholic father beats the mother. The mother cries. The children intervene. The neighbor comes but is not sure of her role." The women erupt repeatedly into nervous laughter. Giang again: "The neighbor convinces the wife to get help. Then, the counselor balls out the husband!" The women dissolve in gales of glee.

The other group is finishing its story. Giang summarizes: "The couple just had a second daughter. The father wanted a son and insists on having more children until he gets one. He beats his wife so she will have sex." No one is laughing.

I am fascinated by the issues that come up in these simple performances. In the Women's Museum, I read a code dated 1812 that identified "seven reasons a Vietnamese man can chase his wife away." "No sons" was first on the list. Van Anh has told me, "This code is not in place now, but the ideas influence men's opinions."

During the break the CSAGA staff members serve snacks and pour tea. Curious participants come to talk to me. One woman wants her picture taken with me, and I am honored. I have been unsure about how I will be received since what I think of as "The Viet Nam War" is remembered here as "The American War." Giang assures me that Vietnamese women want to be connected with foreign women everywhere.

A participant tells me about her life: "I am sixty. My husband was jealous because he thought I was having an affair, which I was not. He beat me for 20 years. I have just gained enough confidence to get a divorce."

A pretty, young woman was so severely raped by her husband that she was hospitalized for three days with internal bleeding. Another woman assesses me and decides I look younger than she does, even though I am a dozen years older. "Years of beatings have aged me," she sighs. "My husband even beat me when I was pregnant."

Every month, the club meeting focuses on a different topic, and this month the subject is Sexuality and Reproductive Rights. Thanh reconvenes the group with a provocative question: "If a woman wants to have sex, can she demand it?" This is a novel idea in a society that ascribes to Confucius' rule that women must obey their husbands. Animated, the women discuss the pros and cons. The consensus:

"Yes, if they are in love."

"If you want to be close, you can play an active role."

"If the couple understands each other, yes."

Next, groups list what they believe are women's sexual rights. Viet Nam's constitution promises "Women have equality with men in all aspects," and sure enough, the first right the women name is "the right to be equal." Then:

"To have the number of children you want—as far apart as you want."

"To ask a man to wear a condom."

"To have sex before marriage." (This is contrary to tradition and stirs so much controversy that Thanh weighs in: "A couple can choose to have

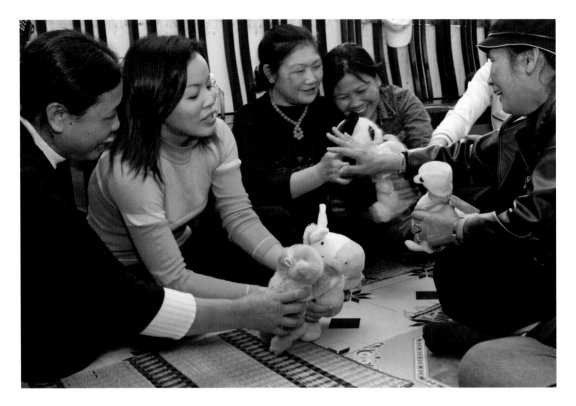

sex or not, if they are responsible and know about reproductive health.")

Last, the women add the right "to say 'I like sex.'" This modern idea is greeted with joyful laughter.

Later, Van Anh reflects, "Members of the club have become stronger. They realize inner strengths they didn't think they had, and can overcome their situations. Now they know there are people around them who can help. They understand their rights. They can speak out, play, laugh, and express themselves, which they have no chance to do at home."

TA XUA COMMUNE

There are 54 ethnic groups in Viet Nam, mostly living in the northern mountains. In 2004, CSAGA trained 21 illiterate members of the Women's Union in Ta Xua commune, where the population is Hmong.

Of 342 primary and secondary students in Ta Xua, only 21 were girls (in the rest of the country, boys and girls attend school in equal number). CSAGA's project report quotes trainees describing the local attitude toward girls and women: "Giving birth to a daughter is bringing up for others, just wasting rice and food for the family."

Women in Ta Xua work 20 hours a day, including ten hours in the terraced fields. They do housework, then embroider clothes until "their eyes so closed that they cannot open, they go to bed."

"Men's head is bigger so whatever they say, we have to follow. They tell us to go fast, we go fast. If there's food, men eat first, any part left by men, then women eat."

"They ask us to stay home, we stay home. If we do not follow, they hit."

"Women are stupid and nonsense so they have to tolerate, accept, even if they don't consent. Power belongs to men."

Women believe that when they die, they will become ghosts in their husbands' families. Indeed, some already are. In late 2003, six women escaped unremitting domestic violence by committing suicide. They went to the forest to eat Ngon leaves, which are poisonous.

Experiential learning like what I observed at CSAGA's Sharing Together Club in Ha Noi, helped Hmong women remember—and rethink—what had been done to them and what they had seen done to other women.

Pictures, photographs, acting, drama, and playing games created an open, friendly atmosphere in which they learned that women have value; that

hitting women is unacceptable, illegal, and violates human rights; and that they must raise their voices to counter violence. The women also mastered active listening, questioning, and conflict resolution.

The trainees created an action plan for countering domestic violence. But when they attempted interventions, abusive husbands turned on them, too. One woman who was habitually beaten went to the fields with her aunt and confided how miserable her life was. Her husband heard about the conversation and used a hoe, right in the field, to beat her so hard she collapsed. A woman CSAGA had trained took the wife home. Over time, the trainee returned many times to help the wife. The husband hit both women. Finally, the wife went to commune officials who, twice, brokered reconciliation. The final time, they decided that if the husband didn't change, the woman could take her children and possessions and return to her mother's house.

Another husband was an alcoholic and, when drunk, beat his wife and children. He directed his wife to find rice or corn to eat; if she failed, he hit her and she ran to the woods to hide. Her children, afraid she would eat Ngon leaves, followed her. They held each other and wept. For her children's sakes, the woman returned home, and when a CSAGA trainee arrived to help, the husband beat all of them.

The Hmong training had been successful teaching women to share, listen, console and encourage victims. But it became clear that more than training women was necessary.

Over the next two years, CSAGA began to train men, create support networks of local counselors and organizations, and use mass communications to teach whole communities that gender-based violence is not only a human rights violation, it is illegal and must be prevented and punished. Between January and October 2006, CSAGA organized 48 training sessions for union members and government agencies.

MY HAO DISTRICT

I arrive at 6:30 AM at Building 3B. Van Anh has contracted with a taxi to take us to the My Hao district in Hung Yen province. We watch the sun rise. The cab never comes. Van Anh, Giang, and Thanh flag down a taxi driver who is willing to take us (and many boxes of training supplies) into the countryside.

Having been told we were going to "a farming area," I assumed wrongly that we would be working in the fields. But we are going to a meeting where the farm women look stylish; the CSAGA women look indisputably chic. I am wearing jeans.

Again the meeting is held in a hall where a white plaster Ho Chi Minh presides. The trainees live in 13 hamlets. There are four men: two radio reporters and two local officials.

CSAGA's goal is that these trainees will help survivors of gender-based violence become participants in society, perhaps even run for public office. Women comprise 27 percent of Viet Nam's National Assembly, the highest percent in Asia, but many women still lack the self-confidence to become candidates, especially if they have been abused.

Five trainees are from the same hamlet. One says, "After our last meeting, we went back and tried to discuss the new ideas we learned. Our husbands said, 'Tradition is better.'"

Another woman reports that in her village, "A woman was sold to do sex work in Iran. She escaped and returned, only to have her husband blame and berate her: 'There are other ways to earn money!'"

With luck, CSAGA's mass communications will influence these men. The government-owned Voice of Vietnam radio network is popular with virtually every Vietnamese family. The network includes all

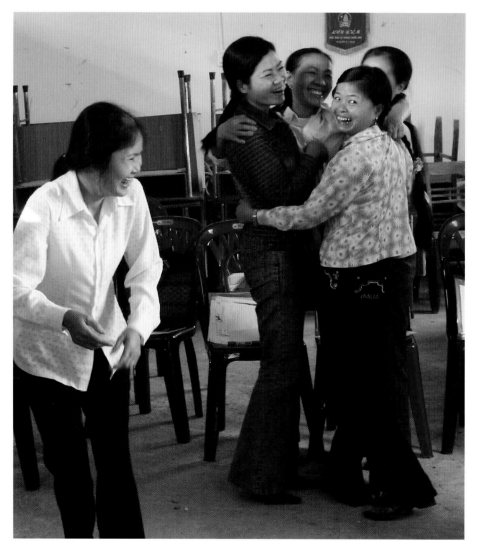

the AM, FM and shortwave stations in the country and its *Voice of Women* program carries material that CSAGA writes about women's rights, domestic violence, and gender equality.

CSAGA also creates articles for print media as diverse as *Capital Women's Newspaper, Science and Life,* and *Beauty Magazine.* Van Anh says, "Two victims have talked about their cases on television. Awareness is the issue that needs to be tackled now."

Like the Sharing Together Club curriculum, today's training is what Van Anh describes as "a circle of experiences that help participants initiate and absorb knowledge." Art and creativity are the foundation of CSAGA's active learning method. Thanh and Van Anh use role playing, games, drawing, and storytelling to change values and teach information and skills. Participants have fun, smile, and laugh. Liberated from the serious lives they lead and reunited with their creative selves, they learn.

WOMEN IN VIET NAM

Is Viet Nam among the world's worst countries in terms of gender equality? Hardly.

Men and women are about equally likely to be educated and employed. On average, both live into their seventies. The government has some enlightened policies (for example, nursing mothers who work can arrange time to breastfeed with full pay). Viet Nam is ranked 89th on the UN Gender Development Index, higher than many Asian countries. In 1982, Viet Nam ratified CEDAW (Convention on the Elimination of all Forms of Discrimination against Women), which the United States has not done.

Viet Nam's five-year national plan charges the Ministry of Culture to "eliminate all backward customs and bad practices that violate women's rights," such as "a young girl has to obey her father, a married woman has to obey her husband, and a widow has to obey her son," and "men are expected to educate women and violence is an accepted method of discipline."

In cities as well as rural areas, across social classes and education levels, research shows that between 37 and 80 percent of Vietnamese women

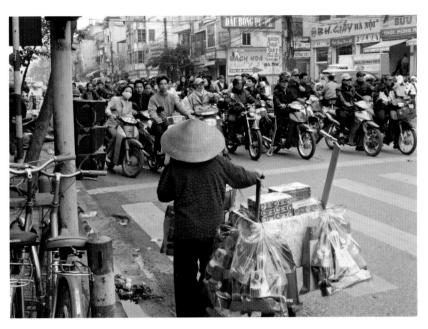

have been abused, and that between 42 and 66 percent of all Vietnamese divorces are caused by domestic violence.

Viet Nam's marriage law guarantees equality between husband and wife but the country's penal code punishes only perpetrators who repeatedly or severely injure family members. For years the government has voiced intentions to stop gender-based violence. CSAGA's work, one piece of the puzzle, is already in place.

WOMEN IN OTHER COUNTRIES

In no country has women's freedom from violence been secured.

At least one of every three women in the world has been beaten, coerced into sex, or otherwise abused in her lifetime. Slapping and socking by an intimate partner are the most prevalent forms of violence against women, who are more at risk of violence at home than anywhere else.

Unequal power between men and women causes violence—and violence perpetuates that inequality. The cycle continues. Many victims come to accept "wife beating" as normal.

In 2006, the UN Secretary General said, "As long as violence against women continues, we cannot claim to be making real progress toward equality, development, and peace."

I leave CSAGA's offices with a final question for Van Anh and Thanh: "You are dealing with an issue that is important everywhere. What would you like to tell women in other countries about gender based violence?"

"I want to tell survivors that they are not alone. They should tell others. There are many around them who can support them," Thanh responds.

"I very much like the saying of Mother Teresa," Van Anh says. "'Life is a challenge. Please be courageous.'"

CUBA
NOURISHING DREAMS

For a week I have photographed Havana's daily dance: children arch their bodies to dive into the sea, teenagers bow to snatch a baseball before it hits the brick street, a teenager practices handstands against a crumbling wall, brides and grooms swoop into the municipal wedding chapel every 20 minutes, a wet puppy shakes drops in all directions, boys balance on top of the traffic barriers, stilt dancers do jigs in the plaza.

Today is Children's Day in Cuba. I visit a school and find myself surrounded by girls who have questions to ask me. After a while, I turn the tables.

"What would you like to do when you grow up?"

"Ballet!" four say, echoing each other. Not for nothing did Gabriel García Márquez call Cuba the "most dance-oriented society on earth."

Ballet is easily as popular here as baseball and the Buena Vista Social Club. Audiences flock to see ballet, and good performances are often appreciated with cheers, stomping, and applause so loud that dancers must stop until they can hear the music again. Professional dancers are allowed by the government to buy cars and travel to international competitions. They are superstars.

In some countries, ballet is an art enjoyed by the elite. But people are poor here. US economic sanctions are still in place. Cuba has not recovered from the 1992 loss of financial support from the Soviet Union. The average wage is $10 per month; doctors, the best-paid professionals, only earn $40 a month. Food is rationed: each day, one bland roll; each month, eight eggs, a few pounds of chicken, a half pound of soy, a few ounces of coffee, cooking oil, and basics like rice and beans. Even if Cubans have enough cash to supplement the rations, groceries are limited: six potatoes may sit on the counter of a typical corner stall. Nourishment for the body is hard to come by, but Cubans are determined to have nourishment for the soul.

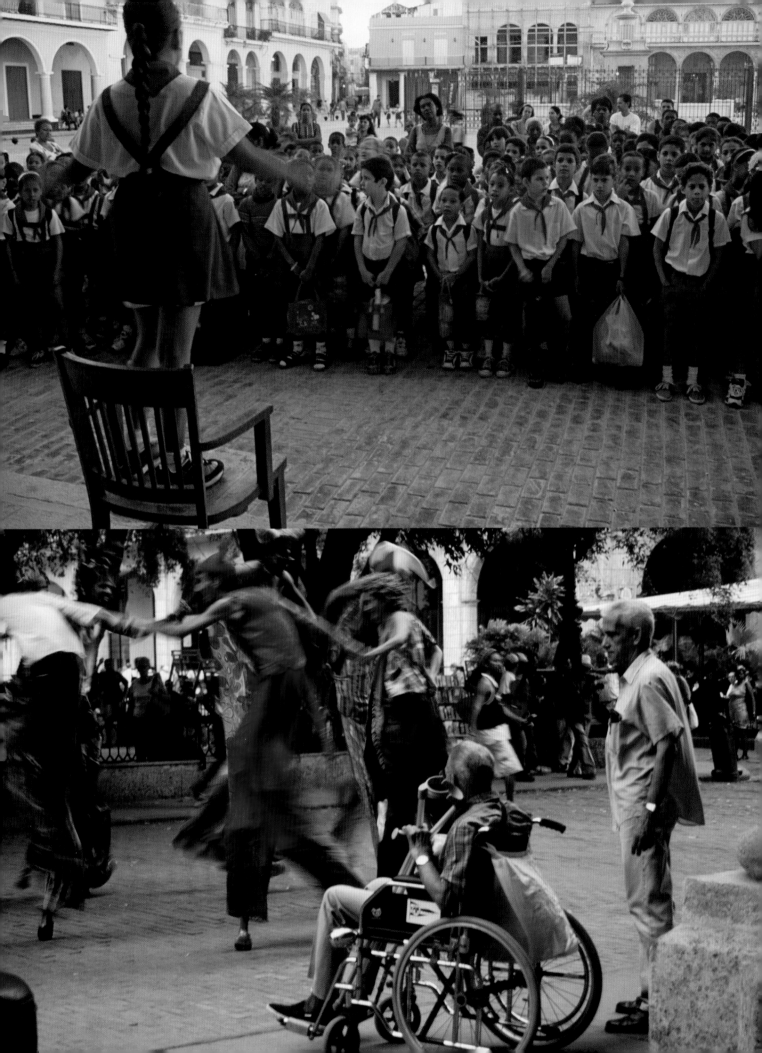

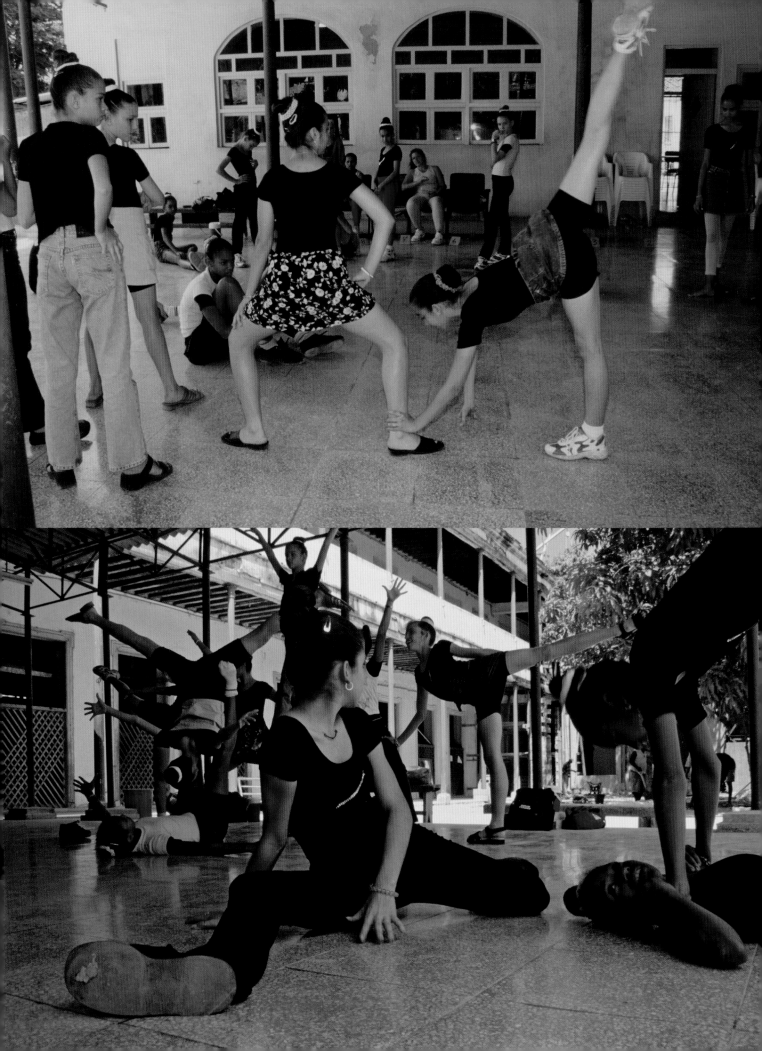

Laura Alonso

In the industrial section of Marianao, a suburb of Havana, there is a gate in an ancient wall. Inside is the crumbling hulk of a decrepit building. Workmen rig ropes and hoist buckets to the second floor, where laborers push wheelbarrows sloshing with concrete past ballet students practicing pliées.

The Centro Pro Danza is a nonprofit school founded in 1988 by Laura Alonso. One thousand students come in three shifts every day to study with its 30 teachers. They can progress from elementary through professional levels, and if they qualify, join

the school—clean a patio, work in the office, or guard the gate."

Laura escorts me on a walking tour of the school. Some rooms have three walls and lots of fresh air. Others are furnished with painter's ladders. But all are occupied with youngsters learning classical ballet, Afro-American, Spanish, folkloric, Arabian, and modern dance, and, newly, Bob Fosse-style jazz dancing. Men in work shirts stir soupy concrete in the courtyard while peering in the glassless windows to observe the classes.

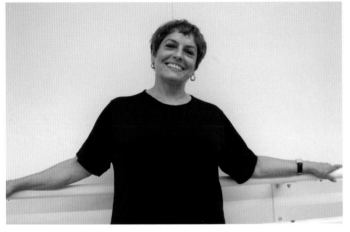

Ballet Classic of Havana, a company Laura founded in 1995 that presents 100 performances annually.

Centro Pro Danza receives no government support beyond a state-provided building (private property is anathema to Cuba's leadership). Canadian funding is making it possible to reconstruct the walls and floors. Ballet schools all over the world send used equipment that their students leave behind. Laura says with gratitude, "I have ten boxes of ballet shoes, jazz, tap (we don't have anybody to teach tap but I have the shoes), leotards, and dance tights."

Pro Danza students' families scrimp to pay the token tuition. "If they don't pay, they don't take it seriously," Laura believes, but she charges the least she can and still pay the teachers. "Five-year-olds who start in Baby Ballet pay 20 pesos per month (less than $1) and come twice a week; older students pay 30 pesos. Professionals pay 40 and come every day. Some students do not pay at all, but their parents help

Noticing the audience, Laura nods. "Humans need to dream. An artist's job is to open a window into this dream world so others can lean on the window sills and look in. I think if we really worked at it we could stop kids from using drugs and alcohol, which is the way they go into the dream state now. Dreaming can get people out of the situation where the only thing they can do is drink and play dominos. We need to take humanity out of that hole. Open windows, get fresh air, let the dreams in."

"Why do you think dance is so important to people?" I ask.

"When human beings were in the caves, the leader of the pack had a second in command, a medicine man who danced, painted, made music, and spoke to the spirits. Religion, medicine, and art were among the first things humans had. So of course people want to dance! If you clap for a little child in a crib, he dances even before he walks. Dancing is very important.

"An example. For our year-end performances we use theaters in Central Havana, so far away that the people around here cannot attend due to transportation problems. But one year, the entire borough came. I asked, 'How did you manage!' 'We went to the bus depot and commandeered two

Specifically, Laura's father married his brother's dance partner, Alicia Martínez. She began to dance at age ten, legend says, because her feet fit the only ballet slippers the school had.

In 1935 Fernando, age 20, returned to Cuba after studying in the United States and fell in love

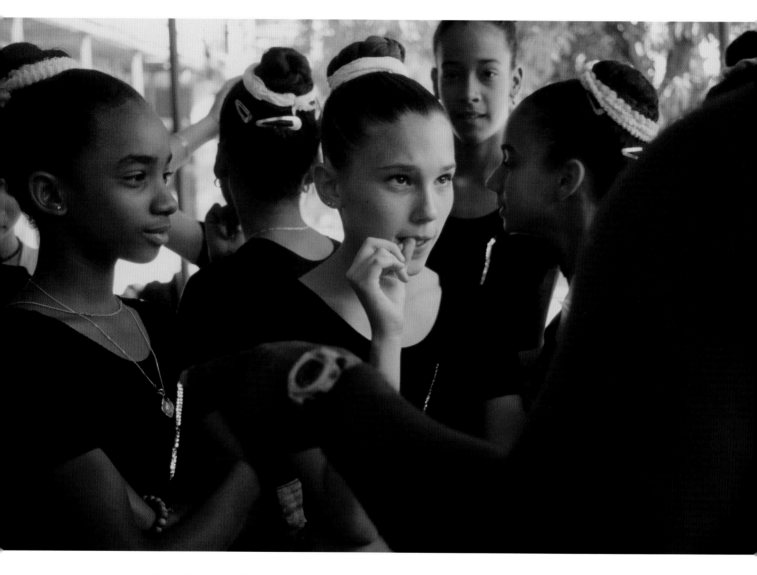

buses,' they admitted. 'Where did you park them?' 'Oh, outside.' They just borrowed the buses! Oh, my God!"

Dancing has defined life for Laura's family. Her grandmother was a concert pianist who, during the Depression, opened a dance and music school. "My father, Fernando, and my uncle, Alberto, studied the violin and piano. But they took one look at their mother's ballet classes and said, "Oh, boy, this is where the pretty girls are!" They started taking ballet and sure enough, my uncle married a ballerina and my father married my mother."

with Alicia. Temporarily, the three friends went different directions.

Alberto joined Sergei Diaghilev's Ballet Russe de Monte Carlo, whose company, over time, included Anna Pavlova, Vaslav Nijinsky, and George Balanchine.

Fernando and Alicia, then fifteen, eloped to New York and lived in a tenement in Spanish Harlem. At that time, only Broadway musicals offered steady income so the Alonsos performed in chorus lines, including in the 1939 production of *Stars in Your Eyes* with Ethel Merman. The show's title described the couple. Soon, Laura was born.

"I always thought every mom and dad danced. It was normal!" It was also normal for her talented parents to continue their careers. "When I was two, I was taken to Havana where my grandmothers cared for me," Laura recalls.

Meanwhile, in New York, Fernando and Alicia Alonso joined Ballet Theatre (which became the American Ballet Theatre). One day prima ballerina Alicia Markova got sick, and twenty-two-year-old Alicia Alonso danced instead.

Later, a *Daily Express* reviewer raved, "Alicia Alonso is technically perfect, dramatically forceful, and very much human, one of the greatest ballerinas in the world." She went on to dance with the best companies, always to accolades.

In Cuba today, "Alicia" and "ballet" are synonymous. In 1948, Fernando, Alicia, and Alberto returned to Havana and launched Cuba's first professional company, Ballet Alicia Alonso. Laura remembers, "My uncle did the choreography, my father was the instructor, and my mother, of course, was the prima ballerina.

"My father needed dancers for the corps de ballet. I had been dancing since I was three. When I was 12, he put me in the corps. My mom had a heart attack over that. She said, 'Once you put her on stage and she feels the applause, that's it! It's like a drug!' She was absolutely right."

When the family refused funding from General Fulgencio Batista's government, Ballet Alicia Alonso was suspended.

The Alonsos used Fernando's mother's institution, renamed Escuela Alicia Alonso, to develop the Cuban school of ballet. Laura remembers, "My father analyzed all the international schools, either from watching my mother's dancing or from choreography." Unlike the Russians (who emphasize arm work), the Danish and Americans (who focus on legwork), or the Italians (who like fast footwork), Cuban school dancers use their entire bodies.

In 1959, Fidel Castro came to power—and came to the Alonsos' house. It was Laura who announced their visitors. "Tell them to come up," Fernando told his daughter. Fidel asked, "How much do you need to start the ballet company up again?" His government gave the family $200,000 and charged them with making ballet available to all social classes.

Ballet Alicia Alonso reopened, renamed Ballet Nacional de Cuba. Its students traveled to Bulgaria in 1964 and took gold medals in their first international competition (as they have everywhere ever since).

For 25 years Laura was a principal soloist with the Ballet Nacional. "But I was too thin," Laura remembers, "so I had health problems. I had to gain weight and if you gain weight, you can't dance."

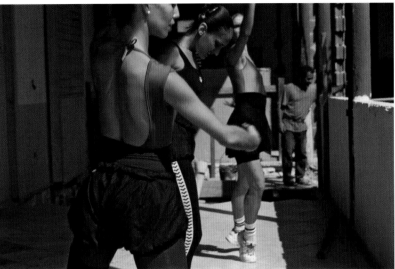

"I started teaching when I was 36," she remembers, and it is testimony to her ability as an instructor that for seven years, Alicia used Laura as her personal coach.

Centro Pro Danza blossomed from the teaching department of the Ballet Nacional. Laura saw a need for a different approach. "The Ballet Nacional has standards: everybody must be equal, the same size with the same features, which is good. We take the others, which is also good. We follow an adventurous, experimental style. We want to do things differently without forgetting tradition."

In 1990, two years after the school opened, Laura's student Jose Manuel Carreño won the *Grand Prix de Ville*, the highest award at the Jackson International Ballet Competition, one of the most important in the world. Carreño is currently a principal dancer with American Ballet Theatre.

Centro Pro Danza students consistently win medals and awards in international competitions. Similarly, professional dancers come from all over the world to study with Laura, an acknowledged master teacher. Her enthusiasm for her work is infectious: "I enjoy teaching immensely. The rehearsals. Taking

people to competitions. Teaching them the craft, the psychology of the role they are going to play. The history. That's what makes a good performance with depth. You need the story behind the story, all of that."

Laura is proud to have been named Best Master Teacher by the Jackson International Ballet Competition, which invented the award for her. They had not given it before nor have they given it since.

"What did you do to inspire this honor?" I ask as we leave a room where limber girls are practicing acrobatics.

"There were between four and five hundred contestants and only six ballrooms to practice in. I noticed that the hallways had wood floors, and began teaching there. A lot of kids meandered in who wanted to join us. I said, 'Sure.' There were some who had nobody to rehearse them, so I rehearsed them. I went to warm up my dancers and there were a whole bunch who wanted to be warmed up, so I warmed them up. I helped them. That's what a teacher is supposed to do."

I can't resist asking, "How is your relationship with your mother? Is she proud of you? Does she view you as a competitor?"

Laura smiles. "She is very proud of me. And she does see me as a competitor but that's okay, we've gotten over that. She is extremely intelligent and brave. She has a good sense of humor. She is a diva." Alicia Alonso performed until she was 74. Her last ballet partner was Laura's son, Iván Alonso, a soloist,

choreographer, and teacher. Today, Alicia still directs the Ballet Nacional.

Laura offers, "I also admire my father very much. He is intelligent, charming, diplomatic. I learned everything from my parents. I hope I got the best of both of them." When Fernando celebrated his 90th birthday in 2005, Laura produced a performance in which the best young Cuban dancers interpreted classic pieces to honor him.

As we explore and observe Centro Pro Danza's two floors of full classes, I consider the number of students who study here every day.

"A thousand students!" I marvel. "Can Cuba use a thousand dancers?"

"Sure they can. Every province has a company and Havana has two, my mother's and mine. Plus many go out with contracts—in every company in the United States there are Cubans. But I teach even the ones who are not going to dance. You have to teach the techniques, stories, and styles so they will be a knowing audience," Laura says.

"Let's pretend you had all the money in the world. What would you do with it?"

"Oh, my God. I would add fruit and vegetables to the rice and beans we serve students for lunch. I would fix an amphitheater for performances. Build a rooming house so we could have more students in a safer environment. Take more students. Pay more to my people who are not getting much. We desperately need transportation (two buses, three cars, and a

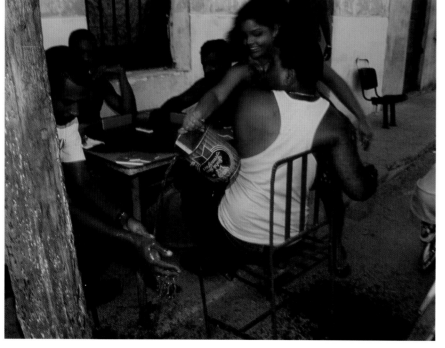

van would do it) because the kids are having trouble getting here. I would put the stage sets in a dry place; the roof leaks on them now. We must fix that.

"I would buy vitamins. When we have money I make everyone take them, even the retired people who guard the doors. If you just give them vitamins, they take them home to their grandchildren so I have a person stand there saying 'Open your mouth, drink, swallow!'"

I push for more. "Let's pretend you have all those things. What else would you like?"

"I hope when I die that I have helped make the world a little bit better. That is the greatest thing any human can aspire to."

"Over time, what changes do you notice in the Centro Pro Danza students?" I ask.

"They become healthier. And they have a different approach to life. When you dance, you learn that you either put in the work or it's not going to happen. If you don't succeed, you try again until you do. There is no shortcut. You learn discipline. The results are right there in front of you in the mirror. Ballet is very strict.

"Also, students learn manners: to say good morning, thank you, to wait their turn and to bow. A girl may be little, but she feels like a princess. That takes them out of their poverty, too."

"And how do their parents respond?"

"With joy. Sometimes I see a man bringing his little girl to school on his bicycle, such a proud papa!"

I am impressed by the enduring spirit of Centro Pro Danza, which provides youngsters with discipline and dreams—and a chance to affirm life despite pervasive material poverty.

MOROCCO
REDEFINING RIGHTS

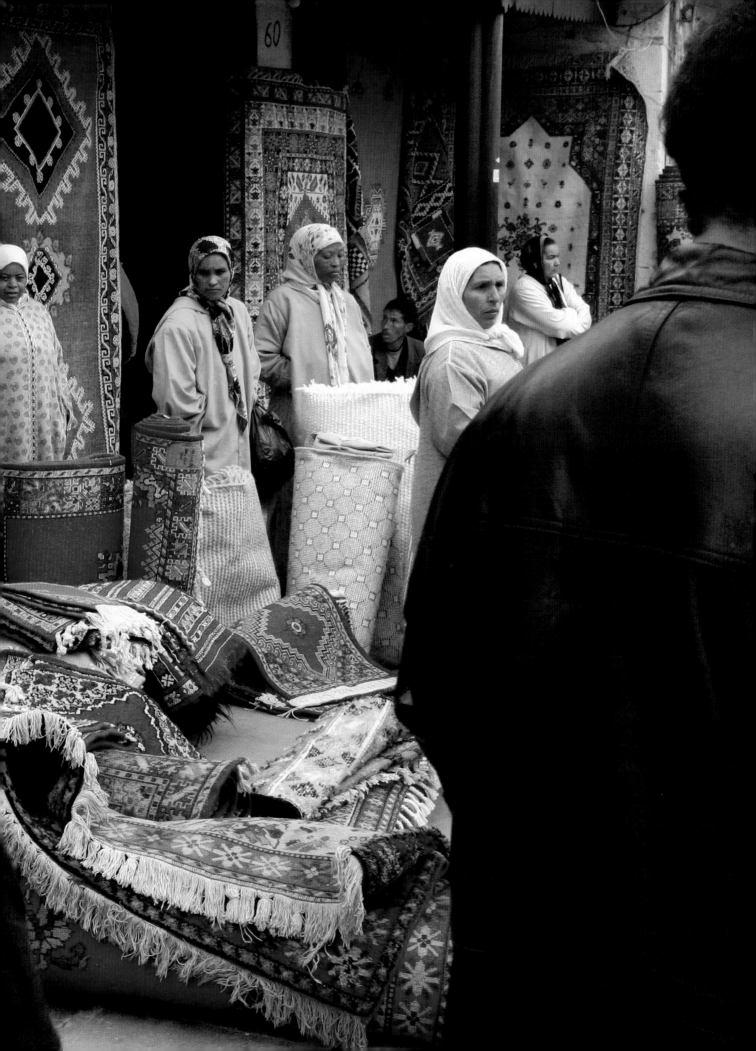

Childless women tossing hardboiled eggs to eels that are swimming in a dark grotto in Rabat hope the offerings will help them become pregnant. Being a mother is traditionally the role for which Moroccan women are most valued.

Thursday mornings, carpet weavers convene on the Rue des Consuls wearing robes and scarves. They watch silently as their husbands unfurl rugs at the feet of potential customers. Colors and patterns litter the covered concourse. Although some weavers hold cell phones, telecommunications seem anachronistic; negotiations proceed exactly as they have for as long as anyone can remember. Commerce is the province of men; women have traditionally needed husbands' permission to do business.

Until now, a young woman, without being consulted, could be married (becoming one of several wives, even without knowing it)—or divorced (losing her house and, if she remarried, losing custody of her children).

But all that is beginning to change. The Théâtre Aquarium is helping women understand that the past is over. The past 50 years show that is a very healthy development.

1957

Morocco's 1957 Moudawana, the Family Code that defined women's roles, was based on the first Islamic legal book created by Imam Malik bin Anas in the eighth century. It represented strict orthodoxy and perpetuated old institutions: polygamy (a man could marry as many as four wives); repudiation (a husband could divorce a wife unilaterally by saying "I divorce you."); guardianship (a husband was responsible for his wife who had to obey him); and inheritance (a son received twice a daughter's share). Many believed that the Moudawana came from the Qur'an; changing Allah's Word was unthinkable.

1985

Mina Tafnout, President of the Rabat chapter of L'Association Démocratique des Femmes du Maroc, remembers what it was like in 1985 when university-educated women activists set out to prove that Islam could not justify the refusal to restore women's rights and dignity. "People said we were women who had problems with men, who wanted to destroy the family structure, who were funded by Zionists."

1993

During the Parliamentary recess in August 1993, King Hassan II made a speech acknowledging that Moroccan women were the subject of discrimination. Mina Tafnout recalls that although "he said nothing very striking in that speech," he showed that discussing the Moudawana was not taboo. The king governs both church and state, and that year Parliament ratified CEDAW (the United Nations Convention on the Elimination of all forms of Discrimination against Women), albeit with reservations. Two women were elected to the 400-member Parliament.

Nouzha Skalli welcomes me to her office in Parliament. A founder of ADFM, she recalls, "In 1993, some modifications were made in the laws that governed women and children's roles in the family. They were minor measures, but showed that the Moudawana was not the Qur'an and could be changed. When we first talked about changing the Family Code, they said it was blasphemy and we should be killed." Skalli's eyes twinkle. "I like to be insolent; it's very important in a society that doesn't give women a place."

In 1999, responding to the UN Fourth World Conference on Women in Beijing, the Moroccan prime minister proposed a National Plan of Action to Integrate Women in Development. Based on research and recommendations submitted by many women's associations like ADFM, the plan proposed redefining women's education, health, legal, and political rights. A passionate national debate erupted.

Islamists described the plan as an attack on the sanctity of the Moslem family, an unwelcome intrusion of international and Western influences into Moroccan women's lives. They did not want women exempted from guardianship during marriage; they did not want polygamy abolished or automatic divorce replaced by court divorce.

Modernists claimed that the plan appropriately emphasized gender equality and universal human rights. They argued that the Moudawana was neither Allah's Word nor a reflection of contemporary family relationships and lifestyles. The plan, they said, would resolve conflicts between international, domestic, and religious laws.

As International Women's Day 2000 approached, the Modernists—a network of about 200 activist women's groups including ADFM—launched a campaign called The Spring of Equality, and planned a march in Rabat where thousands would express support for the plan. Islamists mobilized an opposition demonstration in Casablanca. Skalli remembers, "They knocked on doors and said 'The march in Rabat is the March of Jewish and Western women against Islam. Muslims must go to Casablanca.'"

Estimates vary, but most say that between 300,000 and a million people marched *for* the plan in Rabat. But more (between 600,000 and a million) marched *against* the plan in Casablanca. Television news from that city showed a seemingly endless column of men walking next to an equally endless column of veiled women, both chanting "We define Islam with our bodies and souls," and "Men and women are equal before God." Skalli remembers. "It was a crisis. People were afraid there could be a war."

The prime minister, hoping the 37-year-old king could quell the furor, asked him to arbitrate in his religious capacity as the Prince of Believers. King Mohammed VI, who studied law in France, had been crowned the year before. "In his first speech he said 'It is impossible for our country to go forward while women are marginalized,'" Nouzha Skalli smiles, remembering his welcome, unexpected support.

In 2000, the ruler created a royal advisory board to reform the Moudawana. "He put some religious people and some women on the commission, and also some who wanted to regress," Nouzha remembers. "He told me, 'Give me everything you agree with and don't agree with.'" The commission was to examine all opinions and options.

In November, 2003, King Mohammed VI announced that there would be eleven major changes in the Moudawana. Nouzha Skalli remembers that day clearly, "It was the most beautiful day of my life. I was in my apartment watching television and I heard the king saying 'First…Second…' and I couldn't believe my eyes because it was exactly what we were fighting for. It was wonderful, really." Rachida Tahri, President of the national ADFM organization, went into action, "We called each other in disbelief and joy. Everything we wanted!" The king's amendments were approved by the members of Parliament and the new law went into effect in 2004.

2006

Ahmed Toufiq, Minister of Religious Endowment and Islamic Affairs, helped draft the Moudawana amendments. Tonight, he is opening an exhibit of ancient illustrated manuscripts. A week ago, 100,000 people demonstrated in Rabat against the publication of the Danish cartoons that showed Mohammed despite the long-standing Sunni Muslim objection to portrayals of the Prophet. Morocco is 99 percent Muslim but the minister's soiree demonstrates diplomatic and ecumenical solidarity. Guests include ambassadors from Denmark and Iran, a Jewish rabbi, an Orthodox priest, and a Catholic bishop, all in full regalia. Cake plates tower with Moroccan pastries; waiters carry trays with mineral water and juice, plus coffee and tea that they pour from silver pots held high above guests' glasses. Muslim musicians sing blessings. The minister is forthcoming when I ask about the new Family Code: "It has been well received by women across the spectrum, and has had an important effect psychologically. I think women feel protected by the laws. But there is still work to be done regarding implementation."

Today there are 35 women in Parliament including 6 Islamists, one of whom is Bassima Hakkaoui. I interview her in Parliament's marble hall. Bassima, wearing a silk surah designer scarf, hurries in from a meeting, greeting constituents, answering her cell phone, explaining she has only fifteen minutes. Knowing her party was a key organizer of the Casablanca march six years ago, I ask where she stands now. She is direct: "All parties could agree on this amended Moudawana, which respects the specific Moroccan and Islamic identity. Almost all my constituents were in favor of the new code. We saw, as women, that there was a certain interest in our problems; in this sense, it was very productive. But there are many issues with implementation...the woman herself does not know all her rights...the training of the judges...."

Women in civil society are already working to resolve these issues. Rachida Tahri admits that after the Moudawana changed in 2004, "For a while we rested. But implementation was and is a problem. ADFM is drafting a proposed protocol for training the sixteen new Family Court judges." And the Théâtre Aquarium, whose work I have come to document, is teaching women to understand their rights.

Bassima Hakkaoui

Wy interpreter, Scheherazade Matallah, and I climb the steps to Naima Zitan's apartment, one room of which doubles as an office for Théâtre Aquarium. Three senior members of the organization lean on the table and passionately describe their history and dreams in a cacophony of French and Arabic. They switch from one language to another mid-sentence and everyone laughs as Scheherazade, undeterred, translates the jumble into English for me.

NAIMA ZITAN

In 1994, Naima Zitan, a graduate of the Institute of Dramatic Arts, founded Théâtre Aquarium and produced her first play, *Quarrels,* for elite audiences of Moroccans. She chose the name Théâtre Aquarium to suggest that audiences could watch real life in a fish bowl. "I had no intention of creating an activist association," she admits, but she and her partners, Naima Oulmakki and her brother Abdullatif Oulmakki, began feeling that "eight or ten performances in Rabat were not enough. We were all working in women's associations, and decided to create productions about the situation of Moroccan women that would play in big cities and small villages."

"Abdullatif was working in women's associations?" I marvel.

"Yes! I am 100 percent feminist," he nods.

"If he weren't, he wouldn't be working with us!" his sister laughs.

Naima Zitan continues, "In 2000, we collaborated with a nongovernmental organization, Jossour, to defend the National Action Plan. Our play was called *Stories of Women.* We performed in front of thousands of associations. The opposition demonstrated against us. During this time, we learned that 60 percent of Moroccan women are illiterate. We were shocked and decided to take our performances to them. Between

2000 and 2002, we performed *Stories of Women* 50 times, in rural areas, souks, markets, and mosques. The Moudawana reform is, in part, a result of our activism," she acknowledges without hubris.

"The amendment of the Family Code was extraordinary," Zitan observes. But few illiterate people knew about the new Moudawana and even fewer understood it. "In 2004, we created a new play, *Coquelicot,* to explain the new law."

Abdullatif jumps from his chair and beckons me to the computer, where he has mapped a welter of national literacy data. "We had to work hard to collect this information," he admits, "since the government wanted the statistics to be confidential. In these areas," he says pointing to red districts on the screen, "more than 85 percent of the population is illiterate. That is where we take our performances: to prisons, hospitals, factories, orphanages, and, of course, theaters."

"Our mission is to explain to women what their rights are now. It's not easy for people to change after so many years, but if they don't understand, they cannot demand their rights and the new law is useless," says the visionary Naima Z, who is president and artistic director.

"Before every performance, we ask what people in the audience know about the new Family Code. Usually they give us wrong information and wrong definitions. After the play, we ask them what they learned and what was clarified. For us, it's a technique to evaluate the effectiveness of the presentation. This part is my job because I talk the most," laughs Naima O, whose title is public relations director.

One early afternoon, the two Naimas, Abdullatif, Mbarka El Ouazzani from Jossour, Scheherazade, and I jam into a compact car and head for the suburb of Temara. Naima Z has been working at her job at the Ministry of Culture and, in need of a power nap, falls asleep en route.

Naima O tells me, "Naima and I met when I was working with Jossour, and we decided to try social theater. She is 38, a Berber from the North, an artist. I am 42, an Arab girl from the South, an archaeologist. We both have regular jobs, and work for Théâtre Aquarium out of love." The two appear to be opposites: introvert and extrovert; Zitan chain smokes three packs a day, Oulmakki doesn't smoke; Zitan drinks water at lunch, Oulmakki quaffs a glass of beer. "But we care about the same deep existential questions: why, when, where? In that way, we are exactly the same."

Abdullatif Oulmakki

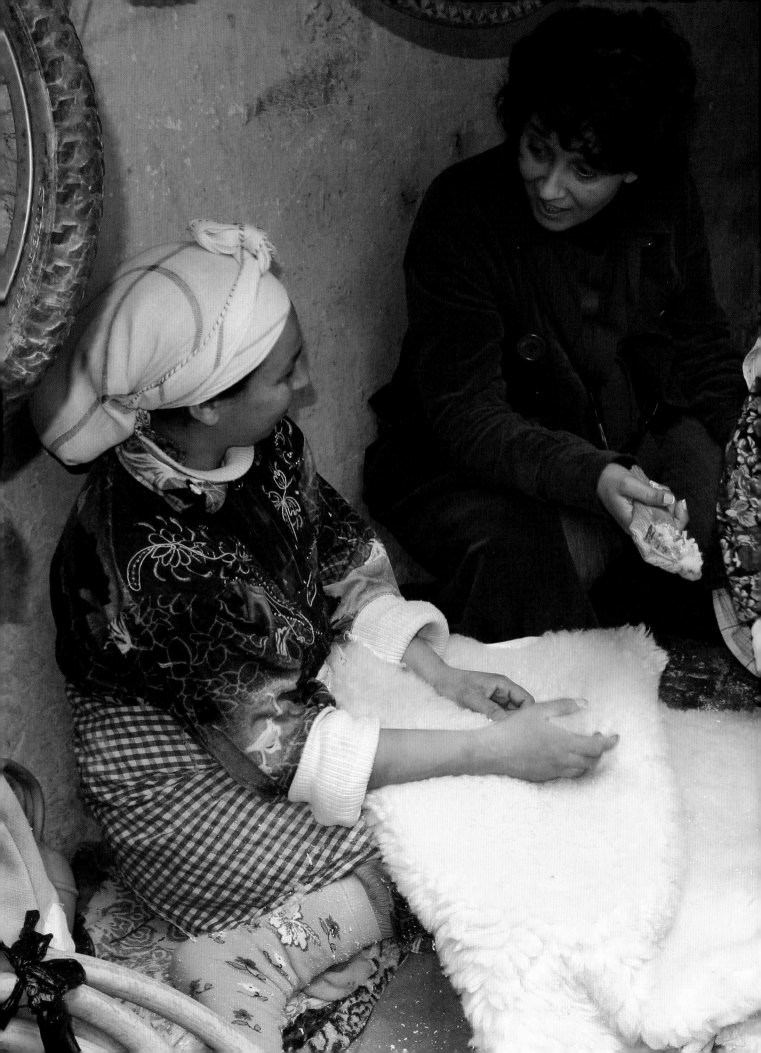

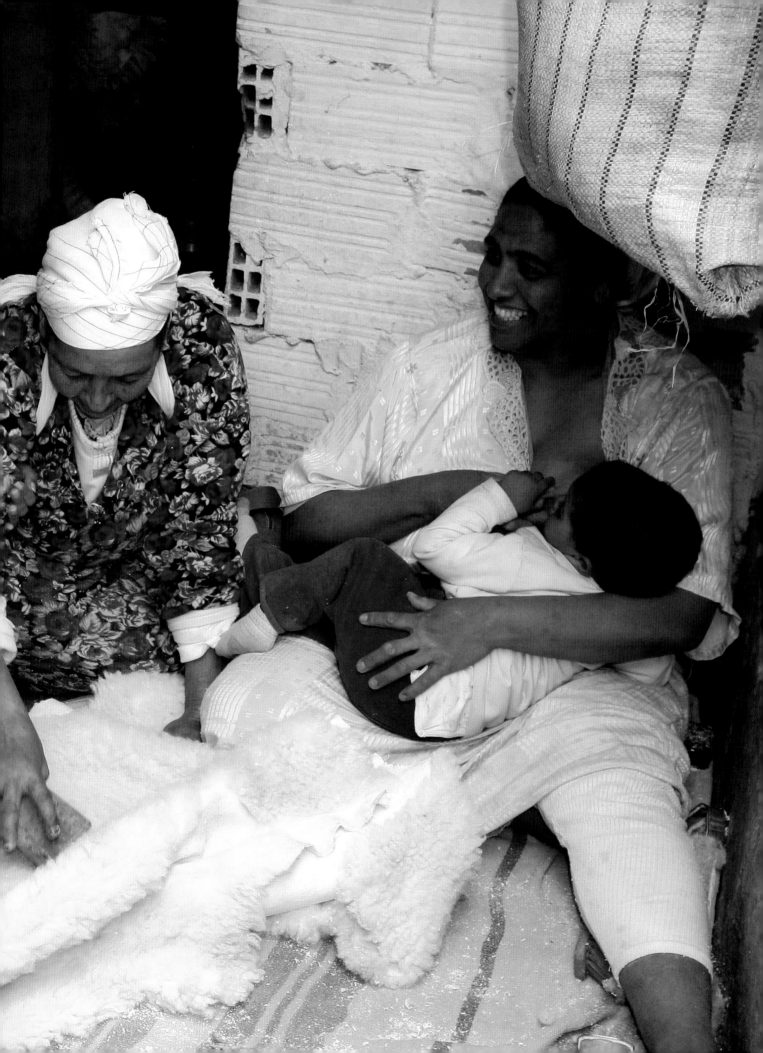

Naima Oulmakki

In contrast to sophisticated Rabat with its bougainvillea- and mimosa-lined streets, Temara is full of poor families who live in drab shanties on lots strewn with refuse. A Théâtre Aquarium banner stretches above a street. Its words, hand-lettered in Arabic, invite people to the play this evening. "Of course most people cannot read that sign," Naima O reminds me. Having worked in advertising for 35 years, I try to imagine how to invite illiterates to a play, given that they don't know what a play is.

"Come with me," Naima O beckons, stepping into the *bidonville* (city made of barrels) and knocking on the first door. As soon as a woman opens it, Naima speaks in animated Arabic, a feminine reincarnation of the Music Man. "You will enjoy the play. You will learn! It is fun! It is free! It happens when you are not busy!" she promises. Who knows what else she says. The housewife laughs in delight, hugs her, and agrees to come.

Naima obviously intends to (and does) knock on every door—but she doesn't stop there. We approach the community well. Naima is surrounded by women carrying water jugs. She enchants them all: joking and cajoling, chatting and challenging ("What do you know about the new Family Code?"), laughing, encouraging and stroking the women who are pleased with the attention and decide, without exception, to attend the performance.

We knock on a door near the end of a block, and are invited inside. While I wonder where the corridor leads, Naima hurtles into a group of women sitting on the floor combing wool. The woman to her left nurses her infant; the woman to her right is a crone; two others help. Naima works with them as if she were a weaver not an archaeologist, talking about *Coquelicot* the whole time. When she stands, they don't want her to leave. A woman invites Naima and me to another room to see her baby. "We cannot afford milk. The baby is dying," the mother says sadly. I have never seen a dying baby. Its head lolls to one side, its body limp, its eyes unseeing. I consider giving the woman money but wonder what will sustain the baby's life after I'm gone. While I am worrying, Naima promises to find an NGO to help.

Everywhere, women allow pictures. Naima's sparkly personality shields me; women whom I could never have photographed if I were alone seem to welcome my flash. As Naima and I walk together toward the last houses, an outraged official materializes and shouts at her in Arabic, "A foreign photographer is taking pictures of our women! That is not acceptable!" He brandishes his credentials. Naima explains that she is with Théâtre Aquarium, an association that is registered with the government. She is appropriately somber at first, but after a while it looks to me as if she is flirting. The two begin laughing. She has convinced him to attend tonight's play.

Coquelicot, 52

The curtain is about to go up on *Coquelicot's* 52nd performance. Having unpacked two vans at 8 AM, ten volunteers have worked all day to install the sets, lights, and a sound system in the borrowed auditorium. Naima Z is everywhere: checking the tilt of a floodlight, adjusting levers on the sound table, coaching the cast backstage. Local men finish setting up folding chairs but there are not enough seats for the 120 people who stream in. Mothers hold their children. Many stand, two and three deep, at the back.

The grants that Théâtre Aquarium receives pay professional actors. The two women and two men who perform tonight are well-known television stars ("People want to come see them. They are experienced and convincing," Naima Z tells me).

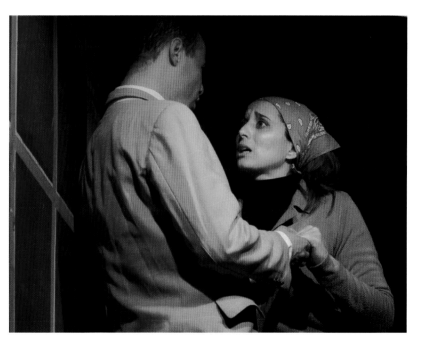

Each of the eleven amendments to the Moudawana has been turned into a slapstick skit. When a young man asks a girl's father for her hand in marriage, her father explains that his daughter herself must decide. The suitor is flummoxed at this turn of events. Twisting his hands and scuffing his feet, he musters arguments and even promises, "You will be free to go out and see your friends!" The women laugh and applaud.

Scene Two: The couple has not been able to have children and the husband confides to his buddy that he is considering divorce. His friend suggests that the man visit a doctor to see if it's his own fault that they have been unable to conceive. The thunderstruck husband has never considered that he might be responsible for the couple's predicament. The women in the audience chortle and clap.

Scene Three: A woman judge asks whether the man's wife has agreed to a divorce. The man frowns in frustration and the couple leaves the courtroom for an awkward private conversation in which he levies a long list of complaints. The wife, having listened respectfully, suddenly shouts, "What are you talking about?! I have done nothing but work for you for all these years. Spent hours washing your dishes! Look at my red hands!" The women cheer.

Afterwards, Naima Z, having produced another successful performance, steps outside to study the sky and enjoy a cigarette. While Abdullatif and the crew break down the sets, Naima O begins her research. Surrounded in the lobby by throngs of local people who obviously consider her their new best friend, Oulmakki asks eagerly, "What did you learn?" Excited men and women jostle each other out of the way, trying to get close enough to talk.

Tonight's performance will take place in Skhirat, south of Rabat. Curtain time has been set so local factory workers can attend conveniently after their shift. We arrive at the factory expecting Naima O to invite women during their lunch break. But the factory is silent. At noon, without notice, the workers went on strike. As we drive away, the two Naimas discuss what to do. They have already paid the actors and Zitan is prepared to proceed "even if there are only ten people." Oulmakki leans her head against the seat: "I have a bad feeling about this."

Ahead of our car is a large truck and as we draw closer, we see about 50 women riding in the back. Abdullatif exults, "They are giving the factory workers a ride home!" Naima O already has her head out the window, shouting to the women in Arabic: "What are you doing tonight? Come to our play!" The women laugh and yell that they have no transportation, they would if they could, thank you.

As the truck turns off to the right, it takes with it the possibility of having an audience.

Naima O is silent. ("I am a tough woman," she has told me, "but my work is hard to do. Once I put on a scarf, walked into a mosque, went to the top, got on the loud speaker, and made an announcement about the play.") I can't imagine what she is cooking up now.

The performance is supposed to occur at a community center usually used by high school students. Jossour and some local youth organizations are sponsoring the show. Naima Z is disturbed by the number of boys who are hanging around ("Rowdy, teenaged boys are not our target audience," she worries) but Naima O sees an opportunity. "Go home!" she commands the kids, "Come back with your mothers!" As they trudge off obediently, she heads to neighboring apartment buildings to knock on doors and try to save the day.

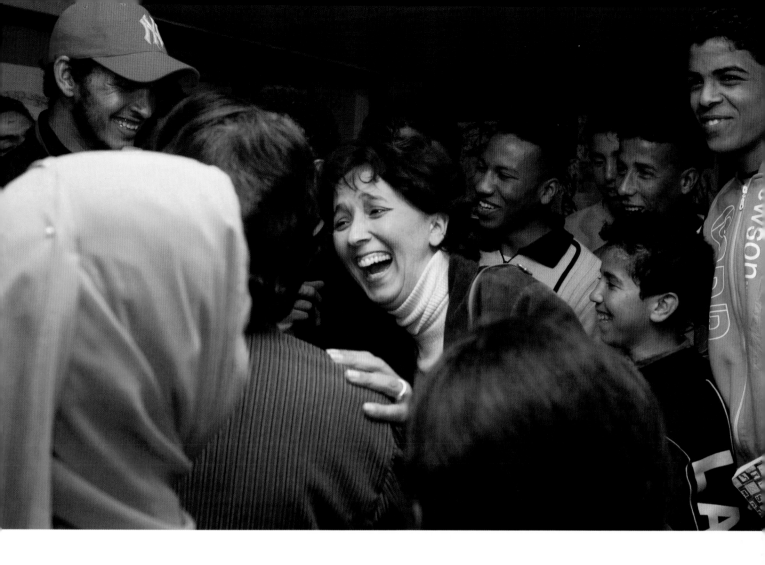

Ultimately, the theater is flooded with people. Women and girls sit on the right side. Boys and men sit on the left side of the aisle where I have inadvertently staked out a chair; mothers with children on their laps join me in the men's section. There is not one empty seat. There is no more room to stand. Some women can't get in and decide grumpily to watch through the auditorium doors. It takes so long to get everyone settled that the performance starts an hour late.

To say the play is well received is an understatement. The audience hoots and claps and howls and stomps. Afterwards, while Naima O does her post-performance research, several students corral Naima Z. (The other Naima marvels later, "I have never seen her talk to anybody after a play, she is always too tired!") The students have drafted a script and want Zitan to take a day off to help them. (Sotto voce advice flies between the Naimas: "I can't!" "You must!") Ultimately, Zitan agrees. Then we are all swept off to a cast party where the local hosts serve slices of fresh-baked cake and pour mint tea from high above,

hitting each glass with astonishing accuracy, saluting the Théâtre Aquarium.

Naima Z had reason to worry about finding time to advise the young thespians of Skhirat. Next month, Théâtre Aquarium (which recently took *Coquelicot* to Spain) will pack cast, lights, sets, and sound system into two vans and play eastern Morocco. They will stay in one city and present in four or five surrounding villages before moving on, until they have completed 20 performances. As if that weren't enough, in two weeks the troop will launch a new production. Théâtre Aquarium, defined by its focus on women's issues, continues to raise consciousness, inspire reflection and debate, and catalyze social, political, and ethical change.

Rouge + Bleu = Violet

Rouge + Bleu = Violet will premier at the National Theater in Rabat. ("It has 1,300 seats," Naima O grimaces. "I stay awake nights dreaming up strategies to fill those seats.") Unlike *Coquelicot*, the new play is a serious, sophisticated drama, with stories layered inside stories. Written partly in French and partly in Arabic, it is intended for psychiatrists, social workers, and policy makers who deal with violence against women. Written and directed by Naima Zitan, the project has been in development for two years. It took that long to decide that the issue was important enough to dramatize. Gender-based violence has only recently been acknowledged; little research existed.

In 2000, a survey of young urban women found that 75 percent were afraid their husbands might use violence against them; 36 percent of those interviewed had already been victimized. A 2003 survey in Fez revealed that the younger the woman, the worse the violence, and that although seven in ten women were beaten, half did not report it. (Reporting is onerous because it requires witnesses. Moroccan courts grant divorce for physical abuse only if the wife can produce two people who have actually seen the beatings.)

The more Zitan learned, the more passionate she became about domestic violence. "We cannot rest on our laurels now that the Family Code has been amended. We must create a culture that denounces all forms of violence against women: physical, sexual, psychological, and economic. Of these, domestic violence is the most grave, difficult to understand, and universal. Our purpose is to inform people about the practice, punish the perpetrators, rehabilitate the victims, reexamine the laws, and educate the public. For two years, 2006 and 2007, we will consecrate ourselves exclusively to disseminating *Rouge + Bleu = Violet*."

I join her in the theater of the Goethe Institute in Rabat for a rehearsal. Videographer Rachid Kasmi screens a rough cut of his short silent film, which will open the play. It features one of the show's two famous actresses, Latefa Ahrrare, and it implies, via her gestures and facial expressions, that she is a victim of violence. Rachid has made a man's movie of a beautiful woman, and Naima feels it shows Latefa looking inappropriately seductive. "It shows no fear, no anger, you must reveal those feelings!" she admonishes him gently. Rachid thanks her.

Dounia Boutazzout and Latefa take positions on the stage and become their characters. Latefa is a renowned movie actress and when she smokes an invisible cigarette, I can almost see a cloud float into the air. But Dounia achieved her fame on television and her voice and gestures seem too small for the stage. After Dounia tries four times to say the line, "I don't know what to do," Naima joins her on stage and demonstrates the action she wants. "Turn your head. Run the words into the next line." She directs constructively, transmitting her wisdom, drawing on her understanding of women and empathy for the human condition.

On March 3, 2006, Théâtre Aquarium premieres *Rouge + Bleu = Violet* to a packed house. It earns glowing reviews.

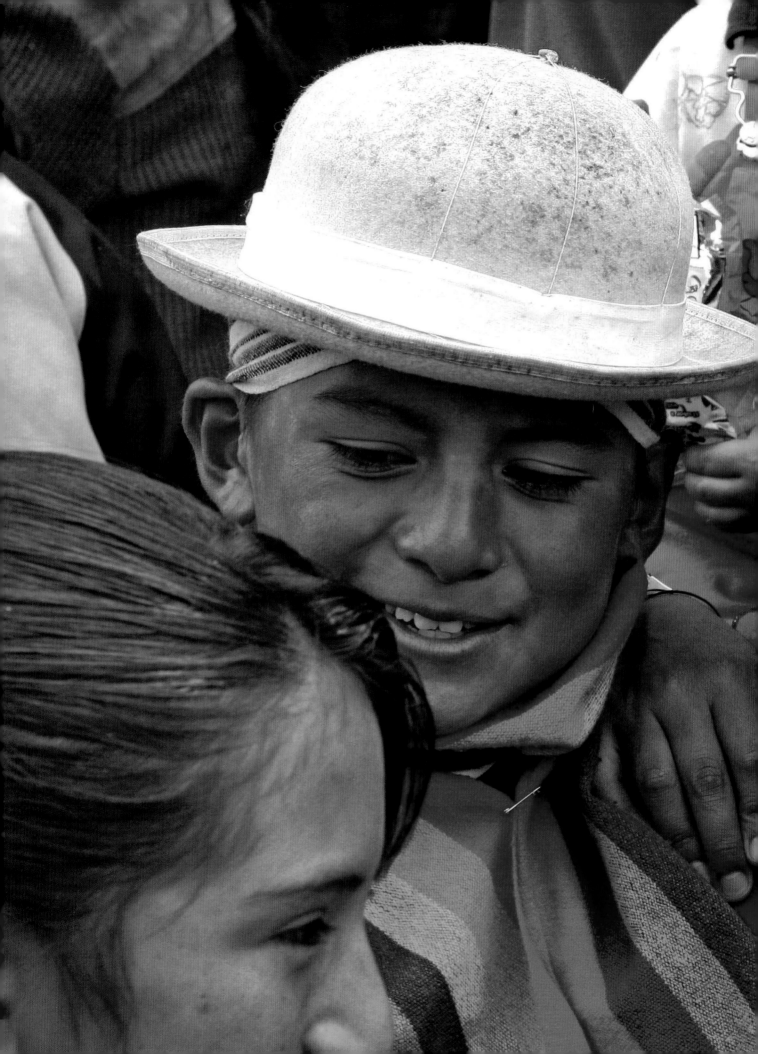

ECUADOR
CLAIMING POWER

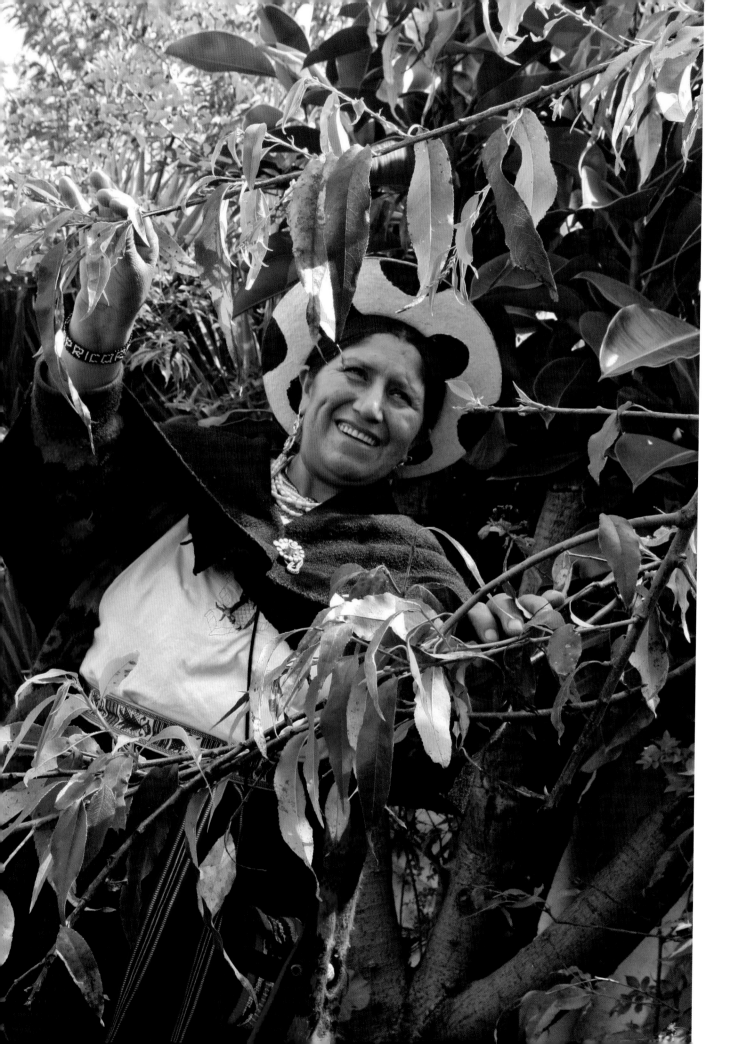

The conference room's cool white walls, large glass table, and pale wooden floor are foils for the view of a garden where bushes and trees shade calla lilies and geraniums. Over the next few hours, the plants begin to seem like a magic garden. That little *arrayan* bush can strengthen bones and make hair healthy. Over there, the tall *capulí* tree that is blossoming with tiny white flowers has leaves that treat colds and flu, and roots that can be used for birth control.

MAMA CARMEN

Mama Carmen carries a circular tray into the conference room and sets it carefully on the table. She wears a long black skirt; a black shawl closed with silver *topos* (pins); a multicolored bead necklace and Capricorn birth-sign bracelet (a reference to the sacred circle of the zodiac)—and a felt hat whose brim, which symbolizes the earth, has dots that represent north, south, east, and west, and whose crown is a metaphor for the heavens.

On her tray is a small bowl of water and a mound of earth encircled by flowers interspersed with sprigs of *wamenga*, a fragrant mountain herb.

Quietly, she begins building a fire at the top of the little hill in front of her. She rubs two holy sticks together, cups her hands around them, and blows the sparks into life. Incense smoke blooms into the conference room. She blows. For fifteen minutes, she continues to blow in silence until suddenly, a pure flame ignites. She smiles, "Fires that take time to start are destroying bad energy." Now, all four sacred elements, fire, water, air, and earth, are present.

Her tray represents the cycle of life. Mama Carmen will conduct this ritual to welcome her daughter's baby in a few weeks. She has already begun to prepare, collecting herbs that grow in the holy mountains and by the sacred waterfalls near her hometown, Saraguro. She makes the eighteen-hour drive every weekend from Ecuador's capital, Quito. Her country garden contains the oregano, parsley, *cherimoya* seeds, and rue that will contribute to her daughter's physical and emotional well-being.

Although her full Spanish name is Maria Carmen Lozano Sarca, the honorific "Mama" signifies respect for her special knowledge. Her Quichua name, Sunatisa (meaning beautiful flower) is the name that the Inca—and Mayan—calendars give to her birthday.

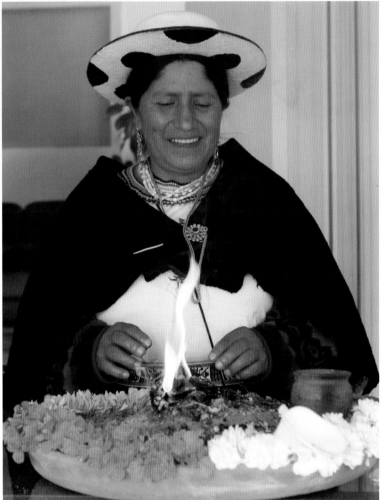

Perhaps it was inevitable that her traditional medicine practice focuses on birth. In Quichua, birth is called "bringing the baby into the light."

Mama Carmen's own first delivery was hardly so poetic. Her son was delivered in a hospital. After she had been in labor for two days, Western doctors and nurses gave her anesthetic and pushed on her stomach to force the birth. She was traumatized by this violence.

Her other four children were born at home. She remembered watching her mother give birth

kneeling, and adopted that system. She had learned about plants from her mother, and about traditional medicine from her father. Her second grandchild's birth will be the fifteenth over which she has presided.

"The first step is to clean the room and protect it from the wind since bad air is bad energy. I prepare the room with natural things: the mother will use natural cotton sheets and rest on a sheepskin rug placed on natural wood.

"The second step is to light the fire. The woman who is in labor walks around the fire, which gives her courage and hope. When the pains come quickly, her husband joins her and her family stands in a circle to share her suffering. Birth is a moment of harmony in which sisters, brothers, mothers, grandmothers, and little children participate.

"The woman kneels and when the baby falls, it makes contact with nature: cotton cloth." Mama Carmen cleans the baby and cuts the umbilical cord with a knife she has carved from a bamboo-like fiber. Then she ties the cord with cotton thread. The placenta is handled very carefully ("it is holy, part of the mother's body") and buried near the kitchen, where women spend time every day.

Mama Carmen washes the baby with water in which rue and Santa Maria plant have soaked. Although the baby will be bathed regularly, the fifth and twelfth days that follow are special occasions when Mama Carmen will perform ritual baths.

"Traditional medicine ceremonies are intended to create equilibrium between heaven, earth, nature, and self. Different rituals, the celebration of thanksgiving or planting for example, require different combinations of sacred components: plants, flowers, fruit, flutes, rocks, food, and drinks."

Josefina Lema is one of the women with whom Mama Carmen works. Josefina is responsible for diagnostics and Mama Carmen for treatment. "Josefina rubs a guinea pig on the body of the sick person, then cuts it open and examines the animal's organs. If the heart is black, there may be a problem with the person's heart. Then I say, this plant will help," Mama Carmen says.

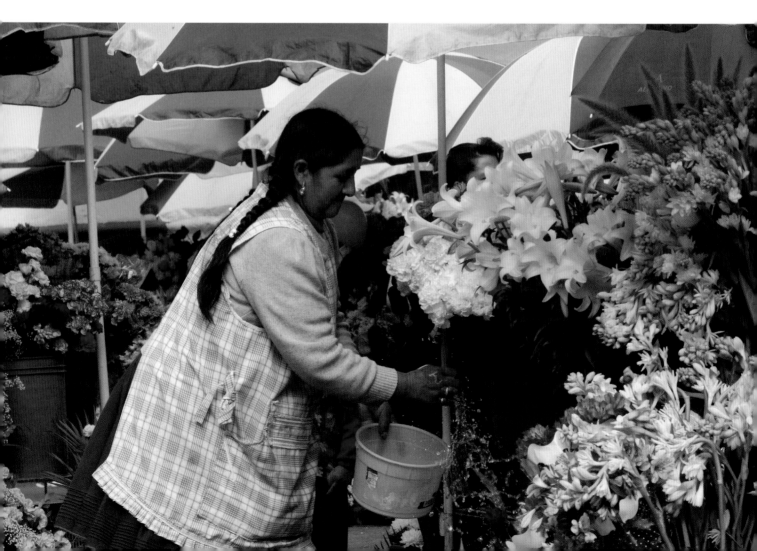

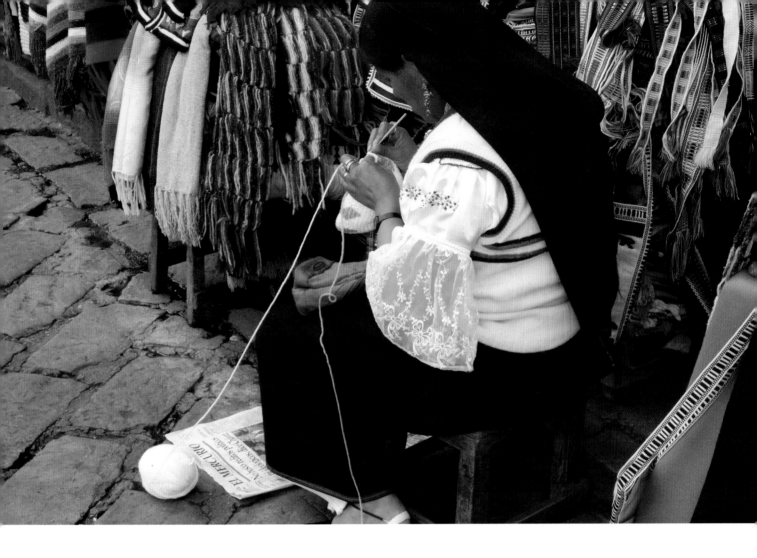

Quichua women play three specific roles: mother, keeper of tradition, and change agent. Mama Carmen is exemplary at all three. As a mother, she cooks, plants, and raises children. She practices traditional medicine. And she does political organizing.

Since 2003, Mama Carmen has worked for FEDAEPS (*Fundación Ecuatoriana de Acción y Educación para la Promoción de la Salud*). Her contributions form part of the organization's initiative, Defending the Knowledge of Women. She has attended many indigenous conferences on traditional medicine, sharing knowledge about everything from seeds to ceremonies at meetings as far away as Canada.

She attended the World Congress of Traditional Medicine in Ecuador in January 2006. "I think there are Mamas and Tituses—spiritual guides—everywhere. The knowledge is one; the forms to express the knowledge are different. We share with the original peoples of all countries in order to defend the natural order of things and create a harmonious balance and peace."

She has attended international meetings of indigenous people in the Caribbean and Peru where delegates discuss economic situation, political goals, and identity. Since, for indigenous people, traditional medicine defines identity, Mama Carmen's contribution is central.

Ecuador, which is smaller than Nevada, is one of the most biodiverse countries in the world. It has 25,000 plant species (North America has 17,000). But Ecuador's traditional medicine heritage is threatened by tribal assimilation and bio-piracy.

Traditional medicine practitioners including Mama Carmen vehemently oppose globalization because foreign pharmaceutical companies have been patenting plants allocated to traditional people by Ecuador's constitution, and making products that indigenous people must now purchase. "Our *cosmovision* is to share, not to sell," explains Mama Carmen.

Mama Carmen's politics were galvanized by discrimination. She weeps now as she describes being beaten at school for wearing traditional clothing and speaking the Quichua language. Thirty years ago, she attended a seminar and learned that indigenous people have been marginalized since the Spanish conquest—but they do have rights.

Pachakutik, Ecuador's indigenous movement, was organized in 1995 with the intention of changing Ecuador's constitution. In 1998, the Constitutional Assembly issued Constitution Number 19, which guaranteed indigenous people equal rights, bilingual education, and protection for medicinal plants and related intellectual property. Today, Mama Carmen sits on Pachakutik's executive committee.

She has also learned to defend her rights at home. After suffering domestic violence and sexual abuse, which she recalls with pain and rage, she drew strength from trips to the mountains and waterfalls, and from meetings with other women—strength enough to go to the police.

In Ecuador men can be arrested for domestic violence. The police issue a special document to abused women that obliges any policeman, anywhere in the country, to help them if they ask. "Just having that paper was enough protection," Mama Carmen explains. Many indigenous women are grateful for this arrangement since Quichua people believe heterosexual marriage is the origin and conservation of society and divorce is not an option.

Although she left school when she was in the fourth grade, today Mama Carmen is earning her high school diploma.

Her dream? "For all women—from Europe, Africa, the Americas—to unify, to share their knowledge, to construct a new order with justice and equality, to rescue the old knowledge, and to prepare the next generations for a new world."

Georgina de la Cruz Inlago

Georgina, one of 25 indigenous nurses in Ecuador, is always sought out by Indian people who come to the hospital in Otavalo. No one else on the medical staff speaks their language or understands their culture.

When she was growing up in Comunidad Eugenio Espejo de Cajas, her parents encouraged Georgina to study "as a way to confront discrimination." She studied. Ultimately, she studied nursing for four years at medical school in Pinar del Rio, Cuba.

Now 38, she divides her time between nursing and working with FEDAEPS, which, almost 20 years ago, pioneered AIDS prevention in Ecuador.

"Indigenous women are more vulnerable to AIDS," Georgina explains. "Machismo is much stronger than in the rest of the population, so women can not negotiate their sexual roles. There is no use of condoms." The people get mixed messages: "The Catholic Church does not believe in condoms and the Evangelicals preach abstinence. Let's face it, that's just not realistic," she says.

"To educate the indigenous community, you must be involved in local life, know the hierarchy, be aware of customs, festivals, agricultural cycles, speak the language, understand the culture.

"There's a lot of shame about sexuality among indigenous people; the subject is kept in the dark. To discuss AIDS with them, you must take the full journey through the subject of sexuality. Until now, the only information most rural indigenous people had was that AIDS kills. Many still believe AIDS only affects gringos, sex workers, and homosexuals. There is so much missing information!

"People who have AIDS are totally isolated. When I began working with AIDS, my family believed I would catch the disease. They would not let me come near my daughter.

"The government has done nothing to prevent discrimination…or to prevent HIV among rural indigenous people. The Minister of Public Health says there are 6,000 HIV-AIDS cases in Ecuador." Georgina scoffs at that number: "So much is not reported that you should multiply that number by ten." The inaccurate statistics have serious consequences: only 7 percent of all infected people are covered by government healthcare and receive antiretroviral drugs. Ninety-three percent receive nothing."

Georgina estimates that a large number of rural indigenous people are illiterate. FEDEAPS has had to be imaginative about developing effective AIDS prevention programs in an environment in which people are uneducated and discussing sexuality is taboo. They sponsor educational workshops and seminars, radio programs, telephone advice lines, and theatrical productions.

Most young indigenous people in the countryside have attended school for a few years. Because they are local and have some education, they have credibility. Georgina trains them about AIDS prevention. In turn, they present socio-dramas about the issue. Older people attend their performances and learn.

Radio is a popular medium. Georgina describes FEDEAPS' spot announcements, which communicate that "AIDS is very expensive and affects the survival of the family. When one person suffers, the whole community suffers. So it is in everyone's interest to learn about AIDS." After having worked for 35 years in advertising, I appreciate the sophistication of this message strategy, which leverages the importance of family and community in the Indian culture. Perhaps only with this approach will people become open to learning about HIV-AIDS.

What does Georgina do for fun? She is working with her village to promote the beautiful hand embroidery that is part of their culture, and will soon launch a website to encourage ethno-tourism. Oh, yes; she is also studying for a degree in Andean Anthropology.

Her village was named for Eugenio Espejo who lived there almost three hundred years ago. His father was Indian, his mother, mulatto. A physician who earned a PhD at age 20, Espejo founded a newspaper and wrote political satire to protest colonialism. This well-schooled man of medicine who championed traditional culture and made good use of the media must be smiling down on Georgina, who seems to be following in his footsteps.

BLANCA CHANCOSO SANCHEZ

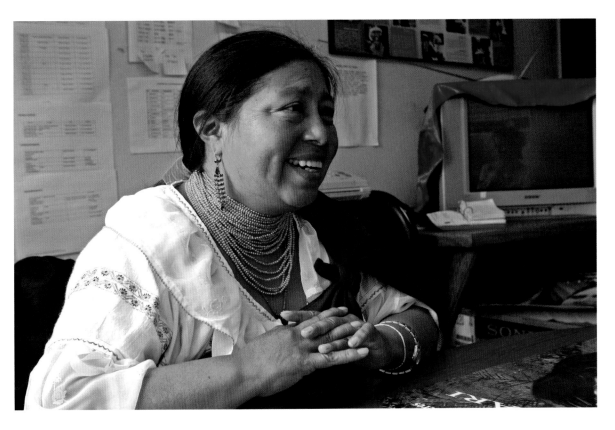

Blanca packs a lot into one sentence. Without taking a breath, she introduces herself: "I am from the Quichua community, born on June 1 in Cotacachi in the province of Imbabura, north of Quito, Andean region, Ecuador, and I will be 51 tomorrow." She speaks with such velocity and energy that everyone in the room stops to listen. People, I suspect, always listen to Blanca.

After she graduated from high school in Quito, she returned to her village to teach Indian children. Walking around the community before school, she became aware of the conflicts that beleaguered local Quichua people. If a land deed were forged by a buyer, which happened often, the owner had to hire a translator to present his case in Spanish to his lawyer. The attorney and the translator/middlemen were paid in cattle or chickens since villagers had no money; soon, villagers also had very little meat.

Blanca, who spoke Quichua and Spanish, began taking the villagers' conflicts directly to the local authorities. She told the indigenous people about their rights. She resolved conflicts effectively, and charged no one. Not surprisingly, she "had to quit my teaching job because everyone asked for my services." The middlemen and the lawyers she confronted were not as happy as her pro bono clients.

"Someone came with a gun to shoot me but the shepherds, who were heading home from their fields, protected me. I was young, and my dignity was always in the mouths of these people. The word 'Indian' was used to insult me. I was called a 'daughter of...' what you can imagine. People said I was a communist. A priest confronted me in church and said that as a communist, I was against God.

"People said I was in bed with everyone. As a normal young woman, men might have wanted to

be with me, but I didn't even have a boyfriend. My mother cried, my father cried; they knew I was not a prostitute and anyway, the people in town were thanking my parents for having a daughter who helped them.

"Seeing how I was mistreated, my parents wanted me to stop my work but I said no. I was not doing what people said. I wanted to continue. So I have continued over and above everything. These are the situations that make me defend the rights of my people. We have fought for the land and struggled for our Indian identity."

In 1973 she returned to Quito with a small group and began to organize a movement, the Confederation of Indigenous Nations of Ecuador, whose Spanish acronym is CONAIE. When the group arrived in the city, they were rejected by the hotels ("Indians!"). Restaurants would not serve them. They wandered the streets at night. "Tough times," Blanca remembers. "That's why I continued. I have been with CONAIE for 33 years."

"Nobody pays you to start an organization," she says with a rueful face. Even though she was the best educated and eldest of eight children, her work did not allow her to support her family. When her father died, a brother who had graduated from high school and two others who left school began to support their widowed mother and siblings. She made a painful decision: she continued her work.

People expected her to stay home after she had a child, but she continued working even then. "I carried my son on my back until he was three, but now he is fourteen." Being a single mother is difficult. "When I have lots of activities, I have to leave him. It has been hard on him, and it is a sacrifice on both sides, not to be together in his adolescence. I don't have a private life. My life has been immersed in a process. As a woman, an Indian, a citizen, I always defend rights."

The unremitting struggle that Blanca and CONAIE have sustained has resulted in many triumphs for indigenous people.

"I was president of Ecuarunari (*Confederación de los Pueblos de Nacionalidad Kichua del Ecuador*) for two consecutive terms. Our struggle was for the vote. We won that."

Amending the Ecuadorian constitution took 20 years. "We made strikes. Some have lost their lives. It was tough." But in August 1998, the amendments proposed to the Constitutional Assembly by the indigenous movement placed diversity at the core of the "refounding" of the country. Ultimately, Ecuador joined South Africa and Fiji as one of the three countries in the world whose constitutions recognize and protect the rights of all people.

Today, Chapter Five, Section One of Ecuador's Constitution guarantees indigenous people all rights—plus access to quality, intercultural, bilingual (Spanish/Quichua) education. It guarantees rights to the indigenous systems, knowledge, and practices of traditional medicine. It guarantees protection of ritual and sacred places, plants, animals, minerals, and ecosystems.

Since 1996, indigenous people have won posts in national elections. The indigenous movement of Ecuador is reputed to be the best organized and most powerful in Latin America ("Twenty years ahead of everyone else," according to a famous Ecuadorian anthropologist). Blanca believes that is because "We have a grassroots process and defined projects. For example, we have defeated three Presidents.

"The first (Abdalá Bucaram, 1997) because of corruption. He took away the health and education budget to pay foreign debt. We took him out.

"The next (Jamil Mahuad, 2000) froze the accounts of all people and stole the money. Dollarization brought the country to bankruptcy. Indians mobilized. He fled.

"The next (Lucio Gutiérrez, 2005) signed the Manta Base and Plan Colombia, plus he was corrupt.(Manta is an air force base the US leases to implement Plan Colombia, anti-drug operations. Indigenous people oppose aerial herbicidal spraying.) When Gutiérrez increased the price of cooking gas, that was the last straw. We threw him down."

Although Blanca doesn't mention it, only weeks before our conversation, indigenous women mobilized against Gutiérrez's successor, Hugo Alfredo Palacio, surrounding the presidential palace chanting *"Fuera todos! Fuera todos!"* (Everybody out!) To them, Palacio is just one of seven presidents in the past nine years who have sold out to bondholders, oil companies, the World Bank, the IMF, neoliberals, and globalization.

How many people does it take to exert this kind of power? Although there has been no official census since 2001, some estimate that 12 to 18 percent of Ecuador's population is indigenous. Blanca believes the number is higher. "Between 40 and 50 percent of the people are indigenous: a large minority. But many are illiterate, so they cannot vote. It has been hard for us to put candidates in office.

"For the past three years, I have been director of Dolores Cacuango School, which offers political education for women." Dolores Cacuango founded the first four Quichua-Spanish bilingual schools in Ecuador in the 1930s.

Blanca describes her school: "Mothers strive for their children to study and they progress—but the women remain behind, completely illiterate. Our school teaches women to read and write, but also to understand the Indians' situation and their rights as women, to have self-esteem, to participate—and exercise leadership—in politics.

"Each community delegates specific women to attend a series of three or four workshops per year for three years. We teach in different provinces every week. Our first group has graduated. One woman is now mayor of a canton. Another is health leader in her province. Four are on the national counsel of Ecuarunari. These are small steps. We are progressing gradually."

There is still much left to do. "Words get lost in the constitution; we cannot fully exercise our rights," Blanca reflects. "Ecuador requires that 35 percent of all candidates must be women; we have not yet reached this percentage. There is a right wing majority in congress, so it is hard to get laws approved."

Blanca, speaking at the World Social Forum, takes a long view: "We must make ourselves more visible as women and as indigenous people. Only this way can we build a democracy that recognizes us... without forgetting where we came from and to what we aspire."

ARGENTINA
CREATING SAFE HAVEN

"We were afraid to talk to you," Ada confides after we've finished taping the interview. Am I overbearing? Is she shy about being in a book? I doubt it; Ada is a sophisticated woman. Her fear must be about something else.

Before coming to La Casa del Encuentro, I tried to imagine what life might be like for the lesbian women, most over 40, whom I was about to meet

here in Buenos Aires. This city seemed to be a woman-friendly place. In the Puerto Madero section, there is a swooping Women's Bridge to a neighborhood where every street is named for a historically-important Argentine woman. The Women's Park, planted with poplars, surrounded by pampas, honors Eva Peron, who founded the Peronist Women's Party and pushed through women's suffrage in 1947. The Madres de la Plaza demonstrated every week for 30 years, demanding justice for those who were "disappeared" by the military dictatorship; only this week did these heroic, now-aged women stop marching. Buenos Aires' laws forbid discrimination against women. Argentina was the first country in Latin America to enact a law requiring at least 30 percent of every political party's candidates be women—and to accept civil unions for same-sex couples. I concluded

life must be comfortable for lesbians in Argentina. But I was wrong.

Nothing suggested how enduring fear is for those who lived through the time when difference was punished by death. When I pick up my camera to photograph the book group at La Casa del Encuentro, three women leave the room. One explains, "If my boss knew I am a lesbian, he would fire me."

In the early 1970s, strikes, riots, and guerillas defied the government, which retaliated with death squads and political kidnappings. In 1976, General Jorge Rafael Videla seized the presidency. His method of reorganizing the nation was euphemistically labeled The Process. Security forces arrested, tortured, raped, and murdered Argentina's citizens during The Dirty War, which ended in 1983. An estimated 30,000 people had been "disappeared."

Lesbians' difficulties were not over. A conservative oligarchy still holds social power. As recently as 1998, ex-army personnel who had been responsible for human rights violations fifteen years earlier were still in the police force; lesbians (along with gay men and sex workers) were abused physically and verbally when officers used their discretionary power to carry out "preventive detentions." The Church (Argentina is 92 percent Catholic) believes women should give birth; lesbians are viewed as aberrant because they play no reproductive role (under Argentine law, they cannot even adopt). Rural areas are the most conservative but even in the capital, many lesbians hide their sexual orientation from their families and employers. Machismo, misogyny, and homophobia are embedded in the country's culture.

FABIANA TUÑEZ

Today I meet the three long-time friends who opened La Casa del Encuentro in 2003. Fabiana Tuñez, 44, describes Desdenosotras, the organization she co-founded that hoped to start a social and cultural place for lesbians that is open to all women. "Women, including lesbians, suffer from oppression. We are not against men; the system is the enemy. Women have been denied expression, a space to meet, a place to get to know each other, to think over issues, plan strategies and voice our needs."

La Casa de las Lunas, a predecessor political, social, and cultural club for lesbians, opened in 1995, but five years later its organizers, always involved in creative pursuits, decided to focus on music. Fabiana, Marta Montesano, and Ada Rico assumed the legacy of La Casa de las Lunas. "La Casa del Encuentro started as a dream. We all wanted a place for women only, especially for women over 40. We combined our savings. We searched for a suitable house."

"Only one of us was a feminist activist. That would be me," laughs Fabiana. "The rest had never taken part in a feminist project before." She inspired political activism at La Casa. "I strive for a real change in society—a society we can be part of as lesbians. This is a joint struggle with all women because lesbians suffer from double discrimination as women and as lesbians. I focus my activism on the possibility of freedom as women. I have been a lesbian feminist activist for 18 years— but for 100 years, women have been trying to be free by making men and women conscious of oppression.

"In Argentina, thousands of women die annually due to clandestine abortions done in very poor conditions. Thousands of women, adolescents, and kids suffer from violence in their homes; I estimate that 40 percent suffer psychological or physical abuse. Many young women, adolescents, and children are kidnapped by trafficking networks, and that is not known to the public. Women over 40 have problems. In rural areas, women have greater difficulties than we do in the city. Women still earn lower wages than men for the same work. Buenos Aires is reputed internationally to be gay and lesbian friendly, which brings lots of tourist money here, yet I can't show up at a job interview and say 'I am a lesbian' without being rejected. Lesbians are both discriminated against and made invisible by society. It may take five or six generations to have equal rights for everyone. I think the best our activism can do is to contribute a small amount toward building a different outlook.

"Our activism is expressed through political, cultural, and artistic activities and performances. We think the ideas out together, to take into account the view of all the participants at La Casa del Encuentro. An artistic director helps express the ideas. We could use theoretical discourse instead, but by working this way, many more people understand what we're talking about. We want everyone who watches us to challenge his or her assumptions. Change is as much internal as external."

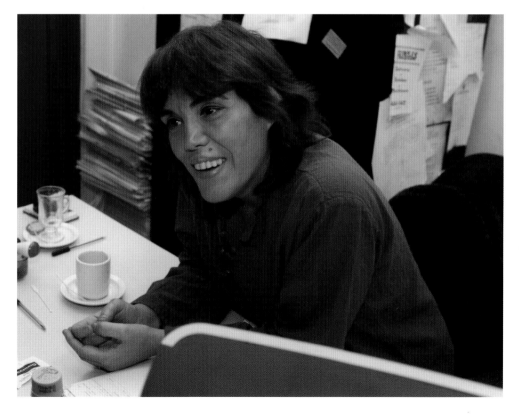

MARTA MONTESANO

Personal experience compelled Marta Montesano, 52, to help start La Casa. "I found out I was a lesbian when I was 24, during the Process. The military regime, supported by the Church, believed that anything different from family values went against nature, was evil, and had to be eradicated. I was surrounded by censorship and repression. I didn't dare say I was a lesbian. If there was an underground network of lesbians, I didn't know about it. I was isolated. I thought being fond of women only happened to me. I questioned whether I was wrong in what I felt. When the Process was over, some lesbian pubs opened but they were raided and everyone in them was arrested. It wasn't against the law to be a lesbian so they were arrested for "disrupting public order." My family is small: my mother, a brother, a niece. If I had been arrested, my family would have found out I was a lesbian. "

"I really wanted a place where women could feel free and not have to go through what I went through. I looked in the papers for ads. Every afternoon, I went by car and saw houses. The first time I entered this house, I felt this was a very special place. It had been built 100 years ago and when the others came to see it, we noticed two bas-relief, art deco women's faces on opposite sides of the stairwell. Those profiles became our logo. On the wall by the stairs to the terrace, there was a sentence written in pen: 'Together, we are strong.' We felt it had been written for us. It became our motto.

"The house was completely run down. We had to paint the walls, put in new doors and windows, and rearrange the rooms so we could hold workshops and activities. We planned the new design. We hired men to do the heavy work but we installed the electricity. I screwed lamps to the ceiling with my own hands. Mine was a family of Italian builders; it must have been their genes coming out!"

La Casa del Encuentro is above a bakery that sells homemade bread, tarts, and pastries. La Casa's entrance on Honorio Pueyrredón is unmarked. Once inside, traffic noises fade. At the top of the stairs, a pastel, floral, stained glass window glows with

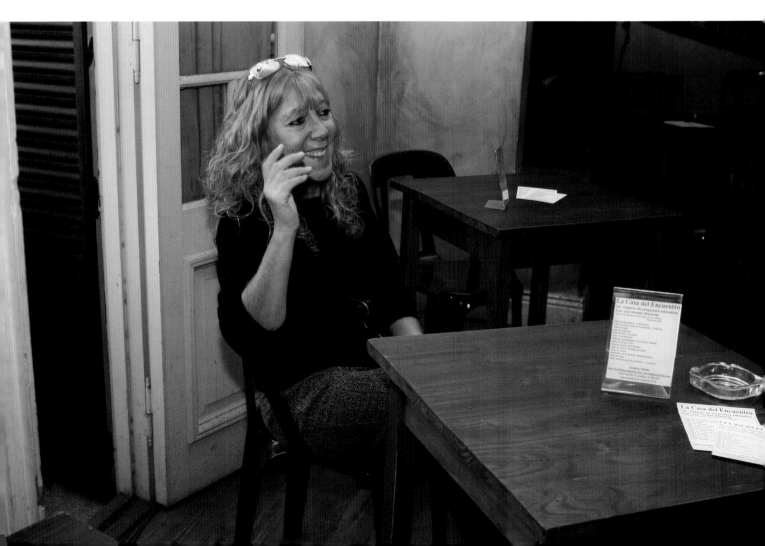

afternoon light. Four rooms open off a wide hall. The walls are dappled with color like an Italian country house. Conical parchment fixtures illuminate the space. Floor-to-ceiling shutters open onto autumn leaves that are beginning to turn. The roof garden overlooks the city.

"October 4, 2003 we had an opening party. Argentinean women are not used to having a well-kept place in nice surroundings, a place for ourselves. Over 200 women came. We were overcome by the number. We had no experience tending tables. If they wanted mineral water, we gave them something else. But it was so good to be here that nobody minded. They were willing to eat snacks standing up or to drink directly from a bottle."

"Only a woman would ask another woman this question, Marta. What did you wear to the opening?"

"A lavender t-shirt, the feminist color!"

The word *encuentro* translates as meeting or encounter. Today, women participate in book groups, music performances, parties, and classes as diverse as Art and Healing, English, Women's Tango, Feminism, and Philosophy.

On Wednesday evenings, the main room is set for dinner with tablecloths, china plates, and wine glasses. Marta, working in the tiny kitchen, creates fresh salad and beef-and-lentil stew for 35 women who stay after class. Marta is employed by a health services company; her job is "just to earn money. I put all my energy and passion here."

She continues as she makes salad dressing, "I have discovered that the only difference between us and straight women is that we are lesbians. There is no other difference. That helped me most: realizing that we shouldn't be ashamed or discriminated against. After talking with more experienced women, it became easier for me to accept myself. That's when I was able to talk to my family."

Perhaps the most public coming out for Marta was her decision to participate in La Casa del Encuentro's street theater performances. "When I began going out on the streets with a sign that said, 'I am a lesbian, I have rights,' I felt no aggression from the people who watched. On the contrary, they were warm. I realized that the problems I had been having were in my head."

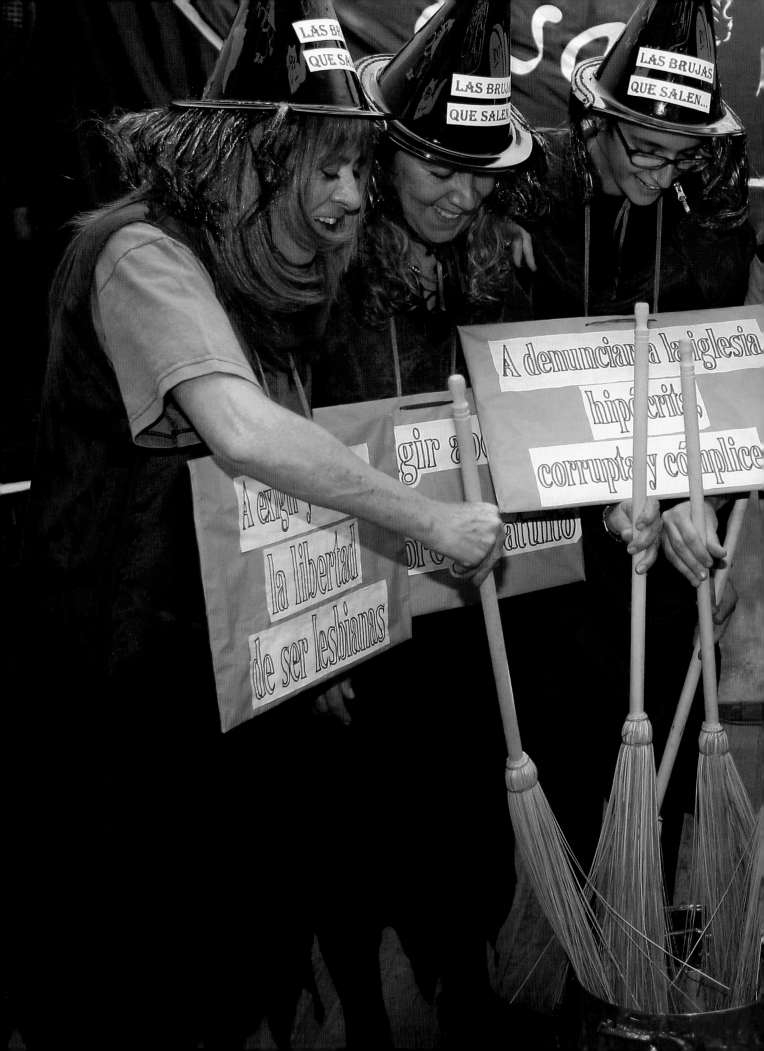

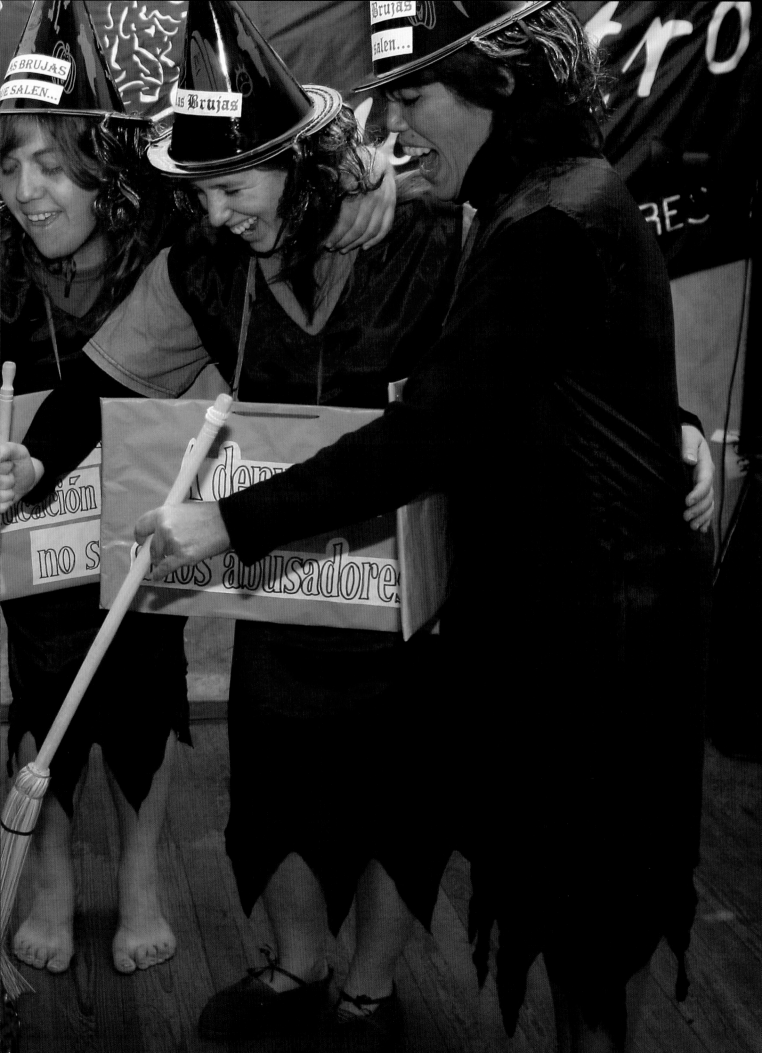

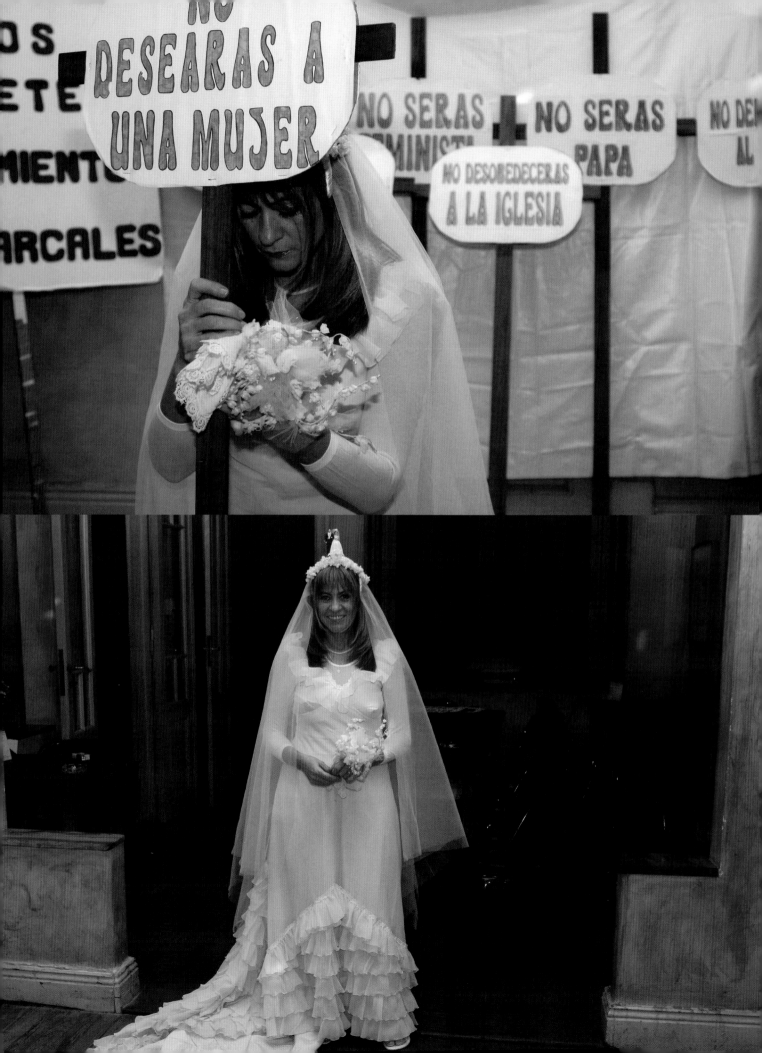

ADA RICO

Ada Rico, 51, plays a starring role in one of those street theater performances—a role that could be the story of her life: "I was married at 15. I already knew I liked women, but felt social pressure to marry and have children. One year was too much for me. I was divorced at 16. After that, I began to connect with lesbians and when my mother asked if I liked women, I said yes. Mother said that since I tried with a man and didn't like it, I should do what makes me happy. Now, I am married to Fabiana.

"My favorite character in our drama *The Seven Patriarchal Commandments* is the bride. The dress I wear was actually worn by a woman who comes to La Casa. She donated everything, even her bouquet. On top of my veil, I wear a little couple like the ones on wedding cakes. I carry a poster with the commandment, "You will not desire another woman." The most powerful part of the performance is when I take the bride and groom dolls off and fling them away. I hope women will feel strong enough to break this commandment.

"We perform on every date that's important for women. On March 8, International Women's Day. On May 28, International Women's Health Day. We performed in front of Congress to urge Argentina's legislators to include gender and sexual orientation in the country's anti-discrimination laws. In October 2005, one hundred women came with us to Mar del Plata for the 20th National Women's Meeting. That day, women who had never participated politically performed with us, body to body, in front of 30,000 delegates. Although the system oppresses us one by one, one liberated woman can help other women free themselves.

"When I was younger, not yet openly lesbian, I didn't look like the lesbians people are used to seeing, who have short hair, short nails, and no makeup; perhaps I created rejection by surprising people. But the opposite is true today. When we go to the streets, women identify with us. We go out dressed for the performance, handing out fliers. When we stop, they clap for us. We stand in front of a flag that says 'Lesbian Feminists,' and they tell us how strong we are. People come close. Lots of men come see us, too.

Congress

Fabiana is in charge of political issues and fundraising. Ada and Marta oversee operations at La Casa. Ada greets guests in person, making everyone feel welcome. "I'm at the door on Saturday nights when we have parties from 8 PM to 8 AM. Maybe 30 (out of 120) women cannot afford to pay 5 pesos (less than $2) and we let them in free. If we changed that, it would violate the main reason for what we're doing."

MONICA SPOSITO

Monica Sposito, 41, has a demanding career in a Brazilian import-export firm, which makes it hard for her to get to La Casa except on Saturdays (when she often is the disc jockey for party music) and Wednesdays (when she participates in the Reflections Group and dinner).

"The Wednesday Reflections Group was our first activity," she remembers. "Someone describes an idea or issue. Maybe she is going through a tough moment in her personal life, which gives rise to challenges, questions, and sparks conversation. Right now, the Reflections Group is watching episodes of *The L Word* as a starting point for discussion. It's a US show, a very different reality. Here, too, women fall in love, quarrel, and betray each other. But the series shows lesbians who are really free. They get together at the Planet Coffee Shop, an ordinary place, hold hands, and kiss each other. When I was in the US, I saw women in the street holding hands; that doesn't happen here. Also,

the lesbians on TV live in luxurious houses and have great cars; that's a huge difference. Nevertheless, we see it as a great step forward, just to have a show directed to us. It was broadcast on cable at midnight and when it came on, we gathered around the TV (`Shh! What did she say?'). But it only ran one season. Now we download it from the Internet."

When she visited friends in Florida in 2001, Monica noticed other differences between the US and Argentina. "I really liked seeing little girls playing soccer. It's something you don't see here. There isn't soccer for women at schools; there are not many women coaches and no women referees."

Monica played professional soccer in Buenos Aires. And now, as the only woman in her company's sales department, Monica is breaking ground again. She sees her work as she sees sports: "It's about goals and opportunities. Constant change gives me a sense of renewal."

VERONICA MARZANO

Veronica Marzano, 31, lives in an apartment whose walls are blanketed by posters. By far the largest is a world map that hangs upside down, with the southern hemisphere at the top. Veronica would like nothing better than to change the world.

"Both my parents were political and social activists. My generation doesn't believe much in politics, but I committed myself to social change. I studied social work and took a job in the shantytowns, working for the local government. The policy of the moment defined what I did: sometimes social welfare, sometimes housing, sometimes vaccines. But the work was quite limited. I came to Buenos Aires from Pergamino looking for two things: a new perspective for my professional work and a place where I could live as a lesbian.

"I studied at the Hannah Arendt Institute, which is run by Diana Maffia, a philosopher and well-known feminist. I had no clue she was a feminist. My first course was on gender and public policy. I started to understand that I had some of the same issues as the women I wanted to help and that true liberation will come from taking back power over our own lives; there could be nothing more revolutionary than that. We are a minority in terms of power, not numbers. If women could speak for themselves, half the world's population would voice opinions at last."

Since women define "feminism" differently, I ask Veronica what the word means to her. "Feminism is both theory and practice. The theory: women are oppressed by a system in which they don't have opportunities to decide how the world should be; at some point we gave men power. The practice is about creating women's points of view, challenging existing concepts, setting new objectives, having our own thoughts and dreams.

"It's hard to work as a social worker with a feminist point of view. Most institutions do not address violence against women or the right of women to decide over their own bodies," Veronica discovered.

"How did you do with the second part of your quest?" I ask.

"I befriended some lesbians and we went to La Casa, where I felt welcome, well treated, cared for. We could all talk to each other despite differences in age, social class, and place of birth. Fabiana and Ada gave me chances to take part in political action, which enabled me to merge my political and social lives. I began to consider my way of life to be a political as well as sexual choice.

"Last year I worked with a social-medical NGO in the shantytown projects. I introduced myself as a lesbian feminist. When I attended the National Women's Meeting in Mar del Plata, some of the shantytown women were attending—as lesbian feminists! It was gratifying that these women gave themselves a chance to identify. In the mass media, if a strong, determined, argumentative woman is featured, the first thing she's accused of being is a lesbian. When you come out, automatically you stop being considered a woman; your opinion counts even less. So what the shantytown women were doing was difficult. And important.

"I believe in empowerment and self-consciousness, and wanted more workshops at La Casa. Ada and Fabiana said I was free to start them. Every woman should have the opportunity to acquire the tools I have because I was lucky enough to have a good education. I wanted to draw as many women as possible and also wanted to charge for the workshops so La Casa could finance itself. One class costs $2 or $3. If women exchange money for knowledge, that makes the student more equal with the teacher. It also gives the teacher an opportunity to share what she knows. No one knows who can pay and who can't. It's important for women to experience this kind of solidarity. Everyone gains."

"What are the most popular workshops?" I inquire.

"Last year, Sartre. Right now, Women's Tango. And many—many!—have signed up for the self defense workshop we will start in June."

ELIDA CUNADO

Elida Cunado, 38, discovered La Casa del Encuentro by chance. "I was feeling lonely, navigating the Internet, and found the website. That same day, I came with a friend. I was afraid of what I was going to find: it had a common door and looked like a family home. I rang the bell. A birthday party was going on. It wasn't a public event but they welcomed me warmly, offered me a glass of champagne, treated me to a slice of birthday cake and hugged me. It was the first time I had been to a women-only space. From that day on, I've loved La Casa and the women I've met here. We have lots of women from the suburbs of Buenos Aires, nearby cities, the interior, and foreign countries.

"I come on Saturdays twice a month, and, to cut my week in half, on Thursdays for the Feminism Workshop. I am still trying to understand this new point of view. I have been a political activist for 12 years now, a member of the decision making group for the trade union of the non-teaching staff at the University of Buenos Aires. There are 10,000 non-teaching staff members in the city. Looking at the University from a feminist point of view, I now understand why a woman, and a lesbian in particular, has such trouble getting to decision-making levels. For example, although I gained support from my co-workers, when it came time to vote, both men and women chose candidates with accepted lifestyles.

"Coming to La Casa, I felt as if a thick veil had been removed from my eyes. I started a new kind of political activity inside the union, working on gender issues. Both lesbian and straight women experience the same problem: institutional power is held by men. We have to create another history, not get places the same way men do.

"I don't believe in fighting for gay and lesbian rights with an aggressive attitude that will shock people. It's more appropriate to show that the only difference is that you choose a person of your sex to love. That's not what most people think. Generally, they believe we lead an evil, creepy, perverse, promiscuous life. When they come face to face with us and we share ideas, have lunch together or work together, they start to understand there is nothing weird about us. Their prejudices break down. Last year, 25 activist women from the University of Buenos Aires union rode on La Casa's bus to the National Women's Meeting in Mar del Plata. It was the largest one ever. For those of us attending for the first time, it was amazing. We held a meeting when we came back and were singing feminist chants."

"Such as?"

Elida sings, "We are bad. We can be even worse!" Then she laughs, "Our male co-workers were terrified! They had been a little afraid before, but now they had reason; our cards were on the table!"

MARIA ALEJANDRA LANDA

Maria Alejandra Landa, 45, meets us at a historical Buenos Aires coffee house. We order lattes, and settle at a little table while the grinder whirs, sending coffee fragrance into the room.

Alejandra, one of the first generation of women in Argentina to become systems analysts and software engineers, discovered she was a lesbian when she was 36. "Maybe that's because it was forbidden during the dictatorship when I was younger. I had been expecting 'that man.' Then I fell for one of my paddle tennis mates, whom I didn't realize was a lesbian: I couldn't identify even my own condition. I had never thought about being a lesbian. The very subject was invisible.

"I joined the Wednesday Reflections Group at La Casa de Las Lunas. It was useful to hear other women's experiences and discover that the heterosexual world is not the only way. When La Casa

del Encuentro opened, it seemed appropriate to have Wednesday Reflections Groups there, and I helped organize them. We talk about many subjects, for example how some lesbians duplicate heterosexual life by repeating masculine and feminine roles. We also talk about issues that affect all women: the need to talk with friends but not wanting to; how to be a mother without being part of a couple.

"Straight women often join us. Opening La Casa to all women is very important. If we didn't, we would be discriminating. Women from 18 to 70 come. Education and economic levels don't matter. What matters is that we are women."

CAROLA DE LA FUENTE

Carola de la Fuente, 61, is Alejandra's partner. For reasons no one knows, her brother called Carola "Ginny" when they were children, and the nickname stuck. We meet for coffee at another historical coffee house that has tango performances at night. Ginny loves tango. She and Alejandra are taking lessons at La Casa.

"I came from a strange background, a mix of bourgeois and aristocrats—poor aristocrats, but aristocrats. My father, a customs official, was chairman of the Democratic Union, a local coalition set up against Peronism in 1944. For political reasons, my family intended to hide in this great city. We moved from Rosario when I was one year old. My parents got help from their families to maintain a high-class way of life. My mother's father paid for our primary education at German schools, and for a live-in maid. We were raised with very formal manners. We sat down for dinner fully dressed with our hair combed and our hands washed spotlessly clean. We went to bed on time. My father's word was law.

"Later, at college, I was lucky enough to get in touch with another reality," Ginny says, her eyes twinkling. "Undoubtedly something went wrong in my conservative education: I am a lesbian and my brother is a left-wing activist who never got married and has children with three different women.

"I wanted to be a professor of folklore and psychology, but I didn't finish my degree. On 'The Night of the Walking Sticks,' the University was raided and many were arrested and beaten. I didn't want to return after that. I had my teaching certificate, so I taught primary school.

"When I was 25, I took my things to my partner's apartment little by little and eventually, I had everything there. My family assumed I was living with a man and just didn't want to introduce him. They got mad, all the time pretending everything was fine. (I've

never talked with my mother about being a lesbian. She knows about it, it's obvious by now, and she accepts it quite naturally. She refers to Alejandra as 'Ginny's friend.')

"Teachers' wages were low and I knew that as a lesbian I would have to become economically independent. I worked at marketing research organizations for 22 years. I had over 300 people in my charge and at one point I was the best-paid person ever in that job. But they fired me.

"One day I saw an ad in a humor magazine. They wanted an advertising/PR director: 'a man with previous experience.' I went through lots of interviews and in the end, the manager asked me to come in. He asked whether I knew the woman psychologist who interviewed me. 'No, I just met her. Why?' 'Because you don't have even one of the characteristics we require, but everyone says we should hire you.'"

Within a month, they made Ginny head of publicity. "It was a situation fraught with difficulties. When a customer was argumentative, they would send me because I was young and pretty. At holiday parties, my bosses harassed me. My boss had a jealous wife who thought he was having an affair with me. Every time he went on a business trip, she called to see if I was in Buenos Aires. She had me followed. I got sick, lost 25 pounds, and quit.

"Two other lesbian women and I started a small advertising business, but unfortunately I learned that lesbian women can be *machista* too. Our main partner did the same things my previous boss had done.

"I was tired of business, so I accepted a job as deputy headmistress of a private school in Lenos. To regain my education skills, I took a degree in social studies and education management. At this point, I was 50 years old. I got up at 5 AM so I could commute, taught between 7 AM and 5 PM, attended classes at 7 PM, and studied at night. At the end of the course, I had a grade of 10 out of 10! In 1996, one of my professors was appointed subsecretary of culture in Buenos Aires and asked me to become an advisor. I have worked there through five mayoral terms and have managed to stay."

"I have never had problems getting to know gay and lesbian people of my social class, a limited reality. I was looking for a place to find different kinds of people, and in that search, I met Ada, Fabiana, and Alejandra. Now La Casa del Encuentro is a fundamental part of my life—the place I have been able to be myself. I have learned a lot from other women, younger and older. I am loved, cared for, well treated. I have felt everyone is my equal. It is the only group with whom I have dared to go into the street as a lesbian. I attended the National Women's Meeting last year, and walked comfortably with a lesbian banner at my back. I have never been an activist on gender issues, so I am learning a lot. But mostly, this is the place where I can stop being the leader and relax.

"I was one of those who proposed the Friends of La Casa. We contribute a small amount of money each month. People in Argentina earn low wages, especially women, but it's worth supporting the only place where women can meet. La Casa del Encuentro is truly our own space."

CARLA CECILIA FERNANDEZ

Carla Cecilia Fernandez, 26, moved to Buenos Aires from Neuquén to study economics. Today, she does communications for the Senator from her province.

She met her partner, Silvina, on the Internet "almost two years ago. What caught our attention was that we were born on February 12. We never exchanged pictures and had no profiles of each other, but we had an emotional connection. We finally met when Silvina invited me to her house, and I rang the bell. I am always late, so although I was supposed to get there at 9:30 PM, I actually arrived at 11:30! It was risky, but it turned out well. Now we are looking for a place to live together that is large enough for her dog and my two cats.

Carla and Silvina attend the weekly feminism workshop at La Casa. "To me, feminism means having a critical position: seeing women's oppression. Everyone in the workshop group is a newbie to feminism, so we read and discuss. I was surprised at the difference between what men and women are paid (there is no justification for that) and by the amount of domestic violence there is. Now, we are talking about whether the world would be a better place if women ruled. I thought men and women were equals. The world is worse than I could ever have imagined; I have decided to do something to change myself and the people around me.

"I always think that you can do something, no matter what place you are in. So I drafted a senate bill about the National Women's Meeting last year (the senator had no idea what it was, perhaps a large tea party. But he didn't care, the Senate approves things like Poncho Day, so why not this?). I have written into the senator's speeches information about international conventions that exist here but are not practiced, such as the ability to sue for domestic violence."

Carla has not come out to her family or employer, so being interviewed for this book is a courageous step. "I have escaped discrimination by making myself invisible. But every time I meet someone, I think 'what must I remember to lie about?' I assume my mother knows. My father does not, and I can't tell him until I can support myself. Silvina's father stopped supporting her when he realized that only his son would give him grandchildren. I know a woman who says she prefers that her lesbian daughter die in the streets. If I walked into my office and said I am a lesbian, I could never have a career. The senator and his staff are strongly Catholic; to Catholics, being a lesbian is an aberration, and no politician can afford to alienate the Church.

"I want to stop lying. If I deny who I am, I cannot be comfortable. I am thinking about adopting a baby from another country—a baby of another race. For my family, that would be terrible. But human rights and racism are the issues I care most about. And animal rights," she smiles, stroking her grey, striped cat.

Maria Angelica Ciansio and Silvia Mariel Palumbo

Folksingers Silvia Mariel Palumbo, 42 and Maria Angelica Ciansio, 52, were organizers at La Casa de Las Lunas, which inspired La Casa del Encuentro.

Silvia remembers, "I was part of a feminist study group in 1990. We presented ourselves as lesbian feminists, a category that never existed here before. We started a publication called *Las Lunas y Las Otras* (The Moons and The Others) and organized a lesbian meeting in 1992: the first. Those things were a freedom yell. I couldn't survive without being a lesbian activist; I had suffered so much oppression in my small town. For me, activism is a healthy, healing act."

"In 1995, we opened La Casa de Las Lunas. Maria Angelica joined us. The house stayed open for five years. We were always looking ambitiously for artistic, political, social, and economic issues. We had program cycles. One cycle was Women's Voices: a monthly production of women's music. Another was

Women Writers, which included some of the most important, beautiful, contemporary poets in Argentina." Maria Angelica remembers, "Once a month on Friday or Saturday, there was a magical night when women read their creations in a theater setting. Many moving things were created by women. In parallel, a political world was going on. We had a feminism workshop; I was one of the coordinators of the Reflections Group."

Silvia: "But our group had economic and internal problems, and at one point, we realized that the energy we had was not enough. We closed the house at the end of 1999, and spent an entire year trying to find ourselves. I was collecting music by women songwriters in Mexico and Argentina, which I sang in concerts. I asked my friends from Las Lunas, "Why don't we record music made by women here in Argentina?" So we began to map women's music that had not been discovered in this country,

Paraguay, and Uruguay. The Global Fund for Women gave us a grant.

Maria Angelica: "We contacted the women somehow. Maybe they had never recorded anything…"

Silvia: "We do not include women whose work includes sexism, machismo, discrimination, homophobia, or racism. We couldn't believe how many talented women there are and how touching their songs are! We interview the women, then bring recording equipment to their houses. When we arrive, we identify ourselves as lesbian feminists. People are really overwhelmed at first, but then they come along ('Oh? Ah? OK! Yes, good.'). Many of the women in the project are lesbians, some openly.

"Our first CD will include six unknown women singers. Each chapter on the CD will have one woman's music, photographs, interview, and biography. We try to record something about her whole life; for example, one woman weaves and her loom makes noise so we recorded that. The women are very different from each other in their activities and songs; the youngest one on this CD is a Mapuche. The CDs will be free, distributed through schools, colleges, and universities.

"This is my life work. We are making a website so the women can connect with each other. We will have workshops with the women about gender and music. We will do live concerts. Las Lunas y Las Otras is the name of our group; Lunas de América is the name of the project."

"Why 'Lunas'? What does the moon mean to you?"

"The moon signifies women's roles: it has energy and cycles: it is born, dies, and is reborn."

I n summer 2006, La Casa del Encuentro's building owners decided to demolish it and construct a high rise apartment complex. Brokenhearted, the women searched tirelessly for a new home. They worried about high rents and moving costs, but finally found space. At the end of September, Ada and Fabiana wrote me: "A very great piece of news: we have a grant from the Global Fund for Women! We were running out of the money we had raised and the loans we had taken. Now, thankfully, we are nearly done with the vast amount of repair and cleaning the new space required. We plan to reopen next Saturday. We are exhausted but delighted. The women who attend Wednesday dinners and Saturday parties have been a big help. They donated a fridge, a very

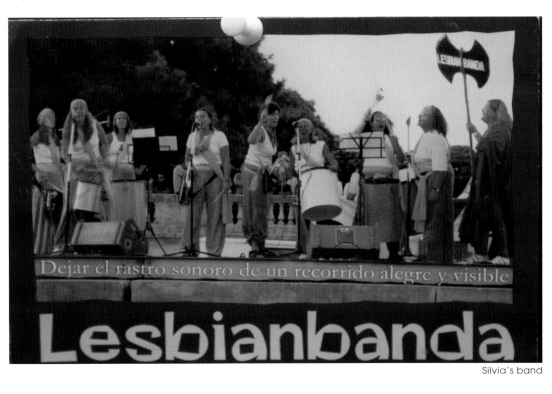

Dejar el rastro sonoro de un recorrido alegre y visible

Lesbianbanda

Silvia's band

valuable antique bookshelf and cupboard, pillows for the couches, plants—and ten of them are paying installments on a new TV. They have helped paint the walls, move things, buy materials, everything. Such commitment is very touching to us. It tells us they value La Casa and everything it represents."

Once again, La Casa del Encuentro is offering women sanctuary, dignity, and community. Silvia Palumbo might say a new moon is peeking through the clouds.

SLOVAKIA
ENDING DISCRIMINATION

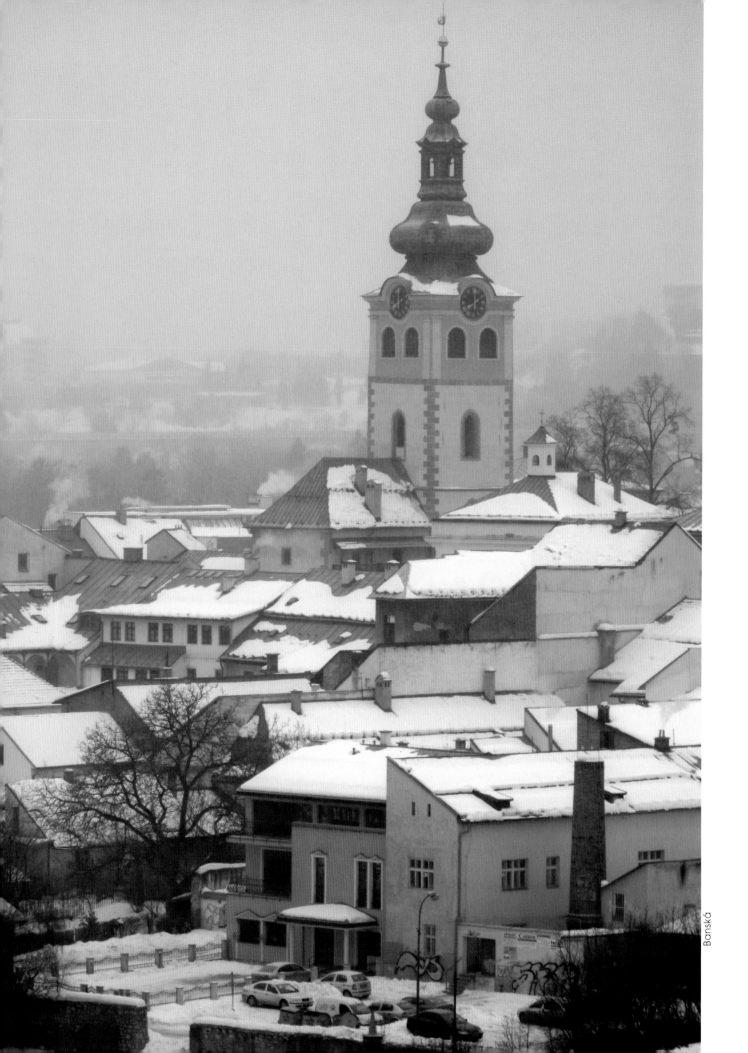

THE SLOVAK ROMA EXPERIENCE

In the 18th century, King Leopold I declared Roma outlaws and ordered all Roma men to be hanged without trial. Empress Maria Theresa tried assimilation. She prohibited the Roma people from speaking Romany or marrying other Romas.

Between the World Wars of the 20th century, discriminatory laws intended to limit Roma mobility mandated that Roma alone carry identification cards and be fingerprinted.

During the Holocaust (in Romany it was called *Porraimos*, "the devouring"), some 500,000 European Roma were killed by the Nazis. Slovakian Roma were banned from public spaces, prohibited from using public transportation, allowed into town only on certain days at specific times, and required to move their houses at least a mile and a half from all public roads. After Germany invaded Slovakia in 1944, there were mass executions. Roma in the south were sent to Dachau.

During Communist rule, policies aimed to assimilate Roma and eliminate ethnic differences. "Gypsy" music ensembles, folk songs, books, and magazines were banned. To combat nomadism, state officials literally broke up caravans, sometimes slaughtering horses in the middle of the night. These authorized actions prevented some 10,000 from migrating.

In 1965, the Czechoslovakian government decided that 600 Roma colonies would be eliminated and residents relocated over a period of five years. Ten thousand people were displaced, among them Jolana Nátherová's family, whose story you will soon read.

Starting in the 1980s, doctors sterilized Roma women, a practice that continues today as physicians advise women during Cesarean birth procedures, "You and your next baby may not live unless we take care of this now." Some mothers only discover later that the operation has happened.

In 2004, the Slovak government cut Roma's social benefits, apparently to encourage them to find work. Unfortunately, they were not hired. Starving, Roma people raided supermarkets in Levoca and Trebisov. The government ordered the largest mobilization of its police and armed forces since 1989 when the Communists departed. Helicopters and planes monitored Roma settlements while police entered Roma homes and beat women and children, sometimes with baseball bats.

Recently a bus driver shouted at two young Roma girls, "You blackies should have been killed in a gas chamber long ago!" A man who was playing outside his house with his granddaughter was kicked by two young boys who shouted, "You dirty black Gypsy! You are going to die!" A mayor, interviewed in 2001, said the only way to solve "the Roma problem" in his municipality was to "eradicate them."

Six decades after the Holocaust, Roma are targets of neo-Nazi skinheads whose treatment is so brutal that, after the Slovak Republic joined the European Union in 2004, Romas began requesting asylum in other member countries. The European Union designated 2005 to 2015 as "The Decade of Roma Inclusion." We will see if it helps.

At dusk, snowflakes make glittering halos around the street lamps in Banská Bystrica's historical square. Bundled people carrying umbrellas greet each other in the February night. Over there: the residence that a copper baron built when the town was one of the most prosperous mining centers in Europe. The clock tower is dated 1552. By then, the Roma had been here for 230 years.

They left Rajasthan a thousand years ago. Arriving in what is now Turkey, some turned north toward Poland and some south toward Egypt. Their Egyptian name, "gypsy," means vagabond or prowler. European Roma consider the name derogatory. As Colum McCann writes, "It's the roving gangs, scams, illiteracy, violence, and silence that get headlines," despite the reality that this ethnic group, as diverse as any other, includes Pablo Picasso and Charlie Chaplin. "Even European newspaper editors are stumped by how they should address the largest minority on the continent."

The preferred name is Roma, derived from the Hindi word "Dom," which refers to the group's musician caste.

I have just flown from Delhi to Frankfurt to Budapest, then traveled by train across the white plains of the Slovak Republic. My itinerary has been something like the Roma's route. The trip has taken several days, punctuated by hauling a 70 pound suitcase up and down snowy steps in train stations. ("Express?" I ask. "No! Stops!" they say at the ticket windows). Newspapers report that ice floes in the Danube have halted the shipping trade, a baby girl has died of the cold, and 150 university radiators have frozen in Košice. I can't imagine making this 3,500 mile trip in a Roma cart pulled by a horse.

Far worse than the arduous journey was the treatment the Roma received on arrival in Europe. At first, Slovakian Roma worked as castle musicians, metal workers, and soldiers in the Hungarian Royal army. But anti-Roma sentiment emerged in the 15th century and the diaspora community was banished to the outskirts of towns, suspected of spying for the Turks. Whether this region was governed by Hungarians, Czechs, Nazis, or communists, Romas were persecuted.

Today, Roma women are doubly discriminated against, thanks to ethnicity and gender. Hospitals in eastern Slovakia put Roma women in separate rooms from *Gadje* (non-Roma) women, and segregate toilet and dining facilities. Ambulances often delay or refuse service to women in Roma settlements, even if they are about to give birth.

Unemployment is a bigger problem for Roma women than men. Both face a competitive market and hiring discrimination. Few have cars to drive into town to work. Although 75 percent finish elementary school, that is not enough education to qualify for good salaries. Men sometimes do unskilled government labor but that alternative is not open to women.

Young girls feel that, having little opportunity for higher education or employment, their only option is to have babies at an early age. Even if a couple earned minimum wage, their income would not equal unemployment benefits, so staying home is a rational choice. Extended families share expenses (on average, living ten to a house) and women take care of the children. Having learned from the communists that "poverty results from personal failure and laziness," Roma women view their poverty with shame. In eastern Slovakian villages, Roma unemployment can be 100 percent, with high levels of alcoholism and domestic violence.

The most recent census (2001) reports that 76,000 Roma live in the Slovak Republic, but no one knows the real number since many Roma self-identify as Slovak or Hungarian to avoid stigma. Officials and activists estimate that the country has one of the largest Roma populations in Europe, perhaps 500,000. By all counts, among Slovakia's seventeen official minorities, Roma are the second largest group and the *Economist* magazine projects they will become the majority by 2060 if fertility trends continue.

About 30,000 Roma live in the central, Banská Bystrica, region. Some are integrated and others live in ghettos in town. But most still live in settlements outside the city limits, as they have for as long as anyone can remember. The more isolated and segregated they are, the deeper and more severe their poverty.

The Slovak-Czech Women's Fund is one of seventeen women's funds worldwide to which the Global Fund for Women has granted seed support to encourage grassroots philanthropy. Local women run the autonomous funds, raise money, and select projects to support. The three organizations in this chapter are grantees of the Slovak-Czech Women's Fund, all run by Roma women.

JOLANA NÁTHEROVÁ

Jolana Nátherová, a 42-year-old teacher, leads Hope for Children, a nonprofit she and her family began in 1994 to support Roma children.

While auditors conduct a routine examination of tax documents in the conference room ("The financial police are here," Jolana laughs), we have tea in the organization's modern office. Cabinets jammed with preschool supplies surround us, and three members of Jolana's family sit at a large table with computers. No programs are in session today, but the children's presence is apparent: kids invented the organization's name and there are stained glass designs made by Roma children on all the windows.

"I grew up in a Roma family. When I was three, the Communists were trying to assimilate Romas and they razed our village—used water hoses to flood and destroy everything. We were forced to buy a house in town. My parents decided it would be better not to bring me and my brother up as Roma children. We stopped talking Romany at home. Our friends who stuck to Roma traditions wanted nothing to do with us. White people didn't want us either. Our childhood was one big isolation. In the end, I was quite happy not being Roma anymore. I was lucky with my skin; it is not that dark.

"I married Martin, who is not Roma. We had three children, but we did not bring them up with Roma traditions. I didn't want my children to feel as I did, that the worst thing that could happen was to be born Roma, unwanted and unacceptable. But children are children. They kept asking if our family were Roma. I said yes, we are. That was the moment when I started to think again: 'Who am I actually? Where do I belong?'

"I couldn't remember Romany but when someone passed me speaking the language, I felt a strong pull. I tried to convince myself: 'I am not what I feel; I am what I look like.'

"One day, I saw poor children inside the garbage bins, rummaging. I heard Romany words. I saw their heads amid the garbage. That moved my heart. I started to cry. I realized I cannot forget what I am; I cannot lead my life without paying attention to this; I cannot deny my origin and the poorness of my people.

"Unbelievably, I put these thoughts and feelings away. One day, I was teaching white children at our church. We were talking about God being the creator, and that it is not in our control to choose who we are born to or where or when. I realized that majority people take privilege from something they have nothing to do with, and I got angry. I realized another thing: the difference between us should not create prejudice, it should make us bigger. How wonderful that we are not all the same but made by the same God. It doesn't matter if we are white, yellow, or black.

"I decided to reclaim my identity. I knew there would be many problems when people began to see me as a Roma woman, but I decided to face it. Roma women must be brave. I decided to help Roma children with my husband and family if they agreed. They did.

Her daughter, now grown, comes to refill our teacups. Having left her snowy shoes inside the front door, she wears fuzzy tiger paw slippers with curled black nails that clack on the linoleum floors. I think it's a great office outfit.

"Our most important program is preschool because 99 or 100 percent of the children think going to school is punishment," Jolana admits.

Most Roma children don't attend preschool. The government does not make it compulsory, most settlements lack facilities, and families can't afford to send several children between the ages of 3 and 6 to school, even for 20 cents per student per month, which is what tuition costs in one village near Banská Bystrica. As a result, Roma children lack basic knowledge and skills, miss out on socialization and communication with other children, and have no chance to learn Slovak, which is the language of instruction in all grade schools.

Not ready for first grade, they are sent to "zero grade," which teaches social, cultural, and hygiene skills. Then they enter "special schools" for the mentally disabled.

Hope for Children's preschool program addresses Roma children's specific needs. Jolana says, "Even if there is something the children don't know or can't do, here they are never criticized or diminished. It was rather difficult for me to get my brain around this approach since I was criticized all the time as I grew up! But a little child is making his own picture. If I respect him, he will respect himself. Sometimes it takes a really long time for these children to believe that they are sweet, lovely, clever, nice. But all of them understand it ultimately. Our staff learns to give 101 compliments and when children finally decide to believe them, their faces become more comfortable, more beautiful.

"Roma children have had no positive touching. When we first tried to touch them," Jolana remembers, "they moved away, thinking they would be smacked. When they had their hands on the table, we started massaging from the end of their fingers, saying 'Clever boy, my little darling,' and they would look at their fingers like, 'What happened to those fingers?!' Now it is no problem to touch the children. One of our volunteers picks them up and throws them in the air, then swings them round and round. They have never had that kind of fun."

Hope for Children runs a program for girls aged seven to fifteen years that includes everything from cooking to family planning and prepares them to be mothers and wives, the two roles their culture expects them to assume.

Jolana explains, "If all they see in their families is violence, bad language, and screaming, how can they be good parents?"

Just thinking about the future is not natural. "Most children speak Romany exclusively until they enter school, and continue to use it at home. There is no word in the Romany language for "future," Jolana explains. "If you ask, 'What do you want to be when you grow up?' youngsters cannot answer. There is a word meaning 'after,' but it's hard to imagine what you will do 'after' your childhood."

"Another missing word is 'love,' she continues. "There is a word for 'like,' but there is no distinction between human beings and inanimate objects—no difference between 'I like the pencil' and 'I like you.'" Convinced that family life would improve if the idea of love were understood, Hope for Children teaches program participants the meaning of love and demonstrates it.

Self-esteem is in short supply among young girls. "Most think they are ugly. Sometimes I give them makeup, but they know nothing about cosmetics so they put lip liner on their eyes. We help, then give them red boas, and take pictures. Even when they see the snapshots, they don't believe they are pretty."

Many Roma girls have babies when they are between 12 and 15 (early by European standards, but not surprising when you remember the Roma's tribal roots in Rajasthan, where girls, matched to husbands when they are young, marry when they reach puberty).

There is one big difference: here, couples frequently do not marry, just live together.

Jolana explains why: "The Slovak government gives *single* parents $66 to $100 per month in benefits for children—not so much, but enough to matter. You get more money for each child up to four, and then benefits stabilize even if you have ten. Romas have many children specifically because when their children have children, there will be more money for the family."

"Our program is about ideal families and relationships. When one of my daughters became engaged, the girls had never known anyone who got engaged. They were mostly interested in the ring. We asked what they wanted in a husband and all they could say was 'a good man.' Now they want many characteristics. He should be hardworking, adore them, help them, be nice, faithful, have a house, and not drink."

Once a week, Hope for Children holds meetings for youngsters whose parents are alcoholics. "In some eastern Slovakian communities, alcoholism among the Roma might be 100 percent. But alcoholism is a matter of degree; everyone drinks."

Jolana opens a photograph album. "Our Alateen program helps children understand that alcoholism is a disease. They learn that there is no ideal, 100 percent-perfect family, and how to keep themselves safe from abuse. Children from alcoholic families have no idea how to say what they feel. Here, they learn to count before they scream. How to calm down. How to say, 'Leave me alone, I am angry.'

"They write letters 'To Alcohol.' Their words are not aimed at their parents. They are allowed to be vulgar and use strong language. The aim is to get their feelings out of their thoughts and hearts. It helps."

Leaving the office, we pass a cabinet topped with a mass of blond curls. I invite Jolana to put on the wig for a picture. She giggles, "That is part of the angel outfit I wear for the preschoolers at Christmas. It goes with a fuzzy white coat and wings." I snap her portrait. Jolana, the Roma angel.

IVANA CICKOVA

Ivana Cickova, 34, helps place abandoned and orphaned Roma children in new homes. "Both black (Roma) and white (non-Roma) families want these children," she says, which inspired her to name the nonprofit she founded in 2002 Chessboard.

We sit at a table in City Hall. Even though Christmas was two months ago, a decorated tree still sits in the corner. Stephen, a Chessboard volunteer, makes us gritty coffee that we all accept graciously before discovering that he has put many spoonfuls of Nescafé in each cup of tepid water.

Taking hers, Ivana reflects that she originally intended to be a waitress. But life changed her mind. "It made me sad to see children go to children's homes. Roma women suffer with five and six children. Sometimes they must give up their newborns because they are too poor to keep them. I try to make it possible for mothers to keep their children because to give up a child is devastating. But if that's not possible, I try to find a foster family so the mother can still visit her child."

There are no good statistics about how many Roma orphans there are in Slovakia. Privacy laws prevent collecting information about any minority group, plus, as Ivana explains, "If you ask a child, 'Do you have a mom?' the child doesn't want to talk about it. Mothers don't want to admit having given up their babies. My guess," Ivana says, "is that there are 15,000 orphans in the country right now. Our group works in Banská Bystrica with about 60 or 70 children a year.

"The fantastic thing is that white, majority families take Roma children. So do Roma families who

can afford it. It is beautiful that majority families try to keep the Roma children's identity, try to teach them Romany. I am on the phone all the time giving advice. Adoptive parents meet with each other, exchanging information, cooperating.

"After a mother gives up a baby, does she begin using birth control?" I ask.

"Not unless we tell her. Sex is a taboo subject between Roma men and women. Partners do not discuss contraceptives. Parents do not tell their children the facts of life."

Ivana describes the dynamics of many couples' relationships: "There is a lot of domestic violence. Adults are not employed. Men drink. He comes home and she is not cooking. She says she had no money for food. He gets angry. He wants sex with her and beats her. She becomes pregnant. Then she is stressed: 'Should I keep the baby, give the baby away, or have an abortion?' Abortions are really not an option; they cost $225 and the women who come to me know it is already too late."

"So you see the same women again and again?"

"Yes, but I hope that will change."

Ivana is trying to teach family planning. "At first, the men didn't like my talking with the women about babies and life. But I invite the men to see that I am doing nothing against them. I have been married fifteen years and my husband is Roma, too; he helps me. Sometimes the men send their wives to me. Sometimes the men come see me. They approach carefully saying, 'How is the weather,' dancing around the subject. I just say, 'Your wife is not using contraceptives; here is a condom.'"

"I am very angry with the media—radio and television, public and private. They show only the worst Roma families. The public wants to see that 'gypsies' are stupid and bad, and have lots of children and don't take care of them. There is no news about the reality that Roma families adopt orphans."

Too bad they don't know about Ivana, I think to myself. She has confided, "I am a foster mother. I have

a biological son but cannot have more children. My foster child, Maria, is almost five now. Her birth mother has three other children and has lost interest in Maria. I have started adoption procedures. Next month, I will officially become Maria's mother."

Outside, Roma children and their mothers are playing in the snow, sharing sleds. The snow is falling heavily. The houses have no heat. What they have is cracks in the walls. Laundry on the clothes lines is getting whiter by the minute.

Ivana's father, Marian Bučko, greets us jovially, wearing a plaid flannel jacket and a baseball hat with the logo of BMW ("My dream car"). Eva, a Chessboard volunteer, describes the organization's effort to hold a Christmas banquet for parents and children. "Roma families each contributed 75 cents and we tried, with this small budget, to make a miracle." Mr. Bučko laughs, "So! Next, the traditional Roma strategy: ask Papa!" He did the fundraising and it was a fine celebration, thanks in part to the music. Ah, music! Mr. Bučko warms to his subject. His personal mission, he explains, is to "be sure Roma children understand that they have a fantastic musical heritage."

We traipse inside where he plays tape after tape of breathtaking Roma music. We listen to a group called The Devil's Violin (www.diabolskehusle.sk) while he tells me about Cinka Panna, a Roma woman who defied the Roma tradition that women should only sing and dance; she played the violin and started her

own band in 1725. He tells about a Roma violinist who played with Louis Armstrong, and about the violinist Ján Berky Mrenica.

It turns out that even Chessboard volunteer Stephen is earning a university degree in music, and plays the accordion at a nearby ski resort. "He reads notes, plays by ear, and is great on many instruments. *Gadje* musicians won't play with him because they look bad by comparison!" Mr. Bučko laughs with pride. Suddenly Stephen's cell phone rings with music he recorded himself, providing convincing testimony to the fact that he is far better at making music than coffee.

HELENA JONASOVA

The Cultural Association of Roma in Slovakia runs summer camps in the mountains for boys and girls aged 7 to 10, and tutors children who are weak in mathematics and the Slovak language. Founder Helena Jonasova says, "We try to show them small steps to make things better. We stress good Roma traditional values, reinforce the value of Roma women and children, and shatter stereotypes."

Helena pulls on her gloves as we walk up a snowy, unpaved street in her neighborhood. Roma homes are built of found materials; a single wall can include brick, cement blocks and plywood. Most houses are cracked and patched. What she describes as "the worst house" is not only decrepit, it has an outhouse, which must be a chilly arrangement. Children come to the windows to watch us, wearing jackets even though they are indoors. The only two-story house for blocks around is owned by a *Gadje* family.

Now 62, Helena retired five years ago from her job at city hall and earned her PhD in social work last year. "That is a big, big, proudness!" she grins. (Indeed! Less than 2 percent of Romas in Slovakia even complete university, much less earn advanced degrees).

She converted her family home into a headquarters for the nonprofit she launched in 1994, and then expanded its staff and activities.

Because Helena's father was a Roma leader, her perspective on Roma issues has always been intimate. "Politicians say 'we are trying to help,' but they have no idea how difficult it is for a mother to take care of the children, get food, cook, or survive from day to day. She has no energy to make things better. She wants to say 'drugs are stupid; sex is bad,' but she is overwhelmed. Poverty at the local level is not at all what is described in government offices."

We shuffle through the snowdrifts toward a playground that the Cultural Association created, "because the children have nowhere to go." There, buried in snow, a brand new red and blue swing set waits for summer. Over a ravine, we can see the abandoned factory that used to employ Roma in this settlement.

Roma view social workers with suspicion ("government people!") but Helena's ethnicity gives her access. She shares her insight into life in the houses we pass on the way back. "Like majority women, Roma women are supposed to take care of the children, house, and husband. At thirteen or fourteen, they are physically and practically ready (they can cook, sew, iron), but not ready

psychologically or emotionally. All they can do is improvise. If their husbands beat them, they think, 'That is life.' Women expect to follow tradition; it is difficult to say, 'I want something else.' Sometimes younger husbands help wash dishes or hang the nappies, but girls hide that fact so the men will not be criticized. They say, 'You stay inside. I will hang the sheet to dry so people think I do the laundry.'"

Helena's boots scuff the snow as she walks more quickly, excited about a dream she is nourishing. She would like to break the Roma taboo against discussing roles and responsibilities, reproductive rights and sex education. "This is a big vision. I would like to be a pioneer and try to establish...talking!"

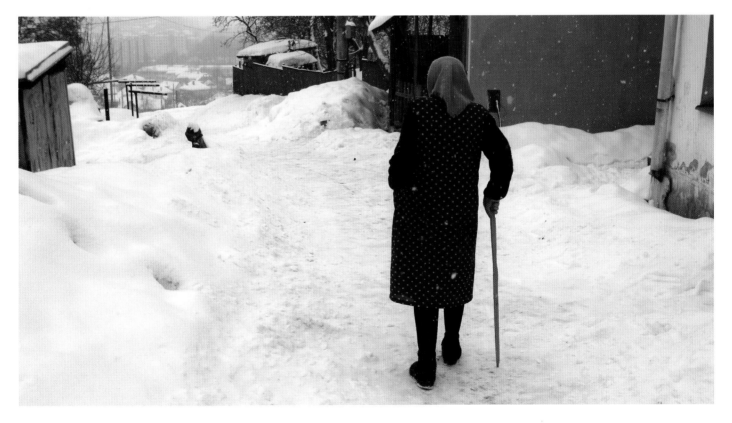

Marianna Mlynárčiková and Andrea Buckova

A recent project that experimented with "talking" was Unisono, a Cultural Association project developed and managed by a Roma woman, Andrea Buckova, 34, and a majority woman, Marianna Mlynárčiková, 35.

The Slovak women's movement had excluded Roma women; this collaboration between minority and majority women was unprecedented. Jolana, Ivana, Helena, and Andrea were among the thirteen Roma women. The four white women were Marianna's art, video, and photography students from the Department of Fine Arts at the University of Mathew Bell in Banská Bystrica. The project goal: to design postcards that illustrate women's rights.

Unisono videographers documented the group's meetings. The DVD shows that the process was as important as the product.

First, participants list the characteristics Slovaks expect of men (tall, handsome, strong, wise, decisive, sexy, rich...) and women (sensitive, understanding, emotional, beautiful, tall, slim, cheerful, devoted, humble, modest, sexy...).

Then, they compare and contrast stereotypes of Roma and non-Roma women, an exercise that stirs lively discussion even among Roma women:

"Roma women do not marry non-Roma men."

"No longer true! These days they do!"

In the third session, the women begin to laugh, tease each other and relax. A participant clambers onto a big sheet of paper. The others trace her body

(amid much hilarity), and then write their thoughts on the paper next to the specific body parts:

"I like it when he bites my ear."

"Temporary hotel for babies."

"I hate bras."

"I love to pee."

"I want to pierce my belly button."

One summer day, the women work outside. In a flurry of creativity, they snip magazine pictures and glue them into collages, sketch with charcoal, draw with felt-tipped pens, brandish cans of fluorescent spray paint and make shapes from colored tape. Some choose to finger paint. Their postcard designs begin to take shape.

Now, as we talk, Marianna and Andrea (nicknamed Baša) spread the women's colorful postcards all over a table in the Cultural Association's office. Each card depicts one of the women's rights that everyone agreed was crucial. The right to education (hens roost under a feather that says "Think?"). Equal rights in married and family life (an engrossed couple arm-wrestles). The right not to be beaten (red letters express pain in any language:

"AUAUAU"). There are more. The Cultural Association for Roma in Slovakia is distributing the postcards to women's groups all over the country.

The Unisono project resulted in more than a new awareness of women's rights. It kindled cross-cultural understanding. The final time the group met, they dipped their hands in paint and made red, blue, orange, pink, green, and purple handprints. When the paint dried, each woman wrote a message on her handprint to memorialize her thoughts. One participant's words spoke for everyone: "Our hands are different. But they are the same."

Few ideas could resonate more with me than this one. *In Her Hands*, the book I created with Toby Tuttle, celebrated the power of women's hands. The Slovakian artists' metaphor is true for women everywhere.

Postcard photos by Marianna ˇ
Mlynárciková

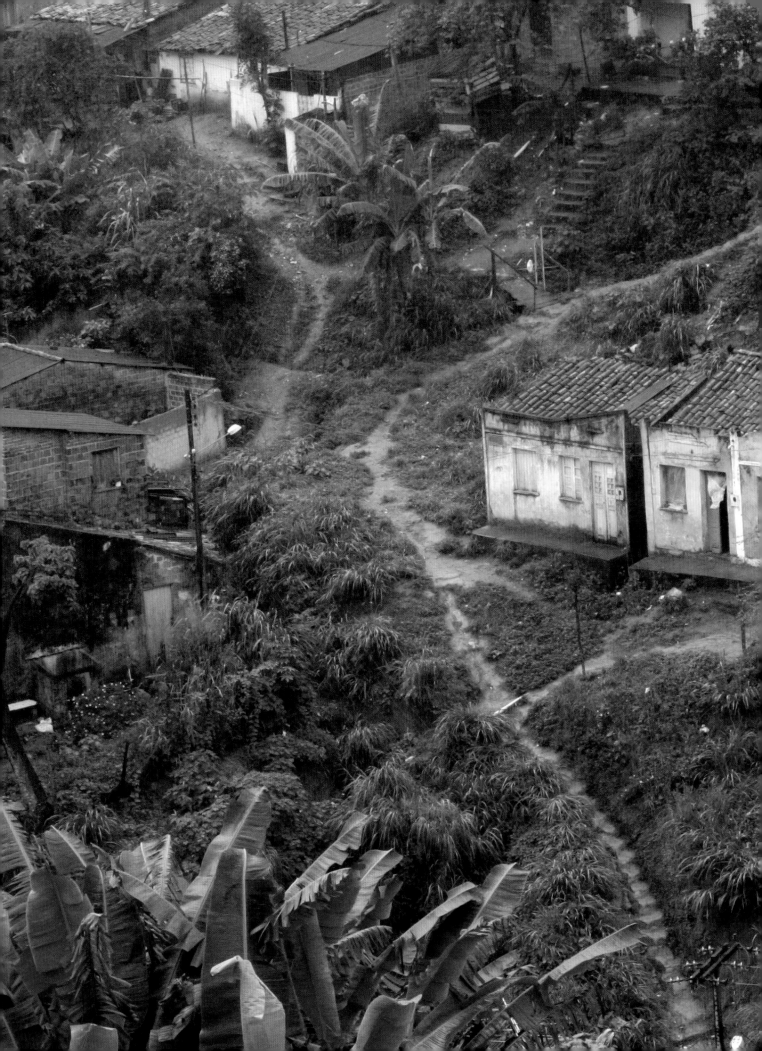

BRAZIL
EDUCATING GIRLS

Rita Conceição shops in the morning market at the corner. Her friend the vegetable vendor helps her select the freshest corn. A woman sitting under an umbrella near buckets of cut flowers offers Rita shining red, green, and yellow peppers. Samba music pounds insistently. A butcher rakes scales off a red fish. Chickens screech from stacked wire cages. A man in his once-white coat pushes past, hauling a newly-butchered cow. Bananas dangle in bunches on a fence. Shoppers make the street impassable. A taxi, surrounded, blasts its horn to clear the way into Rua do Sodré.

Rita loves to cook. She walks up the block every Friday to buy food so she can prepare lunch five days a week for forty little girls who participate in the Bahia Street program. Each day, it may be their only hot meal. Similarly, the hot shower they take when they arrive may be their only chance to bathe; there is no running water where they live. Rita knows what that's like. She, too, grew up in the *favelas.*

A *favela* is not just a poor neighborhood; the word means "invasion." Indigent families build shacks on found land that has no infrastructure. Eighty percent of Salvador da Bahia's population is African-Brazilian, nearly all living in this kind of material misery.

In 1550, African slaves began arriving in Salvador from West Africa and ultimately, 3.6 million were imported to Brazil to work in the sugar plantations, tobacco fields, and gold mines. When the Portuguese Princesa Isabel decreed in 1888 that "slavery is now extinct in Brazil," she had no plan for freed slaves. Samba lyrics tell the story: the princess "freed Brazil's blacks from the whips of the *senzala*" but "left them stranded in the misery of the *favela.*"

Girls who live there today have little hope of a better future; indeed, some have no future at all. Drug lords "govern" the shantytowns, and when gangs fight, bullets easily pierce the walls of the shacks. Open sewers divide the encampments; rats and TB run rampant. The incidence of domestic abuse in Brazil is high; one report estimates that a woman is beaten every 15 seconds. During the rainy season, houses slip down the hill on top of each other. Many young women become pregnant soon after their first periods; some die having illegal abortions. Inevitably, only two employment choices lie ahead: prostitution or cleaning houses (two-thirds of African-Brazilian women work as domestic servants).

Theoretically, education might provide a way out. Children regularly attend the four-hour public school sessions. My friend Joan Chatfield-Taylor and I are staying at a *pousada* across from a government school. At 8 AM, we see students in their "uniforms" (white t-shirt and jeans) hang out the windows, fall asleep on their desks, and play tag inside the classrooms. Brazil's minimum class size is 40 and many rooms have 50 or 60 students. Later I learn that public school teachers are so badly paid that they strike often, and many days don't feel it's worthwhile to come to school. Students, however, go dutifully in order to earn their parents the government stipend that is supposed to assist with school costs. Families may receive $25-45 per month, which they often use for other things.

It's boring and inconvenient to sit in school when you don't learn much. On average African-Brazilians attend school for just two and a half years. If they are among the 14 percent who finish the eighth grade, they may not have learned to read or write. Only 2 percent graduate from high school.

In 1997, two women decided to give girls from the *favelas* an opportunity for a brighter future. They co-founded Bahia Street, a project that complements school classes with rigorous academic courses and empowers the girls as women and as African-Brazilians.

Both founders have deep roots in the *favelas.* Margaret Wilson, who now resides in Seattle and earned her PhD at the London School of Economics, spent years doing research in Salvador's shantytowns. Rita Conceição grew up in the *favelas* and, despite all odds, graduated from Federal University of Bahia.

RITA DE CASSIA DOS SANTOS CONCEIÇÃO

Rita, now 48 and executive director of Bahia Street, settles into her office couch, which is draped in cotton print, and reflects on her journey.

"My mother was the youngest child in a poor family. She made cigars in her town, Muritiba. She could only write her name. My father was raised by an aunt whose parents were slaves. He attended school for three years. My parents were childhood sweethearts. I was born a year after they were married, the first of ten children, eight of whom lived.

"My father worked as a tailor and my mother cleaned houses. When he was diagnosed with TB, she supported the family. She believed education was 'the way out' and wanted all her children to go to school.

"In Brazil, children starting public school are expected to know how to read and write so when I was five, mother paid a neighbor to teach me. I was seven when I started school. I was expected to study, take care of my younger siblings, and sell beer and fish from our bar next door.

"Our house, in Nordeste/Amaralina, was made of clay. When we moved in, I only had four brothers and sisters and everyone lived in one room about the size that my office is now." Rita gestures at her pastel pink office which is about 10 by 12 feet.

"As more children came along, we built onto the house. We paid money for one workman and sand, but the family did the rest. The kids all helped make

115

bricks. Finally, we had one bedroom, two living spaces, and a kitchen, where the children slept. I was lucky: my father was working as a night watchman on the docks, so as the oldest I got to sleep with my mom in the only bed.

"All night, father would fish for our food so we had a healthy diet: fish—with rice, beans and corn, which were cheap. From the docks, he started working on the boats, and then became a captain on the ferry. All of us kids helped him pass the tests so he could get a better job. All of us also worked at mother's family's newsstand. And we studied.

"I liked studying, and the neighbors encouraged me to read a lot. They exposed me to the outside world. In 1964, they took me to a student protest against Brazil's military dictatorship. I participated in street protests at age seventeen. At nineteen, I began working with a street theater, which I continued for ten years. I traveled to São Paulo with the theater, was with people who smoked grass and even though I didn't, my mother, who had always kept the family close, was going crazy. She had completely lost control of me. I took university entrance exams twice and didn't pass. That caused a big fight between us. She told me that I couldn't go to the next protest unless I passed the university test. I had one day to study. I passed. Mother was so angry that she said she wouldn't pay for school.

"I was the first in our family to go to university. I entered at age 23 and negotiated a 50 percent discount on tuition. Mother paid the rest. The professors had light skin but I wasn't aware of the racial problem." Rita runs her hand across her arm. "Mother, who was darker than I, suffered discrimination and protected the family from it."

"Mother died when I was 24 and she was 48, my age now. She had participated in medical tests for contraceptive implants and began having problems. She had always been reserved, but after her death I came to understand that she had been a leader. She helped many who told me that without her, the neighborhood would never be the same."

Rita interrupts herself to take her ringing cell phone to someone in the office next door. "I left private university and attended the free university. I moved into a student dorm with 200 women, a new way of living, an important phase in my life. It took me twelve years to finish university," she says wrinkling her nose. "It was difficult. I was working, studying,

and doing theater. I didn't like the methodology or the academics. There was no opportunity to study visual anthropology, which was what interested me. I graduated from Federal University in social sciences with a specialization in anthropology.

"I had a communications job and it was going nowhere. Someone inspired me to take a photography course. To supplement my income, I photographed weddings and baptisms, which was supposed to be men's work. A male photographer once tried to take my camera away in a church. After that, I photographed at Ingreja Nossa Senhora do Rosário dos Preto, the slaves' church in the *pelourinho*, where I was welcome."

Rita also worked as an interpreter for Margaret Wilson, who was doing anthropological research about the *capoeristas*. *Capoeira* originated from a ritual African dance that developed into self defense against slave masters. Today, it is a fluid, circular form of artistic expression in which two fighters exchange mock martial arts blows inside a circle.

Rita had done *capoeira* for ten years and was able to give Margaret insight into the dance form, as well as into the black culture and women's issues. "We were both Aquarians, so we'd go swimming in beer at a bar and talk about problems that blacks, women, and girls face. We had lots of ideas about what could be done.

"From those conversations, Bahia Street was born. We decided that I would run the Salvador operation and Margaret would be responsible for fundraising." Rita pulls a framed picture of the two of them off the bookshelf and leans over to show us Margaret, white and blond, and a younger Rita with the same engaging smile she has now.

"Bahia Street started in 1997 with three girls. One passed the tests to go to private school. We paid her fees, but she didn't have the background to do well, so we set up a tutorial program to help her, and to help the other girls get good marks on entrance exams. Bahia Street's program still complements schools' programs. Now there are 40 girls between the ages of eight and fifteen, and we focus on public, not private, school students.

JULIANA SANTOS CONCEIÇÃO

Juliana, 21, was among the early Bahia Street students. She has just been accepted at the Steve Biko Institute, which prepares African-Brazilians for the *vestibular*, the university entrance exam. She pulls out a page from the local newspaper, which ran a two-column article about the test. The student in the picture is Juliana herself.

The *vestibular* is a five-hour marathon of multiple-choice and essay questions. Forty students compete for every freshman opening. Candidates are almost never young black women from the *favelas*. Only 2 percent of Brazil's population progresses beyond high school and 80 percent of those who do are white.

"Public university exams are offered once a year. I took one last year but didn't pass. I plan to take three of them this year," says this strategically canny, sparkly young woman.

Third of seven children, Juliana was born in Salvador but lived with her aunt in Muritiba until she was a teenager, which meant she missed out on school. When she returned to the city at age thirteen, "I did the first and second grade together. As the youngest student in adult night school, I studied hard.

I finished the first four grades in three years, then took fifth and sixth grades together.

"Because I was coming to Bahia Street, I never failed a year of school even though I took two years together twice. I learned subjects here before they came up in school. Teachers in government schools just write things on the board and everyone copies the words. At Bahia Street, the goal is to have students learn the subject. But there, the goal was to get through the information on schedule. I helped the students (and sometimes the teachers) understand what was on the blackboard.

"I like children and want to be a teacher. My choice would be to attend the University of Northeast Brazil, which has the best education department. After four years, I would be qualified to teach second, third, and fourth grade in all five basic subjects: history, geography, math, science, and Portuguese. There is an

eighteen-month postgraduate program; I could earn 20 percent more salary for going through that.

"Meanwhile—also because I like children—I am working at Bahia Street. I earn the minimum wage, $175 per month, and will continue so I can afford university transportation, food, and materials.

"My job here is to control the girls." (I raise my eyebrows. I've never seen a less likely disciplinarian than this friendly young woman who is barely older than the girls themselves.) "When they arrive, I make sure they have a shower and are behaving. I serve lunch and snacks mid-afternoon, then try to get them back into the classrooms. It's hard on Mondays when they come in angry from being home over the weekend. Lunchtime is best: they are quiet because they are eating! Snack time is hard: they are all together and there are so many of them! I try to keep an eye on everything and intervene before the problems happen. If they fight, they are suspended. If I say 'stop,' they do; over time, they have come to respect me."

Just in case you think Juliana is all business, consider this: she and her boyfriend love dancing on Saturday nights to the music of *Olodum* and *Ilê Aiyê*, the group with whom she performs during Carnaval. She is, of course, lobbying her beau to attend university. Meanwhile, he amuses them both by fixing her hair.

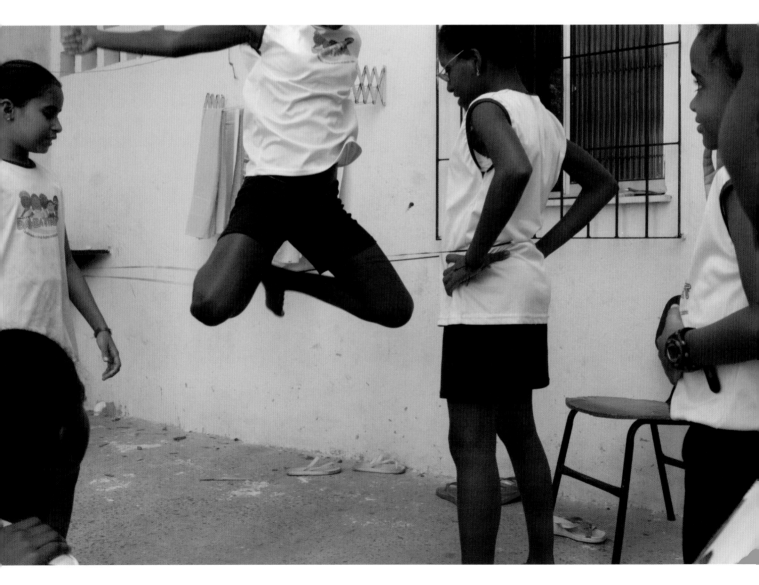

Daza Ifá Ashanti Moreira

Daza, nineteen, passed the *vestibular* and will enter the Federal University of Bahia in August. She took the entrance exam only for that school, which has the best reputation in the city. She will study journalism.

Daza came to Bahia Street when she was thirteen, was part of the project for two years, and is an ardent supporter. "It gave me a much better education and the background to get into university. It answered my questions and doubts about my schoolwork. There is no other project like it in Salvador."

Not only did she benefit from the curriculum complement that Bahia Street offers, but the project awarded her a scholarship to attend a middle-class, mostly white, Catholic, co-ed private school. That must have taken some getting used to for a young woman from the *favelas*.

Her favorite subject in high school was history, although her teachers only mentioned Brazil's slaves quickly, as if they had migrated normally from Africa. "In private schools, many students descend from Portuguese slave owners, so they didn't want to talk about slavery. I learned about it here at Bahia Street."

Daza volunteers at Ceafro, an African-Brazilian center that provides job training for teenagers, and participates in Quilombo, a discussion group for African-Brazilian women.

Her dream job: "working for one of two black magazines, *Raça* (the largest magazine in Brazil) or *Eparrei* (which is more political and includes poems and stories). I write some poetry, but mostly critical texts about social class, poverty, lack of employment opportunities—reality for black people today."

The magazine article she would love to write is "about our ancestors and their influence on the present." She plans to do freelance writing while she attends university, so perhaps she will write that story soon.

Daza says, "I was born and raised in Salvador. I have no contact with my biological father who lives in Cachoeira and doesn't recognize me as his. I live with my mother, stepfather, and two younger half sisters. My stepfather makes the jewelry that my mother sells in her shop. When I was one year old, he made tiny earrings for me."

Today Daza is wearing splendid hoop earrings, each with a cowry shell.

"Do you have an *Orixá*?" I ask.

"Everyone does. I am not initiated into Candomblé, but everything indicates that my *Orixá* is Oxun," Daza smiles.

Oxun, the Yoruba goddess who loves self-adornment, must be smiling back.

CAMILA BARBOSA MACEDO

Camila captures my attention during Bahia Street's ballet class. She is the only one wearing a leotard and exercise shoes, which she got to study dance at private school. At 15, she has the grace and bearing of a classical dancer but that is not her thing. "The teacher is too strict. He says we ask too many

questions. I like belly dancing," she laughs.

For a long time, she has lived with her father's mother. Her grandmother introduced Camila to Bahia Street when she was nine. She became the third student in the program.

"Now my grandmother is 70. She not only attends parent meetings, she is here every week to bring me a towel for the shower, or to deliver a plastic bag. She is practically part of the project!"

Camila's parents, however, are not. Her father is dead (some say he was murdered). Her mother

remarried, moved to the country, and sees her daughter only on holidays.

One of last two girls in the project who are attending private schools on scholarships (Bahia Street has terminated this part of its program), Camila is completing the eighth grade.

I ask about her favorite subject. Animated, she leans forward and gestures so continuously that I can't photograph her without getting blurred hands. "I like math. I hope to work in engineering, perhaps mechanical engineering. There are not many women engineers in Brazil, but women here have made great achievements and are moving into men's professions. Three times a week, I go to Opção, a school that is helping me qualify for Cefet, a technical school. My grades are good but I am studying so hard there's not even time to go to church.

"My life would be different if I hadn't been at Bahia Street. I'd be pregnant; most of my friends are. Most are smoking; I hate cigarettes. I would probably be taking drugs. That's not what I want."

"What do you want your life to be like when you are, say, 25?" Joan asks.

"I'd be working. It would be too early to be married. I would find my grandmother a nice place to live and then think of myself." She finishes almost wistfully: "I would like to have my own house."

Rafaela de Araujos Santos

Rafaela has been coming to Bahia Street for three years. Now fourteen, she is in the seventh grade at a government school.

This afternoon, she is one of five models in the math class' fashion show. Like the others, she has created a recyclable costume using brown bags painted with numbers. Hers is painted in pink and turquoise (her favorite colors). Numbers shine from her outfit and glitter on her skin. It's clear from the way she responds to the cameras that she loves being on the runway.

"You'll be finished with Bahia Street at the end of next year. Then what?"

"My dream is to become an actress. It's difficult, but I'd like to be in the theater. I was in a play here last year. We performed in the Bahia Street garden. Teachers, ex-teachers, students, parents, a study group from the US all came. It was a play from Roman times and I played three roles including the king. As king, I wore an old-fashioned blouse, puffy trousers, and a crown. My favorite line was, 'No, my daughter, you cannot marry this pauper!' Then, as part of the role, I passed out."

Interesting that a young woman whose family is economically impoverished resonates so strongly to this line, I think to myself.

"I live with my mother and brother, who is almost four. Downstairs there are aunts and cousins. A lot of relatives live next door. I take a bus that gets to school in about an hour. I walk from school to Bahia Street and take the bus home at 6:30 or 7 PM. There was another student bus strike last week, so I didn't get home until 9. I was scared."

"What's the worst thing about Bahia Street, Rafaela?"

"I don't like it when the kids fight, when they are in a bad mood, angry. I want to see everybody smiling."

The day Joan and I leave, this sweet girl gives each of us a rubber bracelet. Mine is red and says "God Bless the World," Joan's is blue and says "Support the Troops." Who knows where Rafaela got them. She slips them onto our wrists, smiling and inviting us to visit again.

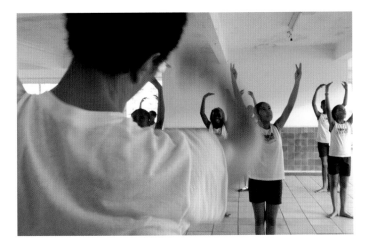

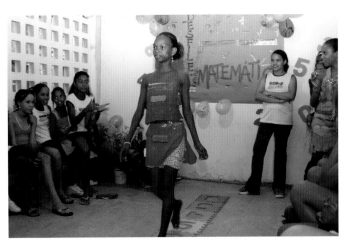

BARBARA DALTRO DE ALMEIDA

Barbara, ten, is in the fourth grade. She is a chatterbox, bursting with contagious energy.

"Did you have a tenth birthday party?"

"There is a party for everyone with November birthdays at Bahia Street. My mother is not employed, so we didn't have a party at home, just snacks and a cake. I brought the leftover cake to the project."

"Where I live, near the Marina, it is not safe. Here there are nice people, nice teachers. I feel at home. I have trouble with some of the exercises, but I like dance and art. I like African dancing."

"I can't stay away from Bahia Street. It's very important for me. This is where I study. I don't study at home, I only sleep there. I live with my mother and stepfather. There are three kids. My eight-year-old brother and I have the same father. The baby has a different father. I like looking after my sweet little sister, Jasmine."

"Do you have a best friend?"

"Yes, Ayisha, here at the project. We fight, but I trust her and tell her things I wouldn't tell other people. She's eleven but sometimes she is very grown up. Sometimes."

"When you grow up, what would you like to be?"

"One dream is to meet the band Calypso. But my real dream is to be an internationally famous model everybody knows because she is intelligent and beautiful. I want to go to the US where I'd have more opportunity. I know it's not like paradise and it would be difficult, but I will fight to study and go to university and go to the United States."

When it's time to take pictures, Barbara starts a sequence of modeling moves that she has perfected down to the smallest maneuver. She switches position every time my camera clicks. I make it a game, wondering how many poses does she know? Seated, she rests her hand on her crossed knees. Click. Stands, leans forward and pouts. Click. Tosses her head, flounces, pulls her dreads over her head, turns her back and peeks, puts her hand on her hip. Each move is expert, as if she were in a studio with seamless background paper, umbrella reflectors, and strobes in front of a camera on a tripod. She could be 30.

"How did you learn all this?"

"Television," she giggles.

Most houses in the *favelas* have no running water. But they do have electricity and some have satellite dishes, as I am about to find out.

THE FAVELAS

Rita and her brother take us to the *favelas*. Although Bahia temperatures have been sizzling, the sky goes from dark to dangerous, the wind whips, and suddenly raindrops become torrents. People run, some shirtless, some shoeless, to find cover.

In one *favela*, a man is sitting in the downpour on the roof of his house, urgently hammering sheet metal to cover a hole that's two feet in diameter.

In a hillside *favela*, people have spread plastic tarps over the raw earth to prevent mudslides and keep their houses from washing down the slope.

In a beachfront *favela*, two children under one umbrella hurry to the wave-swept rocks to collect mollusks for dinner (never mind that the water is awash with sewage).

Christine Eida, a Brit married to an Afro-Brazilian, used to teach English at Bahia Street. She translates as Rita tells how life began for one student from the *favelas*. "Her mother rushed to the hospital after trying to abort her baby. Months later, the hospital called her to come get her live infant. It is not uncommon in a Catholic country, where abortion is illegal, for babies who have been supposedly aborted late in the term to be nurtured until they are old enough to leave the hospital. That little girl is now in Bahia Street. It is hardly good for self-esteem to realize that your mother tried to abort you, so none of us ever told the girl."

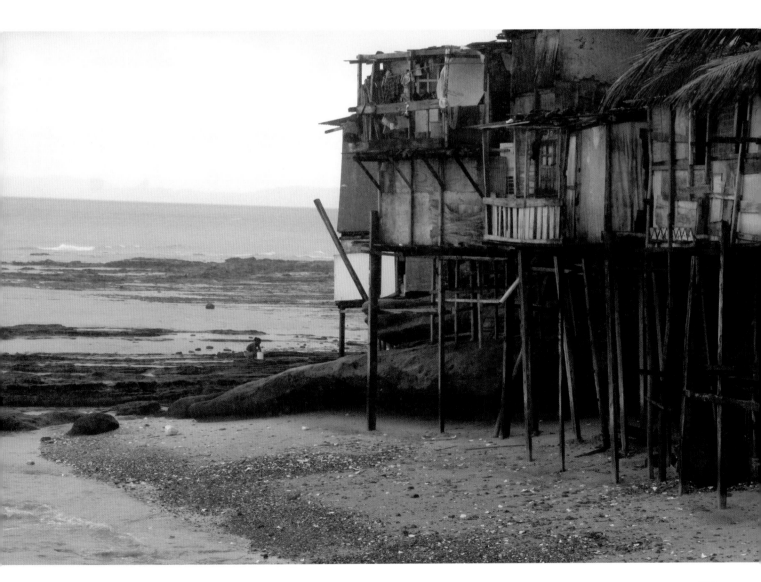

We climb to the third floor of Bahia Street's building, where workmen are constructing a photo lab, a computer lab, and a science lab. Perhaps best, they are building a roof.

Three years ago, Rita wielded a hammer herself to help renovate the lower floors and "to deconstruct gender stereotypes." For the same reason, one day recently she cooked lunch and then spent the afternoon removing a tree in Bahia Street's backyard.

"Women in Bahia are taught to be passive, subservient. We try to teach the girls to be assertive and confident." Rita learned to appreciate these attributes four years ago when an armed gang came to the area where she grew up and threatened to kill a neighbor. Rita confronted the gang. Others who had never seen a woman play that role now involve her in solving their domestic disputes.

Rita wants Bahia Street girls to respect themselves enough to avoid the domestic violence that may face them in the future. "I want the girls to be strong, not fragile," she vows.

"Television—and *pagode* (party music) lyrics like 'You're a dog, you're a dog'—devalue women, but the girls just sing along. We work to make them aware of how women are portrayed in music and the media. In Brazil girls are encouraged to look sexy: by age three they are in heels and makeup, wearing tiny skirts and décolleté tops. In the stores, it's hard to buy girls' clothes—there are only mini-women's styles. At first, our participants resisted wearing the Bahia Street uniform: T-shirts and Bermuda shorts."

Rita is proud that only one girl in the project has ever become pregnant. That is so unusual in this state's sexualized culture that people cite it as one indicator of Bahia Street's success. "We talk about sexuality. In Salvador, the promotion of condoms is cosmetic and superficial. Men wear condoms in their earrings during Carnaval and give them away to the crowd, but that is mostly a show for tourists—in November, nine months later, many babies are born. The government does promote safe sex to the homosexual community. But heterosexual men have lots of sex—and lots of children. Women acquiesce to that lifestyle in order to keep the men. It's the woman who has to deal with the children, and often she takes her suffering and frustration out on her daughters. Macho culture perpetuates this behavior but ultimately, the daughters are the same as the mothers." Rita hires male teachers "to give a sense of family and to provide a positive image of men."

NILSON JOSÉ CARTIBANI DOS SANTOS

The man everyone calls Fio is head of curriculum at Bahia Street. He and Rita have been friends for 25 years, half his life. Rita describes him as "my mother, my girlfriend, my brother, my best friend." Fio laughs, "I have overcome gender."

He believes, "Bahia Street is not just about women. Women's worlds include men. There is an image of males as predators. We need to encourage women to work *with* men."

It's a balancing act for a man to work here. "I feel like a chameleon. At parent meetings, I can be uncle or nephew. The relationships I have with the girls, some of whom I've known since they were eight or nine, change as they grow up. Little girls want to call me Dad (I say, 'You already have a father'). I try to avoid physical contact with the older girls so people don't get the wrong impression. On the other hand, one girl wanted me to be the first to know when she started menstruating. Instead of sending her to Juliana or Rita, I said, "OK, let's go to the drug store."

Fio says his life has been like the song lyrics, "I come from the country with no money in my pocket. I was born in Ubaitaba and raised in Itabuna. When my father, a tax inspector hoping for a better job, entered university in Itabuna, my mother brought us four children to Salvador. I promptly failed at Salvador's best technical high school. After transferring to another school, I graduated in electro-mechanics, which I didn't understand or like. The first *vestibular* I took was for physiotherapy. But what I really wanted to do was draw."

Ultimately Fio studied art education at a private, Catholic university, paying his tuition with a student loan. "I covered monthly expenses by making shoes and bags." At the time he graduated, Brazil changed currency. Deflation followed. "Lucky for me! My educational loan was reduced to virtually nothing!"

He commuted to teach art in three different schools concurrently and enrolled to earn another BA in architecture. But the demands of traveling, teaching, and studying made pursuing a second degree impossible.

Art is still a passion. His abstract watercolors decorate Rita's apartment walls. He is well known as a sculptor who exhibits and sells his work in Salvador galleries. When Joan and I ask to see his work, he ducks into a closet and returns brandishing a small original statue as if it were a Hollywood Oscar.

"A long time ago, Rita and I worked together on a crèche project. I always had breakfast at her house. I knew her mother. After work, we met in bars to have a beer and talk. Her neighborhood was violent and since I had long hair (not the way people expected you to look when we were 19 or 20), we were often stopped and searched by police. When Rita ran a

theater program, I wanted to see her amazing musical play every day, so I volunteered to dress the cast. We didn't have much money but we had lots going on. We never stopped for a moment. Rented a house on the island. Went off on trips."

Fio has worked at Bahia Street for five years, but thanks to his friendship with Rita, has known the project since the beginning. "I started here as a teacher but we needed an educational coordinator. The project already had vision and direction. I thought I could bring things together, make them more consistent.

"Paulo Freire, Emilia Ferreiro and Piaget are well known educators whose theories we adapted. That gives us general guidelines, which we shape to fit each child. There is no conclusion to our method: we discuss it all the time.

"Public schools send us problem children. It's not that we don't want them, but we want students who fit our profile: girls who want to study, whose family income is $175 a month or less, who are African-Brazilians. Often we have to ask about the family since, to avoid discrimination, black girls with light skin say they are white. We would like parents to give the girls their interest, commitment, and participation—but they have too many daily problems. Parents might come once a year to our monthly meetings.

"The girls have a big problem with literacy, mathematics, and Portuguese, the spinal column of education. In schools, during grades two through four, they work on basic skills. At Bahia Street, even if the girls are in grades five to seven, we still work on the basics. There is resistance from the girls: they have already studied these things. But they don't *know* them so they can't move forward.

"A great teacher said, 'Children don't like studying, but they like learning.' Our method is getting them to want to learn. Many feel they want to skip school and come here.

"There's a common saying: 'Don't bury your belly button.' It means something is permanent and will always exist. Bahia Street is a positive experience that will always be part of our students' lives, no matter where their futures take them."

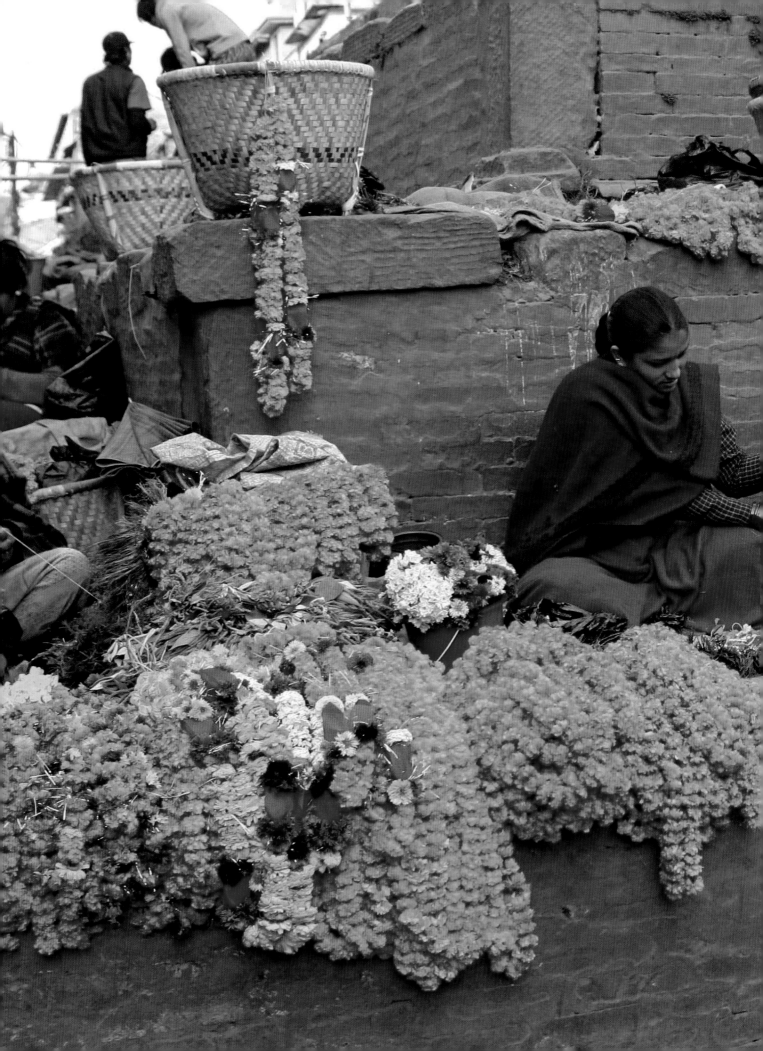

NEPAL
EXPANDING OPPORTUNITIES

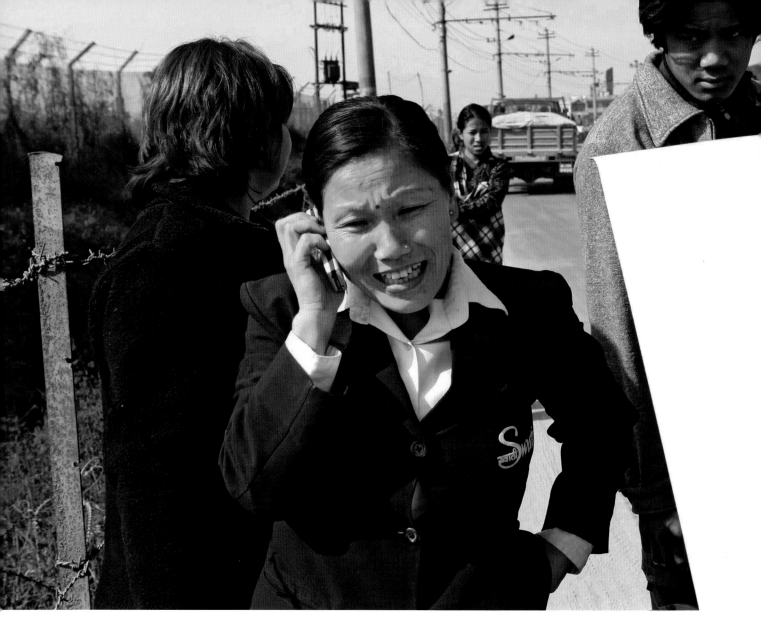

Sangita Nirola and Gaurie Malakar greet me at the airport carrying marigold leis and armfuls of gladiolas. Driver Sharmila Rai waits in the taxi, wearing a chic navy pantsuit. She navigates quickly to the Dwarika's Hotel, a museum-like enclave of buildings carefully crafted from ancient brick and elaborately carved wood. We enjoy a late lunch, seated in a cloistered courtyard. Gaurie looks around and says, "My first job was cleaning rooms in this hotel. I was orphaned when I was nineteen and had to support my younger brother and sister." Gaurie held a series of increasingly senior jobs in the hospitality industry, ultimately managing entire resorts. She was hired six months ago to create a travel agency for the nonprofit that Sangita founded, Swati.

The Nepali noun, Swati, is the name of the goddess of female energy. The name is apt: the organization empowers women to be economically independent. Swati's first course trained women to drive taxis because Sangita saw a need: many women in Kathmandu did not feel safe riding with men. Women taxi drivers? The idea was revolutionary. Until then, here and in most countries, taxis were driven by men. Swati's programs expanded, training women to make handicrafts, operate computers, become beauticians—and soon, travel agents. After they master job skills, Swati helps them start their own businesses.

LAXMI NAKARMI

One Swati entrepreneur is 32-year-old Laxmi, who runs Perfect Corn-Husk Handicraft. She and the ten women she employs work in an apartment near Durbar Square. Their children play on the balcony as the sun sets. Some artisans are making Kumari (living goddess) figurines costumed in red silk and packed in boxes created by a papermaking project owned by other women Swati trained. Some artisans make Christmas ornaments while their colleagues craft keychain decorations. Laxmi's business cards say, "Order any type of handicrafts. We will complete them in a fine way. We can say confidently that we have the capacity to satisfy you."

We leave Laxmi's at rush hour. Sharmila tells us that in the section where Laxmi works, streets have never had names. Everyone living within 300 feet of a landmark gives the landmark as their address, even if the area includes dozens of roads, plus hundreds of homes, shops, and restaurants. The idea of delivering a taxi passenger to a specific destination boggles my mind.

But that is not the most difficult challenge taxi drivers face. Kathmandu's brick, medieval streets are barely wide enough for two cars to pass. Main thoroughfares have no marked lanes. Buses, bicycles, mopeds, and buffalo compete for right of way. Horns create a symphony of stress. "The hardest part of driving in Kathmandu is the traffic," Sharmila admits. At any moment, the car in front of us is as likely to be facing toward us as facing away. Sharmila is focused and calm. I flinch as a truck cuts us off, and ask Gaurie to brief me on current events.

"Maoists have been waging civil war for ten years. Nepal is a constitutional monarchy but on February 1, 2005, King Gayanendra dismissed Parliament and usurped total power, which he said was to control the Maoists. That anniversary, February 1, 2006, will be a day of protest. To prove to the international community that Nepal is a democracy, the king has called municipal elections next week on February 8. Only royalists have entered candidates, most of whom are unqualified; the seven political parties and the Maoists are boycotting the elections. Much of the population wants true democracy and believes Nepal should no longer have a constitutional monarchy."

SHARMILA RAI

Swati's taxi is in the shop, so Sharmila has borrowed one. We head for Bhaktapur, a World Heritage city about nine miles east. Since Swati drivers learn English to describe the history, monuments, temples, monasteries, and palaces in the ancient cities in the Kathmandu Valley, I'm about to see Sharmila in action.

Sharmila, 27, grew up and completed high school in eastern Nepal. She taught children for six months, then, eight years ago, migrated to Kathmandu to become a receptionist for a driving institute. In 2003, she learned to drive and she has been teaching driving for Swati ever since. Twenty-two of her students have qualified for licenses. The newest group will receive theirs tomorrow.

Taxis and buses are required to park outside Bhaktapur, so we walk into the old city past the solid-gold gate of the Durga temple. Thirteenth- and fourteenth-century brick buildings are covered with fantastic animals and towers. A statue of the king sits high on a pole. Sharmila escorts us to a Thanka school where a few women are being taught to paint intricate, sacred mandalas (a job that, until now, has been the province of men). We pass shops full of colorful marionettes and walk through a labyrinth of lanes. Pottery Square is covered with ceramics drying in the sun; some Swati craftswomen paint pots for sale.

Sharmila buys a pottery penny bank for herself. She needs to save. Taxi drivers earn about 3,000 rupees ($42) per month, which Sharmila supplements by teaching (Swati's women's taxi driving class meets two hours per day for four weeks), working as Swati's receptionist and selling her knitting. She is applying for a job driving a staff car for the United Nations Development Program (UNDP) in Kathmandu, which might pay $300 a month. Swati has written her a glowing letter of recommendation.

We head back to the capital during rush hour. Suddenly, our borrowed taxi's engine stops. Men materialize and push our car to the side of the highway. Sharmila opens the hood and everyone peers in. "Wiring problem," one fellow announces, biting the rubber coating off the wires and reattaching them. Sharmila starts the car, everyone cheers, and we drive off.

We go about a mile before the car stops again, this time on a steep incline in the middle of the road. Animals pulling carts cut around us; trucks honk indignantly. Cars and taxis slow into gridlock. Gaurie and I push the taxi uphill while Sharmila steers. Five men help until a bus squeaks past and they climb aboard. Gaurie and I finally shove the car to the shoulder. Again, Sharmila opens the hood and fiddles. She can fix fuses, headlights, taillights; check fuel; change water, oil, and tires. But this problem defies her.

A taxi pulls off the road. Sharmila and the driver work under the hood. In disgust, Sharmila finally calls the owner on her cell phone, tells him to pick up his keys at my hotel, and reclaim his broken-down taxi. She locks the doors and the cab driver extends the professional courtesy of delivering us to Dwarika's.

Never for one minute does Sharmila lose her cool, despite the frustration, heat, traffic, and exhaust fumes. If I were writing her job recommendation to UNDP, I would write: "She is unflappable." (Months later, Sangita emails me that Sharmila got the job: "Yahoo! Isn't that great?" she writes proudly.)

Today the women whom Sharmila taught to drive will receive their licenses. The first group's graduation took place at a five-star hotel, which Sangita arranged to make the occasion feel as important as it was. This time, the graduates will be photographed for a book that will be distributed all over the world; I pick up my camera, vowing to do them proud.

The new graduates are surrounded by their predecessors, who congratulate and welcome them to the profession. Sangita Tapa, 30, who began driving four years ago, is now "driving a huge staff car for DIFID" (the UK overseas aid program). She tells the new drivers, "Start by driving a taxi, but move forward and apply to a nongovernmental organization. Not only do I earn 30,000 rupees ($420) a month, I have six months maternity leave, fully paid!" (Her daughter is now three months old.)

Parvati Bhujel, 25, was also in the first group. Today, she is running the drivers'

training center that her father founded. Basundara Bajracharya, 26, is not only a taxi driver, she runs a sewing business and made the eleven uniforms that Swati's new taxi drivers are wearing proudly. Everyone lines up for a formal portrait to document this important day. I don't need to ask them to smile.

SANGITA NIROLA

Sangita shows me proudly around Swati's new offices, which she designed. The walls are variously apricot and aqua, freshly painted. We enter a boutique filled with crafts Swati women have made. There are workrooms where women are learning to make candles shaped like calla lilies and floating roses. Trainees crowd around a "client" in a small beauty salon, practicing cutting hair. Gaurie is writing the first strategic plans for the travel agency. We are served tea by a woman baker who wants us to test her cookie recipes.

Sangita founded Swati in 2002 with her own savings. "My mission was to help poor women in troubled circumstances. Being a responsible citizen from a good family, I felt I should help those in need and empower women via economic independence so they think of their rights, come out of their houses, balance their home responsibilities with the outside world, be recognized by their families, respected by society, and become good citizens." These are ambitious goals and much-needed remedies. Nepal is one of the least developed, poorest countries in the world. Many Nepalese women are underprivileged, overworked, undereducated, and discriminated

against; they lack self-confidence and are burdened by the Hindu caste and dowry systems.

I am impressed by what Swati has accomplished in just four years. Sangita admits, "I like to move fast. I am in overdrive to make up for the seven years I spent as a housewife. Now that my children are grown, I work from 8:30 AM to 6:00 PM. I often do television appearances and women come to Swati after seeing those broadcasts. By now I am completely satisfied: I love to see my staff smiling as they take initiative. Swati is like a launching pad, a platform. People come here, get training, get confidence, then move further and help others behind them. This is not the end of the story. If one woman can help five women, that is my aim in life. It will spread like that."

At dinner, Sangita's husband, Subash, compares her to a pebble that creates ripples in a pond. Sangita's optimism, energy, and competence radiate through her family as well as her organization. There are posters on the doors of her children's bedrooms: "Smile! It costs nothing!" Her nineteen-year-old daughter was just elected first woman president of the student council at her college. Even the woman

who works at Sangita's house plays an unexpected role; Sangita calls her "the house manager."

Sangita is considering her next career. "Perhaps it will be politics. Qualified people are not in politics in this country. The University of San Diego's Institute of Peace and Justice gave a workshop here called "Women, Politics, and Peace." I was inspired. If I can get a scholarship, I would like to work on a master's degree there." Sangita helped put her husband through graduate school at Bellevue University in Nebraska by working as a Greyhound Bus telephone service representative ("I know every berg and lane in the United States"). Sangita has even put a succession plan in place: "Gaurie is ready to run Swati while I am out of the country studying—and with the Internet, I can work for Swati no matter where I am.

"When I come back from the US, I would like to enter politics and be Nepal's minister of women and children's affairs." Sangita has already begun gathering contacts and credentials that will serve her. "Recently, I was appointed co-chair of the Federation of Woman Entrepreneurs Associations of Nepal's Forum. I was a team leader at the International Labor Organization workshop in Delhi; they said I did a great job; the trainer from Italy appreciated me and boosted my energy." Sangita envisions a future in which "I could run as an independent or join a party. Everywhere I ask women's organizations, 'What are your plans for me as an emerging leader? Use me!'" One attribute of a leader is that s/he thinks beyond "what is." Sangita envisions a better future, convinced that Nepal's current chaos will lead to democracy, peace, and opportunity.

The flight attendant offers a tray: hard candy, and cotton balls for passengers' ears. The plane flies west for half an hour past the snowy pinnacles that divide this country from China. Eight of the ten highest peaks in the world are located in Nepal, including Everest, the tallest, a towering 29,035 feet. I am en route to Annapurna, number ten, which is 26,545 feet. In a few days, there will be a graduation ceremony there. Women trekking guides trained by Empowering the Women of Nepal will receive their diplomas. Women trekking guides? The idea is as iconoclastic as women taxi drivers!

LUCKY CHHETRI

Lucky Chhetri

Lucky Chhetri, 39, founder of Empowering the Women of Nepal, wears a buttercup-colored cotton *salwar kameez* (dress over long pants) and escorts me from the airport to the Fish Tail Lodge in Pokhara. The approach is idyllic: the raft man pulls slowly on a rope to transport us across a quiet river. Stone steps lead to a garden blooming with roses. I am one of two Americans staying here, although the resort is full thanks to a Chinese tour. Above Phewa Lake, snowy peaks seem painted on the clear blue sky.

Twenty-seven trekking guide trainees sit at desks in Empowering the Women of Nepal's classroom. There are poor farm girls, mountain women, orphans, a widow with a child. For a month, the group has alternated between trail experiences and studying English, health, hygiene, first aid, emergency procedures, cultural awareness, environmental responsibility, history, and geography. Now they are learning about leadership. A woman trainer projects statistics and challenges the women with provocative questions.

Lucky's sister, Nicky, 35, observes the class. She and a third sister, Dicky, 37, run 3 Sisters Adventure Trekking, which may hire some of these trainees after graduation. Income from the for-profit trekking company funds the non-profit Empowering the Women of Nepal.

While the trainees write an essay, Lucky and I have tea in her office. To my astonishment, Lucky

admits that she grew up as "a delicate child." She fainted easily, so was kept inside, often in bed. She did not trek until she was 24, when she and her sisters decided to try, starting with an exhausting five-day trek. "We didn't know what we were doing. Same in 1993 when we started our hotel: people asked for eggplant but we served scrambled eggs," she laughs.

In 1994, the sisters started training women as trekking guides, violating the tradition that only men could be guides. "Everyone was against us. They said, 'You are destroying the girls, taking them the wrong direction.' Some thought our business was training girl guides for sexual tourism. (One company thought that was a good idea and actually tried it, but failed). Some people thought it would ruin their reputations if they talked to us. We had not expected these reactions. We felt weak. We wondered if we should change professions.

"No matter how smart women are, many are not confident. We need to tell each other, 'We can do!'" Lucky has proved she can do; despite her tentative start, she graduated from the Himalayan Mountaineering Training Institute in Darjeeling, India and has climbed in the Peruvian Andes as well as the Himalayas. Since 1999, Empowering the Women of Nepal has trained 400 women trekking guides.

After tea, we visit the trainee hostel. Further along the road is the Chhetri Sisters' Guest House with its balcony restaurant and immaculate rooms. The sisters grow organic vegetables in their garden to serve dinner guests. Paragliding Chinese tourists land in the field between the road and the lake as the sun sets. "Be ready at 6 AM," Lucky urges as she drops me at the Fish Tail Lodge.

The raftsman pulls me through the morning mist. I hitch up my backpack, which is full of camera lenses and recording equipment, and walk toward the main road to meet the bus. The trainees are in high spirits, singing, taking snapshots, teasing, and laughing. The gaiety on board contrasts with the foggy scene outside where soldiers patrol. An officer flags us down at a checkpoint and a soldier climbs aboard. He

frowns his way through the driver's documents, then turns to inspect the passengers. Lucky and I are sitting in the front seats, and I wonder whether a foreigner's presence persuades the king's man that no Maoists could be on board. Foreigners are sacrosanct. Tourists are crucial to Nepal's economy—not to mention to Lucky's trekking guides (and Sangita's taxi drivers) whose new careers depend on them.

At the Nayapul trail head, I get a nice surprise. Lucky has arranged for nineteen-year-old Gayatri Sharma to be my interpreter and for Indra Rai to carry my gear (as a senior guide, he is considerably overqualified for this task). Lucky herself will be my guide. The 3 Sisters website defines "guide" as "friend, guardian, teacher, student, advisor, attendant, and sometimes mother," and I am about to experience Lucky in all those roles. While we four reconnoiter, the trainees, most of whom grew up in Himalayan villages, depart with gusto. "I'm here to photograph them, but I don't think I can match their pace," I confess to Lucky. "They will take a break later and wait for us. We are your team and we will go at your pace. This is your trip. Just relax and enjoy it."

The Annapurna range includes five peaks. We set forth below Annapurna South. The trail winds through villages where women in long skirts sweep their porches with whisks. A man sits near a stream giving himself a pedicure with pumice rock. Women wash laundry at a village water spigot. Others separate wheat from chaff. Giggling girls and boys wearing school uniforms scamper down the rock steps as they do every morning. Women with firewood on their backs clamor up the steps, babies slung on their hips. There are no roads and no transportation. This trail is the thoroughfare.

Lucky tells me about her organizations as we climb. "3 Sisters Adventure Trekking conducts about 40 trips a year, ranging in length from a week to a month. Ninety-eight percent of our customers are women from the United States, Britain, and Australia, who learn about us from our customers or from the media (CNN and BBC have done documentaries). We charge $20 a day. Ten dollars goes to the guide, and the rest pays for Empowering the Women of Nepal's two, one-month-

long trainings each year. We have many specialist instructors and provide hostel accommodations for the trainee's first six months, which lets the girls from the villages get started. After that, they earn wages from the trekking company, so they have some money to start their new lives. They may repeat that cycle (training, then working) for four or five years if they want to become a professional guide. Married women cannot be gone for days, so we also offer local tour guide training and other options."

We enter woods full of wild jasmine, orchids, and rhododendrons. Spanish moss drips from the high trees. Indra describes his country: "Small people, big trees!" Thinking about the impressive Chhetri sisters, I laugh: "People may look short, but they are big!"

Lucky tells me about her family. "My parents were Nepalese but lived in Darjeeling, India. Our family had four brothers and three sisters. My father was an inspiring man, supportive of women, always saying, 'Go to school, go to college.' Just before he passed away in 1992, he asked his daughters to keep the family together. That was unusual. It's typically the sons who are asked to do that. Now, one brother works for us full time, another helps in the high season. The others visit. Our mother and nieces are also supporting us."

"Empowering the Women of Nepal. What does that mean?" I ask. "We three sisters are role models for the women. We are both doing business and running a nongovernmental organization. They want to be like us. We share the story of how we started. But the main

Nicky Chhetri

135

thing we teach them is that they should protect themselves by learning skills. That is our main weapon. Women without skills are dependent on men."

The views of the valleys become deeper, grander. Ultimately, it occurs to me that without steps cut into the granite, this mountain would be too steep to climb. We stop whenever I want to take pictures, admire the surroundings, or catch my breath, but by the time we get to a grassy, flat clearing called Australian Camp, I am as bushed as if I had been on a Stairmaster for three hours. Hoping to recover, I lie down—still doggedly taking pictures from an angle so low that the viewfinder only sees underneath the trainees' chins. I am so tired that I actually think this perspective is interesting.

The trainees, who arrived at Australian Camp two hours ago, have organized into three groups, each led by a senior guide trained by Empowering the Women of Nepal, and each charged with presenting a final report before graduation tonight. The Mountain Group gives an interim report now, identifying mountains by name and height as they point to the snowy peaks in the distance. A senior guide purifies mountain water with iodine and fills her canteen. The assistant guides pour hot tea into everyone's cups and distributes trail mix. I stand up, ready for what comes next.

What comes next is unremittingly steep. I count steps to confirm my progress. Lucky encourages me, "You are doing well! You know just when to rest. There is no hurry!" Gayatri grabs my hand when a flat stone comes loose unexpectedly and I wobble off the trail.

When we see a tea house in the village of Pothana, Lucky suggests we stop for a snack. I sit gladly at a picnic table in the sunshine. She goes inside to order a bowl of noodles, then dials someone on her cell phone and converses in Nepali. "Originally," she says to me, dipping into her soup, "we thought we would have graduation here but we have decided to go on to Deurali." (Later, I learn that Maoists were sighted in the woods near Pothana. Without alarming anyone, Lucky has organized Plan B and is guiding us to safety.) The trainees leave quickly but I dawdle and hope Deurali is not too far.

Two more hours on the Stairmaster. I allow myself to stop after every 50 steps—and after every five stops, I sit gasping in the pine needles next to the trail, wondering what on earth I am doing here: in three years, I will be 70 years old! Going back is not an option. I am just tired, which is not terminal. I plunge on.

"If your dreams come true, what will Empowering the Women of Nepal be like in the future?" I huff and puff. "We have two dreams. We hope to develop communities through tourism and are already working in western Nepal, doing Women in Eco-Tourism trainings. During our needs survey, we learned that women's health was a big problem (women are dying during childbirth; children are dying from

malnutrition) so we have a health instructor there, too. Our second dream is to start an Adventure Tourism Training Institute for Women, a postgraduate course for alumnae of the Trekking Guide Trainings. They want more advanced training so we hope to offer professional-level rock and peak climbing."

The ground levels out as we enter Deurali, a wide spot in the trail where there are two guesthouses. Colored banners fly in the wind. A menu board advertises Yak cheese. Gayatri, Lucky and I unroll our sleeping bags on the cots in a simple, clean room conveniently located across from the building with the women's squatty potty. On the flagstone terrace, the restaurant staff is setting out a delicious meal: vegetables with lentil sauce served on rice. We eat at picnic tables in the afternoon sun. While the trainees compile notes for the presentations they will give in a few hours, I chat with two of 3 Sisters' senior guides.

BISHNU THAPA

Bishnu, 24, has a master's degree in sociology and has traveled to Malaysia, Singapore, and Thailand. When a Peace Corps volunteer introduced her to the Chhetris, she didn't even know what trekking was. The first time she tried it, "It was difficult and I was stiff." But that was five years ago. She worked as a porter for two years, then Empowering the Women of Nepal trained her as a guide. After taking Nepal's government training, Bishnu qualified for a professional license. Her customers enjoy the same things she loves: "Mountains, rivers, culture, tradition, friendly people, and good hospitality." Bishnu's enthusiasm convinced her younger sister to become a guide and she is here today, about to graduate. Bishnu is a devoted environmentalist: "Over the past year,

I picked up 660 pounds of trash on the trails and carried it out." The Thapa family includes seven girls; maybe one day 3 Sisters will spawn 7 Sisters!

SITA MAYA RAI

Sita, 33, was born in eastern Nepal, near Everest. Indra was also born there and he introduced her to 3 Sisters. Sita admits to being strong-willed: "Fifteen years ago, my parents didn't want me to go to school. But I worked in a factory in Kathmandu, saved money, and did it anyway." People in her village disapproved of her career choice but "it didn't matter." She has been a guide four years, and has just completed a six-day rock climbing course. "You should see 360 degrees of mountains!" she exclaims. Glad to be breaking new ground for women, she is annoyed when male guides are disparaging. "When they say 'women can't do this work,' I say, 'Not true. We *are* doing it.'" I think to myself that growing up near

Everest has inspired Sita to climb high both literally and figuratively.

GRADUATION

A building perches on stilts near the edge of the cliff, its windows overlooking the deep valley, its wood stove glowing in the cold night. Inside, 27 trainees trade hugs and home addresses. For some, this is the end of one course; for others it is the end of a series. Some may become trekking guides; others may simply have learned enough to have more productive, happier lives. Whatever their futures, this is their final evening together.

It's time for the team presentations: what did the trainees learn today? Lucky has told me that Nepalese students do not wonder "why" or share. They are about to do both.

Sita's Mountain Group presents first. Their spokeswoman describes the Annapurna massif, giving a richer, more detailed picture of the material she previewed at Australian Camp. (I reflect on Lucky's description: "When the women first arrive, I ask their names. Some burst into tears because they are so shy." How far they have come; this woman is articulate and authoritative.)

Next, the Flora and Fauna Group presents a long list of flowers and animals seen in this area. Nepal is one of the most biodiverse countries in the world, and their report is a tour de force of observation and recording. (I remember Lucky's report that "When, after graduation, Empowering the Women of Nepal guides apprentice with male guides, the men admit enviously that the women know more than they do—even though our trainees arrive here not even able to say the English word for marigold.")

Finally, Bishnu's Environment Group talks about social, cultural, and ecological environments. Not only did they collect bagfuls of trail trash (which they delivered to guesthouses to burn), they interviewed villagers. They hypothesized that Hindus live on the flat, Buddhists at high altitudes, and a mix lives in the middle. So on the way up, they researched how many people of each belief lived in the communities. Their information is completely new. The presenter is engaging.

Lucky calls for a vote on which presentation is best (a task that requires both honesty and the ability to set competition aside). The Environment Group wins easily. I can almost hear the learning happen: that is the way everyone wants to present, starting now.

Earlier, Lucky invited me to cosign the graduation certificates. She was confident enough that I would make it up the mountain that she printed my name next to hers on the diplomas: "Paola Gianturco, Chief Guest." Now, she calls each trainee's name, and I deliver the diplomas amid congratulations, applause, and cheers.

The formal ceremonies over, it's time for a game. Lucky produces twelve one-inch cubes, asks each woman to predict how many she can stack, then do it. The youngest trainee, Sajalta Basnet, fifteen, volunteers to go first. "I will stack twelve," she vows, but her hands are trembling and her stack tumbles. "Why did you say you could do twelve?" Lucky presses her. Sajalta says, "We should always try for the top." After everyone else has tried, Sajalta asks for a second turn. She is calmer now, and moves carefully until all twelve blocks stand in a tower. The women whoop and break into applause.

Looking around, they realize that Gayatri and I have not participated: "You have to play, too!" "I have already had one triumph today," I say. "This was the first time I ever trekked, and I got here! So I am not going to make a prediction about this task. I will just do as well as I can." I am surprised to see each cube support the next until there is a stack of twelve. But I know that I have not completely succeeded. Unlike the young trainees, I have not yet learned to bet on myself.

The graduates thank Lucky, their speeches full of feeling. "You have changed my life forever." "I feel I have been let out of prison; for the first time, I have the freedom to live how I choose."

After I go to bed, they sing and dance for hours. I snuggle into my sleeping bag marveling at their beautiful songs, thinking, "What a great way to welcome Saraswati Puja, the festival that honors the Hindu goddess of music and learning."

The next morning, the women seem amazingly fresh, energetic, and ready to trek back. We have only climbed to 7,000 feet, but I have never done anything remotely as athletic and am giddy with accomplishment. Lucky nods, understanding how I feel. "Once when a trainee's father thanked me, he said, 'We gave her birth. You gave her life.'" I smile. That father was exactly right. I am stiff, exhausted—and fully alive.

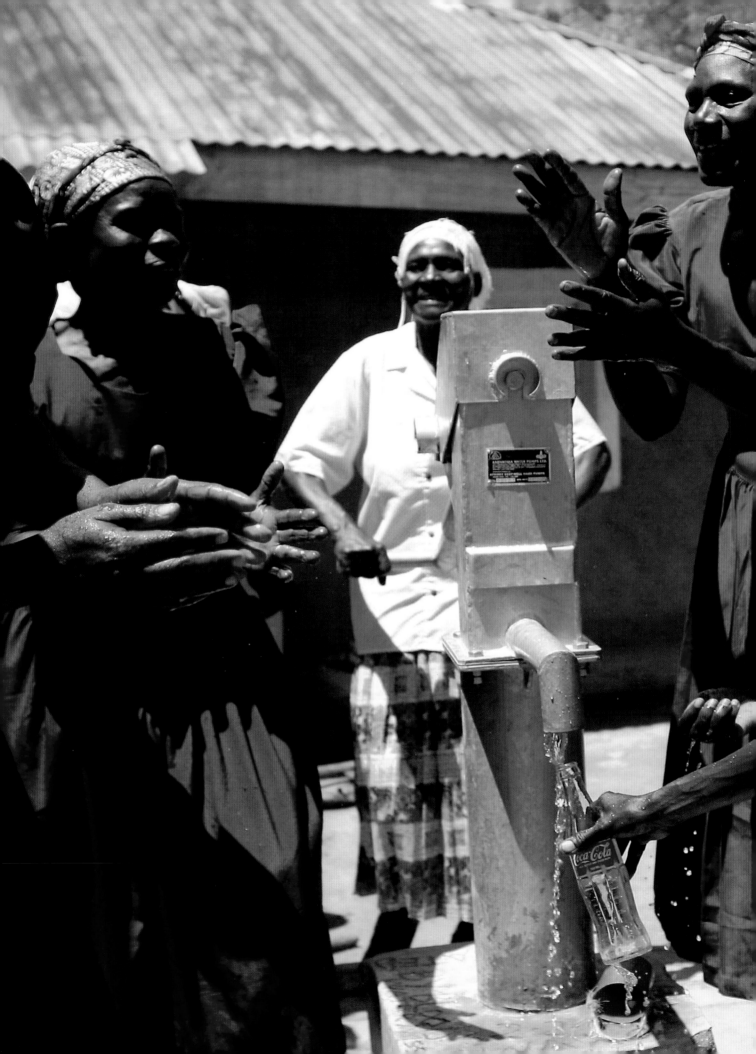

KENYA
ACCESSING WATER

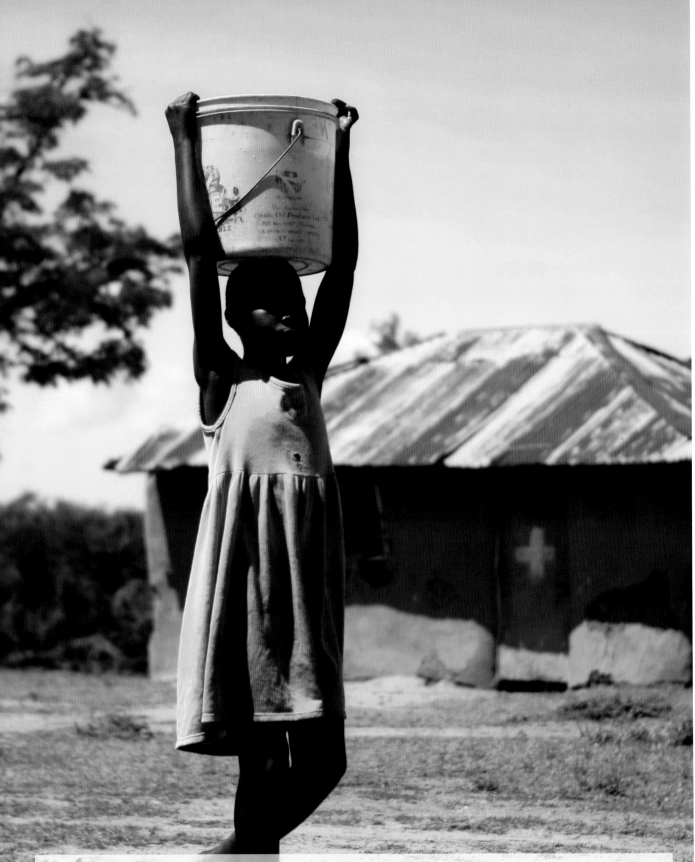

Lake Victoria, the second largest freshwater lake in the world, stretches its fingers toward Kisumu, Kenya. Its brown surface is striated with chrome green and its shore grasses are thick with snails that host the parasite bilharzia. Cities along the shore dump raw sewage into the water. Women fetch water at the edge of the lake each day. "People die at that lake," one woman tells me. "Even *dogs* die at that lake."

Norma Adhiambo

Norma Adhiambo's family used to get water from that lake. Until she was seven, Norma was left alone in the house every morning while her mother and the other children fetched water. When she was old enough, she too, awoke at 5:30 AM and left without breakfast.

The family followed the path through dark villages, fields, forests, stepping carefully to avoid snakes, whispering so the hippos wouldn't hear them and the night runners (people in trances who wander) wouldn't chase them.

They walked three hours, finally reaching the lake where they filled their jugs, then balanced them on their heads. Sometimes the water spilled, and Norma's mother punished her so it wouldn't happen again. The walk back took an hour longer since they had to be careful not to slosh. The water was heavy (a five-gallon jug weighs 40 pounds); Norma's neck and back hurt.

It was early afternoon when they arrived home, too late for school. But the family was making a necessary trade-off: school or starvation. Cooking soup, rice, and vegetables all required water. Her mother boiled water to remove the feathers from a chicken, and mixed water with cornmeal to make *kuon*, the staple bread. Before her mother learned to boil water and let the sediment settle, Norma's family was sick a lot. Nobody knew why.

Today, Norma heads a nonprofit organization of 43 local women's groups that have helped their communities get 73 wells drilled and 13 wells improved. GWAKO (Groups of Women in Water and Agriculture, Kochieng, the village where their work began) was the brainchild of Norma, then a 21-year-old college student, and two friends, Gideon Ojuna and Benjamin Oyoo, whom Norma had recently married.

"Women were suffering," Norma remembers. "There was a water shortage. People were using contaminated river water or water they collected by the roadside. There were all sorts of diseases. We felt so much concern! We decided to do something about it." The trio founded GWAKO in 1998.

Now 27, Norma Adhiambo leads GWAKO quietly, with dignity. In meetings she speaks softly, offering information and insight. The women adore their young leader. After a meeting on Good Friday, grateful GWAKO club members present her with an Easter gift: a chicken, which is a prized possession in this poor rural area. The bird squawks, its copper and brown feathers flying, its wings flapping, seemingly annoyed at being passed off to a stranger. I wonder whether Norma will accept this gift, given that our car is full, she is wearing her church clothes, and avian flu is rumored to exist in Kenya. She climbs in and holds the chicken on her lap, one hand securing its feet, the other stroking its feathers again and again. The bird, transported, doesn't move for the rest of the ride. I believe that I have just seen the secret of Norma's leadership: her peaceful, loving presence soothes, encourages cooperation, solves problems and gets everyone moving in the same direction.

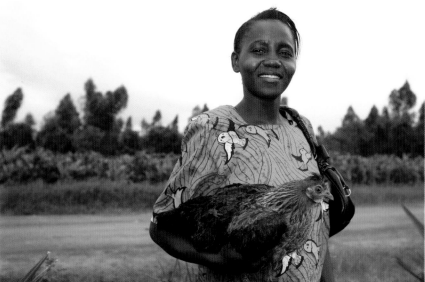

GIDEON OJUNA AND BENJAMIN OYOO

"In August," Gideon explains, "people plant corn and beans. We live on the plains and expect a high yield. Unfortunately rains flooded our lands, and the only thing the women could do was dig channels with their own hands to keep the plants from washing away. The people suffering were the women, doing the donkey work.

"Norma, Benjamin, and I were young and on Mondays and Wednesdays, we dug trenches ourselves. If others came to dig, we made them porridge and sweet potatoes with money from our own pockets; we three did the cooking in rotation. When the floods came, the water found its way out, and people went back to their farming. But we knew this was not a long-term solution."

The trio began doing a needs assessment in the villages near Kisumu. Benjamin had studied Water and Sanitation at the Ramapo College in New Jersey, and taught the other two how to conduct the research. The results did not surprise Norma, Gideon, and Benjamin, but they might surprise people who live where it's easy to turn on the faucet and get fluorinated tap water that prevents tooth decay.

Imagine that you are twelve. Your mother has scrimped to buy a school uniform that makes you proud and hides your poverty. Without notice, your period comes. Your skirt is stained. When you stand to recite in class, you learn how your own blood smells. The boys jeer at you. You are humiliated. There is no privacy, even in the toilet, a pit latrine at the edge of the schoolyard that has walls of cloth that blow in the wind. It smells terrible and you dread going there. It has no water to wash your skirt. It has no water to wash your body. After a month or two, you stop going to school.

Imagine that you are 36. Your husband has AIDS. His immune system could not fight the bacteria in the water he drank daily. Now he is very sick, too weak to be carried sideways on the bar of a bicycle. You and your neighbors take turns carrying him toward the main road on a mattress. Once there, the bus will not take him because he is ill. Since you cannot afford a taxi, you all continue to carry him, hoping you can make it five miles to the community clinic. He does not survive the journey.

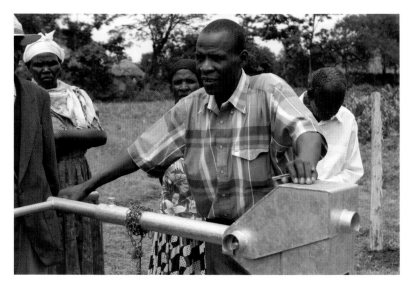

Imagine that you are 80. You've raised many children, maybe nine. They are grown and married with children of their own. Within a few years, all nine are dead and one by one, their spouses die. After the funerals, their children run to your house. The girls come with you to do women's work, fetching water. Mourning and morning merge. When you return, it is too late for you to do your agricultural work. But maybe it doesn't matter. There is not enough water for the cows anyway; there is no water to soften the sisal and make rope to lead the goats; there is not enough water to keep the cotton plants alive. Down the road, your neighbors' rice paddies are dry, the earth is cracking. But you do have a little water. You guard it. You don't know that there are germs in it that can kill you and your grandchildren.

Water is not just a problem in Kisumu. More than half of Kenya's population suffers from waterborne diseases. Just one million out of Kenya's 35 million people have access to clean drinking water. In 2005, the minister of water and irrigation told Parliament that it would cost $900 million that Kenya does not have to meet the United Nations' Millennium Development Goal for 2015 and provide each citizen with 5 gallons of clean water a day. (For reference: average individual consumption in the United States is 105 gallons a day).

Women and children make up most of the population of the Kisumu and Nyando districts of Nyanza Province, where I am visiting. (Many men have gone to Nairobi to find work, or have died of AIDS.) But GWAKO did not become a women's project

because there were more women in the area—or because water is women's work—or because Norma resonated with women's water problems.

Gideon explains the founders' rationale: "Women reach decisions quickly because they move to their husbands' villages when they are married. Men, who have fathers and grandfathers in the village, learn to follow rules and traditions. They can not accept change as quickly. If you work with women, you can achieve many goals."

While studying in the United States, Benjamin saw how much women can do. He says, "Our drillers are men; we love them because they are making a big contribution. But we are looking at having two paid lady drillers." He smiles, "At least that is the recommendation of my office."

Every day, Norma leaves her three-year-old daughter with her mother-in-law and joins GWAKO group meetings, accompanied by Leocadia Olima, a volunteer nurse; Elizabeth Obiero, a volunteer hygiene trainer; Gabriel Obuon, a driller; and Gideon. They discuss the women's needs, progress and goals; inspect and maintain the water pumps; and present seminars. For one week, I go with them.

In April, the wet season, the idea of water shortages seems impossible. A violent rainstorm has just caused six members of Parliament to die in a small plane crash. The country is in shock. The bodies are being buried, Muslims first (Mohamed said the dead must be buried quickly).

The fertile earth is saturated with rain. Our four-wheel-drive car slogs through dirt roads, grinding, growling, protesting. Mud sucks voraciously at the wheels, which spin and spit. I look out the window at the slick leaves and ruminate. No wonder the name of Kenya's capital, Nairobi, means "cold water" to the Maasai. Who said, "Water, water everywhere, and not a drop to drink?" Is it true that 70 percent of the human body is water? That only 3 percent of the water on earth is fresh? I ponder; the rain pours.

When the sky clears, the day is hot. Naked children splash in the ditches by the road where drivers park trucks and bicycles, rinsing off mud; women scoop the water with their hands and drink thirstily.

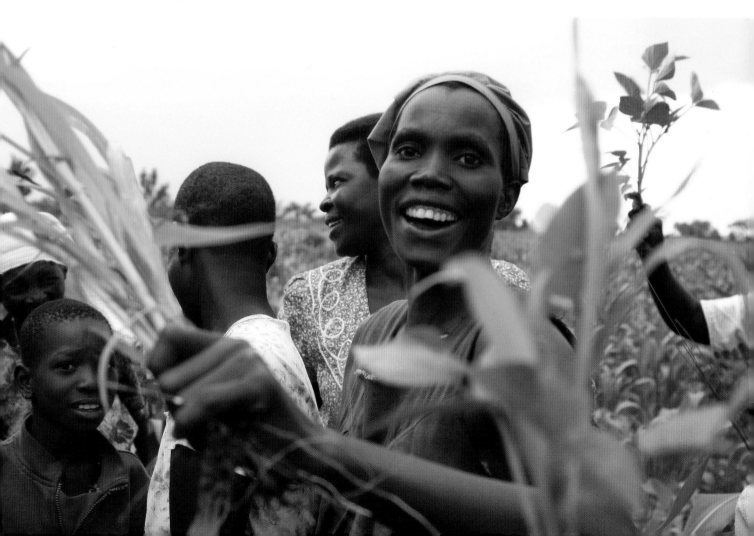

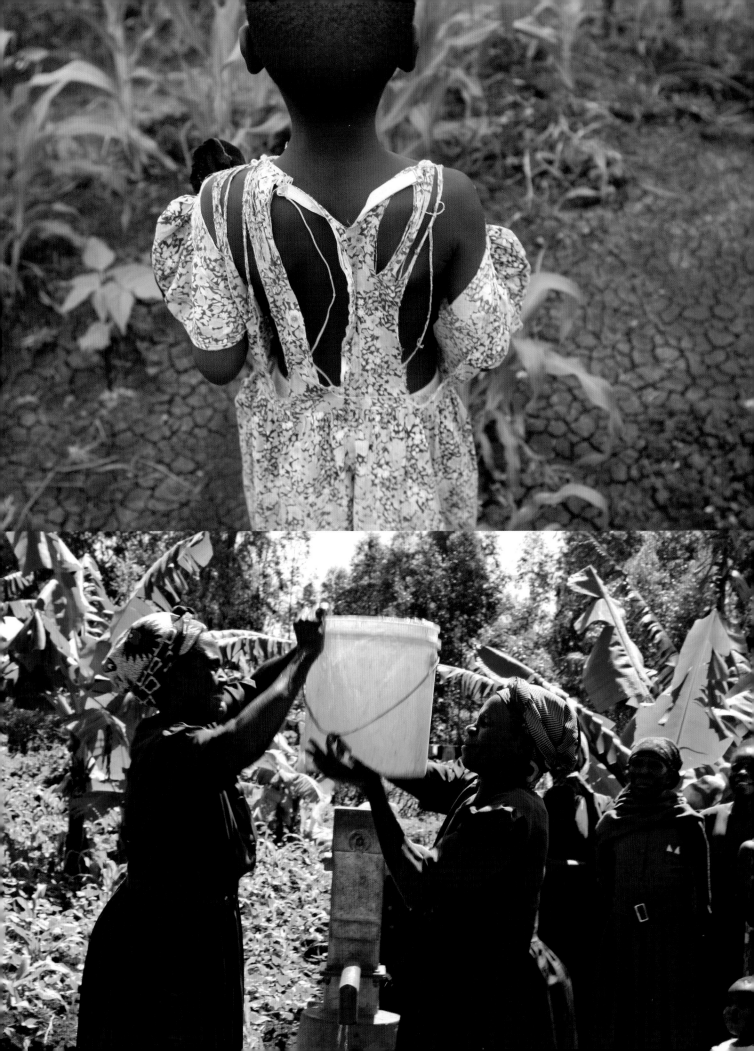

MANYINE

The Manyine GWAKO meeting takes place in a thatched-roof hut where the walls have been covered with lace. Green antimacassars protect the red plush chairs. The women serve tea and *kuon*, both made with pure water pumped from the well GWAKO drilled last year.

All the club members lived in another village, Waneaya, before they married men from Manyine. The chairwoman, 49, came here as a bride in 1975. She brought the other women, one by one, to marry her husband's relatives.

Their well has altered how the women spend their time. Since they no longer walk three hours to fetch water, they have become entrepreneurs. One grows and sells vegetables; another, rice. The third is a butcher; a fourth makes clay pots for sale. Another sells chickens. Two are involved with textiles: one making sisal rope, another sewing school uniforms. Now they have the time (and water) to clean their houses. Their daughters are in school. Their families are healthy.

They insist on being photographed wearing their navy blue GWAKO club uniforms, standing near the pump that changed their lives.

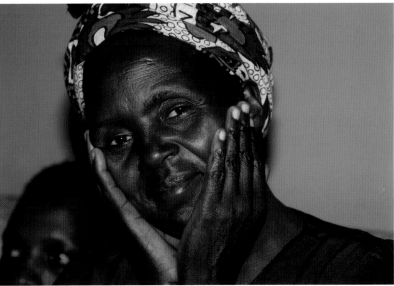

RANJIRA

Dick Awuonda is headmaster at Ranjira Primary School whose 50-year-old building has been condemned. One Sunday morning a classroom roof collapsed. The mud walls and blackboards look as if there has been an earthquake.

Preschoolers and students in grades one through eight still attend classes in the other rooms while Awuonda tries to figure out what to do. Nine families have contributed a total of US $3 to rebuild the facility. (Elementary education is free in Kenya, but parents must pay for the school building, toilets, classroom, and office furniture.)

Awounda reviews the options: "Our teachers are ready to hold classes under the trees and we have large blackboards that we can move outside. But it rains every morning from February to May so that is not a solution..."

Of the school's 400 students, 198 are AIDS orphans, so expecting parents to provide funding is not realistic. Even in two-parent families, necessities such as school shoes are unaffordable; 90 percent of the students attend school barefooted. Uniforms cost $10. "We take children without shoes if they can just get uniforms," Awounda admits.

When GWAKO built a water point (well and pump) at the school, some aspects of life changed immediately. Girls now come to school at 7 AM instead of hunting for water in the mornings. They carry water home from school in the afternoon.

The girls' health club, sponsored by GWAKO, is holding an after-school meeting. Teenaged members are discussing how to avoid the infections they get from using alternatives to sanitary napkins, which cost an unaffordable $1 each. They use socks, old blankets, old clothing, mattress stuffing, handkerchiefs, leaves, and newspapers. GWAKO has just received a grant from the Global Fund for Women that will solve this problem.

NYANGANDE

At Nyangande Primary School, Leocadia slits open a shipping carton and health club members surge forward to get their monthly allotment of sixteen sanitary pads each. Spontaneously they burst into song and dance to the rhythm of their own voices, waving their packages of sanitary napkins in the air. "Hallelujah, the Lord is my shepherd. The Lord is good forevermore!" Their strong voices soar joyfully.

When I was a teenager, I tried to hide my box of Modess under the groceries in the supermarket basket, considering periods a private issue, so at first this jubilant scene seems surreal to me. Then I remember reading that women in the UK have just donated 30 tons of sanitary pads to the women in Zimbabwe; I remember the Ranjira girls' stories about substituting leaves. And I feel like dancing, too.

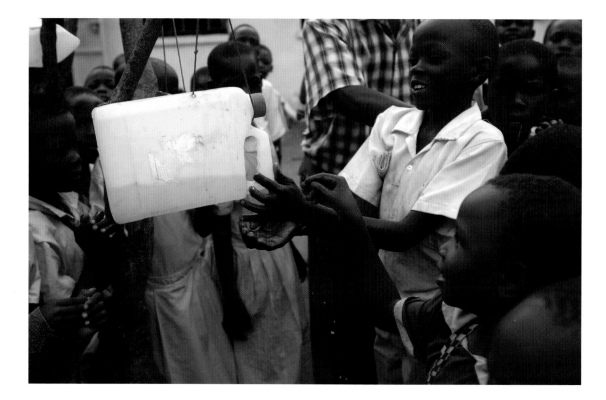

KOBURA

The shiny pump of GWAKO's water point in the Kobura schoolyard is less than a year old. Young boys catch the water in their hands and drink it straight, it is so pure.

They also carry it to their fathers, who are mixing cement and pouring the foundation for three new classrooms. I watch the men push the wheelbarrows. Never has simple labor seemed so symbolic. If only the Ranjira School, with its crumbling walls, had a deeper well! But GWAKO's drill, which is secondhand, cannot cut through rock. An accident of location means that Ranjira's well is far shallower than Kobura's.

Kobura's health club members are responsible for the Tippy Tap, a plastic jug of water that hangs

from a tree in the schoolyard. Children tilt the jug to wash their hands with soap, destroying so many bacteria that infectious diseases here have decreased dramatically.

I ask how life has changed since the school got water, and the children's tell me about another advantage: "Now we can clean the latrines!" (Dick Awounda had told me, "If you were barefooted, you would definitely avoid Ranjira's latrines!") Armed with antiseptic, gloves, and water, Kobura's health club members perform janitorial duty; their latrines are now places kids will actually visit.

PACOP

Our next stop is Pacop, where villagers follow the path to the edge of a cornfield, and gather around their brand new pump. A local man, James Onunga, and his friend in the United States donated half the money for this well. Villagers carried water from the river to mix the cement. GWAKO drillers completed the work in three weeks. This morning, the well will be inaugurated.

A minister from the Africa Inland Church officiates. A church elder reads from the Bible, Kings II, 2:19-22, telling how God "healed the water" by adding salt so it no longer made people sick. "We hope that this water, too, will not make us sick," the people pray. They sing hymns and dance, circling the precious new pump.

While the first woman approaches to fill her yellow jerican, the man who donated the land for the well serves us sodas and chapatti. The boney cow in his yard looks on; even her life is about to take a turn for the better.

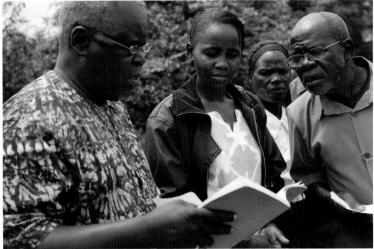

KODEYO

The women of Kodeyo asked GWAKO for a well three months ago. They hope to hear about the status of their application today.

Twenty-six women sit under a tree weaving baskets and telling stories about living without water. Their chairwoman recently lost five cows. "We had been selling their milk to help pay for school fees, but during the drought, they were just eating soil. When they died, they were not even good for meat. We just buried them."

"Our toilets fall down when it floods. That contaminates the water supply and everyone gets sick."

"Last year, we lost our tomatoes. We all sell tomatoes to earn school expenses." An average family with five children could spend half its annual income on required school gear: shoes, socks, sweater, necktie, shirt, skirt or pants, and exam books.

The conversation turns to family finances. "What else is a big-budget item?" I ask. "Firewood to boil water. A small bundle costs $1." (Using one bundle a day could consume a family's entire annual income). Clearly, it would be a financial advantage to have water that didn't need to be boiled.

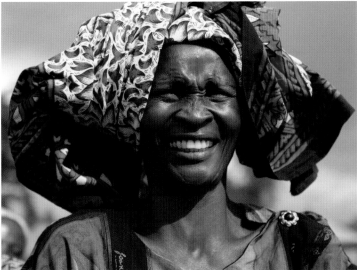

Norma has good news for these women: their well will be drilled next month. The women adjourn to the cornfield where they brandish their hoes, weeding jubilantly, singing, whistling, and shrieking. They teach me to ululate and we stand together in the field, creating a grand, noisy celebration.

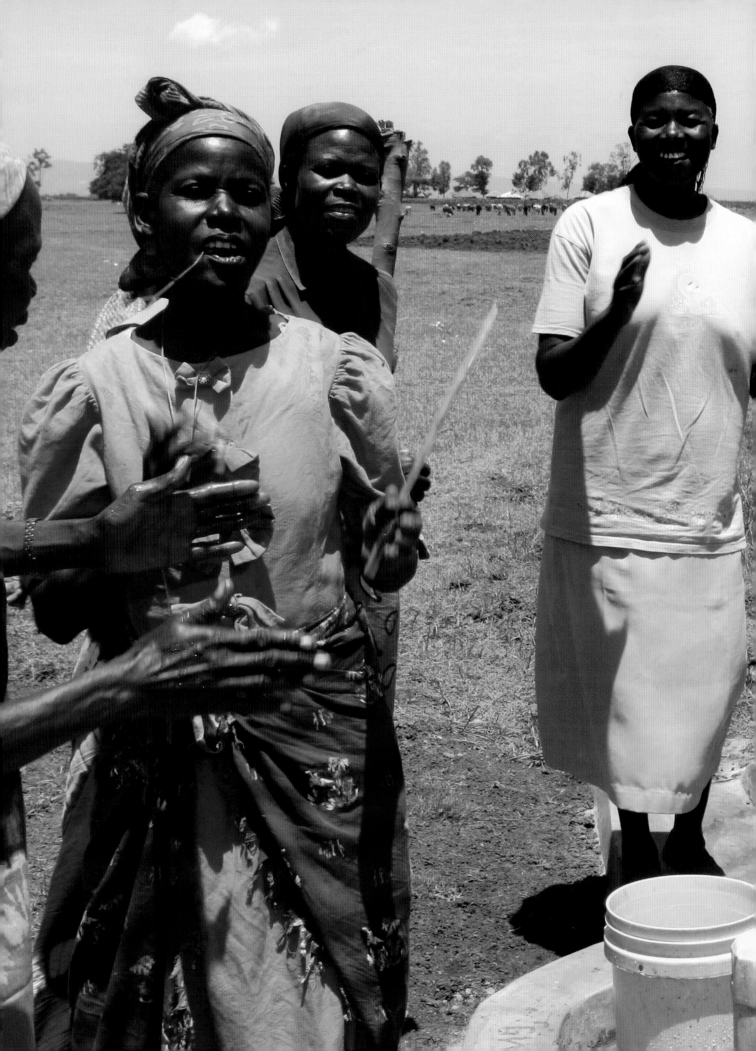

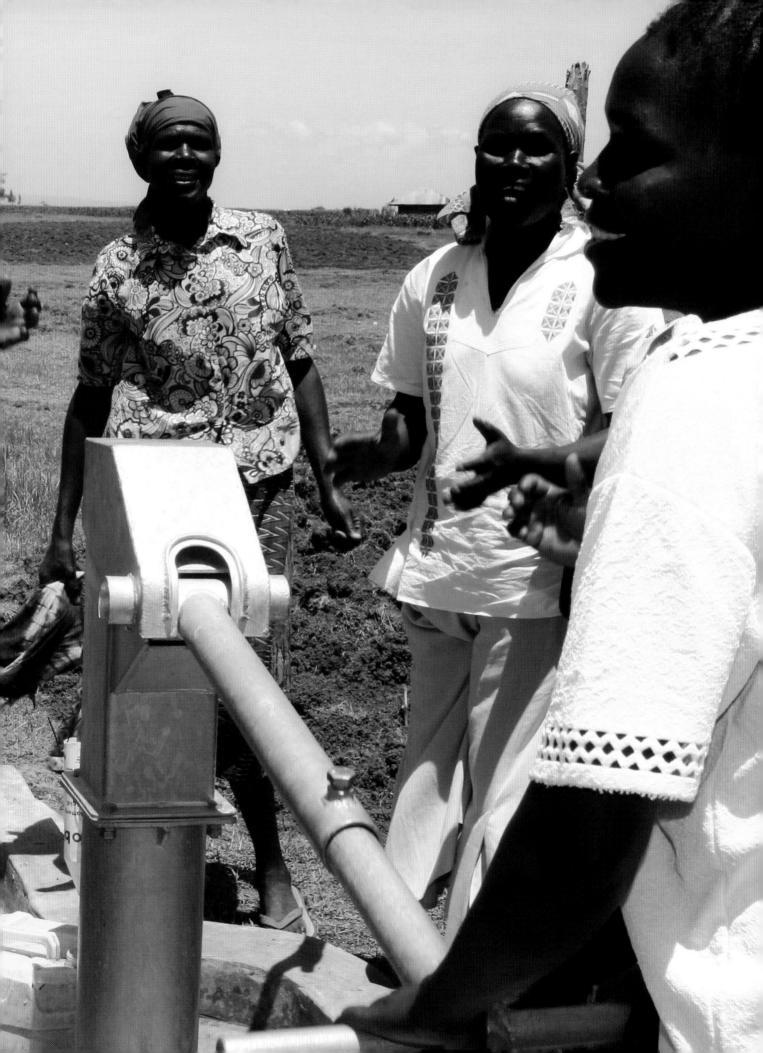

KOKWARO

When the GWAKO group meets in Kokwaro, I invite the women to introduce themselves by saying how many children they have.

"Twelve children; eight dead, four adopted."
"Nine children; six dead, six adopted."
"Eight children; all dead, nine adopted."
"Ten children; all dead, four adopted."
"Seven children; all dead, five adopted."

All these women are widows; their children have died of AIDS. To them, the word "adopted" means "grandchildren."

The UN estimates that the incidence of AIDS in Kenya has declined to 7 percent. I am shocked to hear how many orphans there are here. "So much loss! So much sadness! What do you say to console each other?" Silence. Finally a woman says, "We say God is taking care of AIDS. You see, we are still here; we can take care of the children."

Because unity gives them comfort, the group can address practical matters. Old women cannot walk miles to fetch water, much less carry it back home. They have just filed an application for GWAKO to drill a well. Their dreams of having water nearby are modest enough: they will have healthy children, clean clothes, girls in school, and gardens full of rice and tomatoes.

"Some of those widows could be HIV-positive," I observe sadly to Norma as we drive away from Kokwaro; "what a catastrophe that would be for the orphans." "The worst problem is fear of the test," Norma nods. "If people are HIV-positive, they will be judged as immoral. They could have gotten the virus through blood transfusions or unsterilized hospital equipment, but they are afraid people will think negative thoughts about them, so they eventually die." Norma is quiet, perhaps remembering taking one of her own sisters to be tested, reassuring her that if she were HIV-positive, antiretroviral drugs (which the government provides free) could help. "When we visit women's groups we teach about the disease. Sometimes we invite Mrs. Olima to counsel them."

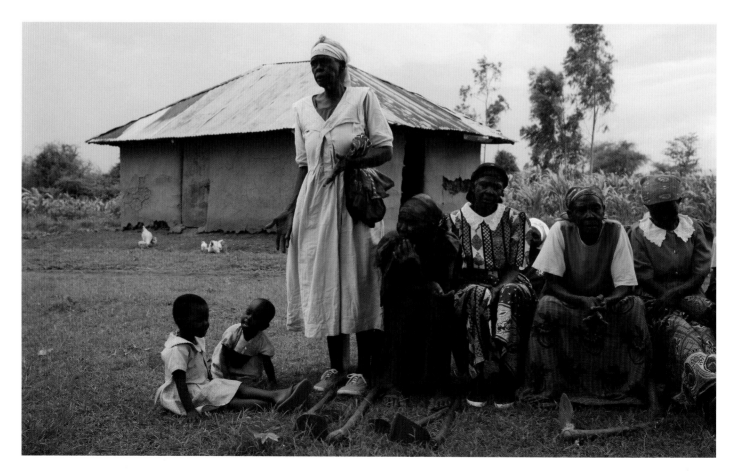

LEOCADIA OLIMA

Leocadia Olima, 55, is a community nurse employed by the Kenya Ministry of Health. A GWAKO volunteer, she has taught seminars to their women's groups for six years, easily switching from English or Kiswahili to Luo to address members in their own language. She describes concrete, simple action steps that can be done at home even by those without education.

She shows club members how to handle water: "Carry it home from the river in a clean container with a closed top. Add three or four chlorine pills (depending on the container size). Pour the water into the first bucket. The next day, pour it into a second bucket; the residue will remain. When the water reaches the fourth bucket, it can be used for cooking and drinking. By the time it has been cooked, it will be pure."

On malnutrition: "Keep hens for eggs. Grow vegetables." (Leocadia thinks nutrition is so important that she and her eight children grow enough onions, tomatoes, carrots, maize, and millet to feed 800 students at two elementary schools).

On waterborne diseases: "Go to the nearest hospital for tests. With diarrhea, which can happen at night when there is no means to get to the hospital, the patient could die. Mix salt and water, boil and cool it, then give it to the patient little by little, while looking for ways to get to the hospital where care and drugs are free." GWAKO women listen closely.

They know from experience that chronic diarrhea can prevent their children's growth and leech the energy required to attend school or work.

Leocadia is planning to retire in five months, but she will continue volunteering with GWAKO. "I am grateful and thankful that GWAKO selected me to be their volunteer. When you have knowledge and keep it within you, it does nothing. If you distribute it, it will help a great deal." When GWAKO started, "People knew they had diarrhea and vomiting, but they didn't know the cause. We added knowledge to the communities. We tell them to change, give them water, and the problem is solved. Water is life. That is all."

NYAMONGE

Gabriel Obuon (nicknamed Gabby), a GWAKO driller, is driving us to these villages and it's a brilliant performance. Our four-wheel vehicle bogs down, mud flying all directions. Gabby collects branches to put under the wheels. Village men, attracted by the screaming tires, arrive to push. The car slithers sideways, skating on the wet earth. After much muscle and effort, the vehicle leaps forward—and immediately mires down again.

Norma, Leocadia, Dorothy Oredo, a volunteer social worker, and I hurry through the cornfields to the Nyamonge women's meeting only to discover that the women prepared, waited, then returned home because we were so late. Under the shady tree chairs sit around a table covered with a lace tablecloth. The women reconvene, bringing Fanta sodas for us.

The 30 members have elected a Water Committee to oversee the group's burgeoning business. Almost 4,000 women use the GWAKO pump. The Committee sells water for 3 cents per gallon and uses the income to buy rice seeds, which GWAKO women have time to farm since they no longer have

to fetch water and haul their laundry to and from the lake.

I ask what characteristics the members considered when they were choosing Water Committee members.

"They should be loving, disciplined, hardworking."

"They should be people who understand the value of good water so they can educate customers."

"They should be good advisers: people of character, transparent, humble, and welcoming when a customer comes, so people will come back."

Weeding rice seedlings

MILLICENT SEDA

Most GWAKO groups sell water to pay for the cost of drilling, then use the income to enable members to launch micro-enterprises. But recently, GAWKO made it possible for individual women to buy wells as entrepreneurs.

Millicent Seda took advantage of this new Water with Credit scheme. Millicent is a dressmaker who teaches sewing at home; her husband works for the Kenya Ports Authority in Mombasa. Together, they saved enough to pay the $1,300 deposit on a well, and signed an agreement to pay the balance in installments.

Water has made it possible for Millicent to grow papaya and vegetables to feed her five children. Water also saved her cows' lives. "The dry season lasts between four and nine months. Before the well, I lifted one cow, almost dead, so it could drink."

Millicent earns between 15 cents and $1.50 a day selling water. Usually, her front yard is full of people carrying empty five-gallon jerricans. She tries to charge prices that are appropriate to each customer's financial circumstances. She might charge 30 cents for 5 gallons—or, if she knows people can only afford a penny, she charges a penny.

This morning, Millicent gives Norma and Gideon her first installment payment, $115; she has eleven more to go.

After the well is paid for, she hopes to use her water income to build a new home. Her dream house "would have five rooms so the girls would not have to look elsewhere for sleeping space, risking rape or murder." (Here, one does not usually share a house with grown children; after age six, children sleep in the kitchen or with a grandmother. Millicent's oldest daughter and son live in a separate house nearby).

St. Catherine's

At St. Catherine's, GWAKO's meeting includes men as well as women. One man believes, "Women think faster. So we joined them. After they formed the group and listed our needs, the whole community voted and agreed that water was the most important." GWAKO's social worker registered the group with the minister of culture and social services. The group sought financing, moved sand to the site and made concrete. The women cooked for the drillers. And now the well is operational.

Members reflect on the days before water:

"A man was trampled by a hippo while escorting the women to fetch water in the dark; his legs had to be amputated."

"Pythons and black cobras, whose venom is highly poisonous, live near the lake where we went."

"We can bathe daily now. The children used to bathe every two weeks…"

"And the men were not bathing at all. Now *that* was a big problem!" The speaker grimaces. Other women wrinkle their noses. Everyone laughs.

ATEMO UGWE

The village of Atemo Ugwe (the name means "We Are Trying") got water four months ago. There is no road to the village so Gabby drives across a field toward the water point, where the breeze blows yellow tree blossoms onto the grass. Women position the armchairs they have carried from their huts. As visitors, we are to sit in their husbands' chairs; the women, as usual, will sit on papyrus mats.

Across the plain, a woman is approaching. From afar she looks like an angel, wearing a long white dress, her new baby wrapped in a white blanket, carrying a royal purple umbrella. She is a member of the GWAKO group, but she cannot stay for the meeting. Today is Good Friday and her infant will be welcomed into her church. She has named her baby for an American woman who came here once. She thinks it is a sign from God that another American woman is visiting on this special day. I am honored by her invitation to visit her church after the GWAKO meeting.

Multitasking, the women make sisal twine during the discussion, twisting it by rolling it against their upper legs. Dry, the fiber takes the hair off their thighs, so they dip it in a cup of water first. They use the finished twine to bind papyrus reeds into mats and to tether animals. "We are selling water so we can buy goats, pigs, and sheep. We can farm, which helps us afford uniforms so our children are in school. We are very grateful."

Norma and Leocadia present health lessons once a month at every GWAKO group meeting. Here, their information has provoked new plans. "We need help with malaria, delivering babies and AIDS testing. In 2000, we managed to build a clinic," says the group's secretary. Six years later, the unused clinic, an adobe building with a blue door, looks new. "When we built it, there was no water. You need water to take pills. Doctors need water to wash their hands. So no doctors came. Now that we have water, we have recontacted them."

Impressed by the women's vision and energy, I ask how their village will be different if I return in five years. "No mud-house dispensary. A smooth road. A secondary school. More primary schools. No mud houses. Good latrines. Perhaps an orphanage." The chairwoman smiles, "When you come back, bring a doctor!"

African Israelites always parade to church, marching to percussion instruments. Just such a parade escorts the new mother and her infant into the church. Mud walls and dim light keep the sanctuary cool. All members of the congregation are dressed in white, and the mother sits in front of the minister. He prays, welcoming the baby. He speaks Luo, the language of Kenya's third-largest ethnic group, which moved here from Sudan in the fifteenth century. In a few weeks, the baby girl will be baptized. Thanks in part to her mother, there will be pure water for that sacred ceremony.

LIFEWATER COMMUNITY CHURCH

Most people in Kenya are Christian (45 percent protestant; 33 percent Catholic; 10 percent Muslim), but GWAKO's distribution of water is ecumenical. Anyone who needs water gets it. For Norma, Benjamin, and Gideon, water and spirituality are closely linked.

I attend the Good Friday ceremonies at the Lifewater Community Evangelical Church, that Gideon, Norma, Benjamin, and Samson Akomo Olweny, the minister, founded four months ago. It is built with simple corrugated metal that shines silver against the dark, threatening sky.

Here, as everywhere, I am honored as "the dear guest from America." The Good Friday service, like the GWAKO meetings, starts with songs and prayers of gratitude for my visit, and ends with the presentation of food and gifts (a basket, a mat, a carefully-printed certificate).

The drillers and their wives sit with other church members. Thunder rumbles. Huge drops splash outside as the Maasai song leader raises his voice, clapping to the music of the hymn.

Minister Samson quotes John 7:37, "If any man thirst, let him come unto me and drink." He is preaching in English to honor me; Gideon translates into Luo for the congregation. Then: the story of Jacob's Well where Jesus talked with the woman from Samaria about physical and spiritual water.

Next, the sermon: Samson bounds down the aisle filled with the passion of his words. "God did not create widows, orphans, and widowers. He created us blessed, prosperous, and beautiful in his sight. The problems we are having are not from politics or from our husbands or wives. The problem is from our hearts; that is where calamities begin. It is upon us to change, to be transformed."

Then he tells the Good Friday story. "By three o'clock, God disarmed the powers of the devil. He has triumphed! Glory! Amen! Glory! Amen!" I reflect on how much hope the Easter story of eternal life must bring in a country were so many are dying of devastating diseases.

Samson invites me to close the service with a prayer. I haven't been to church for a long time, but I stand and pray for them all. And I pray that GWAKO will, somehow, get a rig that can penetrate rock so they can start the 45 wells they can't dig now. Amen.

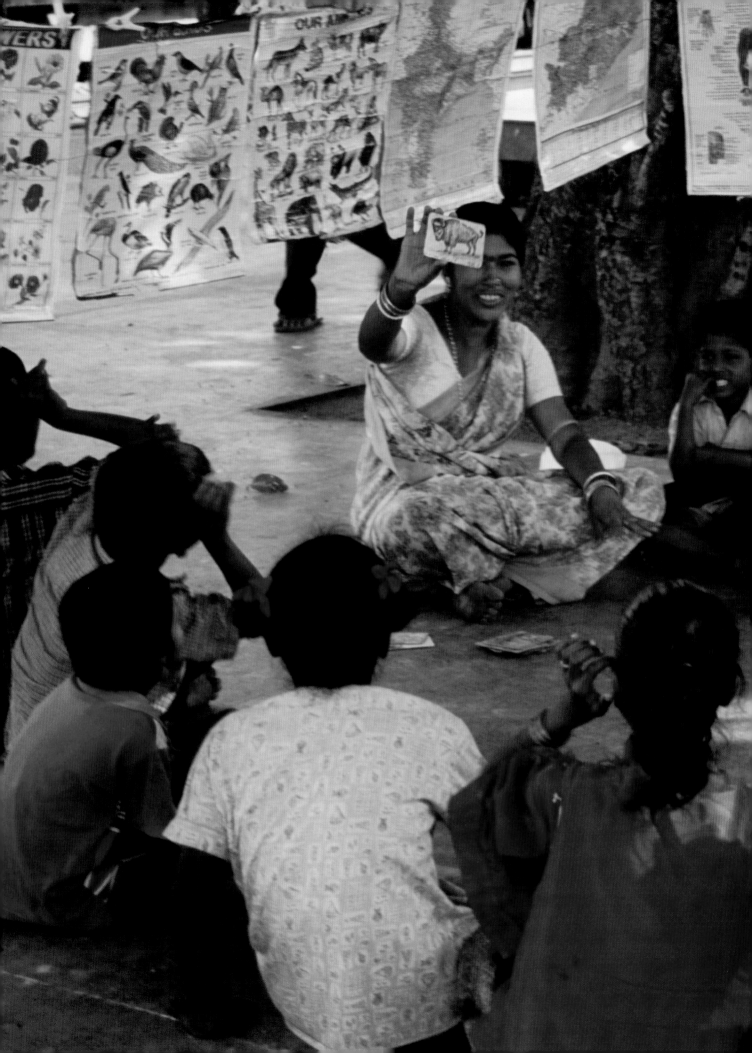

INDIA
TAKING SCHOOLS TO CHILDREN

If your visit to Orissa started near the city of Puri on the Bay of Bengal, you would see women swimming in their saris, fishermen's longboats brimming with shimmering nets, a man taking his camel for a walk on the beach. There would be more cows than cars on the road inland. You would pass miles of paddies where women harvest rice, and shady ponds where they wash their laundry. In craft villages, you would watch as women paint their prayers, and men turn pottery wheels that lie parallel to the floor. In the capital, Bhubaneswar, you could visit 500 temples. At the train station, you might notice commuters buying bananas from a cart and homeless people whose hobo sticks carry everything they own. And there, way at the end of the platform, you would see children sitting in a circle under a tree while hissing engines and screeching freight cars clatter by.

All over India, rural people take the train to the cities hoping to find jobs. Most are disappointed. Newcomers move into squatter communities around the station. They build huts with found materials like garbage bags, shards of wood, and cardboard boxes. The station roof protects them from monsoons; its public toilets and drinking fountains are indispensable. Disillusioned and lacking options, many adults become alcoholics. Some travel on to other cities, abandoning children they cannot afford to feed.

Youngsters earn money sweeping the trains, polishing shoes, selling water in secondhand bottles, hawking used newspapers, and begging. Their destinies seem assured: crime, drug addiction, prostitution, rape, alcoholism. But the risk of those outcomes has been reduced. The children have one woman to thank for their chance at a better life.

INDERJIT KHURANA

When the Khurana family first moved to Bhubaneswar, Inderjit did volunteer work with the children in Mother Teresa's home for the poor. "There was much that I picked up there: I learned to hold no taboos or inhibitions, only humility, love, and a desire to give to those who 'have not.'"

Trained in early childhood care and development, Inderjit found herself "in a new city without friends. I started a play group for my two children, my niece, and my gardener's daughter. The number of students multiplied as others learned about us by word of mouth. I was saddened by the children from the nearby slums

who stood outside the gate for the whole duration of class, unclad or half-clad, the girls carrying babies. My heart was torn between calling them in and facing the ire of elitist society. I made a commitment that whenever I had the means, I would take school to these children."

Twenty million youngsters live on the streets in India; 32 million have no access to elementary education. Inderjit discovered some of the most destitute. "At the station, I located the most unreached children: unprotected, unloved, uncared for. They were ignorant, illiterate, making their own decisions, leading an unplanned life, and finally succumbing to disease, drugs, and molestation." One day at the station, she was approached by a child beggar. "Why aren't you studying?" she challenged. "Who will teach me?" the boy asked. Inderjit promised herself that she would.

"On April 7, 1985, a colleague, Dwivedy, and I went to the train platform. Permitted by a kindhearted station master, we 'set up shop': storybooks, pencils, paper, crayons, towels, and soap. Eleven children came and a morning full of activities followed: telling stories, drawing, coloring, singing, dancing, and finally, washing up. The children used the soap, scrubbed their feet, washed their hair and delighted at being so clean.

"Our once-a-week gathering became an everyday program. By November, we had 114 children. That's when we received our first warning. 'The powers that be' told us that we were misusing government property. Although the ministries concerned with children recognized the school's good effect, the railway did not respond to their reports. Our aim, to take children away from the station of their own volition by showing them a better life, was too far-fetched for them.

"The bombshell was an article in a national daily. The railway bosses gave a 'show cause' notice to the station master and he, in turn, asked us to leave. However he responded to our pleas by moving us to Platform Number Four, which is less used, and asking us to talk to the big boss, the divisional railway manager. I was bold and deeply devoted to our work, so I did just that. I told him I thought our school was the best thing to happen on the platforms, where I had even seen women giving birth.

"After hearing my hope to restore childhood's joys and laughter, he said, 'I don't know you and you have never heard of me.' Thus, he gave us the green light. The railway's attitude has changed unimaginably. They have become cooperative, sympathetic, and willing to help. We have not looked back."

SANDYA BHATTACHARYA

One of two teachers at Bhubaneswar's Train Platform Number Four, Sandya Bhattacharya, like all TPS teachers, stores supplies in a locked trunk. Chalkboards, flash cards, and workbooks help teach The Three R's in three languages: Hindi, Oriya (Orissa's local tongue), and English. Midmorning, Sandy serves tin plates full of porridge, which the students scoop with their fingers, as people do in India. This meal may be the only nourishment the children get all day. Classes resume. Sandya holds up a flash card that pictures an elephant, and the children shout the word "elephant" in all three languages, then act out

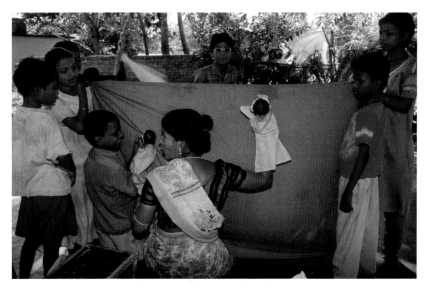

elephant behavior, using their arms as trunks and tusks. Next, she reveals a cat flashcard; the kids raise their hands to say, "Cat!" then draw cats on their chalkboards.

The three-hour session is carefully planned: fifteen minutes of academics, then fifteen minutes of physical activity. Street kids are not used to sitting still. Songs and dance always teach something, like "Put your right hand in, put your right hand out, and shake it all about!" The kids are engaged and oblivious to the curious commuters and clanging trains.

Saturday is hygiene day. The teachers bring soap and give each child a cold bath in the station's water fountain. Nobody is shy; little streakers abound. The children help each other clip fingernails, comb and braid hair, and get dressed again.

It's time for a puppet show, which the teachers present from behind a blanket. Puppets allow the teachers to talk about HIV-AIDS and sexually transmitted diseases, subjects that could otherwise not be discussed comfortably. The kids love the puppet shows so much that when the show is over, they create a spontaneous mini-version using a towel instead of a blanket.

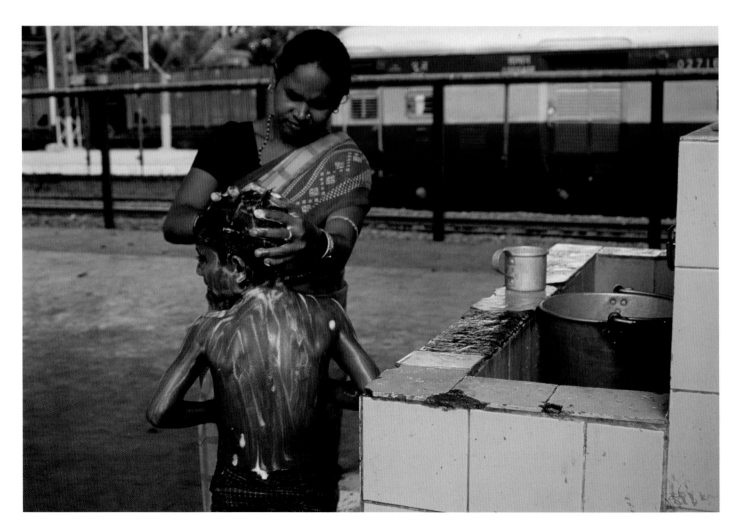

Rama

At noon, the children go to work. A pretty girl named Rama agrees to let me accompany her on the train. Rama was diagnosed with leprosy two years ago but thanks to the doctors who visit the Platform Schools weekly, she seems fine. This morning, Rama shared a wonderful peacock drawing; her teachers encourage her to sell her artwork, hoping that if she can support herself, she won't be tempted by prostitution in a few years.

This afternoon, she and a younger boy are collaborating. He will sweep the floors and she will follow him asking passengers for money. Although The India Railway has a maintenance crew, children who sweep are generally allowed to ride free. Rama and her sidekick board the train that they know carries the best tippers. Our car, which has green, wood-slat benches, is packed with families. This is a local run, and at the first stop Rama and her partner divide 10 rupees (about five cents),

then continue on toward Puri while I transfer back to Bhubaneswar. Some children work the trains for as long as a month, traveling to Delhi or Mumbai before they return to the Train Platform School.

Night school

The night school in Bhubaneswar takes place in front of the station on the platform that is used during the day by taxi drivers. Most students at this school have jobs. A 26-year-old woman, who just started carrying water at a hotel, brings her child and then participates herself. A disabled man pulls his wheelchair up to the platform every evening and listens, learning what he can. While tots practice drawing shapes and teenagers study math, a teacher unpacks a first aid kit to treat a girl who burned her foot in a cooking fire.

Nirak'arpur

In the village of Nirak'arpur, the "station" school is held about a block from the train tracks under a spreading banyan tree with a tree shrine, the center of community worship. It is March, hot here, but under this giant, shady tree, spellbound children study and dance—and learn.

Bhus'andpur

Ninety trains a day roll through Bhus'andpur. The stationmaster shows me the electronic board that allows him to control traffic. He brags about his son, who studies engineering at MIT. He thinks education is so important that he loans the Train Platform Schools an empty building to use as a classroom. Although a different stationmaster ordered me not to take pictures, this man offers me a glass of juice.

Sometimes teachers establish good relationships with people who work on the trains. When a class experienced an epidemic of conjunctivitis, it was the engine driver who gave the teachers boiled, sterile water to rinse the children's eyes (yes, some steam locomotives still operate in India). The outbreak stopped.

This morning, when it's time for dancing, there's a competition. The first girl performs a fast, Cossack-style dance until she's too tired to go on. The second girl tries to dance longer. I watch them, graceful grasshoppers, legs bending then flying, their upper bodies perfectly balanced. Sometimes in Orissa, where this contest is a favorite, the winner dances for three hours.

After visiting six schools, it's obvious that Platform School teachers get consistent, ongoing training and are carefully supervised for quality control. Everywhere, I see engaged children with the same notebooks and chalkboards. By now, I can almost sing the counting song myself, "eight...nine...ten.. ."

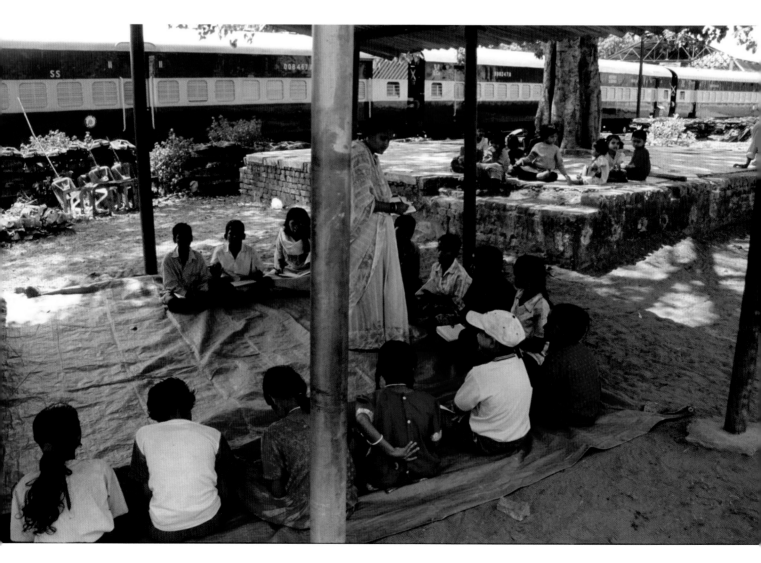

RESULTS

As of 2006, about 350 children attend the twelve Train Platform Schools that are scattered along the railroad line between Bhubaneswar and Puri. When Inderjit started, it seemed to her that children on the platforms lived so far outside "the system" that they would never attend school and get a chance to break the cycle of poverty. Yet, over the past 21 years, about 5,000 children have graduated from the Train Platform Schools into fourth grade in public schools.

If you ask Inderjit to tell you stories about children who make her proud, she will tell you about Sushan Maharana, "a rag picker who came to us at age eight and, when he turned fourteen, refused to continue in school. He learned self-esteem from us and confidence in his winning ways. We trained him for hotel work and got him his first job in a posh hotel. He became a breakdancer there, went to Bombay to be a film star, returned disappointed, learned driving, became the general manager's chauffeur, and learned to speak English like a Brit. Best, with a mentally deranged mother and a father who abandoned the family, Sushan put his sister and his brother through school."

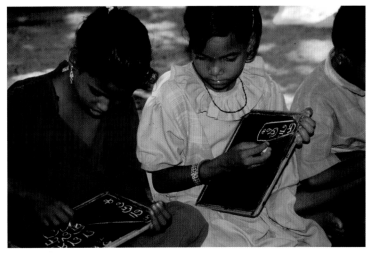

Or she might describe Yashoda, "one of six sisters who cleaned chickens all morning to earn money for the family, she insisted on coming to school much against her family's wishes. She was the only one in her family to finish high school. She exhibited a talent for the flute and, assisted by us, was admitted to a premier music college where she was picked by Orissa's leading flautist for special tutoring. Today, as she works her way through college, she can be seen on TV and heard on the radio."

RUCHIKA SOCIAL SERVICE ORGANIZATION

RSSO is the official name of Inderjit's nonprofit organization, which does more than run Train Platform Schools. It maintains a hotline for children who are in trouble, operates children's shelters, and provides preschool education for sex workers' children. Plus it gives poor children medical care and counseling. Every year it gives aid to about 4,000 youngsters.

Train Platform students who do not transfer into traditional schools can learn work skills at RSSO's training center. There, I watch students learn to clean hotel rooms, which is harder than you might think. If you lived in a "house" made of garbage bags and cardboard, you too would have no idea what to do with beds, sheets, windows, curtains, closets, and rugs. Pictures of hotel rooms help students imagine such environments.

Just as the Train Platform Schools were once an experiment, Ruchika continues to test ways to take education to children who live where there are no schools. Orissa's remote craft villages are such places. One day, I visit a basket village, and witness Inderjit's newest innovation, a cycle cart school.

The teacher pedals into the village, parks under a tree, and opens up the closed cart behind his bicycle. Its doors convert into blackboards. As he pulls out flash cards and workbooks, he is surrounded by all ages of children who want to learn. He hands out chalkboards and goes to work.

I shake my head, smiling in wonder. RSSO's entire operation is a model of creativity, determination, and charity. Mother Teresa would surely be proud.

CAMBODIA
THWARTING SEX TRAFFICKERS

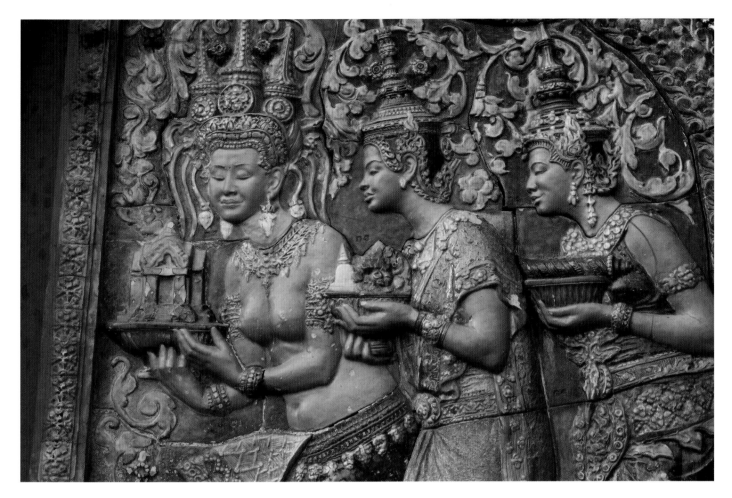

In 1372, a woman named Penh took a walk to the river and discovered a log that contained shining statues of Buddha. She built a temple on top of a hill to hold her precious discoveries. Phnom Penh means Penh's Hill. I can see her temple, Wat Penh, from my hotel window—just there, beyond the traffic roundabout that encircles the only hill in the city.

I walk through the leafy park toward the temple, passing a three-dimensional, polychrome mural embedded in the hillside. It shows women wearing sarongs and carrying food. Perhaps they are supplicants presenting offerings, I imagine. But no, they are embodiments of the ideal Cambodian woman. Since ancient times, a poem, "*The Women's Code of Conduct*," has taught appropriate behavior. Girls learn it in elementary school and mothers teach illiterate daughters to memorize it: "If a husband becomes angry with his wife, she should retire for the night and think about the situation, then speak softly to him and forgive him…. If a man takes a mistress, the wife must calmly allow him to wander…. When the man uses violence, a wife must accept it and not take marital disputes outside the house…"

I skirt around the lotus vendors and people selling palm juice in bamboo cups, then climb many steps between the rearing cobras and roaring lions that decorate the banisters. At the top, monkeys beg for snacks and children invite me to liberate caged birds.

Behind the temple is a shrine with a statue of Penh where visitors light incense and pray. The sanctuary is filled with flowers, altars, Buddha statues, and boddhi trees with fragile, golden leaves. I will return to this haven several times this week, seeking peace.

It is getting dark as I cross the park again en route to my hotel. I cut through the traffic circle, then glance back and see a woman standing under the trees. She is wearing a black pantsuit. Her dark hair falls below her shoulders. I have seen no women here wearing makeup, but this woman's lips are scarlet. I aim my camera at the cars, knowing that my wide lens will capture her image without seeming to. I want to ask Mu Sochua if she knows her.

MU SOCHUA

Suddenly, it occurs to me that this may be the very park where Mu Sochua sometimes joins the prostitutes. That's unusual behavior for a cabinet minister, but Sochua is not a typical cabinet minister.

I think about this woman, who I am to meet tomorrow. Sochua was born in Phnom Penh in 1954. When she was eighteen and the Viet Nam War spilled into Cambodia, she and her older sister were sent to France. "We never imagined that Cambodia would be wiped out by genocide," Sochua acknowledged later. The Khmer Rouge tortured and killed a quarter of the country's citizens. She never saw her parents again.

She went from Paris to California, where her brother lived, and graduated from San Francisco State, then earned a master's degree at the University of California, Berkeley before returning to Cambodia in 1989. She helped resettle refugees living in the camps at the Thai-Cambodian border. There, she met her husband Scott Leiper, an American who works for the United Nations.

Sochua founded Khemara, the first Cambodian women's organization, an income-generation project for women making silk crafts in city slums. She led the Cambodian delegation to the United Nations Fourth World Conference on Women in Beijing. In 1998 she was elected to parliament from Battambang, an area devastated by genocide and landmines. Soon, Mu Sochua became minister of women's and veterans' affairs, a position that had always been held by a man.

Immediately, she launched a five-year strategy called "Women are precious gems," to imply equality with the received wisdom that "Men are gold." She mounted dramatic communications campaigns for women's rights, including television spots showing a girl screaming as she is taken from her family to a brothel—intercut with screaming pigs being sent to slaughter.

Whenever she found women who were exploited, demeaned, or vulnerable, Sochua fought. She drafted legislation against domestic violence. She marched in demonstrations with sex workers to demand healthcare benefits. She organized protests for "beer girls" (women paid by beer companies to promote their brands are vulnerable to sex trafficking).

Sex worker in the park

When a man advertised sexual tourism on his blog and showed women blindfolded with clothespins attached to their nipples, she had him arrested. She created a list of foreign pedophiles and blocked them from entering the country. She brokered deals with Thailand and Viet Nam to repatriate trafficked Cambodian women rather than jailing them as illegal immigrants. She accused local police and village chiefs of being in league with organized sex trafficking syndicates.

She stopped at nothing and it seemed nothing could stop her. But something did. Government corruption ultimately made it impossible for her to be effective. Cambodia is the eleventh-most corrupt country in the world according to Transparency International.

In 2004, Sochua resigned and joined Sam Rainsy Party. Standing in opposition to the government she used to represent, Sochua continues her human rights activities.

"Men seeking sex cruise the groups of women clustered at the edges of the park. The typical encounter is brutish. A man paws a woman's breasts and pushes her onto the grass for intercourse. He's done in minutes; she rejoins the others.

Mu Sochua is considerably older than the rest but in the dark she blends in: slender build, heavy makeup, sexy clothes. When customers appear, the young women move protectively in front of her. She is there to bear witness.

"I want to feel the violence, the reality of these women." She hears about police who rape the women they arrest...and shanties where young men from wealthy families bond by gang-raping streetwalkers. "I am always holding back tears," Sochua says. "With all the power I have, how can I not stop this?"

—O, The Oprah Magazine, November, 2004

A bellhop delivers a note that Sochua wrote at midnight, realizing it was too late to telephone. She is leaving the country on an early plane. She knows I will understand since friends have been arrested and it is dangerous for her to stay. She has arranged for me to visit four women's groups. Her assistant will escort me. Her car and driver will pick me up at nine o'clock. She apologizes profusely, promising that we will see each other in San Francisco next month.

I wonder what could cause such an intrepid woman to flee. *The Cambodian Daily* explains it: four prominent human rights activists were released from prison yesterday, but the government warned that if they are "arrogant," they will be re-arrested, as will others. Sam Rainsy, the leader of Sochua's party, has been sentenced to eighteen months in prison even though he is in exile. Amnesty International, the United Nations, and the European Parliament are disturbed. The United States is threatening sanctions. I have arrived during a period that observers will later describe as one of the worst times in years for Cambodian human rights defenders.

The four groups Sochua selected for me to visit each relate in different ways to sex trafficking. The organization of sex workers is an obvious choice. But the others might not make sense unless you know that women who work in factories, who are poor, or who are victims of domestic violence, are all prime targets for sex traffickers whose best lure is to offer desperate women "a good job" (meaning "as a prostitute").

One out of every ten women in the sex industry has been sold by a member of her own family who was trying to make ends meet. A third of Cambodia's population lives on 50 cents a day.

Cambodia is a source, destination, and transit country for sex trafficking. As many as 100,000 Cambodian women may have been trafficked, many younger than 18. Most are put to work in this country; some are sent to Malaysia and Thailand. Organized crime orchestrates operations, but Cambodia's police, military police, army officers, and immigration officials are deeply enmeshed, actively running, protecting, or cooperating with trafficking rings and brothels. The judicial system frees 94 percent of those accused.

Poor girl sleeping

As promised, Sochua's driver and assistant, Polet, arrive on the dot of 9 AM. We drive through the riverfront area, the epicenter of tourist entertainment. On one side of the street are grass, palm trees, and boats. On the other, honky tonk bars, sidewalk cafés, and Italian fast-food joints selling "happy pizza" made with marijuana. Bicycle taxis (and the city's visitor guides) carry ads promising "friendly hostesses," "attentive girls," "lots of ladies." Sidewalk currency exchanges convert money from virtually anywhere into Cambodian riels so customers can pay for their amusements. Twenty percent of Cambodia's visitors are sex tourists.

THE SEX WORKERS

Further along the river, a hulking ferry boat is permanently docked. It is the headquarters of The Womyn's Agenda for Change, an NGO that shares its space with the Women's Network for Unity. The Network was founded in 2000 by and for sex workers; it has 5,000 members. Its secretariat is meeting today.

The ferry is dim inside, its wooden floor vast. Provocative posters on walls say "Sex work is work!" and (for reasons that will become clear), "We are human beings, not monkeys!" Pry Phallg Phuong, senior program officer for Women's Agenda, welcomes us and volunteers to be my interpreter.

On the way to the conference room, she introduces me to Carol Jenkins, the principal investigator on a huge research study designed to address the one issue that the sex workers said they most wanted to quantify: violence perpetrated against them. When Carol asked for assurance that violence occurred often enough to make the research statistically valid, "They gave me a strong look and said, essentially, don't worry, the frequency is very, very high." Sex workers, trained to conduct interviews, surveyed 1,000 of their peers. Later I read the results: 97 percent had been raped in the past year by clients, gangsters, or police.

Research done with street and brothel sex workers in Phnom Penh:
100% say they pay police money to protect them
97% were raped this year by clients, gangsters, or police
95% work seven days a week
83% send money home to support their families
79% do not know how to write
71% say they have been gang-raped
54% said poverty was the reason they entered sex work
29% have six to ten clients a day

We arrive at the end of the boat where the secretariat is waiting. On three sides, windows face the river. I sit and, against the glare, try to see who is at the huge wooden table. Some are plain, some young, some retired, some simply dressed, one in beautiful attire. A man with graying hair pulled back with a rubber band says he is MSM, Men who have Sex with Men, and team leader.

"Tell me about this group," I invite them.

A woman who introduces herself as a massage girl responds: "Originally we worked with a nongovernmental organization but all they did was tell us to go to the hospital for tests, and to use condoms."

"*You* try to get paid if you insist on condoms," says another. ("Some police make us eat our own condoms," one sex worker tells a reporter later.)

"The NGO looked down on us. They thought sex workers only know what to do in bed."

"At our meetings, we have water and bread. At their meetings, they have transportation and extras."

We started our own group because the NGO was not interested in the things we were interested in."

"What are you interested in?" I ask. Everyone answers:

"What will happen to our children if we die."

"Our HIV-positive children who are discriminated against."

"People who use addictive drugs believing they will cure AIDS."

I ask, "What kind of activities does your group do?"

"Educate others about how to negotiate with police. Help the police if they come to us."

"Try to get antiretroviral drugs for women and children."

"Fight for our rights. Stand together."

"We help sex workers in fourteen provinces." This from the woman who is well dressed and carefully made up. Her voice is so deep it seems to come from her toes. Suddenly I realize there are transgender, lesbian, gay, and straight sex workers around this table. Why am I surprised? Everybody has sex and everybody needs work.

"What are you proudest of having accomplished?" I ask. Everyone answers with the same triumphant words: the drug trials!

"A pharmaceutical company was trying to recruit 960 healthy sex workers for a trial to test an existing antiretroviral drug. They thought it might be used to *prevent* the AIDS infection, not just treat the disease. They wanted to pay us $3 a day to participate. We said, 'If it doesn't work, who will pay for our medical care?'"

"We wanted them to test. It would be great if this drug worked, but we were not prepared to die if it didn't."

"We were talking about human testing here, not animal testing. We are not monkeys."

"'Give us long term medical insurance,' we said, 'and we'll consider it.'"

"The company researcher said 'It will work, no question.' We said, 'So why are you testing then?'"

"And 'why not give us medical insurance, just like guaranteeing a watch?'"

"They said they were just trying to help us. We said, 'If you really want to help us, give us free ARVs.'"

"We are part of a network, so we knew what was going on with their attempts to conduct trials in Cameroun."

"We went to a UNAIDS meeting in Geneva, and later got a form letter Christmas card from them thanking us for our interest and saying 'Keep up the good work.'" Everyone laughs.

"We worked with ACT UP in Paris. We went to the AIDS conference in Bangkok and smeared raspberry jam on the company's exhibit booth, like blood."

"So they called the whole thing off."

"They called it off here, *and* everywhere else."

I am appalled at the corporation's behavior and impressed by this group's effectiveness, but a bit skeptical (I live 35 miles from the company's California headquarters and never heard any of this). Later, I check the story. Every bit of it is true.

Phuong escorts me to the home of a prostitute, another member of the secretariat. We cut through an apartment complex, follow a path through heaps of garbage, and enter an enclave of shanties. Children play in the puddles. A shirtless man greets us, and we climb a wooden ladder to the balcony where, following tradition, we remove our shoes and leave them by the door.

A sleeping woman lies on a floor mat in an unfurnished room that rents for $15 a month. Three people live here: the man who met us, his wife, and the napping woman. There is electricity, but no plumbing (one outhouse serves the entire shantytown) and no kitchen (they buy cooked food). Bath towels nailed over the two windows act as curtains. A bicycle hangs on the wall.

Six other young women sex workers join us, most wearing T-shirts or tank tops and casual pants or shorts. They look exactly like all the women I have seen in Phnom Penh. Only one is striking, dressed in red silk pajamas, wearing heavy fragrance and

carrying a baby who has an alarming cough. The women sit around me and tell me their stories. When they get thirsty, they sip from a green plastic cooking pot.

One woman has been sold four times, first for $300, when she was locked in a hotel room for a week. (Although she doesn't say the man was HIV-positive, virgins are particularly in demand by men who are, due to the myth that they will be cured by having sex with a virgin). Later, she was hired to cook for a family; the husband raped her, then sold her. She was locked into a brothel in Bangkok, the city where her three-year-old son still lives. She was beaten, threatened with a gun, and given electric shocks. When the brothel owner needed money to pay for emergency medical care for his son, he sold her for $20, "just what he could get." An armed man from the Cambodian forestry department "bought me and gave me a gold ring," she remembers. Pretending to be married, they returned to Cambodia. For two weeks, she stayed with him, then ran away. (I applaud and the other women join me, although they have heard her experiences before). Now, she is a sex worker. An NGO taught her to read and write, and she was elected to the secretariat of the Women's Unity Network.

The woman who was asleep when we arrived describes her early life in the countryside. Her aunt sold her into sex slavery. (Two other women in the room were also sold by family members). She escaped when, coincidentally, her older sister was delivered to the same brothel. Although the two were not allowed any contact, one night her sister used a customer's cell phone to call a taxi, sought her out, and they ran away. Afraid to go home, both are sex workers in Phnom Penh.

The other woman who lives here, also a sex worker, says her husband used to sell palm juice on his bicycle but only earned $1 a day, so gave up. The amount she earns "depends on the number of men." She prefers one customer a night so she can come home early; "there can be gangs and violence." She, like all these women, work on the streets or in parks and charge $1 (although they earn less as evening wears on, and even less than that if they have to pay a pimp to find customers). This woman dreams of retiring.

These women are working to quell human rights abuses, but I don't want to use their photographs in this book if it will get them into trouble. Later, I seek Sochua's advice. "I always think of them as my sisters, our sisters. I think we should honor them," she counsels, just like other women who light the dark.

These sex workers' stories are not unusual. In Cambodia there are approximately 50,000 prostitutes, two-thirds of whom were abducted by trickery or coercion. Many were brought here from Viet Nam, the same way that Cambodian women are trafficked to Thailand (every month, that country sends about 1,500 back).

Exact worldwide sex trafficking statistics don't exist, but estimates range from 500,000 to 4 million people—enough to produce revenue of $7 to $12 billion a year. After drugs and guns, sex trafficking is the third most lucrative criminal activity in the world.

SIN LYPAO

Domestic violence makes women susceptible to sex traffickers' offers to take them away. It is even more prevalent than sex trafficking, according to Sin Lypao, co-founder of the Cambodian Women's Crisis Center.

Although a law was passed in 2005 against domestic violence, one in five Cambodian women are victims. "Almost *all* rural families have domestic violence," Lypao explains, "due to men's powerful roles and their use of drugs and alcohol. The only reason some women are *not* beaten is because they earn a lot of money."

The traditional Women's Code sustains the belief that domestic violence is a private matter, a conviction Mu Sochua debunked as minister of women's affairs: "Domestic violence is a national issue, not a family matter. No one can say, 'It's none of my business.'"

The Cambodian Women's Crisis Center was founded in 1997 by two women. Now there are almost 100 on staff, plus 900 volunteers. "When there were two of us, the women cried and we cried, too. Now we are more experienced," Lypao says.

Three offices help about 1,700 women a year, all of them victims of domestic violence, rape, and/ or sex trafficking. The organization provides many services: legal representation, medical assistance, counseling, crisis centers, healthcare, childcare, scholarships, literacy and vocational training, and reintegration into the family and community. CWCC has public education programs and next, plans to offer classes in anger management for men.

Lypao takes me to see the shelter where survivors are learning to do restaurant cooking so they can support themselves. Their children, depending on their ages, attend daycare or academic classes on site.

In 2004, 700 women stayed at the Crisis Center's confidential shelter and a new, larger one is under construction in a distant part of the city, thanks to a grant from the Global Fund for Women. We take a tour. There are a dozen dorm rooms with bunk beds and decorative pillows. Each victim's personal possessions are stored in a basket at the end of her bed. Downstairs are an airy dining room and a job training classroom where women learn how to print T-shirts. Survivors of domestic violence can stay here as long as six months. If a husband wants to see his wife

and she agrees, they meet at CWCC's office, but this space is sacrosanct.

While we are walking along the balcony, Lypao embraces a girl who is about four. "Her stepfather put a hot iron in her vagina. We don't know how to find her mother, so we are caring for her here."

This child's terrible injury haunts me. At the end of the afternoon, I return to Wat Penh. I am not Buddhist, but Penh's temple is beautiful and I am glad for its quiet sanctuary.

CHAN SOPHEA

I take an afternoon off and hire a professional guide, Chan Sophea. We visit the National Museum with its ancient artifacts, and the palace, full of graceful gardens and its temple whose floor is tiled with silver. Sophea tells me that Pol Pot's sister was

King Sihanouk's concubine, so the Khmer Rouge leader lived in the palace. "He was a fiend," I say, not yet aware how well Sophea understands his demonic nature.

Sophea was twelve years old in 1975. She, her parents and her four brothers and sisters were having lunch when soldiers broke through their door and told them to leave "because the city was going to be bombed."

"Pol Pot, educated in France, had learned Mao's ideas and decided to convert Cambodia from a two-class to one-class society in a single day. He had the Khmer Rouge evacuate the city and exterminate the educated and affluent. I never saw my family again.

"When I finally got back to Phnom Penh, I no longer cared if I lived. I found a job in a plastics factory and studied English at night. I copied the dictionary by hand, since I had no money for books."

She has been an English-language guide for ten years. In the beginning, taking tourists to the Genocide Museum and the Killing Fields was painful. Following her first visit, she could not eat for five days. Now, she takes tourists to both every day.

Mug shots of hundreds of men and women line the entrance of the Genocide Museum. Those without numbers were the torturers, those with numbers were tortured. All the faces are young and expressionless. First exhibit: a machine used to cut off women's nipples. Over there, the scaffolding from which people were lowered into tubs of excrement. Up there, chicken wire to prevent prisoners from jumping to their death to avoid the horror.

We drive to the Killing Fields. Here, babies were bashed against trees until they died. Youngsters were forced to shoot their parents. Thousands were killed at the edge of mass graves where their bodies remain.

Sophea describes the events in relentless detail. After two hours, I feel deranged by the stories and confused by her attitude, which seems to implicate me in some way. "This nightmare must have been unbearable to live through," I say, admitting "I can't stand to hear more." She nods, satisfied. "I am telling you every detail because if it ever happens again, I want foreigners to help us. Last time, no one came."

Mu Sochua once said, "Gender-based violence is the legacy of that war." Now, I begin to understand.

The Women Garment Workers

Cambodian factory workers are losing their jobs as companies shift operations to China, where labor costs less and productivity is higher. Garments make up 90 percent of Cambodia's exports and 84 percent of all garment workers are women—in fact, a fifth of all women aged 18 to 25 work in garment factories. As they close, sex traffickers can have a field day.

LAY SOPHEAP

Lay Sopheap, who has conducted labor negotiations for the Free Trade Union of Workers, accompanies me. She was severely beaten twice and believes the assaults were related to her activism, because her assailants (who could have been hired by police, rival unions, or factory management) warned her to stop her FTU activities. She refused and each time fought harder for workers' rights. Sopheap was hospitalized after both incidents, and is now a volunteer at FTU headquarters.

She takes me to Wearwel Cambodia Ltd., where I tour the immaculate, modern factory that employs 1,500 people (1,350 of whom are women). Arun Arya, the general manager who is from India, greets me. The factory is six years old and Arun is proud that 700 employees have worked here for at least five years.

I watch the pattern makers calculate how to cut the greatest number of pieces from a bolt of cloth. They are working on apparel for Levi, Wal-Mart and Sears.

My jaw drops when I see the number of sewing machines in the white, air-conditioned factory that seems to stretch to the horizon. There are 50 machines per line. The women, who wear masks so they won't breathe lint, have on pastel T-shirts that are color-keyed to their tasks. They rotate responsibilities to learn different skills.

Wearwel's facilities include a bright, clean daycare center with Disney characters painted on the walls. There is an infirmary that has beds with embroidered pillow shams, plus a staff doctor and nurse who dispense pills and condoms. The white

tile canteen is spacious and airy. The three-day AIDS training that occurs twice a year is just ending.

I hope for the workers' sakes that Wearwel remains impervious to foreign competition. Twenty Cambodian garment factories have closed in the past two years. UNIFEM estimates that over time as many as 50,000 jobs could be lost and, because half of all factory workers' wages go to their families, 200,000 households could be affected.

Sopheap beckons me into a corridor between the stalls and stores on a busy street. The walkway is so narrow that I couldn't get through if I ate as much as a doughnut. The corridor opens into an eight-foot-wide alley full of laundry. We pass a man who is cooking over an open fire. I peer around. Somewhere here, eight factory workers live. They do not work at Wearwel.

They share a room that is almost filled by a wooden sleeping platform. At the end of the "bed" there is just enough space to walk to the bathroom. Clothes and blankets hang on the walls and a bulb hangs from the ceiling (electricity flows from 6 PM to 5:30 AM).

Even though the door is open and the window has no glass, the room is hot; Rorn, 28, is cooking dinner using a hot plate on the floor. One small pot holds dinner for all eight roommates.

Sopheap and I sit on the platform and talk with four of the women. The other four stand in the alley and kibitz through the window grate. Dina, 22, has been in Phnom Penh longest, four years. The other

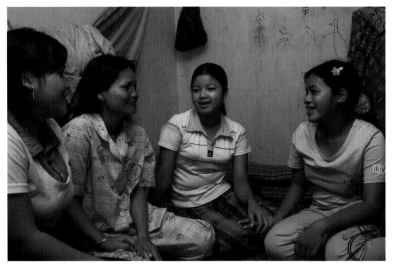

Whenever possible, they volunteer to work overtime, which pays a 1.5 salary multiple and gives them money to send home. The four of them support 32 family members. Each woman dreams of doing a computer job or becoming an interpreter (Dina wants to work for me. "I can read letters if not words," she says, putting her best foot forward), but in fact, all are illiterate, as are 42 percent of Cambodian women.

"What do you like best about your jobs?" I ask.

"Nothing. Our only rest is between 11 AM and noon."

"I got very sick and asked for time off but the general manager wouldn't allow it."

"He doesn't let us go to our villages on New Year's or March 8, Women's Rights Day."

"In fact, he forces us to work overtime on holiday weekends."

They have a question for me: "How much would we make if we were working in your country?" I try to explain that they have the jobs people used to have in my country.

"If the factory closed, what would you do instead?" I ask, thinking of the predatory sex traffickers. All four say they would return to their villages and farm with their families. But I wonder how they would respond if they received a better offer.

three are from a different village in her province. On a typical day, they wake at 5 AM, bathe, cook rice for lunch, and leave at 5:30 to walk to the factory about ten minutes away. Their shift ends at 4 PM.

Pha, seventeen, is job hunting. She worked for three months, then applied at a newer factory but couldn't do the work. Math, fifteen, lied about her age (legally, she should have been eighteen) to get a job in the factory where her sister works.

The women perform various jobs (marking cloth, cutting cloth, cleaning the floor) but they all earn $45 a month plus a $5 bonus if their work is done on time. Their rent is $30 a month; electricity and water cost $10. Each contributes $5 for housing. "Food is expensive," Rorn (the cook) says, "so our money doesn't buy much."

DR. PEN RICKSY

S trey Khmer, meaning "Cambodian Women," is an organization founded in 1998 by seven women who were determined to help their indigent rural sisters become healthy enough to work and skilled enough to be financially self-sufficient. In other words, to make women less vulnerable to sex traffickers' offers of "a good job."

Dr. Pen Ricksy, president, and her staff take me with them to Toul Krang village, a few miles from Phnom Penh. Jammed into Strey Khmer's van (which was donated by McDonald's), we bounce into potholes, traveling through land so dusty that the air is tan. A few motorcycles

zoom past us. We, in turn, streak past haymows that hide carts pulled by boney white oxen.

Ricksy explains that the women we are about to visit are either widows of the war or have been divorced due to domestic violence. A quarter of Cambodia's families are headed by single women trying to support children alone.

The women Strey Khmer has taught organic farming are growing mushrooms under a canvas sheet. In the local market, mushrooms bring 35 cents a pound.

Other women have used Strey Khmer's micro-loans to buy pigs. One who lives nearby proudly displays her herd and brags to Ricksy that the sow is pregnant again.

A third group is about to work in their rice fields, which are irrigated by a water pump the women bought with a $250 loan from Strey Khmer. Eager to show off this new technology, they set forth on foot after flagging down a motorcycle for me. I climb behind the driver and we veer onto a path atop the narrow mounds that separate the rice paddies. Seedlings sprout in pools of water on both sides. Suddenly, the cycle sputters and skitters. The man struggles to regain control. When it's safe, I jump off. He cannot restart the engine. No one else is around. We cannot speak each other's languages. Muttering, he hauls the cycle back onto the path and pushes it forward. I follow dubiously, wondering if I will ever see anyone I know again. Of course I do; the women arrive and laugh boisterously at our misadventure. As I watch them sloshing through the flooded fields, the existence of water in this arid environment seems miraculous. Income from the rice (plus the cabbage, garlic, and water lilies that the water also irrigates) will not only repay the women's loan, but cover land rental and seeds.

Before we leave Toul Krang, Ricksy presents new medical kits to the women who have completed Strey Khmer's midwife training. Thirty percent of all births in Cambodia occur at home, and maternal mortality in this country is ten times higher than Thailand, four times higher than Viet Nam. However, Ricksy tells me, midwives here have never lost a mother or a newborn. They not only deliver babies, but information, acting as ad hoc reproductive health educators. With obvious pride, the women accept the shiny tin boxes that hold surgical scissors and thread to tie umbilical cords.

On the way to Cheong Ek village, I ask Ricksy, 47, about her life. She specialized in obstetrics and gynecology and practiced for 20 years at a public hospital at the same time she ran her own clinic. She was one of Strey Khmer's founders, and now works as its president full time.

A hands-on chief executive, she personally conducts mobile clinics three times a week. Funding for the clinics comes from Lotus Outreach, which promotes public health to eliminate the conditions that produce child exploitation. "Most rural women," she says, "don't have enough money to pay a motor taxi and go to the hospital. They are very happy to see our team."

We drive off the dirt lane onto a Buddhist temple ground, and the staff jumps out to set up under a banyan tree. The nurse converts the van into a curtained examination room. It's quickly apparent that the mobile clinic is a real event! An ice cream cart owner sets up shop. Women sell desserts made from sweet green rice noodles. A woman pedals in, offering sausages from her bike. The women patients begin to arrive, some with children and husbands.

HIV prevalence in Cambodia is dropping, but is still the highest in the Asia-Pacific region. Ricky has diagnosed AIDS in other villages but not this one, and she wants to keep it that way. Only about 18 percent of Cambodians use contraceptives, so Ricksy starts every session with a condom lesson. She explains that the samples being distributed are a brand called Number One. When she holds her index finger in the air to emphasize the name, the women crack up. She takes a condom from the package and, using a wooden penis, demonstrates how to put it on and roll it off with a handkerchief. There are explicit brochures and posters on the tables, but the children are oblivious. A few men take the information and wander away.

The mobile clinic operation is efficient. First, a Strey Khmer staff member greets and registers a woman. Another weighs her. Ricksy talks with her, takes her blood pressure, checks her with a stethoscope, and writes a prescription if necessary. Another staffer gives her free pills and says goodbye.

The clinic closes when the cows come home—literally. They meander down the main road at sunset. In three hours, Ricksy has examined 150 patients. One hundred and fifty. I have never seen anything like it.

Mu Sochua

As planned, I meet Mu Sochua in San Francisco a month later. We have noodles in the international airport before her red-eye flight to Phnom Penh. It is 10:30 PM, and although she looks elegant, she is exhausted. She concedes it is lonely to travel all the time, and difficult to be away from her husband and teenaged daughter. Sochua's suitcase is full of doorknobs for the vacation home her family is building on the river south of the capital. Her mind is on Cambodia.

"What did you think of my country?" she inquires.

"I thought it was full of nice people who deserve a better life."

"The way to a better life," she says passionately, "is to have the opposition party take over and make radical changes."

In December 2006, Sochua became secretary general of the Sam Rainsy Party. In her first message, she said, "When I see our party sign in front of a hut in the most remote village, tears come to my eyes. If the owners of that hut have the courage and pride to show that they belong to SRP, our duty is to make the light glow not just for them but for the entire village." I smile reading about the glow and thinking about this book's title.

Sochua was among 1.000 women nominated for the Nobel Peace Prize.

NICARAGUA
TRAINING TRADESWOMEN

Drive north three hours from Managua, Nicaragua. Turn off the Pan-American Highway when you see the cemetery. Turquoise tombstones mark the graves of Sandinistas from Condega who lost their lives 30 years ago fighting against the military dictator, Somoza. You'll see the captured enemy plane that still looms on the hill like a ghost.

AMANDA CENTENO ESPINOZA

In 1975, Somoza's National Guard broke into the Centenos' family home, kidnapped their nineteen-year-old daughter, Amanda, then imprisoned and tortured her for a week, after which she fled to safety in Mexico. Over the next three years, two of her brothers were killed, and many Condega friends and relatives were murdered. She returned from exile to fight in the south against Somoza's troops. A newspaper photograph of Amanda carrying a machine gun through the jungle later became a well-known poster in Nicaragua.

The Sandinistas won in 1979. They passed laws giving women more rights. The 1986 constitution even required employers to give mothers half-hour breaks for breast feeding. But life was hardly easy. The Northern part of the country was, and is, poor.

Amanda worked for the Sandinista political party, FSLN, studied Marxism in Germany, earned her BA in social science, and

graduated from law school. In 1987, she attended a feminist conference. "That was a defining moment. The practical and ideological merged." She returned to Condega and came out as a lesbian.

With feminist passion born of concerns about class and poverty, she vowed to provide the town's indigent women with job options beyond poorly paid domestic and agricultural work. Mujeres Constructoras was born.

Today the workshop nestles among the few thousand houses that hug Condega's dirt roads. Built of cement blocks, each building has a corrugated metal roof; shutters close over windows with no glass. Cows moo luxuriantly as they wander down the street, roosters screech, dogs bark at nothing, horses clop along with donkeys tied behind them, pigs lather deliriously in the mud after rainstorms. The power goes out often between May and November, which makes it hard to teach welding or to use the power saws for carpentry.

The workshop's early years were devoted to "learning by doing." Amanda raised funds in the United States for the first half of the Mujeres Constructoras' workshop. Tradeswomen from North America, in Condega to build a primary school, helped construct the workshop, too.

"When the forewoman left, my back was against the wall. I didn't know where to start. Necessity has a dog's face: if you need food, you just go out and get it. I began directing the job, just going with my own intelligence," Amanda recalls. Having learned welding, she built a spiral staircase to the second floor. Everyone pitched in, using what they knew and figuring out the rest.

Once the women had a workshop, they continued to share their knowledge and teach each other. They did "odd jobs" to earn money and gain experience.

In 1998, Hurricane Mitch affected everything. Condega is located between two rivers whose raging waters changed course, split neighborhoods apart, inundated and destroyed whole barrios. "At first, we

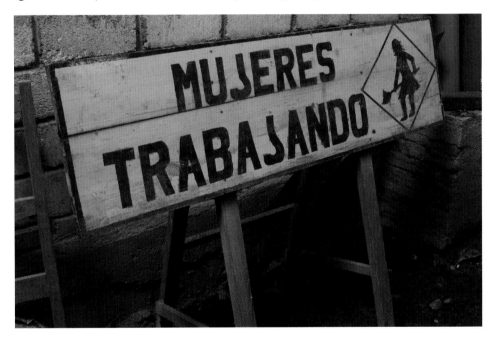

evacuated people with our pickup," Amanda recalls. "After three days we thought to check our workshop." Just a block and a half from the river, it was awash with water. "We carried as much as we could to the second floor and prepared to truck the big machines to higher ground." Fortunately, the move didn't become necessary because the Mujeres were about to need all their equipment.

Mujeres Constructoras set to work building houses for single women whose homes had been destroyed. Amanda negotiated land from the government and contracted to erect 30 houses: an ambitious enterprise given how few—and how inexperienced—project participants were. But help was on the way: emergency relief funds allowed the women to buy a concrete mixer and a concrete block maker. *Brigadistas* flew in from the UK and the US—skilled tradeswomen who worked with, and taught, the Nicaraguan women.

Mujeres Constructoras hired men to build the frameworks of nineteen houses; the women installed plumbing and electricity, then did carpentry work. Amanda supervised the construction of four of the eleven other houses, which the women built alone.

Nery Gonzáles Ruíz

Nery supervised the other seven houses, six of which were finished in six months. Then, because she lost her own home during the flooding, she built the seventh for her family.

How well she remembers move-in day! "I was so poor I didn't even have a spoon," she says, shaking her head. "I cooked on a plank between two cement blocks. But I didn't care. I was happy!" She and her children still live in that house, whose walls are covered with murals created by her artistic elder sons. She has added more rooms and a bathroom.

Nery has had at least six careers. Until she was 26, she was a health worker at a tobacco company. She taught adult education literacy classes. She was employed by a government agricultural project. Throughout, she was a housewife and tailor, sometimes teaching that skill in nearby rural communities.

Her husband left her and, in order to support her six children, she did tailoring from 1 AM until noon every day. (It is hard for Nery to recall this difficult period; tears roll down her cheeks.) Ultimately, she found someone to share her workload so Nery sewed only until 7 AM. The other woman sewed the second shift while Nery studied carpentry at Mujeres Constructoras, where classes began at 8:00.

"You rearranged your life to come to Mujeres Constructoras. Was it worth it?" I ask.

"Now I think more of myself, my future, more about education for my children. Before I only completed the fifth grade, but I returned and finished the third year of secondary school with good grades—in the 85-90 range. I have even changed physically. I was thin. Today I am strong. And now, I teach carpentry here."

Nery's father was a carpenter and she remembers, as a child, collecting wood curls and piling them on her head like a wig—and playing with the odd blocks and triangles he sawed off. Her parents supported her study of carpentry. But her brothers taunted her about "cleaning timber" ("I don't clean timber; I make fine furniture!") and being weaker than men ("I have arms and legs, and I am strong!"). Finally she brought the brother who was the biggest doubter to the workshop and got the last laugh: he realized she was serious. And was impressed.

HELEN SHEARS

Helen, 43, who was born in London, studied art and architecture before she discovered carpentry at age 27. She learned her craft at women-only training centers, then worked as an independent carpenter.

"I was involved in the Solidarity campaign in England, and was a trust member for the House for Nicaragua, which raised money for that country by buying, remodeling and selling a Victorian house. An electrician friend returned from Condega and reported that Mujeres Constructoras needed carpenters.

"For three months I studied Spanish in Spain while working with a woman carpenter there. When I returned, I discovered that Gill Wacey, a carpenter who had been to a formal technical college, was prepared to volunteer with me—and that House for Nicaragua had allocated money to fund training and expenses in Condega.

"We got to Nicaragua in 1994. Day and night we wrote courses with Amanda. Women's carpentry curriculum is different from men's. It's not based on the assumption that the students know about tools and math. But it's the atmosphere, more than the course content, that's different. We spend more time at the beginning sharing stories and information, talking about the working world, helping with math, giving life skills.

"Gill and I helped set up the carpentry workshop and stocked the shelves with the donated tools we'd carried over in our suitcases. There was nothing in the workshop, really. They were building on the floor. As part of the course, participants built two or three workbenches. We tailored our approach to local traditions, asked students to practice math and

drawing, taught about machinery, and showed them how to clean (plane) timber and dry it.

"At the end of one year, we aimed to inaugurate the workshop by showing the students' first products. At first, the tables they made were rickety. At the end of six months, they each made a chair, which is complex and teaches a lot. Six of the eight women decided to make furniture to exhibit. In August 1995 we invited authorities and women from other projects and sold a few pieces.

"I left the next month but returned in June 1996 as a development worker with funding from the Institute for International Cooperation and Development and Catholic Institute for International Relations. I am an atheist and although some Catholics are anti-lesbian, they were fine on both counts. My role was to facilitate carpentry, make contacts for funding, write up the projects, do evaluations, teach, help with administration and get involved at all levels. Now I've been here twelve years and am a Nicaraguan resident.

ADRIANA GONZÁLEZ

Adriana, 27, teaches carpentry like the Energizer Bunny. She is everywhere at once, coaching, measuring, correcting, encouraging, and motivating.

One of five children, Adriana was raised by her grandmother who "gave me lots of love, worried about me, supported my education and gave me advice. She is the best." Adriana's first job was as an apprentice at Mujeres Constructoras in 1999. "I saw women working here, which caught my eye. My grandmother said, 'If you want to go, go!'"

Adriana has been teaching for over two years now and although at first she "was rebellious," now she wants "to make the most of her work." She is "gratified when all the students understand the furniture-making process. If even one doesn't, I am frustrated."

Adriana knows, "When students look for jobs and show a sample, someone will say, 'I don't believe you made that.' The women have to defend their work and skills. To be effective, they have to face their own fear, have confidence in their ability to proceed, and take risks."

MAURICIO RAMÓN GÓMEZ CALDERÓN

Three men teach at the school, including Mauricio, 43, a career electrician who joined the workshop a year ago. Generations of his family have lived in Condega; his parents still do and his grandfather did until he died at age 110.

Mauricio not only works with women, he lives with women. He and his wife have three daughters and unlike many Nicaraguan men, he helps care for the girls, cooks, cleans, helps with homework, and takes them to school. "I can't explain why women are described as "the weaker sex," Mauricio muses. "They have the same mental and physical capabilities as men."

Nonetheless, his first day at Mujeres Constructoras was "a big step." His male buddies gave him a hard time "for training the competition.

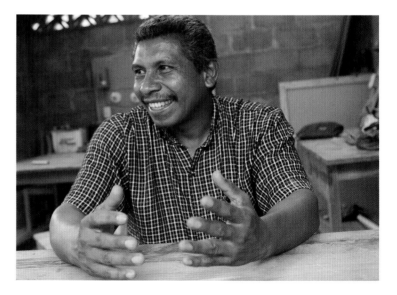

They were more upset because I became a teacher than because I was teaching women. I had only worked with male electricians before, so this is a big, new experience. On the first day, I felt I was entering women's space. I had to be respectful, I was very aware of that. I still want to make sure they feel secure in themselves."

"Are there job opportunities for women electricians here?" I ask.

"Women must make the first step. Everything they learn here, they have to show the world. Link their education to the market." Mauricio knows "many women who have their own business. Some run them better than men."

MARÍA ELIA GUEVARA CENTENO

Like Nery and Adriana, Elia has been here almost ten years. She made doors and windows in the workshop for all 30 houses that were built after Hurricane Mitch. Then she worked at the site. "It was very hot and dry in March, April, and May." Her skin still bears burn marks from the searing sun.

These days, Elia works as a carpenter doing commissioned work: beds, tables, doors, and windows. Newly, she is studying electricity. She—and her family—are serious about education. Although Elia didn't attend school beyond primary level, she is proud of her older children: one an engineer, another a teacher, the third a nurse. And she is proud that her two younger ones are still in school.

At 51, Elia is old enough to remember the war and the people whose names appear on the monument in the square. "When I hear 1970s Bee Gees music I remember all those young people who died."

Elia is the oldest student in the school ("Embarrassing, but it's never too late to learn.") Her husband "was not supportive at the beginning, but now he's gotten used to it."

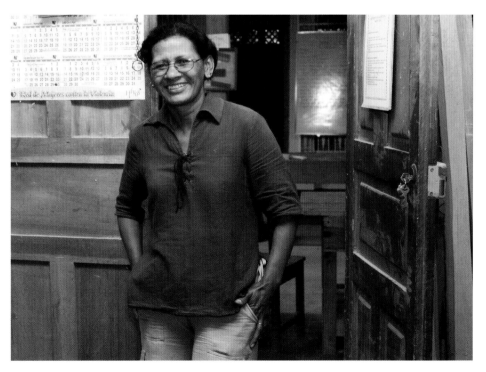

IDANIA DEL SOCORRO SALINAS LIRA

The youngest student is Idania, fourteen. She was sent to live with her mother's mother when her parents separated. Her brothers and sisters, who are younger, live with her father.

Idania gets no help from her parents. When she was nine, she had to borrow money from her grandmother to buy food and clothes. To repay the loan, Idania harvested coffee from 6 AM to 6 PM. "It's not difficult but it's hard work to have a big basket tied to you that tires your back." Five years later, she worries that she still owes her grandmother 400 cordobas (about $22).

An NGO is paying Idania's rent in Condega. It would be a four-hour commute by bus from her grandmother's house to Mujeres Constructoras where she enrolled a few months ago. Idania dreams of finishing the electricity course…and of finishing high school on Saturdays.

Learning has not been easy for Idania, who says, "I had to deal with a lot of feelings. In math, I had low marks at one time, but generally, I do well." She is considering doing domestic work so she can afford to buy the pliers, screwdrivers, and work clothes she needs to do electrical projects.

"What do you do for fun?" I wonder.

"I just started learning how to crochet. I've only been to one class," Idania pulls a needle wrapped in yarn from her pocket. "I feel good in that class. They tell me I am intelligent." Her fingers fly as she demonstrates what she has learned. It occurs to me that both electrical work and crocheting require manual dexterity. Suddenly, I feel more certain about Idania's future.

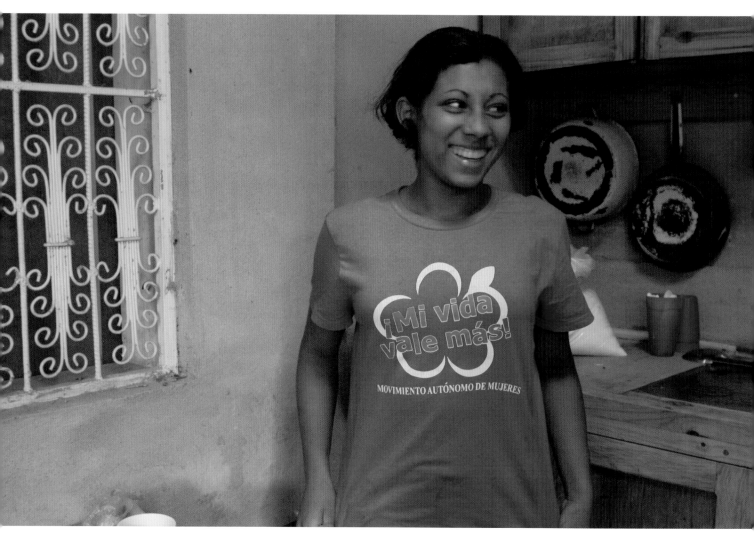

Mariana de los Angeles Rodriguez

I talk with Mariana, eighteen, while the rain is pounding so hard on the corrugated metal roof that we must shout to hear each other. This morning, I watched Mariana putting electrical wires through a conduit on the ceiling. Bracing a foot on the wall, she stood on one leg atop a chair atop a workbench while classmates held things steady. It was a heart-stopping maneuver. "First time I ever climbed a wall!" she laughs.

In general, this young woman climbs high. On her first day, Mariana was elected to represent her electricity class' voice and views—and was soon elected to represent all the students in the school. She has great dreams about what she'd like the school to become: better known and larger, with more students, more classes, and more subjects. She'd like to add building and design, which would help her personally in two years when she starts to study architecture at university in nearby Esteli.

As we talk, the storm blows out the lights. Mariana describes the impact that frequent blackouts have on Condega. "The cybercafé can't run, the food goes bad in the fridge, there are no streetlights so it's dark." And she describes a field trip to a solar panel project, which inspired her to help people who live off the main electrical grid.

Sitting in the dark, she remembers that when she was little and the lights went out, she, her parents, and her four brothers and sisters gathered at the dinner table to sing. Just as she used to do as a child, she sings now in a sweet, light voice, her favorite hymn about St. Francis of Assisi: "He put on simple clothing, left the rich things behind, and focused on God."

Mariana's parents have separated. Life at home was contentious. The five children recommended that their parents live apart. As the middle child and the oldest living at home, Mariana led this initiative. "Now everyone agrees: the separation has been good for all of us."

Thinking about Mariana's leadership at school and in her family, I ask if she would consider coming back to run Mujeres Constructoras after she finishes university. "Yes," she nods, "I would like to." Then she continues with no arrogance at all, "I think I will have earned the right to."

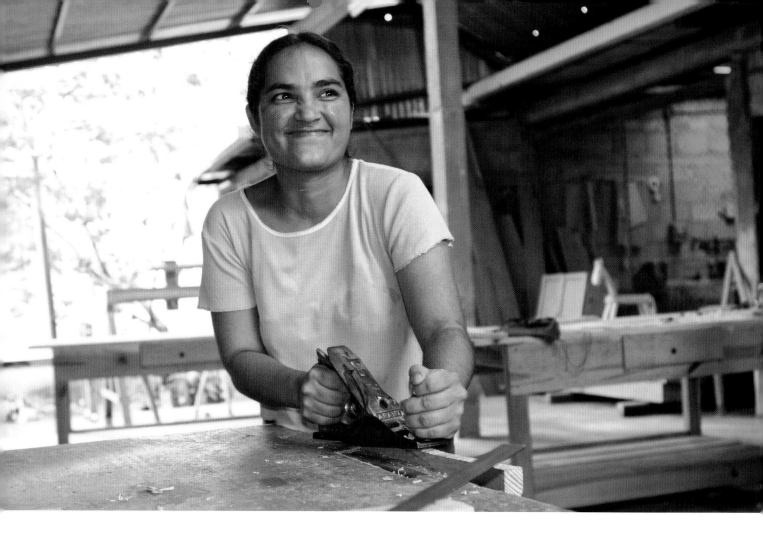

Claudia Julieht Córdoba Pérez

Claudia is a 26-year-old mother of three. Every day before coming to the workshop, Claudia stops to do her family's laundry at her mother's house; she has no water at home. Then she takes her children to school and rides the bus to Mujeres Constructoras.

Both she and her husband are carpenters and they dream of two things: building themselves a big bed and opening a business together.

Both are also poets. The second poem Claudia ever wrote won first prize this week in a competition. Inspired by Mujeres Constructoras' field trip to a deciduous forest, Claudia's poem is about deforestation:

I see the mountain's face becoming sadder.
Your dress is destroyed.
The pines, oaks, cedars...there is nothing left
Of the inheritance God gave us.

ROSA ARGENTINA RUÍZ PERALTA

Two months ago Rosa Argentina, 38, left her husband of nineteen years because she was tired of being beaten. The incidence of alcoholism is high in Condega; domestic violence is endemic.

Rosa moved out when her husband held a knife to her throat. She lost custody of her three children in the bargain. Like other women I interview, Rosa weeps as we talk so I stop recording for a while. She left two months ago. "It's quite difficult. I will get used to it," she says as if to convince herself. "I just have to live my life."

Rosa enrolled in carpentry thanks to a referral from an NGO, Red de Mujeres, which teaches women's rights workshops. "People say carpentry is a man's job, but I didn't want to be dependent on my husband. I wanted to do something that was valued. Red de Mujeres had taught me to be independent, to do my own thing."

As a new apprentice, Rosa made two cabinets for sale. She earned 150 cordobas ($7) for the first,

300 for the second ($16). And she has just enrolled in the welding class. "It's important to learn both; they complement each other."

Rosa left public school at age 15 and when she tried to start again last year, people said, "Why bother? It is death. There is no future in studying." It strikes me that Rosa's efforts to do the right thing were sabotaged by her well-meaning friends.

Venus, the workshop dog, barks wildly at the rolling thunder. The vociferous rooster starts complaining.

"Tell me something," I shout over the din. "Are women here equal to men?"

"No! Men are always boss. They take women's rights. We must fight for them and stop suffering in silence." Suddenly, I believe Rosa Argentina is going to make it.

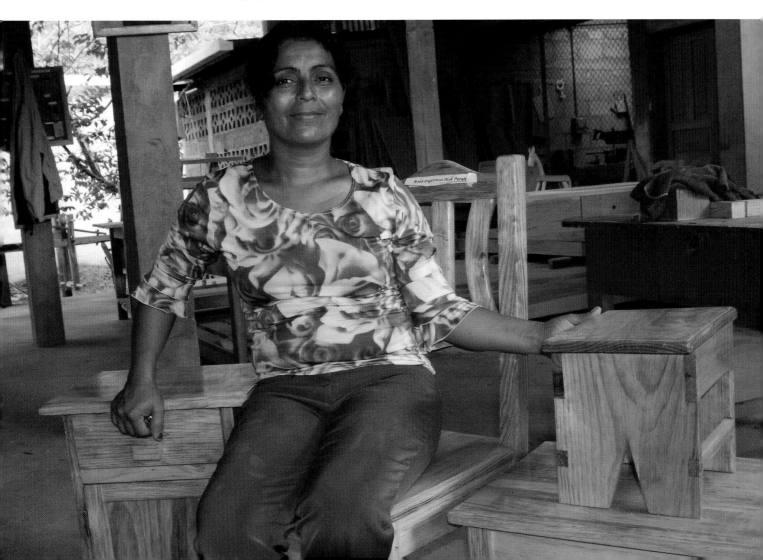

ARACELY RAMOS ROCHA

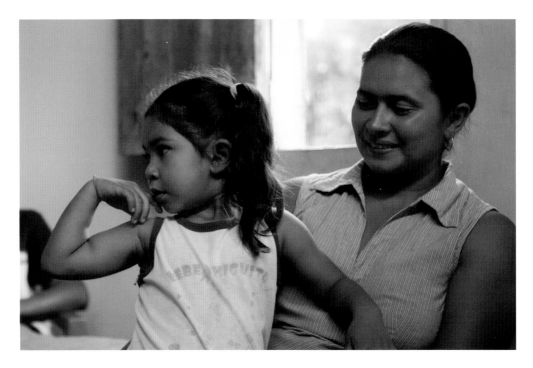

Aracely is now 25. Two years after she finished studying carpentry ("specializing in doors and windows") at Mujeres Constructoras, Aracely was hired. Without ever having had a job, she was trained for two weeks and sent to supervise road construction projects. These days, she oversees four supervisors and crews of 100 people.

Today, she is visiting Mujeres Constructoras for the first time in seven years. She marvels at the work rooms that have been built since 1999, the number of students, and the formal lesson plans that have been written and bound.

Aracely was in her junior year of high school when mutual friends told Helen and Amanda about her. "They came to my house and described the project. I liked the fact that it sounded different. I wanted to try something women don't usually do. Traditional women's skills are taught at home. I wanted to get out of that routine."

We visit the first road she built, which leads to her town, Ducale Grande. En route, she inspects the repairs that are underway, and it occurs to me that Roger Miller got it wrong; the song should have been "*Queen of the Road*!"

Nicaragua receives funding for these roads from the Danish government, which requires that 30 percent of each team be women. Aracely's

organization has a rule: "People lose their job if they create discipline problems. So the men, who were originally rebellious, zip their lips and make the best of it," she reports. One man was not so compliant: Aracely's husband became jealous and, when she refused to quit as he demanded, he left her.

In 2004, she worked on a road in Jalapa that was to be widened. She had to negotiate with local property owners to get the five-foot strip of land that lay adjacent to the road. One day a farmer who had no intention of relinquishing his property threatened to kill her with a pistol. His neighbors intervened, calmed and convinced him.

That year, Aracely fell in love, became pregnant, and worked on the road (or in the office) until her baby was born. After a regular three month maternity leave, she returned to work and is now often sent to projects in other parts of Nicaragua. Her daughter is cared for by her partner's cousin during the day, and by her partner every night. The three-year-old can't understand why her mother is home only on the weekends and works in Dipilto (near the Honduras border) all week. "So I can buy you clothes and shoes," Aracely explains. "I don't *want* clothes and shoes," her daughter negotiates as do children with working mothers everywhere in the world.

Amanda Centeno Espinoza

Amanda thinks about all those who are—and have been—part of Mujeres Constructoras, "Women who come here have already crossed barriers. But I always ask what's going on in their heads, what brought them here, what people are saying about them. The problems can start later when a mother, brother, or boyfriend says, 'You are wasting time, women can't learn these things.'"

"Men and society have mystified these trades. To decide, to set standards—men think these are their qualities." Amanda squints skeptically. "I think they are human qualities."

Over time, she has seen some acceptance of tradeswomen. "By now, certain things have been overcome," Amanda smiles. "If you go into the street nude one day, the next day people won't be so surprised."

Mujeres Constructoras has taught girls as well as women students, produced toys for disabled children, built 20 houses for senior citizens, and filled many custom furniture orders. Today, their vision is "less production and more teaching."

Amanda has been decentralizing the management of Mujeres Constructoras, distributing responsibilities among trusted senior members of the group. The change has given her something that her early life denied her: some time to relax.

Most days she and Helen have lunch at home with Amanda's niece, nephew, and grandchildren, all of whom crowd around the table for veggie tortillas. Amanda anticipates with pleasure this summer's visit from "the daughter who is part of my soul," Raquel Alejandra, sixteen, who is living in Spain.

After lunch, Amanda climbs into a hammock and reads the newspaper. Her cat sits in the sun nearby. Her garden is full of flowers. Her world is at peace.

Helen and I put our elbows on the table and talk quietly about *Women Who Light the Dark.* She shares the first lines of Bertalicia Peralta's poem, "La Única Mujer": "*La única mujer que puede ser la única es la que decide por si misma salir de la prehistoria es la que sabe que el sol para su vida empieza ahora.*" ("The only woman who can be unique is the one who decides for herself to move on from prehistoric times, who knows that the sun in her life starts now.") Peralta's words sing to me; I want to remember always that the sun in my life starts now.

WATCH OU[T]

LET US SAY [NO TO]

HIV/AIDS

The Greatest Monste[r]
Time. Let's Check Our Blo[od]
With **G B H S MBA[NGA]**

Ngoran
Ays B.

CAMEROUN
PREVENTING AIDS, HELPING ORPHANS

Our car, almost alone on the highway on Easter morning, catapults west from the capital of Cameroun, Yaoundé, (where everyone speaks French), toward Bamenda, near the Nigerian border (where everyone speaks English). The driver wants to get home fast, and the speedometer reads almost 100 miles an hour. My first look at the country is a blur.

Little girls in white dresses walk to church on the shoulders of the red earth road. The land is planted with bananas, palms, flame trees, and bushes of yellow flowers. Rust-colored adobe brick houses with louvered windows and corrugated roofs look as if they have sprung from the ground itself.

Even on a holiday, vendors hold up pineapples, papayas, coconuts. In Bafoussam, people sell straw hats with cartwheel brims that double as umbrellas.

Toll gates are oil drums set in the road where a woman collects $1. People surround the slowing car, trying to sell baggies that each contain one inch of nuts.

A friend from Bamenda recommended that I stay at "The Abaya Hotel, which is owned by the government and is secure. The city is dangerous, even during the day." The hotel staff has not been paid for four months. (Half of Cameroun's population lives on $2 a day, but people are especially poor in this area.) Dr. Grace Fombad, who co-founded the Cameroun Medical Women Association in Bamenda, says many families live on $5 a month. Antiretroviral drugs, she points out, cost $6 a month.

GRACE FOMBAD

Grace is a dignified, handsome woman in her mid-forties. Her calm, smooth voice has music in it. It's hard to imagine her childhood in a polygamous family outside Bamenda. Her father had three wives and no interest in educating his children, who comprised the labor force on his subsistence farm. But Grace's mother decided that all four of her children would go to school. Grace was eight when her father died; her mother's brother adopted her and assumed responsibility for Grace's education.

By the time she finished high school, Grace knew she wanted to be a doctor. "I discovered that the University of Bucharest would allow me to skip directly from high school to medical school. Of course, I had to learn Romanian first, so my uncle sent me there." She mastered the language in one year. (Often, Africans master languages easily since there are so many spoken across the continent. Regardless, to learn a language well enough in twelve months to study medicine is impressive!)

After medical school, Grace returned to Cameroun to practice at a government hospital, marry biochemist Rudolf ("I gave him my heart"), follow him to England where he earned a PhD in animal sciences, give birth to four children (one now studying medicine, one pharmacy), and adopt six more.

In 1993, Grace was invited to a workshop in Yaoundé. "Go ahead!" urged Rudolf, "I will stay with the children." Grace returned with an assignment: "I had to create the North West Provincial Branch of the Cameroun Medical Women Association." The group that she and three other women physicians launched now equals the national branch in terms of activities and accomplishments.

"In Africa," Grace acknowledges, "it is difficult to find husbands who are supportive. But I seem to have been a very lucky woman. While I am roaming, Rudolf is both father and mother to the children. It is not easy for him, but he is wonderful at it." Her profession does keep her roaming.

After fifteen years at the hospital in Bamenda, Grace volunteered with the United Nations in East Timor. As if her work weren't demanding enough, "in 2004 I decided to do a master's in public health. I enrolled at Charles Darwin University in Australia. I attended one week every semester as required, but I continued to work in East Timor."

Her new degree convinced the United Nations to hire her full time and send her to Sierra Leone. Today, as a medical officer for UN peacekeeping missions, she is posted to Burundi. She returns to Cameroun for a few weeks every quarter to be with her family and lead the nonprofit that she started.

How does the Cameroun Medical Women Association function while Grace is away? "The organization," she explains, "is made up of doctors, nurses, nutritionists, and community health workers who give their time. They are a mobile, busy group to whom I could not delegate my responsibilities. When I began my first UN contract, we were launching a new project, sensitizing primary and secondary school teachers so they would include HIV-AIDS in their curriculum. Rudolf had typed my grant proposal for the project (computers were not readily available in Cameroun but we had one at home) so he understood better than anyone else what I hoped the project would become. He thought this was my legacy, and that he should not allow it to collapse because of my physical absence." Six hours a day, Rudolf runs a section of the UN animal nutrition research station in Bamenda. Three hours a day, he volunteers as administrator of the Cameroun Medical Women Association.

CMWA has taught more than a million people about HIV-AIDS. The group's purpose grew from Grace's passion. "In 1994, I discovered my brother was HIV positive. He was four years younger than I, the next born. I had grown up with my uncle. Perhaps if my brother and I had lived under the same roof and had opportunities to quarrel, I might not have been as attached to him as I was, but there was a great tie between us; I loved him.

He died in September 1995, before he was 30. I felt I had failed in my duties to humanity. Even with all my medical knowledge, there was nothing I could do, and there was no drug to cure AIDS. If I couldn't cure the disease, perhaps I could at least prevent people from being infected."

The North West Province had the highest prevalence of AIDS in the country. After seeing patients all day, the Cameroun Medical Women began systematically training people whom they identified as opinion leaders and social catalysts.

"We trained 67 community educators who understood the 30 dialects spoken in this area. They talk to particularly vulnerable people about behaviors that spread the disease. In certain tribes, one day each week is called Free For All: a woman can have sex with another man as long as her husband doesn't find out. Then there is widow inheritance: a dying man designates his next of kin to be his wife's new husband and his widow soon infects that man. We try to discourage these practices and give women the option of negotiating safe sex.

"We trained 32 traditional healers. About 70 percent of the people here put their faith in traditional healers. We discovered that traditional healers had no idea that there was HIV-AIDS. They focus on who, not what, causes disease. They treat illness by doing scarification (skin cutting) to release the evil spirits and when they use the same blade for another person, drops of blood transmit the virus."

CMWA has trained 58 teenagers to be peer counselors—and perform plays ("more engaging than lectures") that have educated almost 7,000 high school students. Grace describes one of CMWA's lessons for young people: "Sugar daddies with flashy cars and salaries give girls things their parents can not afford. Whether it's a gift or a ride home, sugar daddies are likely to be HIV-positive and have ulterior motives. We want girls to wait to have intercourse until their relationships are stable, to require condoms— and to inspect the condoms since some men cut off the tops."

CMWA was among the first organizations in Cameroun to take up AIDS as a concern; the subject was not discussed publicly until 2000. Now, six years later, the organization is launching programs that go beyond sensitization and prevention. Their newest programs focus on job and nutritional training for AIDS caregivers and people living with AIDS.

And on helping orphans attend school. In Cameroun, the word "orphan" describes a child who has lost one or both parents. Having lost her father, Grace remembers well that "My uncle gave me a green light. We, too, try to give orphans a green light."

My first morning in Bamenda, Grace arrives 20 minutes late. Her nineteen-year-old adopted daughter, Maklin, went into labor this morning. Grace had been upset that this unmarried girl "got herself in a family way" after the Fombads invested to send her to school, but now Grace is worried about the delivery. We stop at the hospital and find Maklin's brother in the pharmacy line, a process that speeds up when Grace arrives; she worked in this hospital and is greeted with affection and respect. I wait on a long bench with about 30 patients while Grace visits the maternity ward. The woman next to me is eating breakfast: one piece of dry bread.

When we resume, I notice that the windshield on my side of the car is shattered. I hesitate to photograph through the side window because Grace says rolling it down would invite a pedestrian to grab my camera and perhaps my purse. "It is assumed that people who come from other countries bring money," she warns. "Some are even followed from the airport in Douala. I never tell anyone when I am coming because our house could be robbed. If people find out later, the money I arrived with could already be gone."

As we pass the Bamenda airport, which sits in a weedy field, Grace explains that it has never been used. "Pilots say 'visibility is not good here.' But the truth is, nobody much can afford to fly."

"Why are the economic problems so severe?" I ask.

"Corruption and mismanagement," Grace responds.

In 2004, research by Berlin-based Transparency International showed that the number of Camerounians who paid a bribe during the past year was 50 percent higher than anywhere else in the world; in 2006, Cameroun's government was listed among the 25 most corrupt of 163 countries. Later I discover that someone in Cameroun managed to charge $15,000 to my credit card. Officials access money as easily: the government pledged to fund CMWA's AIDS caregiver program, but strangely no money ever arrived; the program launched three months ago and is running on air.

COMFORT BINWING NZEKUMBE

The village of Chomba is lushly green, trees bowing over red earth roads, fields full of vegetables. We are hours ahead of schedule since our hospital visit caused us to change plans. Comfort Binwing Nzekumbe, 34, wearing an immaculate white blouse and red skirt, is washing dishes in a pan outside the compound where she lives. "If you had arrived at 2 PM, I would have had something prepared for you to eat," she apologizes.

What a garden she has! She names the plants she grows in mixed rows to keep the soil (and her family) healthy. There is spinach, cassava, beans, maize, coco yams, bitter leaf, peppers, guava, mint, sweet potatoes, basil, and Irish potatoes—and over there, sugar cane, bananas, and plantains. Even with such bounty to sell—plus body lotion and soap, which she makes when she can afford the ingredients— Comfort cannot afford both things she cares most about: buying antiretroviral drugs ($6 a month plus lab tests)—and paying her three sons' tuition ($9 a month). Her children are not in school.

She is feeling strong enough to volunteer as a CMWA community health representative and walks from door to door distributing literature about AIDS, polio, and yellow fever. Comfort, who attended school through the fourth grade, was recruited by her classmate, Alfred Anye Awah, a CMWA community educator who rides his motorcycle over rutted roads to villages like Chomba. He also helped Comfort come to terms with her illness.

"My husband abandoned me when I was diagnosed. I was pregnant with my last child, who is now almost two years old. But Alfred told me, 'Accept your situation.' He helped me feel free." She began taking antiretroviral drugs six months ago, and shows me her test results, pointing out the CD4 count that indicates how her immune system is faring.

Her children, ages nine, five, and two, have been bathing outside and are surprised to find us sitting around the table. Giggling and naked, they run into the only other room to get dressed. Comfort follows them with loving eyes. "My children have been tested.

They are healthy. Every day, they help me remember to take my medicine."

"When I see a friend suffering, I give them the advice that Alfred gave me. People think it is only through sexual intercourse that you get this thing. But you can even get it through barbers and hospitals. So you must be tested and you must accept your situation. Attitude is a lot. Eat a balanced diet of fruit and vegetables and drink a lot of water." Comfort smiles, "Others can learn from us. If they come closer to us."

GRACE MAHMBO AWAH

Down the road, Grace Mahmbo, 46, lives with her children and grandchildren. She, too, is living with AIDS and like Comfort, is a member of the Presbyterian Church Choir. When I invite her to sing her favorite hymn for me, she belts out "While Traveling Through This Wall of Sorrows": "'I'm on my way to Glory Land.... ' I love this song because while traveling, I got so many difficulties in my life. I lost my mother and father. For fifteen years, I have been a widow with five children and no means. But God is great. I started to get sick in 2000 and it's been six years.

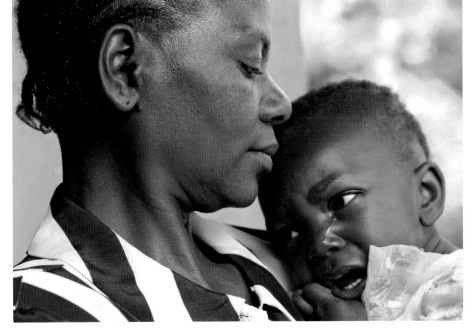

"I began taking drugs a year ago and now there is only a light fever. I look so fresh that people don't believe I am sick. I am using myself as an example. I just stood before the *Fon* (traditional ruler) at a meeting of 100 youth from the village. Six of us who are HIV-positive came to speak to the group. "Look at us. While you are still strong, go do your tests so you will know how to handle yourself. If you are seronegative, abstain until you are married. Condoms fail." One boy said, "If it happens to me, I will hang myself." I said, "How come? Drugs used to cost 300,000 francs a month but now they are only 3,000. Why die?"

Alfred says, "The population in this village is 5,000. So far, I have struggled to get 378 people tested.

Twenty-seven of them are positive, among them seven youths who are keeping healthy. Grace Mahmbo is doing a good job of bringing them together." Grace laughs, "God gave me the sense to do it. Alfred gave me the power. I just say, 'Life is good but time is short. If you live sick, you will have months, maybe a year. You can bring your life back.'"

Grace remembers, "Before my CD4 test, I cried, 'I am sick. I need money. I need help.' An elite gave me 10,000 francs. Alfred gave me a token. Others assisted. Instead of dying silently without money for tests, I opened my mouth and people helped." And now, I think to myself, Grace Mahmbo is opening her mouth to help others.

The next morning, the Fombads pick me up. Called to the hospital at 6 AM, they expected Maklin's baby had been born. Indeed, Maklin went into labor last night, told no one that she was in pain, and received no medical attention. Grace is furious: "They did an ultrasound yesterday! How could no one have noticed that the umbilical cord was wrapped around the baby's neck! The baby was born dead. The girl's brother is taking the body to their village to be buried." On the back seat is a suitcase full of baby blankets, diapers, and clothing. "Let's cancel our appointments today," I suggest. Grace wants to proceed. We drive for an hour to a community clinic to observe an AIDS training workshop. Ironically this is a workshop for new mothers. Grace excuses herself. I watch her outside walking slowly under the trees.

NGU PHEBE TUMBAN ACHIMBOM

Mrs. Ngu Phebe Tumban Achimbom, a nurse wearing a white coat, teaches this class in the open lobby of the clinic. Chickens peck at the floor. Rows of benches are occupied by mothers cradling newborns; their toddlers explore the territory. Phebe was trained by CMWA in 2001, and took a refresher course last year. On Tuesdays she does prenatal training and on Wednesdays, antenatal training. Afterwards, we talk.

"Two of the women in this morning's group are HIV-positive," she confides. "As soon as the women are pregnant, we advise them to be tested." Phebe and two other nurses tell patients their results and do counseling. "If they are seropositive, they cry and we let them cry. Then we talk. Most of them are at least calm when they leave." The women get antiretroviral drugs for six weeks and another dose 72 hours before delivery. Infants get them as soon as they are born. Pediatric syrup for children with AIDS is free in Mginbo, a 45-minute cab ride away.

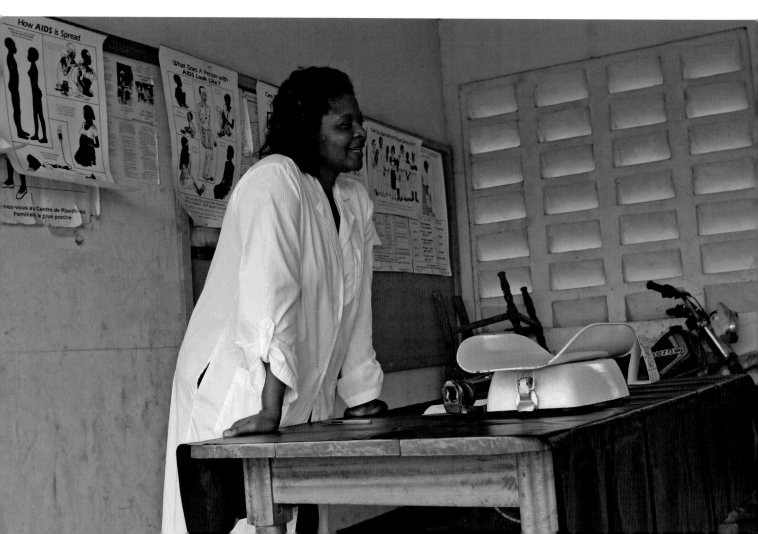

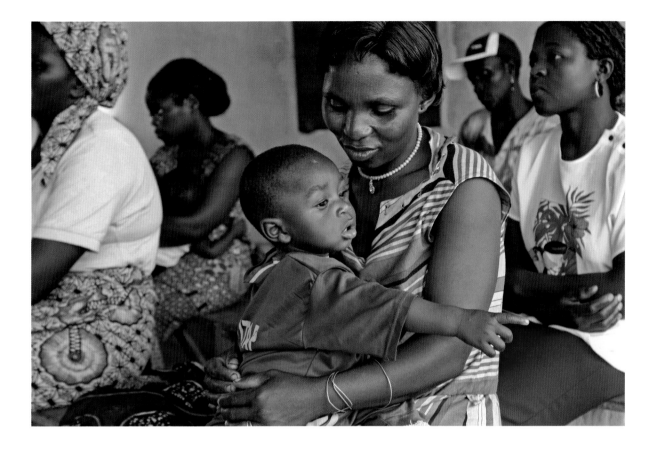

Taxis charge $2 to go anywhere in town. En route to Bamenda, 50 or 60 taxis pass us driving the opposite direction, followed by an equal number of motorcycles, a hearse, and more cabs. This is a funeral cortège. Under their windshield wipers, the taxis carry a photograph of the woman who has died. "Funerals," Rudolf observes wryly, "are the only business in Bamenda that is doing well."

TAMANJI GREGORY FUH

Tamanji Gregory Fuh, a retired nurse, volunteers as a CMWA community educator. He meets us early because the bicycle CMWA provided has broken and he must catch a bus to conduct this morning's AIDS sensitization program. Now in his sixties, his six children are grown, but four adopted orphans still live at home.

Although he teaches all ages, it's the children who have captured his heart. "To them, I am the AIDS Man," he smiles. "Children wonder why people are dying. We talk about it. Recently a small child told me, 'If you remove a jigger from a person with HIV and use the same stick to pull out a jigger from a healthy person, you can transmit the disease.' Imagine a small child understanding that!"

Tamanji is enjoying sitting in one of the four new easy chairs that his adopted son made and delivered as a surprise last weekend. The young man just opened a carpentry shop in town. "I start thinking that my investment in people is not bad!" he smiles, patting the upholstery. "Why should I not feel proud?"

VERONICA ISAITU

Sixteen orphans whose school fees have been paid by CMWA are now running businesses. For nine years, Veronica Isaitu, 25, has dreamed of opening a shop and selling cakes and embroidery.

She has just finished a baking course. The founder of her trade school, Touch of Class, has brought in her own electric beater so Veronica can show me quickly how to make yogurt cake. They usually use a traditional wood vat and spatula because, the school mistress explains, "Most students will cook where there is no electricity."

"When I was sixteen," Veronica recalls as she blends the ingredients in a mixing bowl, "I was thinking of what I could do to help myself. I shared my ideas with one of my aunties. The next year, a cousin connected me to CMWA, which sponsored my studies."

First Veronica learned to sew the intricate traditional ceremonial clothing that is worn by *Fons* and their queens. Right now, younger students are learning embroidery in the front of the classroom while Veronica bakes in the back.

Nowhere do I see an oven. When the batter is ready, Veronica opens the door to the alley and places the cake pans on rocks inside a large, lidded pot over a bonfire.

Veronica has cake and embroidery under control. But reading, writing, and arithmetic are missing. Veronica was born with a twisted leg. Although she moves adroitly with a wooden staff, getting to school was impossible until CMWA gave her a hand bike. "I was so happy! Even my friends were so happy for that! They shouted, 'They have brought your bicycle, they have brought your bicycle! Come and collect it!'"

Now—if she gets a push uphill—Veronica easily travels the two kilometers to school; she will graduate in four years. Then—if she gets seed money—she will open her dream business.

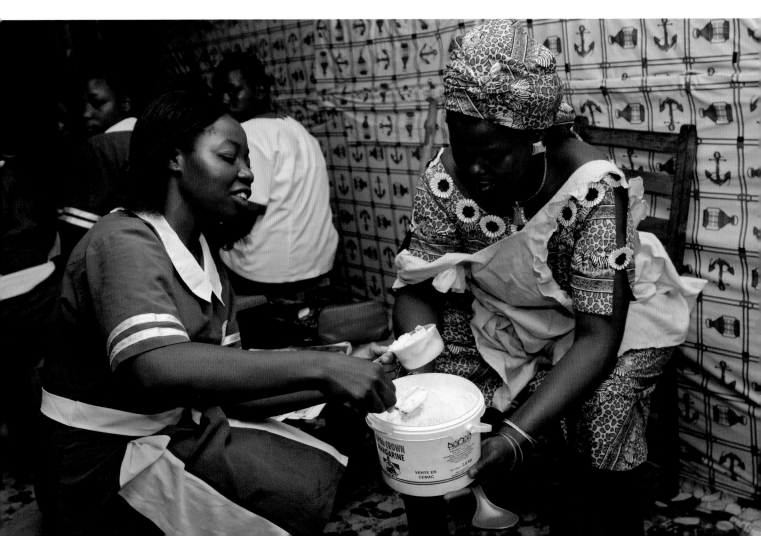

CMWA provides 123 orphans like Veronica with clothing and food, school fees, uniforms and books, and emergency medical funds. The youngsters often earn top grades, even in classes with more than 100 students. In 2005, the first CMWA orphan enrolled in university.

These successes do not come easily, especially since the needs of a family's orphans and biological children often collide. Needy families may sell the school books CMWA gives to orphans. Others may send their own children to school with CMWA's money while they send the orphans to work. CMWA meets these challenges creatively; for example, Grace says, "We pay parents the $4 a boy would earn selling avocados in exchange for their agreement to send him to school."

ROSE NEH

Rose Neh had four children. After two died, she adopted their families. Her small house now contains ten grandchildren and great-grandchildren. When we arrive, the three infants are hungry and fussy. Rose, who is in her sixties, gives one of the twins her breast. Seeing my astonishment, Rose laughs, "I am just giving him comfort." Sure enough, the baby suckles himself to sleep in her arms.

Rose is not confident she will live as long as her mother. "After all, children I delivered are already dead."

Her daughter's son, Demian, was eight when he came to live here. His father was dead and his mother died giving birth to her seventh child. Rose remembers, "When he was small, Demian would sob that life would have been better if his parents were still alive. He was right. I wept with him. There was nothing I could do about the situation."

Rose's son's daughter, Vanesa, "ran away from school to her maternal grandmother's house and was gone two days." The grandmothers met and agreed that Vanesa should return and live with Rose.

One night, Vanesa was very sick and another of Rose's grandchildren had been sent home that day for unpaid school fees. Rose lay awake all night trying to invent a solution. After mass the next morning, Rose greeted Regina Che, a nutritionist who works with CMWA: "'I have been thinking and all my thoughts

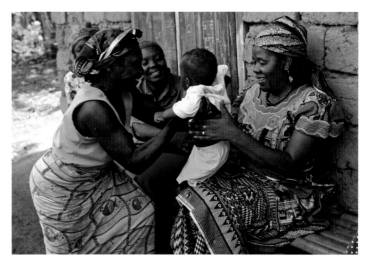

came on you, that I should ask you to loan me 10,000 francs ($20),' I said. Mrs. Che agreed. I took Vanesa to the hospital that very morning, where they gave her medication and she became well. Dr. Fombad told me that CMWA could help with the school fees. Demian now feels that he has many mothers. If CMWA had not come to help me, I would be dead from worry."

Regina, Grace, and I dandle the babies while Rose's daughters cook lunch over a fire behind the house: plantains and black-eyed bean pudding. Rose shows off her proudest possession, a wood spatula for fixing cassava paste, carved for her birthday by her grandson, whom we are about to meet. "Demian

passes my house every morning on the way to school," Regina reports. "He was a real thorn in his grandmother's flesh, very stubborn. But he is a big boy now, dressed in his uniform, looking responsible. His grandmother is puzzled, but thrilled!"

Demian, sixteen, is two years into a four-year carpentry course at the Community Technical and Commercial College, which we visit next. He gets to school on foot (a runner, it takes him 30 minutes, which is what it took us to drive). He demonstrates using the wood plane and running the electric saw, then gives us a tour of the furniture showroom. He can already make beds and tables, and looks forward to making doors. Ultimately, he hopes to establish a carpentry business in Bamenda. Until then, he uses the hours he's not in school to carry water and firewood, farm the family's plot, and if there's time before 8 PM when everyone retires, to play football with boys in the neighborhood.

As we drive away from Demian's school, we hear a loud noise. The entire exhaust system has fallen off Grace's car, and lies like an intestine in the dirt road. The car was "repaired" earlier this week with what we now see are three pieces of wire. In people's yards and fields for miles around, there are rusty auto bodies. Car-casses, I decide, are metaphors for

Cameroun: poor, sick, broken, falling apart. Regina makes a call on her cell phone, which rings back with a lilting Strauss waltz; Rudolf is leaving his office to come drive us to our next appointment.

Rose's granddaughter, Vanesa Niba Alieh, twelve, sits in her classroom with me during recess, completely at ease. "I like studying math. It helps make sense of things," she tells me, explaining that she gets good grades because she is studying hard to become a nurse.

"Do you have toys at home?"

"No."

"Books?"

"No."

"What do you do for fun?"

"Climb trees. I can climb fast and high." I invite Vanesa to tell me where she would like to be photographed. She has five ideas: with her books, with her friends, next to the flag, by a flowering bush, and in front of the sign with her school's name on it.

En route to the Fombads' house for dinner, Rudolf mentions that their son is sick. I reflect on the obvious: from a health standpoint, his family has had a difficult week.

Nothing prepares me to see their fourteen-year-old in a fetal position on the living room rug. Since he was two, he has been medicated against seizures, "The most violent I have ever seen," Grace admits. He can not walk or talk. For two years, he could not see. "This must have devastated you," I say, shocked. "Yes. Our families had no history of West syndrome. I had several bouts of false labor pains during pregnancy; perhaps that caused brain damage. I was depressed for eighteen months after the baby was born."

"Now you understand why we didn't accept when we won the lottery," Rudolf says, offering me a glass of wine. "You won the lottery?" I ask, amazed. (Their house is nice but not palatial and 14 people live here, which makes it obvious why Grace works in Burundi where she can earn a bit more than doctors in Cameroun.)

"Yes," Rudolf confirms, "we won the lottery. Your President Clinton ran a lottery offering 55,000 educated people and their families visas and green cards to come to the United States. Our names were drawn, but we could not transport our son." I think: thousands of people are better off today because this boy kept the Fombads in Bamenda.

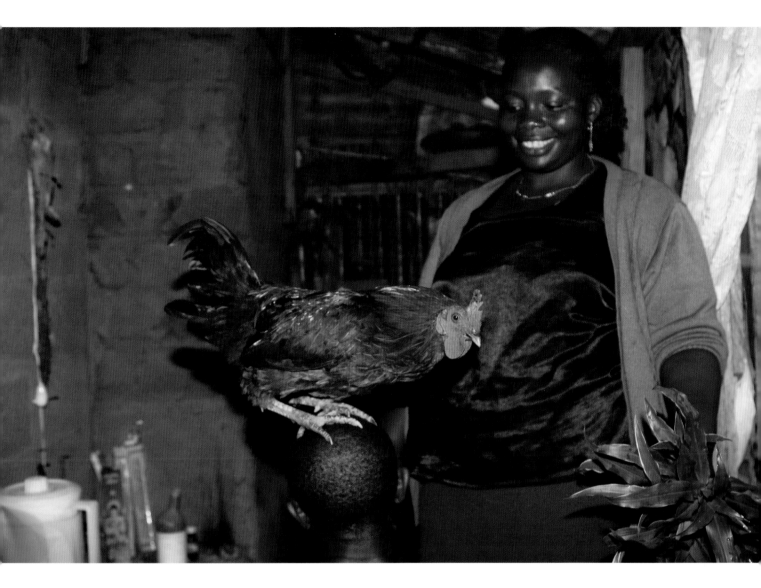

PATRICIA BIH

Some people still believe that there is a cure for AIDS that has not been disclosed. Others attribute AIDS to poison, witchcraft, or taboos.

Patricia Bih, 34, is one of the traditional healers who have been trained by CMWA. I visit her with Grace and CMWA's technical coordinator, Gideon Tamufor. We follow red earth paths through a verdant residential area to the bungalow where Patricia lives. While her patient and his family wait, Patricia offers us juice and sits with us on her burgundy velour couch. In another room, youngsters play noisily; she calls to quiet them. She has four children, including twins, which is portentous. She is a twin herself.

Gideon acts as my interpreter since Patricia comes from the Meta clan and speaks pidgin. She tells me, "As a child, my grandparents used to come to me in my dreams. They took me to visit a lake. They used to carry me, show me the leaves, play with me. When we met people, they explained that I was a healer. That was strange for me. I felt too young to do these things. One night in 1993, they came in a dream and told me that my twin brother, who was in South West Province, was going to die unless I helped. They told me where to find him, explained the difficulties, and showed me the medicine to use. I went to the slopes of Buea Mountain near Douala, found him, and saved his life. Even today, if those who want advice are good people, my grandparents advise me how to treat them."

"In my culture, that is called being a medium."

"Yes."

"What kinds of illnesses do you treat most?"

"Typhoid, malaria, poisoning, barren women."

"What about AIDS?"

"We used to work with those people, but not now. I was one of ten or eleven traditional healers who went to CMWA's training for a week. Now, when my spirits tell me it is AIDS, I send the people to the hospital for treatment. I cannot cure them. I tell them to abstain from sex or stay with one partner. Some understand, others don't."

"Do they take your advice even if they don't understand?"

"Yes, most of them."

"Do you do scarification?"

"That is only for witchcraft. If an individual goes to the hospital for malaria but tablets don't help, it is witchcraft. Scarification releases evil spirits and brings the person back to normal. I learned from CMWA to use a blade for only one person and to apply medicine on a leaf, rather than touching the person's blood."

Suddenly Patricia remembers that her patient has been waiting a long time, and invites us to join them in her temple. Grace and I follow her outside into a room about three by five feet, built of corrugated metal. It's dark inside, but I can see benches along two walls. A mirror and incense sticks on a shelf create a shrine. A cardboard box sits on the floor; in it are two lively chickens.

Patricia pours her patient a large tumbler of palm wine and asks him to remove his shirt.

She explains that later, when she performs the whole ceremony, she will bathe him and pray, but first she wants me to take pictures of her final step. Without further ado, she plops a chicken on the man's head. Surprised, the chicken flaps, manages to find its footing, and balances obediently. My flash, however, shocks the bird, which squawks loudly and flies unceremoniously out the door. Patricia erupts into laughter and dispatches her brother to catch a replacement. I bet even her grandparents are smiling.

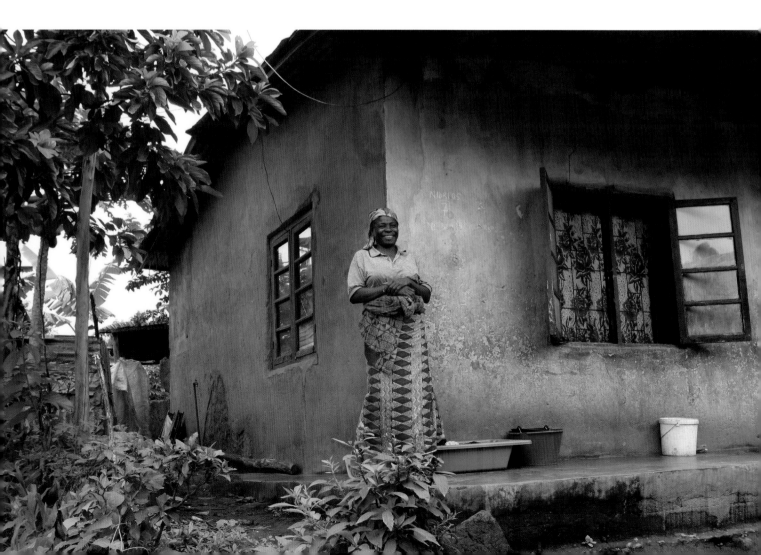

Regina Che

CMWA's nutrition volunteer, Regina Che, has invited the staff to her house for dinner on my last evening in Cameroun. The ancient burl table in her dining room is large enough to seat all twelve of us, and she serves a feast.

No wonder Regina is a good cook. She grew up in a polygamous family and her father had five wives. "Each wife cooked for a week," Regina remembers, "and we would all go and eat with our father. One wife, who had only two children, grumbled because she didn't think it was fair to have to cook for 32 children!" Regina laughs.

Eating well as a child inspired Regina to study nutrition and dietetics in Britain before she returned to work at the hospital where Grace Fombad was practicing. Regina joined CMWA's volunteer force fourteen years ago. When she teaches AIDS caregivers to combine whole wheat and avocado ("It has almost all the nutrients you need!"), she makes it sound delicious.

At dinner, Regina talks less about bread than breadwinners. "In our culture, the breadwinners are supposed to take care of the old people. Our pension is our children. Those whose adult children are dying, lose hope. They expect to meet their people again, but in this life, they can't eat."

A few years ago, Regina represented CMWA at a workshop in Namibia that focused on orphans. Now she helps relieve the older generation's burden by identifying orphans whom the Cameroun Medical Women will sponsor.

I look around the dinner table at Grace and Rudolf, Regina, Alfred, Gideon, the staff members and volunteers of the Cameroun Medical Women Association. This country, with its poverty, corruption, and disease, seems dark. I am awed that in such an environment, these generous people whose own lives are difficult are creating health, hope, and possibility.

NJOKOM THADDEUS ANO

The last thing Njokom Thaddeus Ano expected when he returned to Bengwi to attend his father's funeral in 1996 was that he was about to become a traditional ruler. Njokom had graduated from SATA College in Kumba, married, had six children, and was living in the city, working as a building contractor. His life, he believed, was modern and normal.

The day of the funeral, his father's 36 immediate descendents, princesses and princes like Njokom, followed the road about 30 kilometers from the palace. "We marched to the ceremonial grounds at the top of the hill accompanied by the administration of Cameroun, community members, and neighboring tribes, everyone carrying guns—about 1,000 altogether—to shoot, signifying to the community that the old *Fon* was lost and a new one had to be enthroned."

"We returned to the palace where the traditional dance began, to declare the *Fon*'s death. They started the calling drums to make the population aware that it was true, a new *Fon* would be named. The princesses began the dance, during which the *jujus* (masked dancers) encircled me and marched me out of the crowd to the palace where I met 31 traditional leaders from this division, all seated, looking at me. They asked me to identify myself to confirm my name. And I found that my father had named me to succeed him."

After three months of learning the traditions he was to sustain, Njokom adopted his father's children and assumed economic responsibility for his father's five wives. Today, his land-use decisions, his social and economic policies are broadcast by a messenger who climbs a tree in the market and makes announcements to as many as 5,000 people.

Grace, Rudolf, and I visit on a day when it rains so hard that the red dirt road liquefies into a red river. The *Fon*'s assistants meet us with umbrellas and escort us into the palace, a rambling, unadorned building 28 kilometers from town. As required, we greet the leader with a hollow clap, since it is forbidden to shake hands with traditional rulers. He wears embroidered ceremonial clothes and sits on a throne; the animal skins on the wall signify power. I invite him to describe his relationship with the Cameroun Medical Women Association.

"In 2002, CMWA selected some traditional rulers for an AIDS workshop. It was strange. The *Fons* did not know they could take workshops like that. We got money for transport, writing materials, and meals. Afterwards, we were advised to bring in members of the traditional councils for another meeting. And later, there was a workshop where the male and female youth, selected by the *Fons*, were sent. As a result, the associations that are working against this pandemic go deep into the core of the community."

"Our community used to think it was good to be promiscuous. Now they think they should not permit loose sex. The youth organized themselves to do sporting activities instead of idling around. They learned to speak freely about the epidemic. There is an acceptance of condoms (in the past, you could have corporal punishment for having a thing of that nature). There is a drop in the consumption of alcohol; the use of alcohol during our normal ceremonies has changed. We have cut down on night ceremonies, which were a breeding ground for sexual desires."

Today, Fon Njokom Thaddeus Ano is vice president and spokesman for Fons Against AIDS. He testified at Johns Hopkins' meeting on HIV-AIDS, which was attended by 700 leaders from all over the developing world.

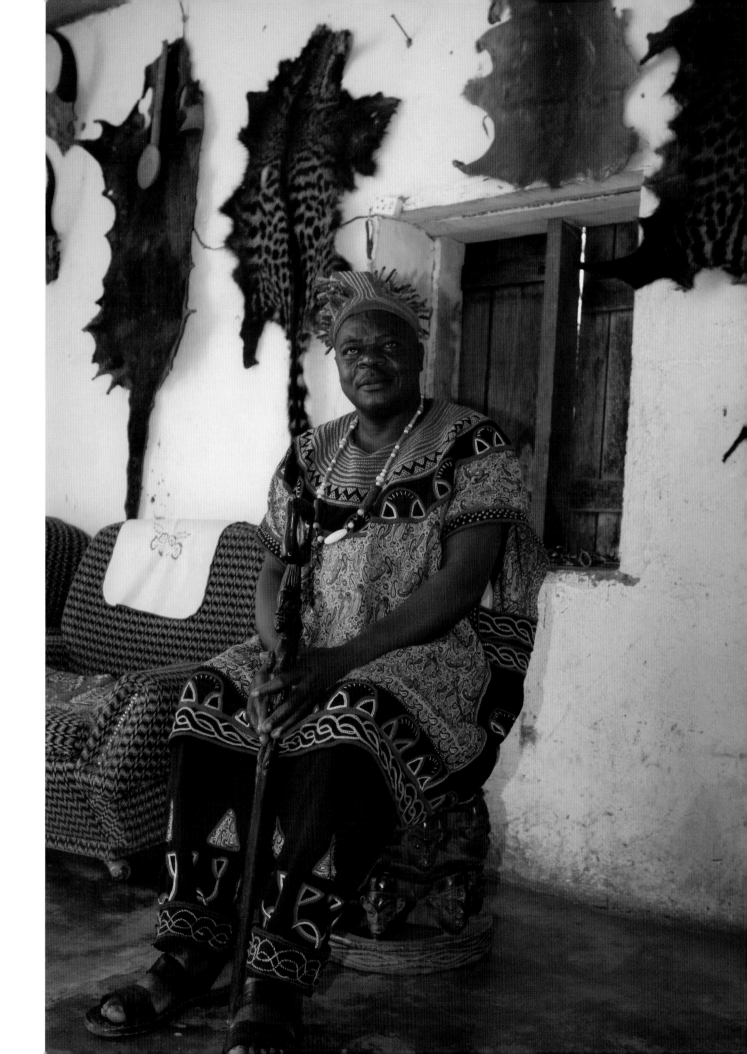

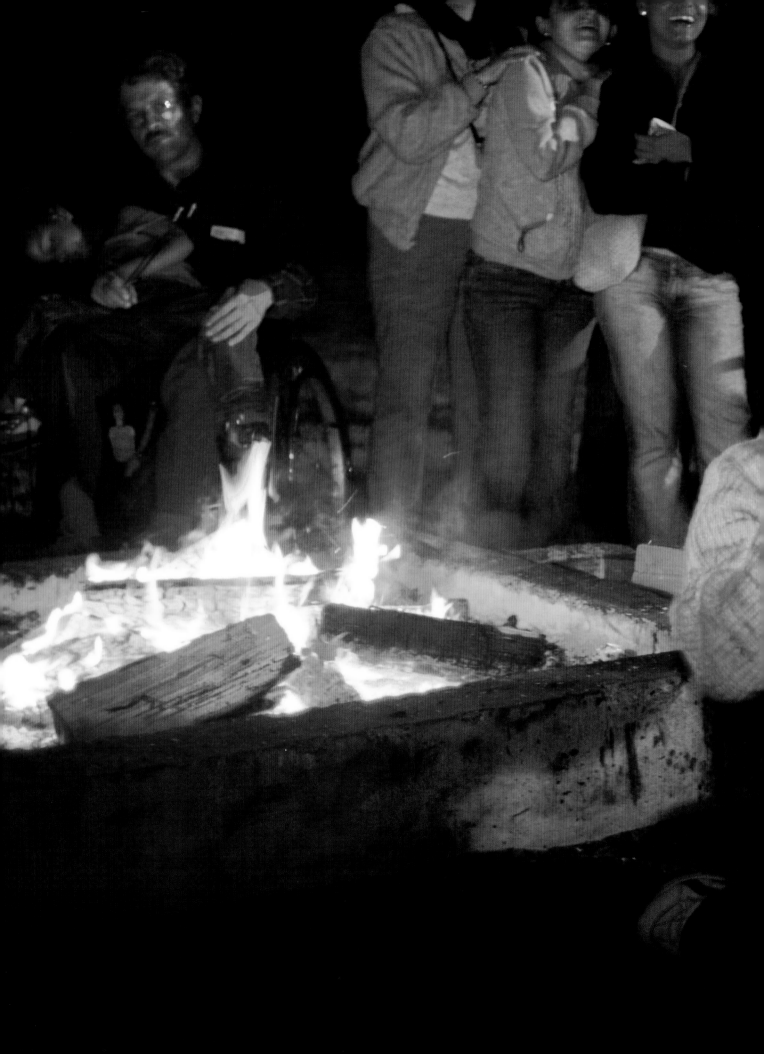

UNITED STATES
ENABLING LEADERS

The America's Junior Miss finals are underway this weekend at the Hilton Hotel in Eugene, Oregon. Girls flock into the elevators wearing tulle and sequins, their performances practiced, faces glowing, eyes on the stars.

I only hope they will grow up to be as beautiful as the WILD women. Thirty delegates from all over the world have gathered for Mobility International USA's third WILD program. The acronym stands for Women's Institute on Leadership and Disability. Participants from 30 countries use 26 spoken languages and seven sign languages. They are blind, deaf, or both; they have had polio, spinal cord injuries, amputations, cerebral palsy, muscular dystrophy, and other disabilities that require crutches, canes, or wheelchairs. They all work with organizations that are improving life for women with disabilities.

This morning is free, so I walk down Eugene's shady streets. There are petunias in front of the city's banks and home-baked dog biscuits in the farmer's market. In the next block, The Saturday market serves tamales, tofu tia, and pad thai; drummers and singers perform; artisans sell tie-dyed T-shirts, Tibetan cards, and scented soap.

I see Ayşe Çiklayedekçi, the Turkish WILD delegate. Together, we marvel at the Celtic jewelry and rawhide drums. She buys hand-painted bookmarks as souvenirs. Anh Loan Luu from Viet Nam appears with her homestay family and their three blond, blue eyed daughters. A bearded artisan notices Anh admiring his fragrant candles and gives her one. Soon, we find Camille Wilson from Jamaica and Magda Trouillot from Haiti, posing in front of a mirror with knitted hats and fuzzy stoles. Many WILD delegates are so accustomed to being stared at that what surprises them is that people here do *not* stare.

Eugene's mayor, Kitty Piercy, has welcomed the delegates. Homestay families feed them, pack their lunches, and drive them to and from meetings. Eugene's Goodwill Industries has prepared a $25 gift certificate in each delegate's name. Last week, local journalists gave them tips on media relations. The transit district has donated passes that enable participants, some of whom have never ridden accessible buses, to travel independently.

The Willamette Valley has beautiful places to bike, fish, canoe, sail, kayak, hike, and jog. Susan Sygall has made it possible for the delegates to swim, camp, go whitewater rafting, and do ropes challenge courses. And more.

SUSAN SYGALL

Perhaps Susan, 53, came by her interest in athletics because her Viennese mother was a world champion figure skater. Perhaps she came by her interest in international travel because her father, born at the border of Poland and Russia, spent fifteen years sailing on ships and spoke nine languages.

Both were Holocaust survivors who did not finish high school. By contrast, Susan grew up in New York, got her BS at the University of California in Berkeley, won a Rotary scholarship for graduate work in Australia, earned a master's degree in therapeutic recreation at the University of Oregon, and received a MacArthur Fellowship, commonly known as the genius award.

Susan, who uses a wheelchair, was injured in an automobile accident when she was eighteen. At Berkeley in the early 1970s, Susan and a few others formed a disabled women's coalition and compared notes. "People were saying to us, 'Ah, too bad, you're nice, but I don't want to go out with you.' Four or five of us would say, 'That happened to me, too!' Instead of feeling bad we decided, 'Those people are crazy. Why are we buying into this? Of course we should think beyond our atrophied legs! Of course we should feel good about ourselves and like who we are! Let's

tell our story the way we want: 'We are loud, proud, and passionate!'" That phrase so aptly described her philosophy that it was copyrighted as the official motto of an organization Susan launched in 1982.

That year, Susan and a friend, Barbara Williams, then a doctoral candidate in therapeutic recreation at the University of Oregon, co-founded Mobility International USA. "We shared a desire for understanding, friendship, and peace among all peoples," recalls Barbara, now a photographer documenting MIUSA's work.

Today the organization runs international exchange and leadership training programs. Susan says, "We've tried to create a family of people with disabilities and their allies. It's expanded to more than 90 countries. Some 2,000 alumni have gone through MIUSA's programs. Through their grassroots contacts, they are changing the world."

"We have always done programs for men and women together, but many times the women didn't speak up or lead. We'd have women's night; they'd come to my house and talk about women's issues and get wild and crazy. We realized there needed to be a unique space for women. As a woman with disabilities,

I feel a sense of responsibility: these are my sisters. Few of us have made it into leadership positions. I thought, if I don't make it happen, who will?"

In 1995, Susan and Cindy Lewis organized a one-day seminar for 250 women at the United Nations Fourth World Conference on Women in Beijing. "It was the best of times and the worst of times. It was the first time so many women with disabilities from all over the world had met; I think of it as the birth moment of the international disabled women's movement. But the place was so inaccessible it was a nightmare."

There have been two other WILD programs, one in 1997, another in 2003. "WILD is very close to me," Susan acknowledges. "There's a feeling of family, a spark that is unique. So much positive energy and caring! I've been doing this a long time, and I am in awe of these women."

WILD is one of the two accomplishments Susan is proudest of. The other: "For 25 years, I traveled all over the world to do trainings. For the past five years, I have chosen to stay in Eugene." Her eyes fill with tears. "I am taking care of my mom, who is 83 and has Alzheimer's. Not an easy decision, but I am proud of it."

Susan doesn't mention her many honors such as Disabled Oregonian of the Year or the President's Award from Bill Clinton. Accolades do not define her. She sees herself at the center of four concentric circles of identity, "First, I am a woman; the second ring is people with disabilities, the third ring is women with disabilities and fourth is Jewish people. I am equally proud of all those."

"In the Jewish tradition, there is *tikkun olam*, "to make the world better." I am lucky to have a way to do my part. I never wanted 'a job.' I wanted something I could be passionate about every day." Her leg begins to jump. When I look alarmed, she assures me, "With a spinal cord injury, spasms are a happy thing, excited.

"I'll tell you what keeps coming to me," she continues, her eyes swimming. "I am so happy and grateful. I am having the most amazing life. Surrounded by incredible women, working with incredible people, I have had the love of incredible parents. I've gotten beautiful recognition for my work; many people work years and don't get recognized. It just doesn't get any better than this. All the dreams I've dreamed have happened. I am grateful for—in awe of—the life I am able to live."

10% of the world's women have mental or physical disabilities
75% of the disabled people in low and middle income countries are women
20% of the world's rehabilitation services go to women with disabilities
1% of the world's women with disabilities are literate
25% of disabled women worldwide are in the workforce (vs. 50% for disabled men)
—Humans Rights Watch, 2006

This afternoon, WILD delegates are learning self-defense. Half pretend to be assailants and the other half greet them with defensive martial arts moves. At first there is nervous laughter but soon the women become serious. They learn to yell, "No! Stop!" and strike at knees and throats, poke eyes, and use their crutches, canes, and wheelchair handles as weapons.

Women with disabilities are vulnerable to violence, especially from family members and caregivers. They are two to three times more likely than other women to experience sexual abuse. Women with disabilities experience forced sterilization and abortion. They are denied information about reproductive health and contraceptives. Their rights to marry and have a family are curtailed. In some countries, it's almost impossible for them to adopt children.

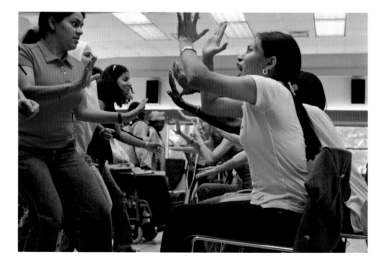

ELIANE MUTESI

WILD delegate Eliane, 26, is Tutsi, the ethnic group that ruled Rwanda until civil war broke out in 1959 and many Tutsis fled into surrounding countries. Eliane was born in Congo. In the mid-1990s, Rwanda experienced devastating genocide. After peace returned, Eliane moved to Rwanda's capital, Kigali. She will finish law school this year. She describes the women with disabilities she works with:

"A lot of people were disabled during the war. Women got their breasts cut off, their arms cut off, their eyes cut out. Men broke women's noses, they have flat noses, there are lots like that. After the war, women were raped; men used branches to penetrate women. Now it is over. There is no more ethnic strife, no more war, no more genocide.

"People think the disabled will get through just like everybody else. But disabled women are very neglected. They are always in the street with their children, spending all day in the sun, always saying: 'I am hungry,' 'Look at my hand,' 'Look at my leg,'

'Help me, help me, even ten francs, please.' Think: if someone asks from morning to night and people give 5 or 10 or 20 francs, at the end of the day, what do they have? The women are not married, so why do they have children? Because they wanted soap. Or clothes.

"It hurts me to see them," Eliane confesses, "I don't have a lot of money, but I can work as a volunteer." She is director of the Disabled Women's Department for Action for Promotion of Local Initiatives for Development.

"I speak with those women to figure out what I can do. I tell them how to protect themselves from AIDS, how to build their skills, what their rights are. I fight sexual violence against them. I try to involve them in our organization, which gives programs in nonviolence and self-respect, and coordinates resources for emotional and financial support, such as teaching soap-making and embroidery."

Susan passes a lighted candle around the circle and invites each delegate to speak a wish for disabled women everywhere. After every sentence there is a buzz of translation. Interpreters sit next to the delegates speaking French, Spanish, and Russian and using sign language. The women wish that all over the world, women with disabilities will have confidence, live without discrimination, be proud of being women, and be loved.

At break, a delegate who is blind walks across the room to the patio door without help from a person, dog, or cane; she has memorized the space. A woman whose fingers are attached to a short arm lights a match deftly. Someone ramps up the music, and spontaneously, everyone dances. The women in wheelchairs do wheelies and turn in circles; they and their chairs are one. Some deaf

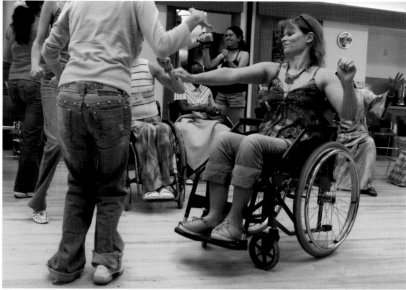

women dance back-to-back and clap shoe soles. Full of energy and exuberance, the 30 delegates raise the roof.

CINDY LEWIS

This evening, everyone goes swimming. Observers are not allowed, so I hear about it from Cindy Lewis, MIUSA's director of programs.

"When we started doing swimming with women, we were stunned by how many said it was the number one, life-changing experience of being here. Many of these women have never worn a bathing suit. It is a big event to get in a pool and not have to be self-conscious. For most, this was their first time in the water. The shallow end was full of women saying, 'Oh, my God, I never thought I would swim.' But you know, there are women who swim Olympic races with one arm."

I tell Cindy, "I heard that a blind woman laughed when floating people bumped her. And that a woman who has hair she can sit on was frightened at first, but when she relaxed she lay back and let her hair free. It floated around her like a halo."

"Yes. These are amazing women."

"How do you find them?"

"We had about 200 applications for the 30 places. We look for women in their 20s and 30s who are affiliated with an organization but do not have years of leadership experience. We want creative thinking and women who can talk specifically, not just rhetorically. We chose one woman per country and try to have diversity of language, region, and disability type. This is the magic mix."

The Spencer Butte ropes challenge course is emotionally, socially, and physically demanding. It teaches about teamwork and relying on others. The MIUSA delegates face their fears, climb, traverse, and succeed. As each woman tries and triumphs, the others cheer for her.

"No one can get hurt; they are safe. The fear is in their minds," Cindy reports.

"It's like a metaphor," Susan says, "about not buying into preconceived notions about what's possible."

Fifteen years ago, MIUSA helped Eugene's Outdoor Program staff develop the Ropes Challenge course.

Then the two organizations collaborated to create a whitewater rafting trip so people with disabilities could enjoy the beauty of the McKenzie River. By modifying the rafting frames to

Photo by Cerise Roth-Vinson

accommodate people in wheelchairs, they made it possible for everyone to paddle and guide the rafts. The WILD women spent a day whitewater rafting before I arrived.

Facing the Challenges of the World

Ukei Muratalieva's mission has led her from her home in Kyrgyzstan to the fir forest of Spencer Butte Park in south Eugene, where she was raised on pulleys Saturday and then dropped in a giant, arcing rope swing called "The Falcon."

"It was fun," she said, adrenaline still pumping several minutes after she was lowered to the ground and released from the swing harness. "Like a bird," she said, laughing between deep breaths. "A very panicked bird."

—Joe Mosely
The Register-Guard
August 13, 2006

Photo by Cerise Roth-Vinson

MABATAUNG KHETSI

Having climbed her first tree, Mabataung, 32, wants to teach other blind women in Lesotho to do it.

"I was so afraid! I was—up! I can't remember what happened, really."

"Think back. What next?" I urge her.

"I went between two or three trees. And came down. It was really amazing. I think even if I return back home and tell them I have climbed a tree they won't believe it."

"How was swimming?"

"Nice. It was warm water. I was floating. I would try it again."

"Did you go whitewater rafting?"

"That was not too bad; I would repeat it. I like this challenge course. Even to be in the water. To be in the boat. I like them. I can see that even if you are disabled or blind you can do everything that able-bodied people can do."

Impressive attitude, I think, for a woman whose sons help her walk to town at home. Mabataung misses her boys, ages ten and three, who "help me a lot. They have their sight because I was not born blind. When I was five years old, I had a rash. My parents took me to doctors who said it was measles. We are eight in my family and it attacked three of us, but I am the only one who became blind. I remember the faces of my parents and my sisters very well."

She learned to use a braille embosser before she entered an integrated school, which she attended, despite discrimination, from third grade through high school. Then she studied communications at International Business College. Today, she works in a telecommunications call center. "It is interesting, well paid, and fun but you have to be polite and listen carefully. There are 20 in my office. I am considered the best," she says proudly. I am not surprised; few people I know listen so well.

Mabataung is president of the Lesotho National League of the Visually Impaired Persons, which annually trains 120 disabled people from all over the country to use a white cane, know their rights, and advocate for themselves. They also learn to make candles. "Our main worry is that after they have been trained, they have no money to buy pots and wax and wicks." Lighting the dark, I say to myself, is no easy assignment.

"Have you learned anything here you can use in your work?" I inquire.

"I learned so much about domestic violence and sexual harassment! I learned that as women we should believe in ourselves and not be misused. We have rights in our country, but can a blind person say she has been ill treated by her husband? They won't believe it. Police won't take a statement. Women just keep quiet and pray to God. But I learned that if you have domestic violence, you can send your husband or partner to a policeman. I really liked that."

The subject of sexuality and disabled women is complicated. Some illiterate women with disabilities believe they cannot become pregnant. Here, I have heard about "night visitors," men who have intercourse with disabled women but don't want to be seen or committed. And about men who are HIV positive, who believe the myth that sex with virgins will cure them, and so rape women with disabilities assuming they qualify. Some women have simply given up hope of having intimate relationships.

CHRISTINE WILK

Christine, 26, and the Empowered Fe Fe's in Chicago have produced a video on sexuality and disability. "It was basically to debunk the myth that women with disabilities don't have sex. That they aren't attractive. That they can't have relationships. We show the video in schools to make people understand we are just like everyone else."

"Tell me about the Empowered Fe Fe's," I ask.

"It's a group of women between 18 and 30 with different disabilities and experiences. We have learned to feel proud of ourselves and our disabilities. We are there for support, to offer our experiences. Everybody comes to the idea on their own: 'Okay, I have a disability, there is nothing I can do to change it, I might as well accept it and live life as normally as possible.'"

"You consider yourself an activist. Give me an example."

"My boyfriend and I went out for Valentine's Day and the people in a bar wouldn't serve me because I looked drunk." (Christine has cerebral palsy.) "It was a very embarrassing and humiliating experience for me. I left thinking 'I can't believe someone would still be that clueless,' but they were. A lawyer wrote a letter for me and the bar staff went through disability awareness training and learned that if someone has a funny walk or takes a little longer to pull out an ID, it doesn't mean they are drunk. The owner wrote me a letter of apology."

Brave as she is, WILD's recreational programs got Christine's attention. "The ropes course was an awesome experience, one I will never forget. We did an exercise called Going In The Trees. I went 50 feet in the air. You go up very slowly, so you look down, then swing 90 feet back and forth. My heart went in my throat. You really lose your breath! I looked terrified! After the second or third swing, I relaxed and had a lot of fun. I'd been swimming but I'd always been a chicken; at first I stayed by the side but eventually I swam in the middle and enjoyed it. Rafting: there were some huge rapids; we went down and then up and I was afraid we were going to flip. The whole raft got wet. But I'm finding I like a little adventure, a little thrill. I think more roller coasters are in the future for me."

HENG LEE CHIN

Lee Chin, 26, and Christine share an age, and a companion. They have been adopted by Desmond Junior, the three-year-old grandson of Ralf Hotchkiss, whose nonprofit, Whirlwind Wheelchair International, helps people with disabilities in developing countries to build wheelchairs from available parts.

Desmond Junior has concluded that Lee Chin must be his age. Not so fast! Lee Chin teaches piano and understands children well. Desmond follows her everywhere (when he isn't ringing the dinner bell with glee).

Like Christine, Lee Chin is an activist. On the flight to Eugene, she even convinced the airline to store her powerwheel chair in the cabin. "They took half an hour to assure themselves the battery was safe, but I stood firm and they finally agreed."

Lee Chin founded a group for people with osteogynesis imperfecta, which caused her disability. "It is very rare. I have only found ten people in Malaysia. When I grew up, I knew I had a disability, but I didn't know what; I never saw people like me. I started this group so others will have friends, a support group, and their families can share."

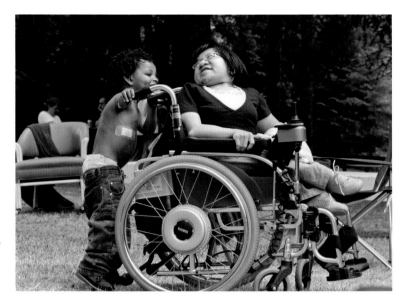

It is buses that most impress Lee Chin about the WILD experience. "The ropes challenge course and the river rafting are exciting but taking the bus means most. I can't even go out of my house alone in my country, it is so inaccessible. Here, I can be independent. I am in charge of my own life. I can't imagine going home; I will lose my freedom."

KAVITA RAMDAS

Eugene's Downtown Athletic Club is a perfect place for a Saturday party. Each woman dresses up to meet Kavita Ramdas, president of the Global Fund for Women, which helps support WILD. She circulates among the tables, listening intently to the women's stories. She speaks Urdu with the delegate from Pakistan and greets others in English, Spanish, and French.

The public joins us for dessert. Homestay families, program sponsors, interested Oregonians, local men and women with disabilities, and journalists jam the ballroom. Susan's mother is here in her wheelchair.

Each delegate has prepared a short speech. Poised, the women stand together and pass the microphone sounding, Susan would say, loud, proud, and passionate. Teuta Halilaj from Albania sings a lyrical love song. Yvonne Zimba from Zambia sings a rousing call to action, *"Ndefwaya uku bako!"* (I want to be part of what we will achieve as women!)

Then Kavita addresses the WILD women as "my colleagues." She remembers that "Women with disabilities rocked Beijing by demanding, 'What kind

of feminist movement is this that can translate into Japanese but not into sign language?'" She is proud that the Global Fund for Women has granted $1.5 million to 111 groups in 59 countries that are working on issues that affect women with disabilities.

The next morning the delegates board two school buses that grind over the hills to the coast. En route, Magda Ivonne Rios, who is from Colombia, videotapes while Aracelis Guerrero from the Dominican Republic gives every delegate a bracelet woven with the colors of her country's flag; the women wear them for the rest of the program. An hour later, the buses cut down through the forest to the shore.

Dina Mohamed Abd Elfattah from Egypt is blind so I try to describe the circling gulls, sandcastles, waves, white wildflowers on the hillside, and clusters of rocks along the shore ("Touch them. They're rough, like cinders.") As we walk, Dina, who works for Barclays Bank in Cairo, tells me she had never before been swimming or river rafting. She now thinks "Disabled women of all kinds, together, can do everything."

Turkish Ayşe Çiklayedekçi splashes her feet in the stream that spills into the sea, and collects stones to remind her of this halcyon place. "See that house up there? I would like to marry the man who lives there, and stay here forever."

Ludmila Iachim from Moldova has always dreamed of beaches (Jenny Chinchilla from El Salvador laughs, "Really? I dream of snow!"). For all her dreams, Ludmila has never actually visited a beach. She wheels her chair into the ocean shallows to collect shells.

Jamaica's delegate, Camille Wilson, is freezing. She huddles under a blanket with Eliane, Isatou Sanyang from Gambia and Saara Hirsi from Somalia. All of them, accustomed to heat, wonder what on earth they are doing at the beach on such a cold day.

The wheelchairs with fat, inflatable tires are a great success. Elenoa Lavetiviti from Fiji takes her turn gliding comfortably over the rocks and sand, and others follow eagerly.

Isabel Arcos from Ecuador walks with crutches the full length of the sandy cove and back. Having used crutches myself, I watch in awe. How can anyone's arms be that strong? Isabel acknowledges that over the past 10 years her strong arms have won Ecuador three gold medals in international wheelchair races.

ISABEL ARCOS

Isabel's first international flight took her from Quito, Ecuador to Miami to Los Angeles to Eugene. "What are your first impressions of the United States?"

"There are lots of ramps. Even the buses have ramps. In my city, not even one bus is accessible." (I keep expecting WILD women to be impressed with Oregon's pure air, spectacular scenery and hospitable people, but delegates rave about ramps. Eugene is not perfectly accessible, but by comparison with cities in the global south, Eugene looks like the gold standard.)

Isabel, who had polio when she was eight months old, works as a secretary in Ambato (90 miles south of Quito), is divorced, and has a teenaged daughter. Having graduated

from university in mass communications, she is the spokesperson and leader of Women with Disabilities.

She also handles media relations for Ecuador's Association of Persons with Disabilities, which she co-founded.

"We want to enforce the laws in our constitution so every person with disabilities can have the same rights, the same access to work. We have one of the best laws in Latin America. Our association fought for this law. Others supported it but we have the most organization, so we were crucial," she says proudly.

The next day, everyone moves to Camp Serene, 40 miles west of Eugene. Relocating 30 people and their possessions is logistically complicated. Lydia Shula, MIUSA's executive project specialist, directs the operation. Some delegates carry their duffel bags into accessible rustic cabins. Watching, our woman bus driver is amazed: "One of them has an issue and three of them are there to help!"

Adroitly, Ayşe pitches her tent in the woods. I engineer mine. It's a while before any of us has time to look around. Tall evergreen trees cover 35 acres. The Long Tom River runs past. Behind the barbeque pit is a spring-fed pond. There is no cell phone reception. There is silence.

DEBBIE KENNEWELL

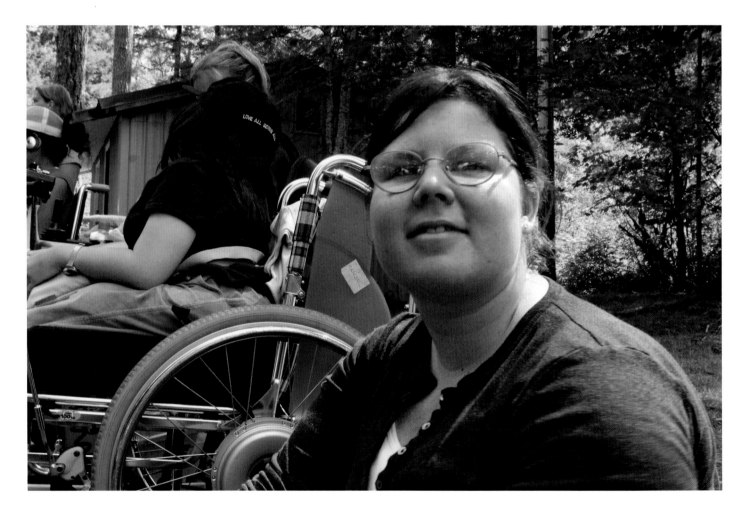

The largest tent on the campground belongs to the deaf women, who pitch it in a circle of trees. Magally Rodriguez from Peru and Magda Rios from Colombia, who are both deaf and blind, prepare to move in. Debbie Kennewell, 22, from Australia and Kelli Barnes, who will interpret for us, join me at a picnic table.

Debbie glances at their blue tent and signs, "Two of the women had never been camping. They said, 'Oh my goodness, how do you do this?' This tent is just like mine, so I helped set it up." She laughs, "I think it's big enough, don't you?"

"It looks like a tent hotel!" I agree.

Three years ago, Debbie and some friends set up an organization called Deaf Youth Networking, which includes youngsters from all over Australia. "We started with ten and now there are 40. We do activities, share ideas, do research. We go camping every year. I love camping!"

I have read that there are two opposing views about deaf people. Audiologists consider deafness to be a deficit but many deaf people consider that an "outsiders view" that breeds paternalistic, discriminatory behavior. The other perspective is that deaf people are a culture whose members relate to the world visually; sign language provides group coherence and identity. I ask Debbie which view she shares.

"Being deaf is definitely not a disability. It is definitely cultural. I do not consider myself disabled at all," she says.

"Then why attend a conference called Women's Institute on Leadership and Disability?" I wonder. "I came to learn, to bring back skills that will help make life more accessible for deaf people, more equal."

Debbie's mother, father, and a sister are also deaf. At first Debbie attended an integrated school with deaf and hearing people, but "my parents were gesturing, talking, and signing at the same time. They decided to put my sister and me in a deaf school to learn Auslan (the acronym for Australian Sign Language). When I was young, speech therapy was compulsory and because my aunts and uncles are hearing, we communicated using voice so we could get to know our entire family.

"As an adult, I do not read lips or use voice. I use my native language, Auslan. It is natural for me in my culture. I went to a deaf school, have deaf friends, am involved in deaf sports and work with deaf teams. Melbourne hosted the 2005 Deaf Olympics. I competed in beach volleyball. We were seventh. It was great fun."

Debbie, a college freshman, would love to teach science in secondary school.

"You are an athlete, an Australian, an activist, a woman, a student, a deaf person. How do you introduce yourself?"

"As a deaf person. I might tell you my name and that I am Australian. But I definitely identify as deaf."

KELLI BARNES

Our sign language interpreter, Kelli, 34, works at the University of Oregon. Kelli even signs talking alone with me. I tease her about this, but she is doing it on purpose: "I want people nearby who are deaf to understand." I reflect on how much information comes from overhearing conversations and how much hurt can occur if others seem to be talking about you.

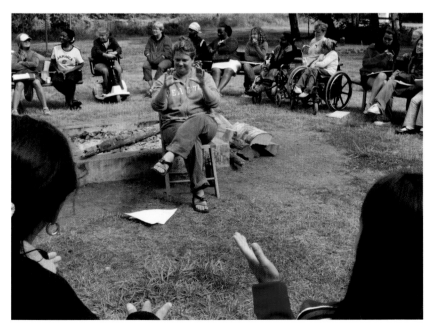

Kelli can hear, but grew up with two deaf brothers. Her whole family used sign language and she learned it when she was two. "I studied deaf education, which celebrates the culture," she tells me. "Deaf people are very visual. They love pantomimes and charades, and do them for entertainment." Martha Pacay from Guatemala demonstrates this one evening when she acts out a story about a mother whose baby won't stop crying. Everyone is captivated, laughing and shouting ideas to calm the infant. Hers is the noisiest "silent" performance I've ever seen.

For three days at Camp Serene, the WILD women attend MIUSA's Gender, Disability and Development Institute. American-based international development organizations, including three headquartered in Oregon, present workshops and discussions.

Lalla Tahara Haidara from Mali is honing her leadership skills as president of the Association of Women with Disabilities of Tombouctou. After a small group discussion we take a break and Lalla surprises everyone with the news she is pregnant with her fourth child, which inspires happy congratulations.

The group sits in the sunshine to role-play different approaches to fund-raising for their organizations. Almost everyone wants to talk with Bessma Mourad from the Global Fund for Women, whose simple application procedure is appealing.

Samia Al-Sayed from Syria wonders where to find funding for her disabled women's organization since the United States has levied sanctions against

Martha Pacay

her country. "Try the UN or funders based in Europe or Asia," someone suggests. At this moment, a butterfly settles on Susan's head and stays. And stays. "That's a good sign!" she says quietly, holding absolutely still.

SAMIA AL-SAYED

Samia, 39, was refused a visa twice but succeeded on the third try. "I am here and it is marvelous. I had traveled to Arab countries (Saudi Arabia, Algeria) and I went to France for medication when I was a child. But this is my first time in the United States. My main dream is to go around the world. And, as a friend said, now I have gone halfway!"

A computer engineer, Samia works in Damascus as IT manager of the biggest hospital in Syria. "I am so glad really, because I proved to others that even disabled, I did something with my life." Due to polio, Samia uses a wheelchair.

"How do you get around Damascus?"

"I worked two jobs at once so I could buy a car. I use it a lot because I can't walk too much. I can drive and be free."

Although she was married for four months, "it was a bad experience. I married a disabled man who used a wheelchair. I chose him and fought my family to marry him, but we struggled for nothing. My degree was better than his. He was not open enough to understand me. Lots of bad things happened. But—only four months. It was okay.

"After getting divorced, I started again. I changed my specialty (I had been doing biomedical engineering in the hospital lab). I studied hard and got a degree in English (my second language was French). Now I am working on becoming a Microsoft-certified engineer.

"I went to a normal school without knowing disabled people. After university, I tried to connect with them. Eleven of us just started an organization for women with disabilities. Also, I volunteer with Japan International Cooperation Agency, and work in the rural areas doing community-based rehabilitation. We help parents start small businesses so they can send their children to school. We loan them money for kiosks where they sell fruit, vegetables, sewing.

"What has it been like for you to stay in an American home?"

"Coming here has changed my point of view. Everything I knew about the USA depended on CNN and the media. All of them are really wrong. Humans everywhere are the same; even in my country they are polite, nice. Here, I learned about everyday living, the shape of houses, dealing with children. And they learned from me."

"For example?"

"Here, children become 18 or so and take off to live alone. In my region, girls and boys don't leave their families until they marry. I am 39 and I live with my family. If the mother and father become older, the child takes care of them. We don't put our parents in a hotel, they live with us. It's hard to imagine, but they tell me that's the culture."

"What did they learn from you?"

"They changed their point of view about a Muslim girl. They found she is clever, she has graduated, she has liberty and can use her skills. I am religious and even though I am disabled, I have a good position, drive a car, do what I want. I have a free life."

"Anything else?"

"I cooked for them. Tabouli with lots of vegetables—and grape leaves rolled around rice, tomato, garlic, onion, lemon, and some spices, cooked in olive oil. They liked that! I like cooking—and making sweets, especially on holidays."

"What would you like me to know that I don't know to ask?"

"About my disability. I am happy about it. It made me strong. I take everything easy because it is God's will, not my fault. I hope I have the strength to do many remarkable things in my life."

"What have you learned here?"

"How to be clever and get things you need. How to fund-raise. How to work in a team—we don't use this way of working. To help each other. Rafting, swimming, lots of things that were in the past like a dream for me.

"Did you like the ropes challenge course?"

"I loved flying. Maybe my next step is to become a pilot!"

ISHRAT FAZAL

Ishrat Fazal from Faisalabad, Pakistan, had polio as a child, and uses a wheelchair. Her parents made sure she was educated. "Pakistani children, not taught about disabilities, pushed my chair fast. I fell in rough places, injured." But in high school, she had "a fortunate accident:" she fell in love with Shawan Shehzad.

Most married women in Pakistan move in with their husbands' families, but Shawan's parents rejected Ishrat "since I was not a normal person." They were embarrassed by her condition and convinced that her children would be disabled.

Today, Shawan earns $50 a month distributing bills for the government's water

and sewage department and Ishrat earns $17 as a coordinator at the Society for Disabled Women. Their income is not enough for their family, which includes two sons and a baby daughter. "We cannot afford transport, a good house, toys, even enough milk," she says.

People in Faisalabad were astounded to hear that Ishrat had been selected to attend a program in the United States. "America is everything," she smiles.

Her sister, who teaches English, helped her learn the language in 15 days. I can't imagine learning a language so quickly and ask for confirmation: "Fifteen days?" In response, she tilts her head diagonally.

"What does this mean," I ask, trying to copy her nod, and she collapses in giggles at my awkward effort.

"Means yes!" she laughs, "Fifteen days!"

Traveling from Pakistan to London to San Francisco to Eugene was not easy. And she is not used to the American palate: "The food is killing me!" But she is overjoyed with her first visit to a beach: "Our ocean is far away."

Although she came here dreaming of living in the United States, by the end of the week she says, "Now I know things to do in Pakistan." She plans to launch a public awareness campaign that will change perceptions of disabled people.

She doesn't yet know it, but she is off to a good start with the media. Her picture will be on the cover of *New Mobility* magazine, which will feature the WILD program in its November 2006 issue.

Teuta Halilaj

Teuta lives in Tirana, the capital of Albania. When she was paralyzed in an automobile accident, she volunteered to give her husband a divorce, little expecting that he would accept immediately. She felt her life had ended. Over time, she says, "I realized one can cry or one can smile. I decided to smile."

Her buoyant energy and vivacious personality make her the center of the action. Watching her dance in her wheelchair inspires everyone to join in.

During a break in a session about raising money, Teuta sits at a Camp Serene picnic table plucking the delegates' eyebrows. Everyone implores me not to take pictures, feeling they look undignified. But Teuta says, with a wink: "This is fundraising! I charge one million US dollars!"

Every evening at Camp Serene, the women have enjoyed campfires, made s'mores with graham crackers and marshmallows, presented funny skits, and played charades—as well as percussion instruments from all over the world.

By the last day of the program, the delegates have collected all they can carry from Goodwill: a giant teddy bear for Camille, a bag full of stuffed animals for Ayşe, a

beaded lavender dress for Yvonne. Samia, a frugal shopper, has filled five bags for $25. Karine Grigoryan from Armenia has loaded up with gifts for her physical therapists.

The delegates have written action plans to improve life for people with disabilities in their own countries. But one plan is for them: they create a team to design a website so they can share best practices and stay in touch.

On the other coast, a United Nations committee has also been meeting for three weeks. It has taken five years to draft the *Convention on the Protection and Promotion of the Rights and Dignity of Persons with Disabilities*. On August 26, the committee agrees to a document that the General Assembly will approve in December and that countries will ratify, starting in March 2007. The Convention confirms the equality of women with disabilities. It is the first human rights convention of the 21st century.

Before I leave Eugene, I stand at the front of the meeting room and thank the WILD delegates for allowing me to photograph and interview them. "I have looked at the photographs every night and they are beautiful because you are beautiful."

Jenny Chinchilla from El Salvador is crying when she comes to hug me. "People don't usually think we are pretty," she says as she gives me a printed prayer. On the back she has written, "You have discovered the beauty."

Susan presents me with a WILD T-shirt. Wendy Padilla from Honduras and Alejandra Venegas from Chile, thinking about the title of this book, show me how they sign "good morning," a gesture like the rays of the sun.

Teuta escorts me to the door in her wheelchair. She takes off a beautiful bracelet with pale, faceted stones, and puts it on my wrist. When I get on the airplane, only window seats are left. As we lift off, sunshine bounces off my new bracelet sending spangles dancing all over the ceiling. Passengers around me look up. Where are the sparkles coming from? I smile to myself. From women who light the dark.

WILD WOMEN IN ORDER OF APPEARANCE:

Ayşe Çiklayedekçi
Turkey

Anh Loan Luu
Viet Nam

Camille Wilson
Jamaica

Magda Trouillot
Haiti

Eliane Mutesi
Rwanda

Ukei Muratalieva
Kyrgyzstan

Mabataung Khetsi
Lesotho

Christine Wilk
United States

Heng Lee Chin
Malaysia

Teuta Halilaj
Albania

Yvonne Zimba
Zambia

Aracelis Guerrero
Dominican Republic

Dina Mohamed Abd Elfattah
Egypt

Ludmila Iachim
Republic of Moldova

Jenny Chinchilla
El Salvador

Isatou Sanyang
Gambia

Saara Hirsi
Somalia

Elenoa Lavetiviti
Fiji

Isabel Arcos
Ecuador

Debbie Kennewell
Australia

Magally Tudith Minaya Rodriguez
Peru

Magda Ivonne Rios
Colombia

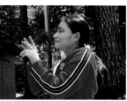
Martha Pacay
Guatemala

Lalla Tahara Haidara
Mali

Samia Al-Sayed
Syria

Ishrat Fazal
Pakistan

Karine Grigoryan
Armenia

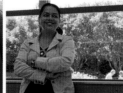
Wendy Padilla
Honduras

Alejandra Venegas
Chile

Maria Constantin
Romania

ACKNOWLEDGEMENTS

Women who Light the Dark would not exist without people who live all over the world: teachers who helped me learn my craft; travel agents who helped me navigate the globe; program officers who paved the way; well-connected people who opened doors; friends who gave advice and ideas; interpreters who helped interview and check facts; specialists who contributed background information; photographers who offered pictures of events I didn't see; subject-matter experts and writers who reviewed the manuscript and shared suggestions; the publishing team that transformed the project into a volume; professionals who helped promote the book and create the website, www. womenwholightthedark.com. I enjoyed working with each of them and am grateful for their time, expertise, and encouragement: Mim Adkins, Mathilde Agoustari, Maya Ajmera, Myriam Alami, Ashley Allen, Ioana Apostol, Angelika Arutyunova, Jennifer Astone, Kiki Bauer, Mandy Behbehani, Florigna Bello, Debbie Bertouchi, Balbir Singh Bhasin, Robert Blunt, Maricruz Gonzáles Cárdenas, Joan Chatfield-Taylor, Margaret Cheikosa, Anna Chemhere, Archana Chhetri, Patience Chizodza, Linda Clever, Craig Cohen, Jean Comaroff, Alev Lytle Croutier, Marge d'Wylde, Annie May de Bresson, Wes Del Val, Nancy Deyo, Sarah Dotlich, Ellen Dudley, Christine Eida, Estelle Freedman, Rodolfo Rivero Gil, Ann Marie Ginella, Tessa Gordon, Tiya Gordon, Leanne Grossman, Esther Hewlett, Abby Hill, David Hill, Darril Hudson, Stephen Huyler, Bour Inthava, Brenda Juwao, Margaret Kaufman, Jackie Keith, Anoop Khurana, Viera Klementova, Zuzana Klemenska, Patricia Klever, Susan Krieger, Jena Lee, Jing Lyman, Evelyn Mafeni, Regina Marler, Sheherazade Matallah, Gladys Sonia García Marcel, Magdalene Mayer, Nicky McIntyre, Maria McKee, Fatema Mernissi, Babu Mohapatra, Juanita Montalvo, Becky Morris, Muadi Mukenge, Jessica Mupotsa, Lucia Murinova, Nicoline Nche, Melissa Nunan-Lew, Irvine Nyamapfene, Rachida Ouldba, Pry Phally Phuong, Pech Polet, Daniel Power, Josefina Ramon, Charo Marquez Ramos, Khadija Rhachi, Gemmah Riushoko, Kim Roberson, Carol Roberts, Marcela Rodríguez, Sara Rosen, Cerise Roth-Vinson, Ly Rozamy, Nicole Sanchez, Rob Sangster, Scott Sangster, Seak Sina, Gayatri Sharma, Nina Smith, Liz Spander, Loveline Afor Tangwan, Nguyen Thu Thanh, Dechen Tsering, Daoud Tyler-Ameen, Verónica Ruiz Viteri, Jenifer Wanous, Alex Webb, Nick Weist, Barbara Williams-Sheng, Jeany Wolf, Soraya Yar, Kinyny Florena Yerima, Zeina Zaatari.

Information, Contacts, and Bibliography

Women in this book live in very different environments. The United Nations Human Development Index (HDI) is a composite of each country's life expectancy, education, and income. The Gender Development Index (GDI) adjusts that number to reflect the disparity between women and men.

	HDI	GDI	Female Life Expectancy (15+ years)	Female Literacy Income	Female Earned Income	Ratio Female to Male Earned By Women	% Parliament Seats Held
United States	8	8	80.2	--	30,581	.62	15.0
Argentina	36	32	78.4	97.2	9,258	.53	36.5
Slovakia	42	36	79.2	--	6,764	.58	16.7
Cuba	50	--	79.5	99.8	--	--	36.0
Brazil	69	55	74.8	88.8	6,004	.57	9.1
Ecuador	83	--	77.5	89.7	2,796	.55	16.0
Viet Nam	109	80	72.9	86.9	2,271	.71	27.3
Nicaragua	112	88	72.4	76.6	1,747	.32	20.7
Morocco	123	95	72.2	39.6	1,742	.25	6.4
India	126	96	65.3	47.8	1,471	.31	9.2
Cambodia	129	97	60.1	64.1	2,007	.74	11.4
Nepal	138	106	62.4	34.9	995	.50	6.7
Cameroun	144	109	46.2	59.8	1,435	.49	8.9
Zimbabwe	151	113	36.0	--	1,527	.58	20.8
Kenya	152	111	46.5	70.2	1,037	.83	7.3

Source: United Nations Development Program, Human Development Report 2006

Organizations whose contact information is asterisked are grantees of the Global Fund for Women.

INTRODUCTION
Contact:
The Global Fund for Women, Kavita Ramdas, President and CEO, 1375 Sutter Street, Suite 400, San Francisco, California 94109; Tel: 415-202-7640; Fax: 415-202-8604; Email: gfw@globalfundforwomen.org; Website: http://www.globalfundforwomen.org
More Reading:
Piercy, Marge, The Moon Is Always Female, Alfred A. Knopf, New York, 1980 (Poem excerpted from "The Low Road.")

ARGENTINA
Contact:
*La Casa del Encuentro, Fabiana Tuñez, Rivadavia Av. 3917, Buenos Aires, Argentina; Tel: 54-11-49-82-25-50; Email: desdenosotras@yahoo.com.ar; Website: http://www.lacasadelencuentro.com.ar
*Las Lunas y Las Otras, Silvia Palumbo, Estados Unidos 2272, Dpto. A, Buenos Aires, 1227, Argentina; Tel: 54-11-4942-4976; Email: spalumbo@infovia.com.ar; Website: www.silviapalumbo.com.ar
More Reading:
"Encontradas." Edición Mensual, Ano 1, Noviembre 2004, Diciembre 2004, Abril 2005; Edición Aniversario Octubre-Noviembre 2005
Human Rights Watch, Human Rights Developments, http://www.hrw.org/worldreport99/Americas/Argentina.html
International Gay and Lesbian Association, World Legal Survey, http://www.ilga.info/information/legal_survey/Americas/argentina.htm

BRAZIL
Contact:
*Bahia Street, Rita de Cassia Dos Santos Conceição, Director, Rua do Sodré No 413, Centro Dois de Julho, Salvador, Bahia 40060240, Brazil; Tel: 011-55-71-322-7680 or 011-55-71-353-2610; Email: ritacliff2003@yahoo.com.fr or ritacliff@terra.com.br; Website: http://www.bahiastreet.org
More Reading:
"Brazil: No Black and White Matter," The Economist, July 15, 2006, p.38
Buarque, Cristovam, "Causas da vergonha," Epoca, August 4, 2003

CAMBODIA
Contacts:
*Strey Khmer, Dr. Pen Ricksy, President, #2 Deo, Street 294, Sangkat Tonle Bassac, Khan Chamcarmon, Phnom Penh, Cambodia; Tel: 855-012-862-985; Tel/Fax: 855-023-996-457; Email: streykhmer@yahoo.com.kh
*Cambodian Women's Crisis Center, Sin Lypao, #42F, Street 488, Sangkat Shar Deum Thkaov, Khan Chamkarmon, P.O. Box 2421, Phnom Penh, Cambodia; Tel/Fax: 855-023-982-158; Email: cwccpnp@cwcc.org.

kh or cwccpp@gmail.com; Website: http://www.cwcc.org.kh
Women's Network for Unity, c/o Womyn's Agenda for Change, #1, Sisowath Quay, Srah Chork, Khan Daun Penh, P.O. Box 883, Phnom Penh 12000, Cambodia; Tel: 855-012-222-171; Tel/Fax: 855-023-722-435; Email: womensnetwork@womynsagenda.org; Website: http://www.womynsagenda.org/programs/sexworker/SW/swnu.html
*Free Trade Union of Workers of the Kingdom of Cambodia, Lay Sopheap, #28B, Street 222, Sangkat Boeng Raing, Khan Daun Penh, Phnom Penh, Cambodia; Tel/Fax: 855-023-216-870; Email: ftuwkc@forum.org.kh
More Reading:
Attacks and Threats Against Human Rights Defenders in Cambodia Briefing Paper, Cambodia League for the Promotion and Defense of Human Rights, December 2006
Becker, Elizabeth, "When the War Was Over: Cambodia and the Khmer Rouge Revolution," Public Affairs, New York, 1988
Boothe, Karen Louise, "Cambodian Shelter Jittery Year After Attack," Women's E-News, January 17, 2006
Brouwer, Andy, Mu Sochua Giving Women Voice, September 2006, http://andybrouwer.blogspot.com/2006/08/mu-sochua-giving-women-voice.html
Brown, Louise, Sex Slaves: The Trafficking of Women in Asia, Virago Press, London, 2001
"Cambodia, Where Sex Traffickers are King," New York Times, January 15, 2005
Chandler, David P., A History of Cambodia, West View Press, Boulder, 2000
Collins, Jennifer and Kuch Naren, "Two Unsolved Rapes and Killings Belong to a Larger Trend as More Cambodians Report Sexual Assaults," The Cambodian Daily, May 13-14, 2004
"Constraints Faced by the Garment Industry," Cambodian Review, January 2006
Consultative Group Meeting, Council for the Development of Cambodia, Statement by Her Excellency Mu Sochua, Minister, http://www.cdc-crdb.gov.kh/cdc/musochua_statement.htm
"Cracking Down on Sex Traffickers," International Herald Tribune, January 25, 2006
Evans, Kate, "Meet the New Urban Woman," Phnom Penh Post, February 24, 2006
Gilboa, Amit, Off the Rails in Phnom Penh: Into the Dark Heart of Guns, Girls, and Ganja, Asia Books, Bangkok, 2000
Harding, Andrew, Trapping Cambodia's Sex Tourists, BBC News, June 11, 2005, http://newsbbc.co.uk/1/hi/programmes/from_our-own-correspondent/4078304.stm
Human Trafficking, Cambodia, http://www.humantrafficking.org/countries/cambodia
"Invisible Chains, Sex Work and Slavery," Anderson Cooper 360 Degrees, CNN, January 28, 2007

Jenkins, Carol, "Cambodian Sex Workers Conduct Their Own Research," Research for Sex Work, Issue 8, June 2005
Jenkins, Carol and Andrew Hunter, "Empowering Sex Workers, Does It Matter?" June 2005, http://www.alternativevisions.org/publications/empowering%20sex%20workers.pdf
Kristof, Nicholas D., "A Cambodian Girl's Tragedy: Being Young and Pretty," New York Times, December 12, 2006
Lynne, Liz, "Debate on Sex Trafficking in Cambodia," European Parliament speech, January 11, 2005, www.lizlynne.org.uk/speeches/3.html
McDermid, Charles and Cheang Sokha, "Unsafe Abortions Take Huge Toll," Phnom Penh Post, January 13-26, 2006
Mills, Edward; Beth Rachlis; Ping Wu; Elaine Wong; Kumanan Wilson; Sonal Singh, "Media Report of Tenofovir Trials in Cambodia and Cameroon," BMC International Health and Human Rights, August 24, 2005, http://www.pubmedcentral.nih.gov/articlerender.fcgi?artid=1242229
Mithers, Carol, "The Garden of Evil," O, The Oprah Magazine, November 2004
Mu Sochua, "Message, Dear Friends and Colleagues," http://www.samrainsyparty.org/srp_activity/2006/decemvber/message_from_musochua.htm
Mu Sochua, http://www.hughsroom.com/musochua.html, http://www.wshu.org/news1/newsaudio/sochua
"Mu Sochua is Recipient of Vital Voices Anti-Trafficking and Human Rights Award," April 26, 2005, http://www.vitalvoices.org/desktopdefault.aspx?page_id=219
Mydans, Seth, "Cambodian Leader Cracks Down in Bid to Solidify Power," New York Times, January 9, 2006
Poynton, Dan, "Sex Workers' Violent Lives," Phnom Penh Post, Issue 15/25, December 15-29, 2006
Schwartz, Abigail, "Sex Trafficking in Cambodia," The Journal of Asian Law, Volume 17, Number 2, Spring 2004
"A Sudden Outbreak of Niceness," The Economist, February 25, 2006, p.50
Trafficking in Persons Report, Office to Monitor and Combat Trafficking in Persons, U.S. Department of State, June 5, 2006, http://www.state.gov/g/tip/rls/tiprpt/2006/65983.htm
2006 Transparency International Corruption Perceptions Index, http://www.infoplease.com/ipa/AO781359.html
Trafficking in Women and Girls, Facts & Figures on Violence Against Women, UNIFEM, http://www.unifem.org/campaigns/november25/facts_figures.php?page=5
"U.S. Research Community May Take Lessons in Medical Ethics from Cambodian Prostitutes," August 12, 2004, Alliance for Human Research Protection, http://www.ahrp.org/infomail/04/08/12.php
Vicheka, Lay, "Cambodian Women and Barriers to Social Participation," January 3, 2005, http://www.mekong.net/Cambodia/barriers.htm

"Women Garment Workers and the Impact of Trade Liberalization in Cambodia," Newsroom, UNIFEM East and Southeast Asia Regional Office, January 14, 2005, http://www.unifem-eseasia.org/newsroom/CMD-GW-050217.htm

CAMEROUN
Contact:
*Cameroun Medical Women Association, Grace Fombad, Bamenda Provincial Branch, First Floor, New Life Annex Building, Rooms 1 and 2, Hospital Roundabout, P.O. Box 548, Mankon Bamenda, North West Province, Cameroun, West Africa; Tel: 237-7323604 or 7619858 or 7880414; Email: cammedwomass@yahoo.com
More Reading:
Altman, Lawerence K., "Grandmothers from Africa Rally for AIDS Orphans," *New York Times*, June 6, 2006
Dugger, Celia, W. "Ford Foundation to Announce Africa Initiative," *New York Times*, June 2006
Rural Poverty Portal, *Rural Poverty in Cameroon*, http://www.ruralpovertyportal.org/english/regions/africa/cmr/index/htm

CUBA
Contact:
Centro Pro Danza, Laura Alonso, Ave 51 No. 11805, esquina a 118, Marianao, La Habana, Cuba; Tel: 53-260-91-42 or 260-86-10
More reading:
Alonso, Alicia, http://michaelminn.net/androa/index.php?alonso_alicia
Campoy, Ana, "Ballet, Cuba's Enduring Revolution," http://journalism.berkeley.edu/projects/cuban2001/story-ballet.html
DePalma, Anthony, "What Was Once Theirs," *New York Times*, January 21, 2007
Harvey, David Alan, *Cuba*, National Geographic Society, 1999
Mantavia, Karina, "Where There's Smoke," *The London Independent*, March 4, 2998
Mirror Dance, Alicia Alonso and the National Ballet of Cuba, http://www.pbs.org/independentlens/mirrordance/balletcuba.html
Pasanovas, Pablo, "Fernando Alonso: Classic Ballet in the Land of Rumba," January 2005, http://www.cubanow.net/global/loader.php?&secc=6&cont=show.php&item=93
Sanchez, Martha, Laura Alonso, *Maitres of All*, Ministry of Foreign Affairs, Republic of Cuba, June 2004, http://www.cubaminrex.cu/English/Look_Cuba/Culture/LauraAlonso

ECUADOR
Contacts:
*Fundación Ecuatoriana de Acción y Educación para la Promoción de la Salud (FEDAEPS), Irene León, Directora General, Baquerizo Moreno 166 y Tamayo (Casilla-PO Box-17-21-1404), Quito, Ecuador; Tel: 593-2-222-3298; 223298; 2556964; 2904242; Fax: 011-593-2-252-4481; Email: director@fedaeps.ecuanex.net.ec
Escuela Dolores Cacuango, Blanca Chancoso, Coordinadora, Julio Matovelle 1-28 entre Vargas y Pasage San Luis, Edif. El Conquistador, 1er. Piso, Quito, Ecuador; Tel: 593-02-2580700; Fax: 593-02-2580713; Telefax: 593-02-2239188; Email: esdcecua@uio.satnet.net; Website: http://www.ecuarunari.org, http://mujerkichua.nativeweb.org
More Reading:
Adams, Dick, "Fight for Identity, Justice: The Indigenous People of Ecuador Are United in Their Fight," *St. Petersburg Times*, February 21, 2000
"International Women's Day—Ecuador: Indigenous Women—Still a Long Way to Go," Inter Press Service, March 10, 2003, http://www.quechuanetwork.org/news_template.cfm?lang=2&news_id=619
León, Irene, editor, *For a Diverse and Plural Millenium*, Agencia Latinoamericana de Información, Quito, 2001
León, Irene, editor, *Action Plan and Specific Declarations*, Agencia Latinoamericana de Información, Quito, 2001
León, Irene, editor, *Women in Resistance, Experiences, Visions and Proposals*, Agencia Latino Americana de Información, Quito, 2005
Macdonald, Theodore, "Voices of the Unvanquished: Indigenous Responses to Plan Columbia," *Cultural Survival Quarterly*, Winter, 2003
Segundo, Saca Q. and Luis Quizhpe Q., Inés Tene S. Fanny, *Elementos Culturales que Identifican A Los Indígenas Saraguros, in Los Aspectos: Tecnólogicol, Administrativo-Jurídico y Ecólogico*, Federación Interprovincial de Indigenas, Saraguros, 2001

Saavedra, Luis Angel, "Growing from the Grassroots," *New Nationalist*, May 2003, http://www.newint.org/issue356/growing.htm

INDIA
Contact:
Ruchika Social Service Organization, Mrs. Inderjit Khurana, 3731-A, Sriram Nagar, Samantarapur, Old Town, Bhubaneswar 751 002, Orissa, India; Tel: 91-674-2340583 or 91-674-2340746; Email: rssobbs@hotmail.com or info@ruchika.org; Website: http://www.ruchika.org
More Reading:
Briski, Zana, *Born Into Brothels: Photographs by the Children of Calcutta*, Umbrage Editions, New York 2004
Chauhan, Raj and Preeti, *Ruchika Visit*, http://www.ashanet.org/siliconvalley/projects/ruchika/set_visit_2002_ruchika.html and *Waiting for Rajdhana*, http://www.ashanet.org/nycnj/events/2002/20020120-indventure/projects/train.htm
Heydlauff, Lisa, *Going to School in India*, Shakti for Children/Global Fund for Children, 2005
Inderjit Khurana, www.pbs.org/opb/thenewheroes/meet/khurana.html
Innovators for the Public, www.ashoka.org/node/2544
Kumar, Hari/Gentleman, Amelia, "AIDS Groups in India Sue to Halt Patent for U.S. Drug," *New York Times*, May 12, 2006
Mishra, Pankaj, "The Myth of the New India," *New York Times*, July 6, 2002, A23
Train Platform Schools, www.globalfundforchildren.org/ourwork/profile_india_india.html

KENYA
Contact:
*Groups of Women in Water and Agriculture, Kochieng, Norma Adhiambo, P.O. Box 569, Ahero 40101, Kenya; Tel/Fax: 254-57-2020939; Email: nadhiambo@yahoo.com
More Reading:
Finnegan, William, "Leasing the Rain," *The New Yorker*, March 21, 2003
"Girls to Get Sanitary Pads," *The Standard*, January 30, 2006, p.8
Ngome, Joseph, "Thirst Amid Search for Solutions to Water Problems," *Kenya Times*, November 7 2005
Ojanji, Wandera, "Hit by Drought, Rains Promise Nothing," *The Sunday Standard*, April 15, 2006
Ojwang, Anderson, "Ray of Hope for Villages Ravaged by Epidemics," *The Standard*, January 2, 2006, p.16
United Nations Summary, Human Development Report 2006, *Beyond Scarcity: Power, Poverty and the Global Water Crisis*, http://hdr.undp.org/hdr2006/pdfs/summaries/HDR2006_English_Summary.pfd
"Waterborne Diseases Afflict Half of Kenya's Population," *Angola Press*, June 17, 2006, http://www.angolapress-angop.ao/noticiae.asp?ID=259534
"World Bank, Water Problems, Poverty Linked," *Kenya Times*, March 17, 2006

MOROCCO
Contacts:
*Association Démocratique des Femmes du Maroc, Rachida Tahri, President, 9, Rue Dixmude, 2 Étage, App. 6, Benjdya, Casablanca 20012, Morocco; Tel: 212-22-44-25-93; Fax: 212-23-21-45-47; Email: adfmcasa@menara.ma
*Théâtre Aquarium Maroc, Naima Zitan, President/Metteur en Scène, 4, Rue Karbala, Appt. No. 6, Rabat, Morocco; Tel: 212-63-13-24-79 or 212-66-16-22-39; Email: nazitane@yahoo.fr
More Reading:
Ghazalla, Iman, *Sculpting the Rock of Women's Rights*, University of Minnesota Center on Women and Public Policy, 2001, http://www.hhh.umn.edu/centers/wpp/sculpting_rock_rights.html
Guide to Equality in the Family in the Maghreb, Women's Learning Partnership for Rights, Collectif 95 Maghreb-Egalite, 2005
"In His Father's Shadow," *The Economist*, April 8, 2006, pp.45-6
Laskier, Michael, "A Difficult Inheritance: Moroccan Society Under King Muhammad VI," *Middle East Review of International Affairs Journal*, Vol. 7, No. 3, September 2003
Mohammed VI & Salma, http://www.nettyroyal.nl/salma1.html
National Guidelines in Morocco—National Plan for the Integration of Women to Development, http://www.ilo.org/public/English/employment/gems/eeo/guide/maroc/topic1.htm

Soudan, François, "Islamist Movements in Morocco: The Saber and the Quran," *World Press Review*, Vol. 49, No. 11, http:www.worldpress.org/mideast/752.cfm
Tahri, Rachida, *Women's Political Participation: The Case for Morocco*, Pretoria, South Africa, November 2003

NEPAL
Contacts:
*Swati, Sangita Nirola, Executive Director, P.O. Box 8361, Maharajgunj, Kathmandu, Nepal; Tel/Fax: 977-1-444-0320; Email: info@swatinepal.org.np; Website: http://www.swatinepal.org.np
*Empowering the Women of Nepal, Lucky Chhetri, P.O. Box 284, Lakeside, Khahare, Pokhara-6, Nepal; Tel: 977-61-524066 or 977-61-540231; Fax: 977-61-532249; Email: ewn@3sistersadventure.com; Website: http://www.3sistersadventure.com/EWN
Sisters' Creation, Perfect Corn-Husk Handicraft, Laxmi Nakarmi, Proprietor, Lalitpur, Sundhara, Tyagal Tole, Kathmandu, Nepal; Tel: 977-1-554-0334; Email: dirga_nakarmi@hotmail.com or meee1002000@yahoo.com
More reading:
"Candidates Hide Away," *Bangkok Post*, January 29, 2006
Costello, Jeanne, "Trekking through Nepal," *Monterey County Life and Times* pp.D1, 3
Kaplan, Robert D., "Who Lost Nepal," *Wall Street Journal*, December 20, 2005
Nepal's Path to Peace 2006, Reuters Chronology, www.alertnet.org
"Power Grab Protest vow," *Bangkok Post*, January 28, 2006
Ranjitkar, Siddhi B., "Sincerity of Nepal's King," *Scoop Independent News*, April 24, 2006, http://www.scoop.co.nz/stories/HL0604/S00276.htm
Sengupta, Somini, "As Nepal Shakes Up Ancient Order, All Is Up in the Air," *New York Times*, December 17, 2006
Sengupta, Somini, "Nepal, in a Climate of Contradictions, Prepares to Vote," *New York Times*, January 31, 2006
"Three into Two," *The Economist*, November 26, 2005, p.52

NICARAGUA
Contact:
*Asociación de Mujeres Constructoras de Condega, Amanda Centeno, De la Escuela Julio Cesar Castillo Ubau, 2 Cuadras y Media Al Norte, Condega, Depto. De Esteli, Nicaragua; Tel: 505-752-2303; Fax: 505-752-2203; Email: mcc@ibw.com.ni, hshears@ns1.sdnnic.org.ni
More Reading:
Campañeras, Ed. by Gaby Juppers, Latin American Bureau, London, 1994
Collison, Helen, *Women and Revolution in Nicaragua*, Zed Books, London, 1990
Ferrari, Melissa, "Interview with Amanda Centeno Espinoza, Coordinadora, Asociación Colectivo de Mujeres Constructoras" *Ms. Magazine*, October 26, 1999, http://www.homemakers.com/Ms_Interview.html
Ropper, Alison, *Fragile Victory, Nicaraguan Community at War*, George Weidenfeld & Nicholson Ltd., London, 1987

SLOVAKIA
Contacts:
Cultural Association of Roma in Slovakia, Helena Jonasová and Andrea Bucková, Na Hrbe 16, Banská Bystrica, Slovak Republic; Tel/Fax: 421-905-740-849 or 421-48-414-8552; Email: kzrsr@kzsr.sk; Website: http://www.kzsr.sk
Chessboard, Ivana Cickova, Kyncelovska cesta 42, Banská Bystrica, 97401; Tel: 421-904-532-984; Email: kzrsr@kzrsr.sk
Hope for Children, Jolana Nátherová, Manager, P.O. Box 12, Banská Bystrica 974 11, Slovak Republic; Tel: 412-48-4130698; Email: hfc@stonline.sk or Jolana@ozhol.sk
*Slovak-Czech Women's Fund, Viera Klementová, Country Director for Slovak Republic, Baštová 5, 811 03 Bratislava 1, Slovak Republic; Tel/fax:. 421-254-417-937; Email: klementova@womensfund.sk; Website: http://www.womensfund.sk
More reading:
Body and Soul, Forced Sterilization and Other Assaults on Roma Reproductive Freedom in Slovakia, Center for Reproductive Rights, 2003
Bucek, Jan, *Land, Ownership and Living Environment of Roma Minority in Slovakia*, Department of Human Geography, Comenius University, Bratislava, Slovakia, http://lgi.osi.hu/ethnic/relations/bucek

Case Study, Slovakia: Labour, Equality and Bread, Spolu International Foundation, www.spolu.nl/m3c5_casestudy_sk.html

Decade of Roma Inclusion, www.romadecade.com

The Euromosaic Study, Romani in Slovakia, Research Center on Multilingualism, http://ec.europa.eu/education/policies/lang/languages/langmin/euromosiac/slok3_en.html

Fonseca, Isabel, *Bury Me Standing: The Gypsies and Their Journey*, Vintage Departures, October 1996

Gypsies, www.goodmagic.com/carny/gypsies.htm

History of Banskà Bystrica, www.bbb.sk

McCann, Colum, "The EU's Ugly Little Challenge," *Los Angeles Times*, January 6, 2007

Orgovanova, Klara, *Roma in Slovakia*, www.slovakia.or/society-roma.htm

Panna, Cinka, "The Roma Musician Who Conquered Austro-Hungary," www.spectacularslovakia.sk/ss2003/13_cinka_panna.html

Pohl, Otto, "Gypsies Gain a Legal Tool in Rights Fight," *New York Times*, May 7, 2006, p.6

Poverty and Welfare of Roma in the Slovak Republic, The World Bank, Foundation S.P.A.C.E., Ineko, The Open Society Institute, 2002

Sanford, Allister, *Day to Day*, NPR, April 27, 2004

Sdruzeni Dzeno, *Brief Analysis of Roma Migration from Slovakia to Czech Republic*, Prague, Czech Republic (undated)

"Separate and Unequal for Gypsies," editorial, *New York Times*, March 11, 2006

Slovak Helsinki Committee, *Report on the Implementation of the Framework Convention of the Council of Europe on the Protection of Minorities in Slovak Republic*, September 1999, http://www.minelres.lv/reports/slovakia/NGO/slovakia_NGO.htm

Slovakia, January–December 2004, Amnesty International, http://web.amnesty.org/report2005

VIET NAM
Contacts:
* Center for Studies and Applied Sciences in Gender, Family, Women and Adolescents (CSAGA), Nyguen Van Anh, Director, P.801-B3 Lang Quoc te Thang Long, Tran Dang Ninh, Cau Giay, Ha Noi, Viet Nam; Tel: 84-4-7569869, 84-4-7569547; Fax: 84-4-7560869; Email: csaga@fpt.vn or vananhnguyen@csaga.org.vn; Website: http://www.csaga.org.vn/default.en.asp

More Reading:
"Curious What the Future Holds? Consult a Fable," *Viet Nam News*, January 22, 2006, p.10

Country Presenters Outline Struggle Against Violence, December 2, 2003, United Nations, Bangkok, http://www.unifemeseasia.org/newsroom/dv%20conference3%20-%2002122003.htm

"Domestic Violence Law to Protect Women, Families," *Viet Nam News*, June 11, 2006, http://vietnamnews.vnagency.com.vn/showarticle.php?num=03POL061106

"Empower Women to Help Children: Gender Equality Produces a 'Double Dividend' that Benefits Both Women and Children, UNICEF Reports," *Unicef Media Centre*, Hanoi, December 11, 2006, http://www.unicef.org/Vietnam/media_5421.html

The Issue: Violence Against Women and the International Response, http://www.unifem.org/campaigns/november25/issue.php

Luke, Nancy et. Al., "Exploring Couple Attributes and Attitudes and Marital Violence in Vietnam," *Violence Against Women*, Vol. 13, No. 1, 5-27, Sage Publications, 2007, http://vaw.sagepub.com/cgi/content/abstract/13/1/5

Mainstreaming Gender Equality in Family in Vietnam's Population and Reproductive Health Programmes, Swiss Agency for Development and Cooperation, United Nations Population Fund

Martignoni-Bourke, Joanna, *Implementation of the Convention on the Elimination of All Forms of Discrimination against Women by Vietnam*, World Organization Against Torture, Geneva, July 2001

"More Countries Have Laws Banning Domestic Violence, Says UN Women's Rights Official," *UN News*, November 22, 2006, http://www.unifem.org/news_events/story_detail.php?StoryID=552

Rydstrøm, Helle, "Encountering 'Hot' Anger", *Violence Against Women*, Vol. 9, No. 6, 676-697, Sage Publications, 2003, http://vaw.sagepub.com/cgi/content/abstract9/6/676

"Training on Counseling Skills Against Domestic Violence for staff of Women Union," Evaluation Report, 2004, http://www.ngocentre.org.vn

United Nations Convention on the Elimination of All Forms of Discrimination Against Women, Consideration of Reports Submitted by States Parties under Article 18 of the Convention on the Elimination of All Forms of Discrimination Against Women, Vietnam, June 22, 2005

United Nations General Assembly, *In-Depth Study on All Forms of Violence Against Women*, Report of the Secretary General, July 6, 2006

United Nations, *Vietnam National Action Plan*, http://www.un.org/womenwatch/daw/country/national/vietnam.htm

WHO Multi-country Study on Women's Health and Domestic Violence Against Women, Initial Results on Prevalence, Health Outcomes and Women's Responses, World Health Organization, Geneva, 2005

"Women's Union Tackles Domestic Violence," *VietNamNet Bridge*, March 14, 2006, http://english.vietnamnet.vn/social /2006/03/550137

UNITED STATES OF AMERICA
Contact:
*Mobility International USA, Susan Sygall, CEO, 132 E. Broadway, Suite 343, Eugene, Oregon 97401, USA; Tel: 541-343-1284; Fax: 541-343-6812; ˅ Email: info@miusa.org; Website: http://www.miusa.org

More Reading:
American Deaf Culture, http://www.signmedia.com/info/adc.htm

Bose, Joeyta, "UN GA Passes Landmark Convention on Rights of Persons with Disabilities," *International Women's Tribune Centre*, GlobalNet #315, December 21, 2006, http://www.iwtc.org/315.htm

Byzek, Josie, "The WILD Women: Challenge Yourself, Challenge the World," *New Mobility Magazine*, November 2006, http://newmobility.com/review_article.cfm?id=1217&action=browse

Curulla, Mary Ann and Jennifer Strong, "Community Partnerships for Inclusion Challenge Course Development-Empowering Exercises for the Disabled: Eugene, Oregon and Mobility International USA," *Parks and Recreation*, May 2000, http://www.findarticles.com/p/articles/mi_m1145/is_5_35/ai=63090610

Mosley, Joe, "Facing the Challenges of the World," *Register-Guard*, August 13, 2006

Schemo, Diana Jean, "Turmoil at Gallaudet Reflects Broader Debate Over Deaf Culture, *New York Times*, October 21, 2006, A9

United Nations, *Convention on the Rights of Persons with Disabilities*, http://www.un.org/disabilities/convention/facts.shtml

Women and Girls with Disabilities, Human Rights Watch, http://hrw.org/women/disabled.html

ZIMBABWE
Contact:
*The Girl Child Network, Betty Makoni, Director, 131 Duri Road, Unit F, Seke, Chitungwiza, Zimbabwe; Tel: 263-70-21509 or 263-91-288251; Fax: 263-70-31132; Email: gcn@zol.co.zw; Website: http://www.gcn.org.zw

More Reading:
"Attorney General's Office Defends Decision in Msindo trial," *The Herald*, June 9, 2006

Bartholomew's Notes on Religion: Mugabe's Sects Appeal Wears Off, February 18, 2006, http://blogs.salon.com/0003494/2006/02/18

"Chipadze Primary Deputy up for Indecent Assault," *The Mehanda Guardian*, March 24-30, 2006

"Chitungwiza Man Faces Indecent Assault Charges," *The Herald*, June 1, 2005, Court Reporter column

Hammer, Joshua, "Letter from Zimbabwe, Big Man; Is the Mugabe Era Near Its End?" *The New Yorker*, June 26, 2006

"I Was Framed, Macheke Teacher Tells Court" *The Herald*, February 3, 2006

"Macheke Rapist Convicted," *The Herald*, March 18, 3006

"Matron Held Door Whilst Girl was Raped" *The Sunday Mail*, March 19-25, 2006

Court Reporter, "Msindo Granted $10M bail," *The Herald*, April 8, 2006, p.8

Mungure, Blessing, "MPs, Chiefs Implicated in Rape; Comment, Intensify War on Child Sexual Abuse," *The Manica Post*, April 7-13, 2006, p.1, 4

"Msindo Charged with Rape," *The Standard*, February 12, 2006

"Ngezi School Boarding Master Fired," Motsi, Tandayi, *The Herald*, March 24, 2006

"Obadiah Msindo Arrested," *The Herald*, April 4, 2006, p.1

"Odzi Man Accused of Raping His Three Sisters," *The Herald*, February 8, 2006

"Police Dither on Msindo Rape Trial," *The Standard*, March 12, 2006

"Rapist Gets 10-Year Jail Term," *The Herald*, March 24, 2006

"Teenagers Accused of Rape," *The Herald*, February 3, 2006

UN Office for the Coordination of Humanitarian Affairs, *Zimbabwe: Activists Demand GBV Law*, March 7, 2006; *More Children Abused as Situation Worsens*, January 23, 2006; *Tackling the Impact of Customs on AIDS*, August 17, 2004; http://www.irinnews.org/

"Zimbabwe: Can It Get Worse?" *The Economist*, May 27, 2006, p.46

"Zimbabwe: Poor Wretched Women," *The Economist*, March 18, 2006, p.50

INTERNATIONAL WOMEN
More Reading:
Borges, Phil, *Women Empowered: Inspiring Change in the Emerging World*, Rizzoli, New York, 2007

D'Aluisio, Faith and Peter Menzel, *Women in the Material World*, Sierra Club Books, San Francisco, 1998

Demonte, Claudia, *Women of the World: A Global Collect of Art*, Pomegranate, San Francisco, 2000

Ehrenreich, Barbara and Arlie Russell Hochschild, *Global Women: Nannies, Maids and Sex Workers in the New Economy*, Metropolitan Books, New York, 2002

Eicher, Joanne B. and Lisa Ling, *Mother, Daughter, Sister, Bride: Rituals of Womanhood*, National Geographic, 2005

Freedman, Estelle B., *No Turning Back, The History of Feminism and the Future of Women*, Ballantine Books, New York, 2002

Gianturco, Paola and Toby Tuttle, *In Her Hands: Craftswomen Changing the World*, powerHouse Books, New York, 2004

Gianturco, Paola, *Celebrating Women*, powerHouse Books, New York, 2004

Gilligan, Carol, Byllye Avery, Wilma Mankiller, Letter Cottin Pogrebin, and Marie C. Wilson, *Woman*, Running Press Book Publishers, Philadelphia, 2000

Goldman, Paula, *Imagining Ourselves: Global Voices from a New Generation of Women*, New World Library, Novato, 2006

Kasmauski, Karen and Peter Jaret, *Impact from the Frontlines of Global Health*, National Geographic, Washington D.C., 2003

McCorduck, Pamela and Nancy Ramsey, *The Futures of Women, Scenarios for the 21st Century*, Warner Books, New York, 1996

Murray, Anne Firth, *Paradigm Found: Leading and Managing for Positive Change, Learning from the Early Years of the Global Fund for Women*, New World Library, Novato, 2006

Nebenzahl, Donna and Nance Ackerman, *Womankind: Faces of Change Around the World*, The Feminist Press at the City University of New York, New York, 2003

Nouraie-Simone, Fereshteh, *On Shifting Ground: Muslim Women in the Global Era*, The Feminist Press at the City University of New York, New York, 2005

Saibi, Zainab, *The Other Side of War: Women's Stories of Survival and Hope*, National Geographic, Washington DC, 2006

United Nations Development Program, "Gender-related development index," *Human Development Report 2006*, pp.363-383

Whittaker, Dane E., *Transforming Lives $40 at a Time, Women + Microfinance: Upending the Status Quo*, Copyright Dana E. Whitaker, Opening Eyes, Berkeley, 2007

INDEX

Abaya Hotel (Bamenda, Cameroun), 200
Abd Elfattah, Dina Mohamed, 225, *232*
ADFM (Morocco), 53, 54, 55
Adhiambo, Norma, 145, *145*, 146, 147, 152, 153, 157
Africa Inland Church (Kenya), 151
Ahrrare, Latefa, 64
AIDS. *See* HIV-AIDS
Al-Sayed, Samia, *228*, 228–29, 230, *232*
 alcoholism, 106, 195
Alonso, Alberto, 46, 47
Alonso, Alicia, 46–47, 48
Alonso, Fernando, 46–47, 48
Alonso, Iván, 48
Alonso, Laura, *45*, 45–49
American Ballet Theatre (New York City), 47
Annapurna mountain range (Nepal), 133, 134–36, 140
Ano, Njokom Thaddeus, 212
Apostolic faith (Zimbabwe), 22
Arcos, Isabel, *225*, 225–26, *232*
Argentina, 78–97
 Catholic Church, 82, 84, 97
 domestic violence against women, 81
 lesbians in, 4, 78–83, 87–88, 90–96
 military/political repression, 80, 93
 the Process, 80, 82
Arya, Arun, 179
Association of Persons with Disabilities (Ecuador), 225–26
Association of Women with Disabilities (Tombouctou, Mali), 228
Atemo Ugwe well (Kenya), 158–59
Auslan (American Sign Language), *227*
avian flu, 145
Awah, Alfred Anye, 202–3
Awuonda, Dick, 149, 150

Bafoussam (Cameroun), 200
Bahia Street (Salvador, Brazil), 114–15, 116–17, 118–25
Bajracharya, Basundara, 130
ballet, Cuban, 4, 42, 45–49
Ballet Classic (Havana), 45
Ballet Nacional de Cuba (*formerly* Ballet Alicia Alonso), 47, 48
Ballet Russe de Monte Carlo, 46
Bamenda (Cameroun), 200, 205
Bamenda airport (Cameroun), 202
Banská Bystrica (Slovakia), 102, 106
Barnes, Kelli, 226, *227*, 227–28
Basnet, Sajalta, 141
Batista, Fulgencio, 47
Battambang (Cambodia), 170
beer girls (Cambodia), 170
Berger, John, 6
Bhaktapur (Nepal), 130
Bhattacharya, Sandya, *163*, 163–64
Bhubaneswar (India), 162, 163
Bhujel, Parvati, 130
Bhus'andpur school (India), 166
Bih, Patricia, *209*, 209–10
bilharzia, 144
Bobo, Reginah, 14, 15
Bomba, Gillian, 23
Boutazzout, Dounia, 64
Brazil, 112–25
 Bahia Street, 114–15, 116–17, 118–27
 domestic violence against women, 114
 education, 114, 115, 125 (*see also* Bahia Street)
 favelas (shantytowns), 4, 114, 115–16, 122–24
 sexualized culture of, 124
 slavery in, 114, 119
Bucaram, Abdalá, 77
Bučko, Marian, 107–8
Buckova, Andrea, *114*, 110–11
Buena Vista Social Club (Havana), 42
Buenos Aires, 80, 81

Cambodia, 168–83
 CWCC, 176–77
 domestic violence against women, 171, 172, 176, 178, 181
 garment workers, women, 178, *178*–80

government corruption, 172
 Khemara, 172
 Khmer Rouge, 172, 177–78
 midwives in, 181
 poverty, 173
 sex trafficking, 4, 172, 173, 176, 178
 sex workers, 172–73, 174–76
 Womyn's Agenda for Change, 174–76
Cambodian Women's Crisis Center (CWCC), 176–77
Cameroun, 198–213
 economy, 202
 government corruption, 202
 orphans in, 201, 206–7, 211
 sexual practices, 201, 212
 traditional medicine, 209
Cameroun Medical Women Association. See CMWA
Camp Serene (Oregon), 226–28, 230
capoeira (dance), 116
Carreño, Jose Manuel, 47
Cartibani Dos Santos, Nilson José, 124, 124–25
La Casa del Encuentro (Buenos Aires), 80–83, *86*, 87–89, 90–92, 94, 97
La Casa de las Lunas (Buenos Aires), 81, 92, 96
caste system, 132
Castro, Fidel, 47
Catholic Church (Argentina), 80, 82, 95
Catholic Institute for International Relations, 187
Ceafro (Salvador, Brazil), 120
CEDAW (Convention on the Elimination of all Forms of Discrimination against Women), 39, 53
Celebrating Women (Gianturco), 4
Centeno Espinoza, Amanda, *186*, 186–87, 197, *197*
Center for Studies and Applied Sciences in Gender, Family, Women, and Adolescents. *See* CSAGA
Centro Pro Danza (Havana), 45–46, 47–49
Chan Sin, 177–78
Chancoso Sanchez, Blanca, *75*, 75–77
Chaplin, Charlie, 102
Charles Darwin University (Australia), 201
Che, Regina, 207, 211, *211*
Cheong Ek (Cambodia), 181
Chessboard (Slovakia), 106, 107
Chhetri, Dicky, 134, 135–36
Chhetri, Lucky, *135*, 134–37, 140–41
Chhetri, Nicky, 134, *135*, 135–36
Chhetri Sisters' Guest House (Pokhara, Nepal), 134
Chihota Empowerment Village (Zimbabwe), 11
Chikowero, Robinson, 26–27
"Child Abuse and Exploitation" (Matanga), 23
child rape in Zimbabwe, 4, 11, 14, 18–19, 22, 24, 26, 27
Chinchilla, Jenny, 225, 231, *232*
Chinhire, Sarah, 15, 23
Chinyoka, Loveness, 19
Chitsotso Empowerment Village (Zimbabwe), 27
Chitsotso mountain (Zimbabwe), 10, 26
Chizodza, Patience, 22
Chomba (Cameroun), 202
Ciansio, Maria Angelica, *96*, 96–97
Cickova, Ivana, *106*, 106–8, 110
Çiklayedekçi, Ayşe, 216, 225, 226, 230, 232
Clinton, Bill, 208
CMWA (Cameroun Medical Women Association), 200–202, 204–7, 211, 212
Communists, 101, 103
Community Technical and Commercial College (Bamenda, Cameroun), 208
CONAIE (Confederation of Indigenous Nations of Ecuador), 76
Conceição, Juliana Santos, *117*, 117–18
Conceição, Rita De Cassia Dos Santos, 114, *115*, 115–16, 123–24
Condega (Nicaragua), 184–85, 191, 193
Confederación de los Pueblos de Nacionalidad Kichua del Ecuador (Ecuarunari), 76
Confederation of Indigenous Nations of Ecuador (CONAIE), 76
Confucianism, 31, 35
Constantin, Maria, 232
contacts, 234–36
Convention on the Elimination of all Forms of Discrimination against Women (CEDAW), 39, 53

Convention on the Protection and Promotion of the Rights and Dignity of Persons with Disabilities, 231
Coquelicot (Théâtre Aquarium, Morocco), 61–63
Córdoba Pérez, Claudia Julieht, 194, *194*
CSAGA (Center for Studies and Applied Sciences in Gender, Family, Women, and Adolescents; Viet Nam), 31–32, 36, 37, 38, 39. *See also* Sharing Together Club
Cuba, 40–49
 ballet in, 4, 42, 45–49
 economy of, 42
Cuban school of ballet, 47
Cultural Association of Roma (Slovakia), 108–11, *111*
Cunado, Elida, 91, *91*
CWCC (Cambodian Women's Crisis Center), 176–77
cycle cart schools (India), 167
Czechoslovakia, 103. *See also* Slovakia

Dachau (Germany), 101
deafness, perspectives on, 227
Deaf Olympics (Melbourne, 2005), 227
Deaf Youth Networking (Australia), 227
de Almeida, Barbara Daltro, 122, *122*
de Araujos Santos, Rafaela, 121, *121*
Decade of Roma Inclusion (2005–2015), 101
de la Cruz Inlago, Georgina, *74*, 74–75
de la Fuente, Carola, 93, 93–94
de los Angeles Rodriguez, Mariana, 193, *193*
del Socorro Salinas Lira, Idania, 192, *192*
Demian (Camerounian boy), 205–6, *206*
Democratic Union (Argentina), 93
Desdenosotras (Argentina), 81
Desmond Junior. *See* Hotchkiss Jr., Desmond, 224
Destiny of Africa Network, 19
Deurali (Nepal), 137
Devil's Violin, 107
Diaghilev, Sergei, 46
diarrhea, 153
Dina (Cambodian woman), 179–80
Dirty War (Argentina), 80
Disabled Women's Department for Action for Promotion of Local Initiatives for Development (Kigali, Rwanda), 219
Dolores Cacuango School (Quito, Ecuador), 77
dowry system, 132

The Economist, 14, 102
Ecuador, 66–77
 biodiversity in, 71
 childbirth, 69–70
 CONAIE, 76
 Constitution, 72, 76
 discrimination, 71–72, 74
 domestic violence against women, 72
 Ecuarunari, 76
 FEDAEPS, 71, 74
 indigenous movement, 76–77
 Pachakutik movement, 76
 traditional medicine, 69–70, 71
Ecuarunari (Confederación de los Pueblos de Nacionalidad Kichua del Ecuador), 76
Eida, Christine, 123
El Ouazzani, Mbarka, 56–57
Empowered Fe Fe's (Chicago), 223
Empowering the Women of Nepal, 133–34, 135–36, 139, 140–41
Eparrei, 119
Espejo, Eugenio, 75
Eugene (Oregon), 216, 225
European Union, 101
Everest, Mount (Nepal), 133

favelas (Brazilian shantytowns), 4, 114, 115–16, 122–24
Fazal, Ishrat, *229*, 229–30, *232*
FEDAEPS (Fundación Ecuatoriana de Acción y Educación para la Promoción de la Salud; Ecuador), 71, 74
Federal University (Bahia, Brazil), 114, 116, 119
Federation of Woman Entrepreneurs Associations of Nepal's Forum, 133
feminism, 89, 95
Fernandez, Carla Cecilia, 95, *95*

Ferreiro, Emilia, 125
Fez (Morocco), 64
Fish Tail Lodge (Pokhara, Nepal), 134
Fombad, Grace, *200*, 200–202, 204, 207, 211
Fombad, Rudolf, 200–201, 204, 205, 208, 211
Fons Against AIDS (Cameroun), 212
Free Trade Union of Workers (FTU; Cambodia), 179
Freire, Paulo, 125
FTU (Free Trade Union of Workers; Cambodia), 179
Fuh, Tamanji Gregory, 205, *205*
Fundación Ecuatoriana de Acción y Educación para la Promoción de la Salud (FEDAEPS; Ecuador), 71, 74

garment workers, Cambodian women, *176*, 176–78
Gayanendra, King, 129
GCN clubs. *See* Girl Child Network
GDI (UN Gender Development Index), 39, 234
Genocide Museum (Cambodia), 176
"The Girl Child" (Chinhire), 23
Girl Child Network (Zimbabwe), 4, 10, 11, 14–15, 18–19, 22, 26–27
Girl's Empowerment Villages (Zimbabwe), 10, 11, 26–27
Global Fund for Women, 4–5, 6, 97, 103, 149, 224–25
Gómez Calderón, Mauricio Ramón, *190*, 190–91
Gonzáles, Adriana, *190*, 190
Gonzáles Ruíz, Nery, 188, *188*
Goodwill Industries (Eugene, Oregon), 216
grassroots women's groups, selection for study, 4–5
Grigoryan, Karine, 230, *232*
Groups of Women in Water and Agriculture, Kochieng (GWAKO), 145, 147, 149–59
Guerrero, Aracelis, 225, 232
Guevara Centeno, María Elia, 191, *191*
Gutiérrez, Lucio, 77
GWAKO (Groups of Women in Water and Agriculture, Kochieng), 145, 147, 149–59
"gypsies" (Roma; Slovakia), 4, 101–9

Haidara, Lalla Tahara, 228, *232*
Hakkaoui, Bassima, 57, 57
Halilaj, Teuta, 224, *230*, 230–31, *232*
handicrafts, Nepalese, 130–31, 132
Hannah Arendt Institute (Buenos Aires), 89
Ha Noi (Viet Nam), 30, 31, 32
Hassan II, King, 53
Havana, 42
HDI (UN Human Development Index), 234
Himalayan Mountaineering Training Institute (Darjeeling), 134
Hirsi, Saara, 225, *232*
HIV-AIDS
 in Cambodia, 173, 179
 in Cameroun, 4, 201, 202–3, 204, 209–10, 212
 in Ecuador, 74
 in Kenya, 146, 154
 in Zimbabwe, 11
Hmong women, 36–37
Ho Chi Minh, 34
Hoàng Kim Thanh, 32, 34–36, 39
Holocaust, 101
Hope for Children (Slovakia), 103, 104–5, 106
Hotchkiss, Ralf, 224
Hotchkiss Jr., Desmond, 224
House for Nicaragua (England), 189
Human Rights Watch, 218
Hurricane Mitch (1998), 187
Hwange Empowerment Village (Zimbabwe), 11

Iachim, Ludmila, 225, *232*
India, 4, 160–67
 Bhus'andpur school, 166
 donations following earthquake, 5
 homeless children in, 162–63
 Nirak'arpur school, 165
 Rama's story, 165
 RSSO, 167
 Train Platform Schools, 162, 163–67
India Railway, 165, 166
In Her Hands (Gianturco and Tuttle), 4, 5, 27, 111
Institute for International Cooperation and Development, 187
International Labor Organization, 133

International Women's Day, 54
Internet, 133
Isabel, Princesa, 114
Isaitu, Veronica, *206*, 206–7
Islam, 53, 54
"I Will Not Be Silent," 22

Jackson International Ballet Competition, 47, 48
Japan International Cooperation Agency, 229
Jenkins, Carol, 174
Jonasova, Helena, *108*, 108–9, 110
Jossour (Morocco), 56, 62

Kashambira, Clifford, 22
Kasmi, Rachid, 64
Kathmandu (Nepal), 128, 129
Kennewell, Debbie, *226*, 226–27, *232*
Kenya, 142–59
 family finances, 151
 GWAKO, 145, 147, 149–59
 Kobura Primary School, 150
 Kodeyo well, 151
 Kokwaro well, 154
 Lifewater Community Church, 159
 Nyamonge well, 155–56
 Nyangande Primary School, 150
 orphans in, 154
 Pacop well, 151
 Ranjira Primary School, 149, 150
 religion, 159
 sanitary napkins in, 149–50
 St. Catherine's well, 157
 water access/waterborne diseases, 4, 144–45, 146–47, 155 (*see also* GWAKO)
Khemara (Cambodia), 172
Khetsi, Mabataung, 222, *222*, *232*
Khmer Rouge, 172, 177–78
Khurana, Inderjit, *162*, 162–63, 167
Killing Fields (Cambodia), 178
Kisumu (Kenya), 146
Kitchen God legend, 30–31
Kobura Primary School (Kenya), 150
Kodeyo well (Kenya), 151
Kokwaro well (Kenya), 154

Lake Victoria (Kenya), 144
Landa, Maria Alejandra, 92, *92*
Lavetiviti, Elenoa, 225, *232*
Lay Sopheap, *179*, 179–80
Heng, Lee Chin, 224, *224*, *232*
Leiper, Scott, 172
Lema, Josefina, 70
Leopold I, King, 101
lesbians, Argentine, 4, 80–83, 87–89, 90–96
Lesotho National League of the Visually Impaired Persons, 222
Le Thi Hong, Giang, 32, 34–35
Levi, 179
Lewis, Cindy, 218, *220*, 220–21
Lifewater Community Church (Kenya), 159
Linh Tam hotline (Viet Nam), 32
Lotus Outreach (Cambodia), 179
Las Lunas y las Otras, 96, 97
Luo language (Kenya), 157
Luu, Anh Loan, 216, 232

Macedo, Camila Barbosa, 120, *120*
Madres de la Plaza (Argentina), 80
Maffia, Diana, 89
Maharana, Sushan, 167
Mahmbo Awah, Grace, *203*, 203–4
Mahuad, Jamil, 77
Makoni, Betty, 10, 11, 18, 19, 22, 24, 26–27
Malakar, Gaurie, 128, 129, 130, 132, 133
Malik bin Anas, 53
Mama Carmen, *68–69*, 69–72
Mandizvidza, Carol, 18
Manta Base (Ecuador), 77
Manyine (Kenya), 149
Maoists (Nepal), 129, 136
Mapfumo, Pamela, 15
Marzano, Veronica, 89, 89–90
Masere, paramount chief, 10
Matallah, Scheherazade, 55, 56–57

Matanga, Enia, 23
Math (Cambodian woman), 180
Mazango, Nyasha, 22, 26, 27
McCann, Colum, 102
McDonald's, 180
Mginbo (Cameroun), 204
MIUSA (Mobility International USA), 217–18, 220–21, 226–28
Mlynárčiková, Marianna, *110*, 110–11
Mobility International USA. *See* MIUSA
Modernists (Morocco), 54
Mohammed, Prophet, 55, 147
Mohammed VI, King, 54
Montesano, Marta, 81, 82, 82–83, 87
Moreira, Daza Ifá Ashanti, 119, *119*
Morocco, 4, 50–65
 CEDAW ratified by, 53
 Coquelicot, 61–63
 domestic violence against women, 64
 literacy, 56
 Moudawana, 53, 54–55, 56, 61
 religious makeup of, 55
 Rouge + Bleu = Violet, 64
Mosely, Joe, 221
Mother Teresa, 39, 160
Moudawana (Family Code; Morocco, 1957), 53, 54–55, 56, 61
mountain guides, Nepalese women, 4, 133–37, 139–41
Mourad, Bessma, 228
Moyo, Costa, 22
Mrenica, Ján Berky, 108
Msindo, Obadiah, 19, 22, 24, *24*
Mufanebadza, Charmaine, 23
Mugabe, President, 19
Mujeres Constructoras (Nicaragua), 187–97
Muratalleva, Ukei, 221, 232
Mu Sochua, 172–74, 176, 178, 183, *183*
Mutesi, Eliane, *219*, 219–20, 225, *232*
My Hao district (Viet Nam), 38

Nairobi, 147
Nakarmi, Laxmi, 129
Nátherová, Jolana, 101, *103*, 103–5, 110
National Guard (Nicaragua), 184
National Museum (Cambodia), 175
National Plan of Action to Integrate Women in Development (Morocco), 54, 56
National Women's Meeting (Mar del Plata, Argentina, 2005), 87, 90, 91
Nazis, 101
Neh, Rose, *205*, 205–6
Nepal, 126–41
 biodiversity in, 140
 Empowering the Women of Nepal, 133–34, 135–36, 139, 140–41
 handicrafts in, 128–29, 130
 mountains, 133
 political history, 129
 Swati, 128–29, 130–32, 133
 tourists, 135
 women's health, 136–37
 women taxi drivers, 4, 128, 131, 130–31, 135
 women trekking guides, 5, 133–37, 139–41
New Mobility, 230
Nguyen, Van Ahn, 32, *33*, 34–36, 38, 39
Niba Alleh, Vanesa, 207, 208
Nicaragua, 184–97
 alcoholism in, 195
 domestic violence against women, 195
 Mujeres Constructoras, 187–97
 tradeswomen in, 4, 188–90, 192–93, 194–96
Night of the Walking Sticks (Argentina), 93
night runners (Kenya), 145
Nirak'arpur school (India), 165
Nirola, Sangita, 128, *132*, 132–33
Nyamajikia, Barbara, 18
Nyamonge well (Kenya), 155–56
Nyando (Kenya), 146
Nyangande Primary School (Kenya), 150
Nzekumbe, Comfort Binwing, *202*, 202–3

Obuon, Gabriel, 147, 155
Ojuna, Gideon, 145, 146–47, 159

Olima, Leocadia, 147, 150, 154–55, *155*, 159
Olweny, Samson Akomo, 159
Onunga, James, 151
Operation Restore Order (Zimbabwe), 11
Oredo, Dorothy, 155
Orissa (India), 167
orphans
 in Cameroun, 201, 206–7, 211
 in Kenya, 154
 in Slovakia, 106–7
"Orphans" (Mufanebadza), 23
osteogynesis imperfecta, 224
Oulmakki, Abdullatif, 56–57, 62
Oulmakki, Naima, 56, 60, *60*, 62–64
Outdoor Program (Eugene, Oregon), 221
Oxun, 119
Oyoo, Benjamin, 145, 146–47, 159

Pacay, Martha, 227, *228*, *232*
Pachakutik movement (Ecuador), 72
Pacop well (Kenya), 151
Padilla, Wendy, 231, *232*
Palacio, Hugo Alfredo, *77*
Palumbo, Silvia Mariel, *96*, 96–97
Panna, Cinka, 107–8
Penh (Cambodia woman), 171
Pen Ricksy, *180*, 180–81
Peralta, Bertalicia, 197
Peron, Eva, 80
Peronism (Argentina), 93
Peronist Women's Party (Argentina), 80
Pha (Cambodian woman), 180
Phirl, Ellito, 18
Phnom Penh (Cambodia), 171
photographs, power of, 6
Piaget, Jean, 125
Picasso, Pablo, 102
Piercy, Kitty, 216
Piercy, Marge, 5
Plan Colombia, 77
Pokhara, 132
Pol Pot, 175
Pothana (Nepal), 136
the Process (Argentina), 80, 82
prostitutes in Cambodia, 172–73, 174–76
Pry Phallg Phuong, 174
Puri (India), 162

Quarrels (Zitan), 56
Quichua people (Ecuador), 69–72, 75
Quilombo (Brazil), 119
Qur'an, 53

Rabat (Morocco), 52, 60
Raça, 119
Rai, Indra, 135, 139
Rai, Sharmila, 128, 129, 130–31
Rai, Sita Maya, 139, *139*
Rama (Indian girl), 165, *165*
Ramdas, Kavita, 4, *224*, 224–25, 234
Ramos Rocha, Aracely, 196, *196*
Ranjira Primary School (Kenya), 149, 150
Red de Mujeres (Nicaragua), 193
Rico, Ada, 82, *86*, 87, 90, 97
Rios, Magda Ivonne, 225, 226, *232*
Rodriguez, Magally, 226, *232*
Roma people (Slovakia), 4, 101–9
Rorn (Cambodian woman), 179, 180
Rouge + Bleu = Violet (Théâtre Aquarium, Morocco), 64
RSSO (Ruchika Social Service Organization; India), 167
Ruíz Peralta, Rosa Argentina, 195, *195*
Rusape Empowerment Village (Zimbabwe), 11, 26
Rushoko, Gemma, 26
Rwanda, 219

Salvador da Bahia (Brazil), 116
Sam Rainsy Party (Cambodia), 172, 173, 183
Sandinistas, 186
Sanyang, Isatou, 225, *232*
Saraswati Puja, 141
scarification (skin cutting), 201, 210
Sears, 179
Seda, Millicent, 156

The Seven Patriarchal Commandments, 86, 87
sex trafficking/sex workers in Cambodia, 4, 170–71, 172–74, 176
sexuality and disability, 222–23
Sharing Together Club (Viet Nam), 35–37, 38
Sharma, Gayatri, 135, 136, 137, 141
Shears, Helen, 189, *189*
Shehzad, Shawan, 229–30
Sherukuru Primary School (Mutasa, Zimbabwe), 22
Shona culture (Zimbabwe), 18
Shula, Lydia, 226
sign language, 227
Sihanouk, King, 177
Sin Lypao, 176–77
Skalli, Nouzha, 53, *53*, 54
Slovak-Czech Women's Fund, 103
Slovakia, 99–111
 alcoholism, 106
 domestic violence against women, 107
 education, 104, 108
 family planning, 107
 housing, 108
 orphans in, 106–7
 Roma experience, 5, 101–9
Society for Disabled Women (Pakistan), 230
Somoza Debayle, Anastasio, 186
Sposito, Monica, 88, *88*
St. Catherine's well (Kenya), 157
The Standard (Zimbabwe), 19
Steve Biko Institute (Salvador, Brazil), 117
Stories of Women (Zitan), 56
Strey Khmer (Cambodia), 180–81
Sunnis, 55
Swati (Nepal), 128–29, 130–32, 133
Sygall, Susan, 216–18, *217*, 220, 231

Tafnout, Mina, 53, *53*
Tahri, Rachida, 54, 55
Tamufor, Gideon, 209
Tapa, Sangita, 131
taxi drivers, Nepalese women, 5, 128, 129, 130–31, 135
Ta Xua commune (Viet Nam), 36–37
Temara (Morocco), 60
Tet (lunar New Year; Viet Nam), 30
Thailand, 174
Thapa, Bishnu, 139, *139*, 141
Théâtre Aquarium (Morocco), 52, 55, 56, 60–64
3 Sisters Adventure Trekking Company (Nepal), 134–37, 139
Tippy Tap water jug, 150
Toufiq, Ahmed, 55
Toul Krang (Cambodia), 180–81
tradeswomen, Nicaraguan, 4, 188–90, 192–93, 194–96
traditional medicine, 69–70, 71
Train Platform Schools (India), 162, 163–67
Transparency International, 172, 202
trekking guides, Nepalese women, 4, 133–37, 139–41
Trouillot, Magda, 216, *232*
Tumban Achimbom, Ngu Phebe, *204*, 204–5
Tuñez, Fabiana, 81, *81*, 87, 90, 97
Tutsis (Rwanda), 219
Tuttle, Toby, 4, 5, 27, 111

UN Development Program (UNDP), 130
UN Fourth Conference on Women (Beijing), 54, 172, 218
UN Gender Development Index (GDI), 39, 234
UN Human Development Index (HDI), 234
"La Única Mujer" (Peralta), 197
Unisono (Slovakia), 110–11
United States, 214–31
 MIUSA, 217–18, 220–21, 226–28
 water consumption, 146
 WILD, 4, 216, 218–19, 221, 223–28, 230–31, *232*
University of Bucharest, 200
University of Buenos Aires, 91
University of Mathew Bell (Banská Bystrica, Slovakia), 110
University of Northeast Brazil, 117
University of San Diego, 133
UN Millennium Development Goal, 146

Venegas, Alejandra, 231, *232*
Videla, Jorge Rafael, 80
Viet Nam, 28–39
 CEDAW ratified by, 39

CSAGA, 31–33, 36, 37, 38, 39
 domestic violence against women, 4, 32, 35, 36–37, 38, 39
 ethnic groups, 36
 My Hao district, 38
 Sharing Together Club, 34–37, 38
 Ta Xua commune, 36–37
Viet Nam War/American War, 35, 170
¡Viva Colores! (Gianturco), 4
Voice of Vietnam (radio network), 38
Voice of Women, 38

Wacey, Gill, 187
Wal-Mart, 177
"Watch Out" (Bomba), 23
water access/waterborne diseases, 5, 144–45, 146–47, 155. *See also* GWAKO
Wat Penh (Phnom Penh, Cambodia), 171, 177
Wearwel Cambodia Ltd., 179
Whirlwind Wheelchair International, 224
White House (Zimbabwe), 15
WILD (Women's Institute on Leadership and Disability; U.S.), 4, 216, 218–19, 221, 223–28, 230–31, *232*
Wilk, Christine, 223, *223*, *232*
Willamette Valley (Oregon), 216
Williams, Barbara, 217
Williams-Sheng, Barbara. *See* Williams, Barbara
Wilson, Camille, 216, 225, 230, *232*
Wilson, Margaret, 114, 116
witchcraft, 210
women
 with disabilities, 4, 217–18, 219–31
 health in Nepal, 136–37
 Hmong, 36–37
 music by, 96–97
 status/rights in Argentina, 80, 81
 status/rights in Brazil, 120, 124
 status/rights in Cambodia, 171, 172, 181
 status/rights in Ecuador, 77
 status/rights in Islam, 53, 54
 status/rights in Kenya, 146, 147
 status/rights in Morocco, 52–55, 56
 status/rights in Nepal, 132–33
 status/rights in Nicaragua, 186, 195
 status/rights in Slovakia, 110–11, 111
 status/rights in Viet Nam, 31, 35–36, 38, 39
"The Women's Code of Conduct" (Cambodia), 169, 174
Women's Institute on Leadership and Disability. *See* WILD
Women's Museum (Ha Noi, Viet Nam), 31, 35
Women's Network for Unity (Cambodia), 172, 174
Women's Park (Buenos Aires), 80
Women's Union (Viet Nam), 34, 36
Women with Disabilities (Ecuador), 225
Womyn's Agenda for Change (Cambodia), 174–76
World Social Forum, 77

Yaoundé (Cameroun), 200
Yashoda (Indian flutist), 167

Zanu PF (Zimbabwe), 19
Zengeza High School (Chitungwiza, Zimbabwe), 10
Zimba, Yvonne, 224, 230, *232*
Zimbabwe, 8–27
 child rape, 4, 11, 14, 18–19, 22, 24, 26, 27
 economy of, 10–11, 22
 Girl Child Network, 4, 10, 11, 14–15, 18–19, 22, 26–27
 Girl's Empowerment Villages, 10, 11, 26–27
 girls' school fees, 14, 15
 male role models, 26
 poetry/performance, 18, 23, 27
 sanitary napkins in, 14–15, 150
Zitan, Naima, *56*, 56–57, 61–65

WOMEN WHO LIGHT THE DARK

Published in the United States by powerHouse Books,
a division of powerHouse Cultural Entertainment, Inc.
37 Main Street, Brooklyn, NY 11201-1021
e-mail: info@powerHouseBooks.com
website: www.powerHouseBooks.com

First edition, 2007

Library of Congress Control Number: 2007929834

Hardcover ISBN: 978-1-57687-396-0

Printing and binding by Midas Printing, Inc., China

Creative direction by Kiki Bauer
Book design by Ioana Apostol
Cover design by Ariana Barry
Index by Roberts Indexing Services

A complete catalog of powerHouse Books and Limited Editions is available upon request;
please call, write, or visit our website.

10 9 8 7 6 5 4 3 2 1

Printed and bound in China

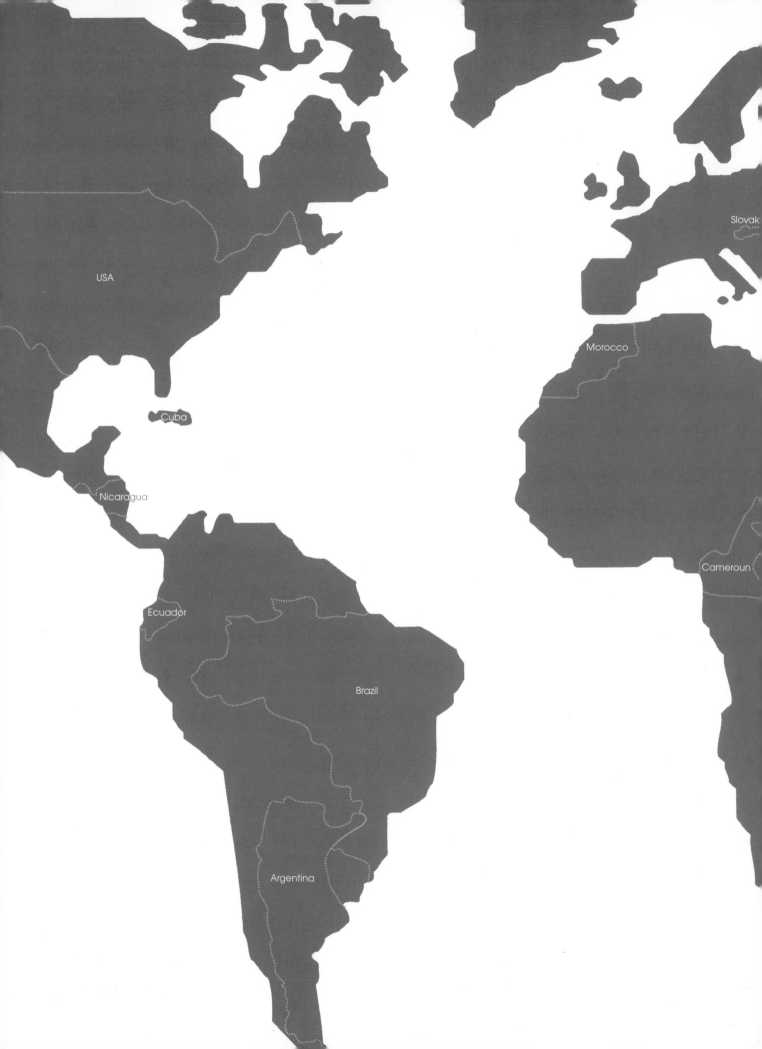